THE SPIRIT AND THE VISION
The Influence of Christian Romanticism on the Development of 19th-Century American Art

American Academy of Religion
Academy Series

edited by
Susan Thistlethwaite

Number 84
THE SPIRIT AND THE VISION
The Influence of Christian Romanticism
on the Development of
19th-Century American Art

by
Diane Apostolos-Cappadona

Diane Apostolos-Cappadona

THE SPIRIT AND THE VISION
The Influence of Christian Romanticism on the Development of 19th-Century American Art

Scholars Press
Atlanta, Georgia

THE SPIRIT AND THE VISION
The Influence of Christian Romanticism
on the Development of
19th-Century American Art

by
Diane Apostolos-Cappadona

Library of Congress Cataloging in Publication Data
Apostolos-Cappadona, Diane.
 The spirit and the vision : the influence of Christian romanticism
on the development of 19th-century American art / Diane Apostolos-
Cappadona.
 p. cm. — (American Academy of Religion academy series ; no.
84)
 Revision of thesis (doctoral).
 Includes bibliographical references (p.).
 ISBN 1-55540-974-1 (cloth). — ISBN 1-55540-975-X (paper)
 1. Art and religion—United States. 2. Romanticism and art—
United States. 3. Romanticism—Religious aspects—Christianity.
4. Art, American. 5. Art, Modern—20th century—United States.
I. Title. II. Series.
N7903.7.A66 1995
701'.04—dc20 94-7797
 CIP

Printed in the United States of America
on acid-free paper

For my parents

who raised me in the church of light
and who gave me my first sense of
the vision that is America

TABLE OF CONTENTS

LIST OF ILLUSTRATIONS

1. Eunice Pinney, *The Cotters Saturday Night*, © 1994. 1815. Pen and watercolor, 12 1/8 x 14 5/8 inches (.307 x .378). National Gallery of Art, Washington, D.C. Gift of Edgar William and Bernice Chrysler Garbisch. (1971.8330 [B-25657]/DR). c 1994 National Gallery of Art, Washington, D.C.

2. E.W. Clay, *The Methodist Camp Meeting*. Lithograph published in 1837 by H.R. Robinson. Collection of The New-York Historical Society, New York City. Courtesy of The New-York Historical Society.

3. Lydia Sigourney, *Teaching the Scriptures*, 1840. From Religious Souvenir from 1840, opposite page 154. Courtesy of the Department of Special Collections, Van Pelt-Dietrich Library, University of Pennsylvania, Philadelphia. (Sp-F263).

4. Raphael, *Madonna of the Chair*, 1510-1515. Oil on panel, 71 cm. diameter. Pitti Palace, Florence. Courtesy of Alinari/Art Resource, New York.

5. Benjamin West, *Portrait of Mrs. West and her Son Raphael*, © 1994. 1770. Oil on canvas, 36 inch diameter. Utah Museum of Fine Arts, Salt Lake City. Gift of The Merriner S. Eccles Foundation for The Merriner S. Eccles Collection of Masterworks, Permanent Collection, Utah Museum of Fine Arts, University of Utah. (1982.002.003). Courtesy of the Utah Museum of Fine Arts.

6. Sassetta(?) or "Osservanza Master" (Sienese School), *St. Anthony Tempted by the Devil in the Shape of a Woman*, 15th century. Egg tempera on panel, 14 7/8 x 15 13/16 inches. Yale University Art Gallery, New Haven. University Purchase from James Jackson Jarves. (1871.57).

7. Washington Allston, *Elijah in the Desert*, 1817-1818. Oil on canvas, 48 3/4 x 72 1/2 inches (123.8 x 184.2 cm.). Museum of Fine Arts, Boston. Gift of Mrs. Samuel Hooper and Miss Alice Hooper. (70.1). Courtesy, Museum of Fine Arts, Boston.

8. Washington Allston, *Moonlit Landscape*, 1819. Oil on canvas, 24 x 35 inches (61 x 88.9 cm.). Museum of Fine Arts, Boston. Gift of William Sturgis Bigelow. (21.1429). Courtesy, Museum of Fine Arts, Boston.

9. Washington Allston, *Beatrice*, © 1994. 1816-1819. Oil on canvas, 31 1/4 x 25 1/4 (76.8 x 64.1 cm.). Museum of Fine Arts, Boston. Anonymous Gift. (59.778). Courtesy, Museum of Fine Arts, Boston.

10. Washington Allston, *Miriam the Prophetess*, 1821. Oil on canvas, 65 x 48 1/2 inches. Collection of The William A. Farnsworth Library and Art Museum, Rockland.

11. Jean Honoré Fragonard, *A Young Girl Reading*, © 1994. 1776. Oil on canvas, 32 x 25 1/2 inches (.8111 x .648). National Gallery of Art, Washington, D.C. Gift of Mrs. Mellon Bruce in memory of her father, Andrew W. Mellon. (1961.16.1 [1653]/PA). c 1994 National Gallery of Art, Washington, D.C.

12. Washington Allston, *A Roman Lady Reading*, 1821. Oil on canvas, 30 x 25 inches. Collection of the Newark Museum. Purchase 1965 The Membership Endowment Fund. (65.35).

13. Thomas Cole, *The Course of Empire: The Savage State*, 1836. Oil on canvas, 39 1/4 x 63 1/4. Collection of The New-York Historical Society, New York. (1858.1). Courtesy of The New-York Historical Society.

14. Thomas Cole, *The Course of Empire: The Arcadian State*, 1836. Oil on canvas, 39 1/4 x 63 1/4 inches. Collection of The New-York Historical Society, New York. (1858.2). Courtesy of The New-York Historical Society.

15. Thomas Cole, *The Course of Empire: Consummation of Empire*, 1836. Oil on canvas, 51 x 76 inches. Collection of The New-York Historical Society, New York. (1858.5). Courtesy of The New-York Historical Society.

16. Thomas Cole, *The Course of Empire: Destruction*, 1836 Oil on canvas, 39 1/4 x 63 1/2 inches. Collection of The New-York Historical Society, New York. (1858.4) Courtesy of The New-York Historical Society.

17. Thomas Cole, *The Course of Empire: Desolation*, 1836. Oil on canvas, 39 1/4 x 61 inches. Collection of The New-York Historical Society, New York). (1858.3). Courtesy of The New-York Historical Society.

18. Thomas Cole, *The Oxbow* (The Connecticut River near Northampton), 1836. Oil on canvas, 51 1/2 x 76 inches. The Metropolitan Museum of Art, New York. Gift of Mrs. Russell Sage, 1908. (08.228). Courtesy of The Metropolitan Museum of Art, New York.

19. Thomas Cole, *View of Schroon Mountain, Essex County, New York, After a Storm*, 1838. Oil on canvas, 99.8 x 160.6 cm. © 1994 The Cleveland Museum of Art. Hinman B. Hurlbut Collection. (1335.17). Courtesy of The Cleveland Museum of Art.

20. Thomas Cole, *The Notch of the White Mountains*, (Crawford Notch), 1840. Oil on canvas, 40 x 61 1/2 inches (1.016 x 1.560). National Gallery of Art, Washington, D.C. Andrew W. Mellon Fund. (1967.8.1 [2328]/PA). © 1994 National Gallery of Art, Washington, D.C.

21. Thomas Cole, *The Mountain Ford*, 1836. Oil on canvas. 28 1/4 x 40 inches. The Metropolitan Museum of Art, New York. Bequest of Maria De Witt Jessup, 1915. (15.30.63). Courtesy of The Metropolitan Museum of Art, New York.

22. Albrecht Dürer, *Knight, Death and the Devil*, 1513. Engraving (Meder 74), .246 x .188. National Gallery of Art, Washington, D.C. Gift of W.G. Russell Allen. © 1994 National Gallery of Art.

23. Thomas Cole, *The Hunter's Return*, 1845. Oil on canvas, 40 1/8 x 61 1/2 inches. Amon Carter Museum, Fort Worth. (1983.156). Courtesy of the Amon Carter Museum of Art, Fort Worth.

24. Thomas Cole, *The Return*, 1837. Oil on canvas, 39 3/4 x 63 inches (100.97 x 160.02 cm.). In the collection of The Corcoran Gallery of Art, Washington, D.C. Gift of William Wilson Corcoran. (69.3). Courtesy of The Corcoran Gallery of Art, Washington, D.C.

25. Thomas Cole, *The Cross in the Wilderness*, 1845. Oil on canvas, 0,610 x 0,617 (0,61 diameter). Louvre, Paris. (R.F. 1975-9). Courtesy of Giraudon/Art Resource, New York.

26. Thomas Cole, *The Voyage of Life: Childhood*, 1842. Oil on canvas, 52 7/8 x 77 7/8 inches (1.343 x 1.977). National Gallery of Art, Washington, D.C. Ailsa Mellon Bruce Fund. (1971.16.1 [2550]/PA). © 1994 National Gallery of Art, Washington, D.C.

27. Thomas Cole, *The Voyage of Life: Youth*, 1842. Oil on canvas, 52 7/8 x 77 7/8 inches (1.343 x 1.977). National Gallery of Art, Washington, D.C. Ailsa Mellon Bruce Fund. (1971.16.2 [2551]/PA). © 1994 National Gallery of Art, Washington, D.C.

28. Thomas Cole, *The Voyage of Life: Manhood*, 1842. Oil on canvas, 52 7/8 x 77 7/8 inches (1.343 x 1.977). National Gallery of Art, Washington, D.C. Ailsa Mellon Bruce Fund. (1971.16.3 [2552]/PA). © 1994 National Gallery of Art, Washington, D.C.

29. Thomas Cole, *The Voyage of Life: Old Age*, 1842. Oil on canvas, 52 7/8 x 77 7/8 inches (1.343 x 1.977). National Gallery of Art, Washington, D.C. Ailsa Mellon Bruce Fund. (1971.16.4 [2553]/PA). © 1994 National Gallery of Art, Washington, D.C.

30. James Smillie after Thomas Cole, *The Voyage of Life: Youth*, 1849. Private Collection.

31. Frederic Edwin Church, *Niagara*, 1857. Oil on canvas, 42 1/2 x 90 1/2 inches (107.95 x 229.87 cm.). In the Collection of The Corcoran Gallery of Art, Washington, D.C. Museum Purchase, Gallery Fund, 1876. (76.15). Courtesy of The Corcoran Gallery of Art, Washington, D.C.

32. Frederic Edwin Church, *The Heart of the Andes*, 1859. Oil on canvas, 66 1/8 x 119 1/4 inches. The Metropolitan Museum of Art, New York. Bequest of Mrs. David Dows, 1909. (09.95). Courtesy of The Metropolitan Museum of Art, New York.

33. Frederic Edwin Church, *Twilight in the Wilderness*, 1860. Oil on canvas, 40 x 64 inches. © 1994 The Cleveland Museum of Art. Mr. and Mrs. William H. Marlatt Fund. (65.233). Courtesy of The Cleveland Museum of Art.

34. Frederic Edwin Church, *The Icebergs*, 1861. Oil on canvas, 64 1/2 x 112 3/8 inches. Dallas Museum of Art. Foundation for the Arts, anonymous gift. (1979.28). Courtesy of the Dallas Museum of Art.

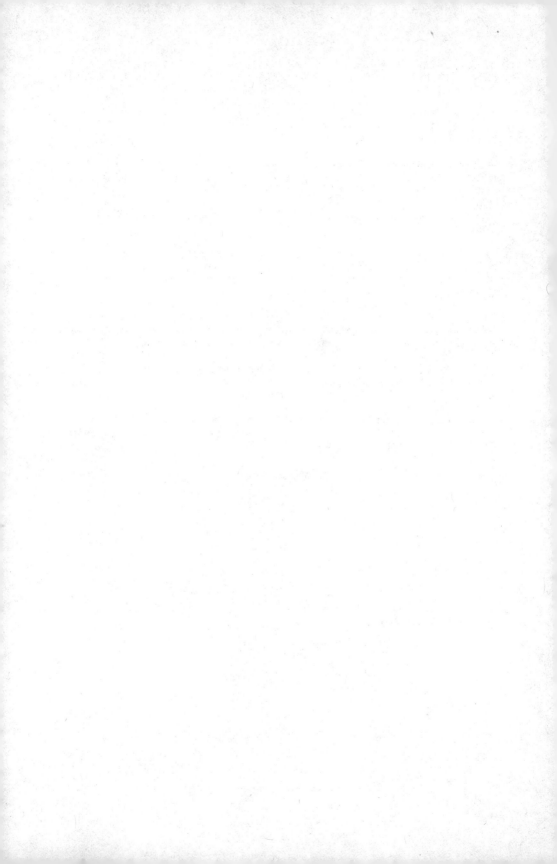

ACKNOWLEDGMENTS

No scholarly endeavor is a singular achievement; the emotional and intellectual support provided by one's academic family permits survival of the pitfalls and discoveries of research and writing. I am fortunate to be a member of an academic family that has nurtured both my doctoral dissertation and this revision. Research librarians are crucial to any scholarly project. I am pleased to acknowledge the assistance offered me at the Alderman Library, University of Virginia; Archives of American Art; Archives of the Episcopal Church; Archives, The Cleveland Museum of Art; Archives, Episcopal Diocese, Boston; Archives, First Church of Cambridge, Congregational; Archives and Department of Painting, Louvre Museum; Bancroft Library, The University of California, Berkeley; Beinecke Rare Book and Manuscript Library, Yale University; The Boston Athenaeum; The Cambridge Historical Society; The Connecticut Historical Society; Flora Lamson Jewett Library, Graduate Theological Union; Graduate Library, The University of California, Berkeley; Greene County Historical Society; Hawthorne-Longfellow Library, Bowdoin College; Houghton Library, Harvard University; Lauringer Library, Georgetown University; Massachusetts Historical Society; Munson-Williams-Proctor Institute; National Gallery of Art Library; National Museum of American Art Library; The New-York Historical Society; New York Public Library; Archives, Olana State Historic Site, Hudson; St. John's Episcopal Church, Ionia, Michigan; Sterling Memorial Library, Yale University; Stowe-Day Foundation; Surrogate Court, Greene County Courthouse; Thomas Cole Foundation; Vassar College Library; and Watkins Library, The Metropolitan Museum of Art.

During the course of my research, I attended three special symposia: "The Thomas Cole Symposium," Trinity College, Hartford, November 1983; "Insight and Inspiration. The Italian Presence in American Art: 1760-1860," Fordham University, November 1987; and "American Paradise: Aspects of Hudson River School Paintings," The Metropolitan Museum of Art, New York, December 1987. I am grateful to both the sponsors and the scholars of these symposia who willingly shared their research-in-progress. The revision of *The Spirit and The Vision* from a doctoral dissertation into a book benefited from a Research Grant from the American Academy of Religion (1990), a Grant-in-Aid-of-Research from the American Council of Learned Societies (1989), and a Travel-to-Collections Grant from the National Endowment for the Humanities (1990). These funds supported additional research on American ministerial collections and patronage, and the history of the first books on Christian art.

All the manuscript and nineteenth-century publications cited in this text are authentic to the original materials. Idiosyncratic punctuation, erratic grammar, and misspellings have been retained to preserve the character of the original texts. This is especially true for the transcripts of handwritten manuscripts by Louis Legrand Noble and Frederic Edwin Church.

Lillian B. Miller, the director of my doctoral dissertation, offered her time, critical counsel, and her own scholarship as a model for intellectual inquiry and professional integrity. The "outside" examiner of my doctoral committee, R. Laurence Moore, provided an extensive critique of both my dissertation and this revision. I am grateful to the "anonymous readers" of the dissertation I submitted to The Academy Series for their constructive reports. Although I have received much support in the writing of *The Spirit and the Vision*, any errors in interpretation or fact are strictly my own.

This book, like the dissertation from which it evolved, is dedicated to my parents who in the tradition of the *Upanishads* were my first teachers. Their mutual love for nature, American art, and the vision that is America are reflected in the themes of this text. Their greatest gift to me was the freedom and the unceasing support to pursue a life in the academic world.

Georgetown University
Washington, D.C.
December 1993

INTRODUCTION

Signifying the enthusiasm of a new generation of Americans, John F. Kennedy proclaimed,

> I look forward to an America which will steadily raise the standards of artistic accomplishment and which will steadily enlarge cultural opportunities for all of our citizens. And I look forward to an America which commands respect throughout the world not only for its strength but for its civilization as well.[1]

Unlike the thirty-fifth President, America's earliest statesmen and citizens were more attentive to the pragmatic requirements of the new nation. Their concern, if any, for the arts was, to say the least, peripheral. Benjamin Franklin counseled: "To America, one schoolmaster is worth a dozen poets, and the invention of a machine or the improvement of an implement is of more importance than a masterpiece by Raphael."[2] Yet in less than one hundred years, on the eve of Civil War, Americans identified themselves as having a distinctive culture a keystone of which was the emergence of an identifiable American art. A visual communicator of cultural values, American art found that religion was a central element of American culture.

The parallel, yet interdependent, emergence of Christian Romanticism in American art and religion was integral to the transformation of middle-class values. I have differentiated this middle-class mode of American Protestantism, that is, Christian Romanticism from the Second Great Awakening and from Transcen-dentalism. In contrast to the first, it placed emphasis upon nurture, education, and process in religious experience rather than sudden conversion; in contrast to the second, it remained Christocentric, ecclesiastical, and interpreted nature as symbolic of the divine rather than

itself being divine. As a mode of American Protestantism in the middle years of the nineteenth century, Christian Romanticism was a response to the social changes within American culture including women's literacy, spiritual domesticity, and the idealization of childhood. The period from 1820 to 1860 witnessed an ideological and theological permutation intrinsic to the dramatic progress generated by basic socio-political changes. The cultural identity crisis of this period revolved around the question, "What does it mean to be an American?" Christian Romanticism played a central role in the answers of antebellum middle-class America.

To clarify this theological posture in antebellum American culture, the careers and writings of Horace Bushnell (1802-1876) and Henry Ward Beecher (1813-1887) are examined. Both derived their thought ultimately from Samuel Taylor Coleridge. They and other like-minded clergymen characteristically encouraged art as a means of religious pedagogy and inspiration. More an informal mode of thought than a formalized theological system, Christian Romanticism denied denominational boundaries by stressing the importance of personal religious experience and the living of the Christian life over ritual practices and creedal affirmations. One of the distinguishing characteristics of this theology was its emphasis on intuition and an idealization of the family, especially of motherhood. Christian Romantics, like Bushnell and Beecher, argued that Christian living must be freed from creedalism and dogmatism. Advocating the freedom and responsibility of the individual to live a Christian life, they minimalized sacramentalism and ritualism, and emphasized nurture. As a prescientific and critical mode of theological inquiry, Christian Romanticism established the foundation for modern social ideas by stressing ethics, practicality, and pragmatism. In its celebration of the American way of life, these theologians revitalized the early Christian tenets of a God who acted in history and the concept of kingdom building.

Christian Romanticism refocused American Protestantism from a Christ who was Judge and Redeemer to a Jesus who was a moral teacher. Commensurately, this new formulation of American Protestantism translated childhood depravity into childhood innocence, and ritual and rubrics (however minimal) into ethics. Additionally, the transformation of the individual Christian from one totally dependent upon God's salvific grace into a partner in the process of salvation was simultaneously liberal but limited. A Christian Romantic interpretation of the individual did not espouse the limitless potential of the human or the anthropocentricism identified with Romanticism. Rather, the romantic interpretation of the human person was modified by a recognition of both fallibility and finitude. Further, the

individual did not exist or operate within a vacuum, but within a community. For the Christian Romantic, the religious center of that community was transferred from the ecclesiastical edifice to the Christian home.

Following Coleridge's *Aids to Reflection*, Christian Romantics perceived the human person as subject to a continuing process of development. They interpreted revelation as a series of unfolding moments of illumination or divine wisdom, not as one all-encompassing and dramatic conversion experience. In acknowledging the supernatural character of revelation and miracles, they interpreted nature as symbolic of, but not synonymous with, God. Christian Romanticism in antebellum middle-class American culture, through the theologies of Bushnell and Beecher, supported a Christianity based on God's gift of love and on the family as an ideal instrument for fostering true Protestantism.

Both as a theological and a religious system, Protestantism stressed literacy. The theological import of "the Word" and therefore of a literate laity were distinctive characteristics of the Reformation tradition. In its American modes, Protestantism advocated a laity that regularly studied the bible in a familial context (fig. 1). By the nineteenth century, American Protestantism's educational interest assumed wider ramifications with the establishment of Christian organizations such as the American Tract Society and the American Bible Society (1816) which published Christian almanacs, bimonthly Christian magazines, and Christian children's books, disseminated bibles, and the formal establishment of the American Sunday School Union (1824), thus insuring the Christianization of America.

This "Christianization" was specifically Protestant as the fundamental American fear of "Romanism" or "Catholicism" was another factor in the east coast American Protestant support of the dissemination of books and education. The Rev. Orville Dewey noted that "the great effort...to establish Sunday schools in the Valley of the Mississippi" arose from a misapprehension "concerning the spread of the Catholic faith in the United States." Acknowledging that this increase had been "occasioned by emigration...or by the natural growth of population," and not by "progress", or conversions, he was cognizant of the theological errors of Catholicism, and believed that "there is a spirit in our institutions which will sooner or later control the power, and correct the errors, of every sect." At the last, the clergyman argued, this "growing strength of the Catholic interest" would be countered by "the growing candor...of the Protestant world", and result in a healthful examination of the claims and the forms of Christianity.[3]

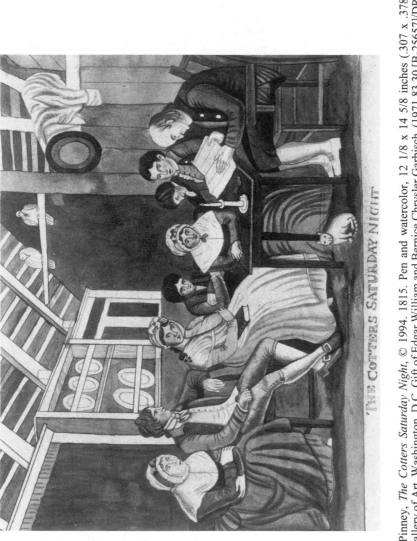

THE COTTERS SATURDAY NIGHT

1. Eunice Pinney, *The Cotters Saturday Night*, © 1994. 1815. Pen and watercolor, 12 1/8 x 14 5/8 inches (.307 x .378). National Gallery of Art, Washington, D.C. Gift of Edgar William and Bernice Chrysler Garbisch. (1971.83.30 [B-25657]/DR). © 1994 National Gallery of Art, Washington, D.C.

On the more formal level of education, American Protestantism which had established primary and secondary schools during the colonial period conceded them to public control between 1820 and 1860. In their place, the churches advocated the ideal of private, i.e., denominational, sponsorship of higher education.[4] Such ecclesiastical interest in higher education resulted in both an educated ministry for the church and a classical education for the professions. A major legacy of the Second Great Awakening was the institutionalization of Christian education and its promotion to all levels of American society.

The cultural implications of the Second Great Awakening surfaced throughout the 1830s and 1840s. This period of rapid development and growth in all aspects of American culture was symbolized by the movement from a colonial to a national economy, from a household to an industrial work force. As the focus of the American economy began to shift from agriculture to industry, lifestyles and domestic styles were necessarily re-structured as husbands and fathers no longer worked at home. As families became less dependent upon their land and their home activities for income, they became more dependent upon salaries. Simultaneously from the 1820s into the 1840s, there was a shift in the sources of domestic help from American farm girls to female immigrants from Ireland, and later in the century from the southern and eastern European countries.[5] Such a source of available "cheap" but good labor would later have repercussions in the anti-papist fears of the late 1840s and 1850s.

Changes in the role of the American homemaker were evidenced by the profusion of kitchen and household utensils, and changes in the style of American cuisine, especially in the variety of cookbooks, during the antebellum period. These technological and cuisinary advances increased the means by which middle-class American women created a good home and leisure time.[6] For some middle-class women, freed from chores by tech-nology and servants, leisure time became a reality. With fathers home less and mothers less occupied with chores, the religious and educational nurture of children fell to mothers.[7]

These economic and domestic transformations were paralleled in the religious sphere. Clerical disestablishment was finalized in 1833 when Massachusetts voted to cease state support of Congregationalism. A triumph for the competitive, commercial, and individualistic spirit that was defined then as "American," disestablishment removed a traditional source of stable revenue for ministers and churches. Shifting economic and political patterns infringed upon the structures of American Protestantism as disestablished ministers became subject to the whims and tastes of their congregations.

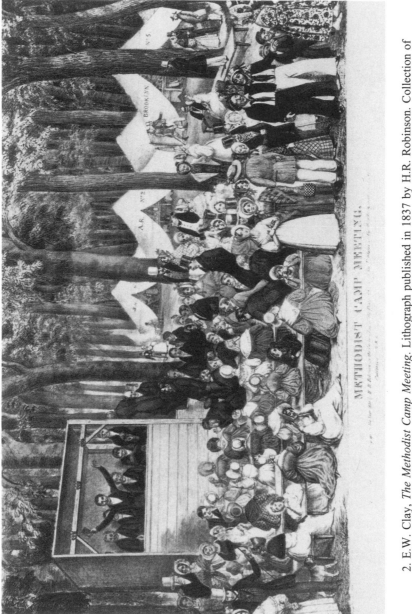

2. E.W. Clay, *The Methodist Camp Meeting.* Lithograph published in 1837 by H.R. Robinson. Collection of The New-York Historical Society, New York. Courtesy of The New-York Historical Society.

Ministerial mobility increased as financial security and geographical stability waned. The great age of preaching (fig. 2) was ushered in as ministers sought to draw bigger and bigger crowds at their Sunday sermons, not with the primary intention of saving those souls but of increasing their collections. Popular preachers brought in financial resources toinsure both their salaries and church expenditures.

Ann Douglas examined the situations of these disestablished ministers and middle-class women of antebellum America. These two "disestablished" groups formed an alliance which brought about major theological and societal changes in nineteenth-century America. As American culture became feminized, American Protestantism softened its patriarchal bias and began to advocate the maternal dimensions of religious experience and practice.[8] This move towards a domestic spirituality is analogous to the shift Perry Miller identified as that from an Old Testament to a New Testament theology (fig. 3).[9]

Further the simultaneous development of "the popularization of knowledge"[10] resulted in the development of American publishing through the first penny newspaper (1833) and inexpensive books and magazine, such as Godey's *Lady Book* (1830). The establishment of the public library system paralleled the changes in the educational system. America was evolving into the land of the free, the brave, and the literate. Disestablished clerics and disestablished middle-class women became the leading proponents and consumers of this new American literacy.

The changing status of these middle-class women had implications for both the domestic and the religious spheres. There was a direct correlation between the expanded maternal role in the familial structure and the increased role of women in the church. As mothers became "nurturers" in the home, they found themselves the attendant majority in the church's congregation. Women began to enter the educational professions as primary and secondary school teachers. The introduction of female teachers both had an intellectual climate brought about by Romanticism advocated a kinesthetic immersion in the world whose developmental scheme supported progress over tradition, the idealization of childhood, and new styles of Christian theology.

The idealization of childhood played a crucial role in middle-class American culture and religion. This ideal of the child and of childhood was popularized by the romantic poetry of William Wordsworth and Samuel Taylor Coleridge, especially in their *Lyrical Ballads*, which were well known in the United States. In the traditional Puritan view, a child was a depraved and ignorant creature, guilty with the stain of Adam's sin. At some climactic

3.Lydia Sigourney, *Teaching the Scriptures*, 1840. Illustration opposite page 154, *Religious Souvenir for 1840*. Courtesy of the Department of Special Collections, Van Pelt-Dietrich Library, University of Pennsylvania. (Sp-F 263).

moment, appropriately around puberty, a child experienced a resounding and undeniable moment of grace and became "converted" to God's love. From that day forward, the child was no longer a child but an adult who accepted adult responsibilities and was a true Christian. For the romantic, however, the child though perhaps tainted by Adam's sin was a miraculous sign of God's gifts and eager for parental nurture. This idealized image of the child reflected the romantic principle of organicism in its emphasis on the gradual unfolding of the human personality and of the Christian faith.[11] The idealization of childhood entered American culture at the same time as the promotion of Christian knowledge through the Sunday School Movement, the development of public education, the cult of true womanhood, and the disestablishment of the clergy.[12]

Romanticism's emphasis on the new was transformed in the American context to the ideal of the virgin land untouched and unsullied by either history or humanity. Nature had its own momentum and was capable of providing meaning, possibilities, and religious attitudes once it was freed of traditional historical associations. Americans replaced the worn-out legacy and historic associations of Europe with the virgin land of their own wilderness. For the Christian Romantics, the Virgin Land once transformed into Nature symbolized the Paradise Garden regained and signified God's actions in human history. As opposed to the Transcendentalist sense of timelessness in nature, the Christian Romantics interpreted nature as the dramatic setting for the unfolding of God's universal plan. The search for a visual icon for this new identity led middle-class Americans to turn to the landscape and to the eventual identification of America with the Garden of Eden. The emergence of an indigenous landscape tradition in nineteenth-century American painting fused philosophically with the kinetic interpretation of nature, theologically with the Christian Romantic reformulation of America into the kingdom of God on earth, and politically with the new nationalism. These new middle-class attitudes were celebrated in art and literature.

Christian Romanticism developed concurrently with landscape painting in America. The emergence of an American landscape tradition that was both rhetorical and historical had affinities to and was influenced by Christian Romanticism. Among those artists who were influenced by this new romantic fervor were Washington Allston (1779-1843), Thomas Cole (1801-1848), and Frederic Edwin Church (1826-1900). For each of these artists, the discussion focuses on the artist's self-interpretation; visual affinities to Christian Romanticism; relationships with clergy; and individual religious interpretations of the American landscape. These three artists shared common bonds in their understanding of the artist as social and moral teacher, of the didactic role

of art in society, and of a God who acted in history. Although the Christian character of these artists was obvious, the exact nature of their spirituality has never been identified as other than Protestant. Modern scholars have recognized that none of these three painters can appropriately be labelled a Luminist painter or a Transcendentalist Christian. Their relationships with each other and with the theology espoused by two leading contemporary clergymen established a matrix for a Christian Romantic reading of their art. The art of Allston, Cole, and Church expressed and served the dominant middle-class religious ideology of the time, Christian Romanticism, as distinct from the more elitist and regional work of the Transcendentalist writers and Luminist painters. Analyses of the major paintings of these three artists clarifies the affinities and influences that existed between the religious and the artistic in Jacksonian and pre-Civil War America.

American clergymen, including both Christian Transcendentalists and Christian Romantics, were the leaders of culture and arbiters of social values in the antebellum period. As the chief articulators of the ideals of culture and morality, Christian Romantic ministers presented an argument for the integration of art, nature, and religion. A survey of the published and unpublished writings of these men argues for a larger cultural and social milieu supported by the tenets of Christian Romanticism than might be evident from a study of Bushnell's and Beecher's texts. These ministers were joined in the creation of an American culture by the moral arbiters of that society--the mothers of the middle class. Together these artists, ministers, and mothers refocused Protestantism as central to the self-definition of antebellum America.

ENDNOTES

1. *John F. Kennedy 1917-1963: Chronology, Documents, Bibliographical Aids* ed. Ralph A. Stone (Dobbs Ferry, N.Y.: Oceana Publications, Inc. 1971), p. 23.

2. Quoted in Lillian B. Miller, *Patrons and Patriotism. The Encouragement of the Fine Arts in the United States, 1790-1860* (Chicago: University of Chicago Press, 1966), p. 13.

3. Orville Dewey, *The Old World and the New; of, A Journal of Reflections and Observations Made on a Tour in Europe* (New York: Harper Brothers, 1836), Vol. I, p. 154.

4. During the antebellum period, the College Founding Society began the establishment of western colleges along the models of Yale and Princeton. Of the 516 colleges and universities established prior to the Civil War, only a handful had no religious affiliation or foundation. See Winthrop S. Hudson, *Religion in America* (New York: Charles Scribner's Sons, 1965), pp. 155-6.

5. Glenna Mathews, "Just a housewife." *The Rise and Fall of Domesticity in America* (New York: Oxford University Press, 1987), p. 95.

6. Ibid., pp. 10-11. See Mathews's discussion of the parallel developments of cookbooks with sentimental novels, and needlework magazines with women's magazines; see p. 17.

7. See Colleen McDannell, *The Christian Home in Victorian America, 1840-1900* (Bloomington: Indiana University Press, 1986), and Ann Douglas, *The Feminization of American Culture* (New York: Avon Books, 1978 [1977]), for more in-depth studies of the effects of industrialization upon the domestic structure of the American family.

8. Douglas, *The Feminization of American Culture*, esp. Chapter 3, "Ministers and Mothers," pp. 94-139.

9. Perry Miller, "The Garden of Eden and the Deacon's Meadow," *American Heritage* 7.1 (1955): 58. See also McDannell, *The Christian Home in Victorian America*, p. 107.

10. See Merle Curti, *The Growth of American Thought* (New York: Transaction Press, 1951 [1943]), pp. 335-57.

11. "Organicism" is a difficult term to define. Organicism is herein understood as the fundamental principle of growth and development in romantic philosophy. Each part of the human body, the person as an individual, and the person in the context of the family and the larger communities, was governed by the principle of organicism. It was the romantic principle of the connection of the parts to, within, and with the whole. Simultaneously, organicism denoted an internal energy or dynamism which propelled the organic developments and relationships to occur. Organicism was the symbolic expression of the romantic quest for unity.

12. Degler, *At Odds*, p. 74.

CHAPTER I

The Emergence of Christian Romanticism
in Antebellum America

Coleridge's *Aids to Reflection* and Christian Romanticism in America

Although better known to twentieth-century readers as a poet and *litterateur*, in antebellum America Samuel Taylor Coleridge was acknowledged as a philosopher and a theologian.[1] In particular, Coleridge's Aids to Reflection, published in an American edition in 1829 with a prefatory preliminary essay by the then President of the University of Vermont James Marsh, played a significant role in the development of antebellum American intellectual and religious thought.[2] Although its influence was not immediately felt, the success of *Aids to Reflection* was assured when the American edition required a second printing in four months. Within the decade, the popularity of *Aids to Reflection* was indicated by the simple fact that it was difficult to keep Marsh's edition stocked in some bookstores. In 1853, W.G.T. Shedd published the first American edition of Coleridge's collected writings which became the standard American text for more than a century.[3]

Not all American intellectuals and theologians responded to Coleridge's texts or ideas with enthusiasm. In 1819 Richard Henry Dana, Sr., a good friend of Marsh's and the future father-in-law of Washington Allston, broke his relationship with *The North American Review* when other members of the editorial board objected to his championing of Wordsworth, Byron,

and Coleridge.[4] In 1847 Noah Porter, Jr., a professor and eventually president at Yale College, acknowledged the British poet's influence as a Christian philosopher noting his assertion of Christianity to its true dignity, his recognition of the indispensable importance to theologians of a sound and scientific philosophy of man, and his development of a new method for theological inquiry. Porter's lengthy analysis of this influence on the American theological community evidenced no geographical restriction to New England.[5] Further interest in this theology was not limited to a single Protestant denomination. Like the romantic impulse, Coleridge's ideas ran the gamut of American Protestantism.

The attraction of *Aids to Reflection* was its personal and spiritual tone. One of the central themes of all of Coleridge's texts was the relationship between Understanding and Reason. He explained that "the CHRISTIAN FAITH (in which I include every article of belief and doctrine professed by the first Reformers in common) IS THE PERFECTION OF HUMAN INTELLIGENCE."[6] The Understanding was concerned with the phenomenal world of sense-perception. This mode of thought was identified as "scientific", that is to say, it separated, analyzed, measured, classified; judged by cause and effect; and was concerned with the means rather than the ends. On the other hand, the Reason was concerned with the religious and the poetic, it was an intuitive knowing that transcended time and space. Through the Reason human beings discerned the spiritual unity and the spiritual reality of what was known by the Understanding. Coleridge's distinction between Understanding and Reason was similar to his distinction between Imagination and Fancy. Reason involved Imagination. The imaginative process was part of human reason. Like Imagination, Reason had the special function of seeing the whole in the parts and of comprehending the parts as a whole. Both Reason and Imagination had the power to identify with the reality beyond the senses such as the knowledge of other selves and of God.

For Coleridge, Reason was fundamentally moral. As such, Reason included the moral sense or the conscience which was the synthesis of reason and the will. Therefore to know the good inherently meant to do the good. At its highest level, Reason was fidelity which required an act of the apprehension of spiritual truth. For Coleridge as distinct from Schleiermacher, Kant, Hegel, and Schelling, "Christianity is not a theory, or a speculation...but a life and a living process."[7] There was a logical progression in this program from the acknowledged religious needs of human beings through the moral sense to the pragmatic dimension of lived experience. So in the reading of text, the reader moved from "Prudential Aphorisms" to "Moral and Religious Aphorisms" to "Aphorisms on Spiritual Religion." The

reader became the subject of the text as a form of religious thinking and spiritual experience was elicited through the act of reading. For Coleridge's readers, the intellectual path became experiential and spiritual. *Aids to Reflection* was simultaneously the author's spiritual autobiography and the reader's grammar of assent for "Christianity is not a theory, or a speculation; but a life;--not a philosophy of life, but a life and a living process...TRY IT."[8]

What Coleridge identified as Reason, the Romantics called the Heart. His explications initiated a new hermeneutic of the human person, Nature, and the God-human relationship. Human beings were more than rational creatures, and Nature was more than the world of inanimate objects. An intuitive sense of the divine had been implanted in human beings by God. By means of this sense, that is Coleridge's Reason, human beings were capable of the direct perception of supernatural truths. Through Reason, human beings received moral law which emanated from the universal core through Nature. Hence, the possibility of an apprehension of God through Nature. The question was simply how such an apprehension was to be defined.

In the American context, the Emersonian Transcendentalists and the Christian Romantics, both of whom claimed lineage from Coleridge, attested to different explanations of this apprehension. For the Emersonian Transcendentalists, the highest form of spiritual communion between God and the human person was this apprehension of direct perception through the inner eye of the human soul of God as Nature. Whereas, on the other hand, for the Christian Romantics, the spiritual affectivity of a symbol and of symbolic language was empowered by Coleridge's understanding of Reason and Nature, and therefore knowledge of Nature was an apprehension of the symbolic presence of God. Despite the theological variations, Coleridge influenced the middle-class religious and spiritual attitudes of antebellum America.

Bushnell's Christian Nurture: Developing a Christian Romantic Theology in the Age of Spiritual Domesticity

With the publication of the first edition of *Discourses on Christian Nurture* in 1846, Horace Bushnell emerged as a leading spokesman in the Congregationalist Church.[9] From 1833 to 1847, his own sense of Christianity and the Christian faith was "nurtured" through his daily experiences as a pastor and his spiritual development from reading Coleridge's *Aids to Reflection*. As Bushnell's religious thinking developed, a survey of his sermons indicated an emphases on those issues crucial to *Discourses on*

Christian Nurture--the revivals, social change, industrialization, revelation, gradualism, organicism, original sin, and baptism. Denouncing the overemphasis on individualism and dramatic conversion experience prevalent in the theologies of his youth such as that preached by Nathaniel Taylor, Bushnell found that the "organicism" and "unfolding development of faith" discussed in Coleridge's *Aids to Reflection* to be commensurate with both the popular sentiments of his community and his own personal faith. As with Coleridge's volume, Bushnell's texts were singled out for their experiential authenticity.

The seeds of Bushnell's texts and religious thinking were formally presented for the first time in the pamphlet entitled *Discourses on Christian Nurture*. After the controversies over its original publication in 1846, his *Views of Christian Nurture* was published in 1847.[10] Bushnell's later texts were interpreted as extrapolations and defenses of his earlier position as he dealt with the continual relationship between Protestantism and American culture, the role of the family, and his embodiment of Coleridge's ideas, especially in terms of human development and language. Specifically such books as *God in Christ* (1849), *Christ in Theology* (1851), and *Nature and the Supernatural* (1858) represented a more than typical nineteenth-century interest in Christology since the center of Bushnell's theological enterprise was the idea of Atonement.[11] A similar theological interest was discernible in *Discourses on Christian Nurture* whose pragmatic and theological response to the changing structures and values of middle-class America identified it as the Congregationalist preacher's fundamental contribution to American cultural history.

Throughout his professional life as a minister and as a theologian, Bushnell acknowledged his intellectual and spiritual debt to Coleridge,[12] whose *Aids to Reflection* influenced the American minister's development of his ideas of Christian nurture. They shared a common interest in language, especially in an understanding of language's experiential and symbolic properties. Seeking to examine why words were symbolic and how language operated, Bushnell attempted to replace his "country language" with one appropriate to his theological and pastoral purposes. Finding Coleridge's discussion of the gradual unfolding of faith and of spiritual experience valid, Bushnell understood his varied "conversions" through the British thinker's explication of organic nature and the gradual process of religious thinking.

The spiritual tone and experiential foundation of *Aids to Reflection* formed an accepted mode of autobiographical discourse within both the Christian and American traditions. The self-reflective nature of Coleridge's language and methodology forged another bond with Bushnell. Coleridge's

fundamental commitment to an ecclesiastical institution and to a modification of the traditional Calvinist tenet of human depravity to one of human fallibility, made him, like Bushnell, a mediator between Protestantism and romanticism. Further, they shared an understanding of the role of aesthetic discernment, and its relationship to moral action, together with a romantic sensibility towards symbol and methods of interpretation of symbol.[13]

In Coleridge's *Aids to Reflection*, Bushnell found more than a model for the mediation of Protestantism, romanticism, and contemporary American culture. He also found a methodology and hermeneutic to express his interpretation of Christian Romanticism as an appropriate religious style for the American middle class. Bushnell's texts evidenced his responsiveness to the cultural shifts in middle-class lifestyles, so that *Christian Nurture* survived the transition from controversial to traditional theological texts.[14] A central theme of Views of *Christian Nurture* was the organic role of the family in the socialization of each child into the Christian faith. Such familial responsibility was a natural reflection on the American theologian's own childhood and his own role as a parent. His nurturing family was empathetic to the idealized interpretation of the child in process of Christian development rather than predestined as a sinful creature.

However, Bushnell did not completely subscribe to the idealization of childhood in the manner of the Emersonian and Unitarian Transcendentalists neither did he accept the traditional Calvinist teaching of natural depravity.[15] The Transcendentalist interpretation, as he understood it, argued that the child's state of innocence placed the child, not the adult, closest to God. The romantic emphases on human reason, goodness, and educability delineated a positive reading to human nature. The child as the exemplary human being was not only closer to God but became also the paradigm for salvation. Simultaneously, the child was responsible for his or her own intellectual and spiritual development.

On the other hand, Bushnell was opposed to the traditional Calvinist position as interpreted in the revivals and dramatic conversions popularized during the Second Great Awakening. Children were neither totally depraved and ignorant creatures indelibly tainted with Adam's sin, nor were they solely dependent upon God's forgiving grace. Like Coleridge, The younger American represented a median position within the boundaries of the Protestant tradition and with the modernizing influences of romanticism.

For Bushnell, the fundamental goodness of the child's mind and heart "is implied in a Christian state."[16] He defined the meaning and purpose of "Christian nurture" as,

> What is the true idea of Christian education?--I answer in the following proposition, which it will be the aim of my argument to establish, viz.:

That the child is to Grow Up Christian. In other words, the aim, effort and expectation should be, not as is commonly assumed, that the child is to grow up in sin, to be converted after he comes to a mature age; but that he is open on the world as one that is spiritually renewed, not remembering the time when he went through a technical experience, but seeming rather to have loved what is good from his earliest years.[17]

The sensibility, principles, and language employed in his discussions of the nature of the child and of the role of education were shaped by Coleridge. Although there was no primary evidence to attest to Bushnell's reading of any other Coleridge text than *Aids to Reflection*, the British thinker's ideas on education and on childhood were well known in antebellum America and may have come to the younger minister through various published excerpts and discussions in journals.[18]

Coleridge's writings on education were scattered references in such diverse texts as *Aids to Reflection*, *Biographia Literaria*, *The Friend*, *Lay Sermons*, *Miscellaneous Criticism*, and *Shakespearean Criticism*.[19] Although a Romantic perspective governed his interpretation of the child and of education, his actual formulations were distinct and identifiable from the more generalized idealization of childhood. The Romantics' interest in human growth and development naturally evolved into the adulation of the child as a central symbol in romantic literature.[20] Education was a natural process of growth and development. For Coleridge, the child was born with Reason which was not fully developed and Understanding which was dormant. Very young children did not think, reflect, intuit, or have any awareness of the divine principle that operated within them. Rather, the child existed in a state of innocence, that is in a simple, indistinct wholeness. The careful coordination of the process of education and of individual development resulted in each child's fulfillment of intrinsic potential.

Coleridge's plan for the education of the child, from infancy to maturity, was based on the simple and natural principle of parental nurture and loving interaction. "In the education of young children, love is first to be instilled, and out of love obedance [sic] is to be educed."[21] He argued for the development of the child's mind through a natural progression of human relationships with the maternal relationship as the foundation for the experience of nature to relationships with other children to formal education.[22] In this process, the child's inherent sense of love and trust was supported resulting in the development of conscious thought and a moral will. For Coleridge, education was not solely dependent upon human beings. God was as active in the educational process as he was in all other aspects of human experience and history.[23]

Both Bushnell and Coleridge stressed the primary role of human experience in the process of knowing God, and indicated that nature was a singular source of this knowledge. They advocated that the fundamental organic relationship of parent and child extended outward to the church and to the community[24] since human person, whether child or adult, was perpetually in the process of becoming.[25] As such the Christian, whether child or adult, was dependent upon God for the dynamics of spiritual development. The infant was a passive and receptive being who came into the world without any formal or preconceived judgments or abilities[26] which would develop through the course of one's life. The result of this process, the child turned adult, was dependent upon the actions and decisions of the parents.[27] For Bushnell, human development and parental guidance led to the living of the Christian life as "it is the only true idea of Christian education, that the child is to grow up in the life of the parent, and be a Christian in principle, from his earliest years."[28]

The path of Christian nurture was not without detours or pitfalls, neither was it a straight or simple road. Rather, Christians, whether children or adults, were constantly confronted with a recognition of their finitude and guilt. This experience of limitations and of dependence upon God's grace separated both thinkers's romantic interpretations from those of the Emersonian and Unitarian Transcendentalists. Bushnell described the spiritual journey of Christian Romanticism as

> ...no vegetable process, no mere onward development. It involves a struggle with evil, a fall and rescue. The soul becomes established in holy virtue, as a free exercise, only as it is passed round the corner of fall and redemption, ascending thus unto God through a double experience, in which it learns the bitterness of evil and the worth of good, fighting its way out of one and achieving the other as a victory.[29]

Beginning at birth, the first religious instruction any child received was in the form of parental nurture which for Bushnell must be Christian nurture leading towards the ultimate development of a Christian society.

By the time *Christian Nurture* was revised into its third and final edition in 1861, Bushnell had expanded his text from 66 to 407 pages. His extended topics reflected changes that occurred in the domestic arenas and in the role of middle-class women in antebellum America. The textual additions focused upon cultural or social issues more than theological ones. For example, Part II or "The Mode" of *Christian Nurture* was the pragmatic application of the theology of baptism explicated in Part I or "The Doctrine." The topics covered in Part II included "Family Government," "Plays and Pastimes, Holidays and Sundays," "The Christian Teachings of Children,"

and "Family Prayers." "Religion never thoroughly penetrates life, till it becomes domestic," he wrote in his earlier text, for "[l]ike that patriotic fire which makes a nation invincible, it never burns with inextinguishable devotion till it burns at the hearth."[30] In his later *Christian Nurture*, Bushnell identified the source and center of that "domestic religious sphere" as the most sacred office of motherhood. Since the child had "no will as yet of its own," it was the mother's responsibility to "plant the angel in the man...Nothing but this explains and measures the wonderful proportions of maternity."[31] As "the disestablished ones" in the domestic spheres, to use Ann Douglas's phrase, middle-class women, under Bushnell's influence began to fill the voids in their daily lives with the responsibilities of "Christian nurture." In this way, this minister's texts were the theological explication of a secular fact--the changing role of women and the family in middle-class antebellum America.

In *Christian Nurture*, Bushnell addressed other issues of cultural and social significance such as proper attire and behavior for young Christians, church membership for children, and appropriate domestic religious activities, including the fact that "good conversation...is better than sermons."[32] Just as his audience and his thematic concerns had shifted so too had the author's purpose been transformed from a pastoral and spiritual reflection on the theological debates of the 1830s to the sanctification of the family for the preservation of American Protestantism. "This training, in short, of a genuinely, practically all-embracing, all-imbuing family religion, makes the families so many little churches." He further concluded that these "little churches" were "better, in many points, as they are more private, closer to the life of infancy, and more completely blended with the common affairs of life."[33]

Christian Nurture was as much an experiential and spiritual statement of the journey to faith as it was a pragmatic and cultural statement of the Christian life. Following in the tradition of the early Christian theologian Augustine and the American Puritan minister Cotton Mather, this book became Bushnell's spiritual autobiography, a mode of discourse which had a defined role within Christianity. Neither a chronological recitation of biographical data nor a remembrance of one's life, spiritual autobiography was a normative style of recollection which brought coherence to one's individual Christian conversion and spirituality. This pattern of autobiography offered a paradigm for other Christians as spiritual autobiography was experiential and theological in language and themes while the structure varied from writer to writer. In Bushnell's case, his own childhood experiences were the foundation for *Discourses on Christian Nurture*.[34]

The fundamental text and the later expansions testify to Bushnell's continuing Christian development which drew upon his experiences as a parish minister, and later as a minister-at-large. In its first edition, *Discourses of Christian Nurture* was a succinct presentation of a theology of baptism and its implications for the contemporary Christian. In its second edition, *Views of Christian Nurture* presented a theology of the family. In its final edition, *Christian Nurture* was a cogent presentation of a theology of baptism and the family combined with a practical guide for the daily implementation of this domestic spirituality. In each successive edition Bushnell's clarified his original ideas in a fashion similar to his evolving understanding of his own spirituality. In the preface to the final edition, he testified that

> I need offer no apology for retaining the old title, in a volume that is new; or for reasserting, with more emphasis and deliberation after an interval of years, what the years have only established and made firm in my Christian convictions.[35]

The lengthy career and multiple publications of this text indicated both the author's considerable effort at revision and the personal significance of this work.[36] As both his first book and as an example of developmentalism in romantic thought, *Christian Nurture* was the expression of Bushnell's thought based upon his own life experiences and spiritual development.

In *Christian Nurture*, the minister responded to and reflected the social changes as well as the theological debates within American Protestantism. Bushnell's unique combination of spirituality, morality, autobiography, pragmatism, and social responsiveness allowed him a wider audience than his Hartford congregation. He was therefore able to develop a median position between Orthodox Calvinism and Transcendentalism. From his readings of Coleridge's *Aids to Reflection*, Bushnell came to his own interpretation and practice of self-reflection, aesthetic discernment, and symbolic discourse upon which he adapted the Christian message to the social and cultural concerns of the American situation.

Conscious of the threat of both Transcendentalism and the "Calvinist tradition" to his position as a practicing theologian and pastor, Bushnell initially intended that *Views of Christian Nurture* become a vehicle for his personal and institutional survival. In this effort, he sought to re-define the role of the Christian minister. Rejecting the role of oratorical preacher or dramatic revivalist, Bushnell defined his role as that of a moral philosopher[37] seeking to enlighten and to convert his people and their children, to strengthen his church, and to reaffirm his position as a Christian minister.

Although by modern standards, his texts seem conservative, conventional, and bland, throughout his career, Bushnell's theological texts were

controversial. Almost tried for heresy by the associated Congregational churches of Connecticut on account of his then new book, *God in Christ*, Bushnell expounded views of the trinity, the incarnation, and the atonement that were interpreted as potentially seductive and destructive of Christian souls. Employing a new romantic vocabulary, the American theologian indicated that all Christian creeds were attempts to present a single truth, that the Bible should be read as poetry, and that religion operated primarily through the imagination. To his detractors, Bushnell's presentation was a theological novelty which was based on a disregard for tradition and doctrinal precision.

By his death in 1876, Bushnell was revered as a major spokesman for mainline American Protestantism. His published sermons and texts sold well, and he was a popular and well-known speaker. His interpretations of the role of women, Christian nurture, and the social and religious consequences of Reconstruction were representative of middle-class American culture and theology.[38] For example, in his "Discourse on the Slavery Question," Bushnell opposed the enslavement of human beings on scriptural grounds, and attacked the Fugitive Slave Law of 1850. In his attacks upon the Roman Catholic Church and the influence of "Popery" in American life, Bushnell voiced the fears of many middle-class American Protestants.[39] He delivered the oration, "Our Obligations to the Dead," at the July 26, 1865 Commemorative Celebration in honor of the Yale College Alumni who served in the Civil War, in true evangelical fashion, proposing that the trials of the war would purge the nation of its sins just as the sacrificial blood of Jesus as the Christ had saved humanity from eternal damnation.

His popular and well-known lecture for the Litchfield County Centennial Celebration, "The Age of Homespun," was a lament for the Puritan Arcadia of religious and social values that America had once been. Bushnell decried industrialization and progress because of the revolution these had wrought in domestic life and social manners. His idealized conceptions of home and the family grounded his opposition to woman's suffrage. In 1869, Bushnell published his *Woman's Suffrage: The Reform Against Nature* in which he explained that men symbolized the "law" while women symbolized the "gospel" which he defined as subject to the "law" but representative of "grace". Women's moral superiority was evidenced by their ability to supersede the law when necessary, while appearing to be submissive. This fundamental moral superiority combined with feminine sentimentality and worldly ignorance to make women more Christian than men.[40]

He also wrote a re-interpretation of classical Christian doctrines, especially the Christological doctrines concerning the meaning and purpose of Christ's role in human salvation.[41] Bushnell argued against the traditional idea that Jesus as the Christ was sent by God only to satisfy the divine anger over human sin, rather God acted according to the laws of love, not out of anger for Jesus as the Christ died on the cross as a result of God's love for humanity. As the "Father of Protestant Liberalism," he was best remembered for the transition from Orthodox Calvinism to Protestant Liberalism. However, Horace Bushnell was more than a transitional figure in the history of American Protestantism--he was a leading Christian Romantic theologian of the nineteenth century. Although not formally concerned with the development of a systematic theology, he was committed to the survival of the Christian, i.e., Protestant, tradition in America. Through the assimilation of central Romantic ideas and the rejection of several "traditional" Calvinist teachings, Bushnell was able to reformulate and revive American Protestantism.

Beecher's Norwood: From a "Manly" Christianity to the Feminization of America

In 1843, Henry Ward Beecher presented a series of Sunday evening lectures to his congregation at the Second Presbyterian Church of Indianapolis on the moral and spiritual dangers which he believed endangered the virtues of American youth.[42] Published first in the local paper, *Lectures to Young Men* established the young minister's reputation as a leading evangelical preacher in the west. Each lecture began with a passage from sacred scripture which was analyzed for its practical applications to daily life. Then the author offered advice on the behavior appropriate to a young Christian in the face of the temptations and secular aspects of daily life in the middle-class American west such as idleness, gambling, dishonesty, intemperance, theater-going, licentiousness, luxuriant living, and libertinism.

Throughout the series of lectures, Beecher advised young men to follow the fundamental "Christian" and American virtues of industry, economy, charity, obedience, duty, humility, and trust in God, in all their activities in the modern world.[43] His association of religion with cultural identity was not new but had a long American tradition,[44] but his contribution was the integration of this middle-class American cultural identity with Christian Romanticism into a religio-nationalist posture.

Although Beecher's advice, in its form and content, might be better deemed "revivalistic" and was more "orthodox" than romantic and evangelical,[45] his style and his language identify his Christian Romantic sensitivity.

The consistent use of metaphors from nature and the arts throughout the lectures developed his argument and the appropriate "Christian" position.[46] For example in "Lecture IV: Portrait Gallery," the young minister employed the over-arching metaphor of a walk through a portrait gallery as a way of opening the eyes and the minds of young men to the fundamental variety of evil in human nature as the wit, the humorist, the cynic, the libertine, and the politician were depicted in the two forms of demagogue and party man.[47]

Beecher's use of this metaphor of the portrait gallery and the capacity of the arts to express human nature revealed both his basic aesthetic sensibility and his recognition of the didactic role of art in theology. Although the earlier traditions of a Jonathan Edwards or a Lyman Beecher might have dictated the use of nature metaphors in sermons, Henry Ward Beecher's use of nature and art metaphors was distinctively different in style and intent. The younger preacher saw the natural order as alive with God's presence and art as a fundamental human expression imitating "the Divine Artist."

In the 1846 edition of *Lectures to Young Men*, Beecher added an eighth lecture "Practical Hints" on the pragmatic aspects of human affairs including Christian family life and the role of education.[48] It was the duty of every citizen to be educated not for self-betterment, but for the benefit of his fellow citizens,[49] and to qualify for an honest participation in public affairs.[50] The cultural and societal changes affecting the American middle class of the 1840s were evident; for example, the interest in geology as well as geography, and the integral role of the arts and of the fine arts in the educational process.[51] Although convinced of the necessity and right of each individual to an education, Beecher emphasized self-education as he saw educational institution(s) as limiting. He regarded the education of women as a societal duty not simply as an individual prerogative. This passage concluded with an emphasis on the role of literacy and the availability of books.

For Beecher, cleanliness and good health were next to godliness,[52] and one could not be a good Christian without being a good citizen, which required a sense of responsibility, moral virtue, and literacy. Being a good Christian was more than an assent to a creed of dogmas or faith; rather, it was a way of life.[53] Christianity was not a series of dogmas, philosophical or metaphysical, but a rule of life in every phase of human existence.

Like Bushnell's *Christian Nurture*, Beecher's first book *Lectures to Young Men on Various Important Subjects* was published in three editions each of which was expanded to relate to the changing cultural climate. The first edition of seven lectures was published in 1845 in the west where

Beecher was then preaching. *Lectures to Young Men* sold out the initial edition of 3,000 copies requiring a second edition by 1846. Beecher added an eighth lecture entitled, "Practical Hints," to the second edition which was available to buyers in the eastern cities. The publisher reported sales of over 60,000 copies prior to the publication of the third edition of 1873[54] to which Beecher added three lectures on "Profane Swearing," "Vulgarity," and "Happiness."

Beecher's *Lectures to Young Men* were his preliminary study in human psychology and revealed his eventual alignment with the developmental interpretation of the human person appropriate to the Romantics. Like Coleridge and other Romantic thinkers, Beecher contrasted the different styles of thought which categorize human beings, especially in distinguishing the genius from ordinary men (i.e., Coleridge's genius and talent).[55]

Beecher's preface to the first edition, which was reprinted in the ensuing editions, explained his reasons for publishing these public lectures and indicated the influence that Coleridge's *Aids to Reflection* had upon his thinking.

> I ask every YOUNG MAN who may read this book not to submit his judgement to mine, not to hate because I denounce, nor blindly to follow me; but to weigh my reasons, that he may form his own judgement. I only claim the place of a companion; and that I may gain his ear, I have sought to present truth in those forms which best please the young; and though I am not without hope of satisfying the aged and the wise, my whole thought has been to carry with me the intelligent sympathy of YOUNG MEN.[56]

Just as *Aids to Reflection* become a spiritual guide for its readers, so too did *Lectures to Young Men*. Both texts were distinguished by the experiential tone of its discussions and examples. Beecher advocated human reason as fundamentally moral, therefore once a young man came to know the good he would do the good and thereby reject evil. Further Christianity was not espoused as a speculative or philosophic faith but as a practical life process. In reading *Lectures to Young Men*, Beecher hoped that his readers would acquire the necessary skills for individual judgment and find an explanation of the Christian Life. *Lectures to Young Men* was a grammar of moral and social assent in the way that Coleridge's *Aids to Reflection* was a grammar of spiritual and moral assent.

Although there was no objective evidence which affirmed Beecher's reading any of Coleridge's theological texts, he would have heard the outlines and implications of Coleridgean ideas from either his father, Lyman Beecher,[57] his elder brothers, his brother-in-law, Calvin Stowe, or his fellow theological students and later clerical colleagues. Whether Beecher identified

these ideas as "Coleridgean" or understood their roots in the German Romantic Tradition is not at issue; rather, Beecher's assimilation and presentation of Christian Romanticism as interpreted by Coleridge's American disciples, such as James Marsh and Horace Bushnell, is. Henry Ward Beecher's great gift was not original thinking, but the capacity to interpret major religious ideas and synthesize these with the societal changes in nineteenth-century America.

In August 1847, Beecher accepted the call of the Plymouth Church of Brooklyn. The Henry Ward Beecher who came East to minister and to preach had developed a successful program which integrated the central themes of what was becoming the American cultural ethos. Since his Brooklyn congregation was a better educated and culturally sophisticated audience, the young preacher began to study the more recent theological developments and to modify his own revivalistic concerns. His interest in the new theology was aroused by a reading of Bushnell's *Views of Christian Nurture*. Even though Beecher could not fully accept Bushnell's position, he had empathetic feelings as, "Bushnell developed a new theology around God's love, as defined by Christ's sacrifice, and advocated by a symbolic and intuitive attitude towards religious truth."[58]

Responding to both the changing intellectual and theological currents as to the new social and cultural patterns of antebellum America, Beecher modified his conception of God from one based on fear to one grounded in love which became the motivating force in every Christian life. In response to such an experience of God's love, a Christian was motivated to good and right action in daily life. Just as Bushnell's *Views of Christian Nurture* provided a theological justification for the changing status of women and the family in antebellum America, his sermons and lyceum lectures suggested a theological foundation for the Reform Movement in antebellum America. Through his regular publications including his columns in the New York *Ledger*, *The Christian Union*, *The Independent*, *Plymouth Pulpit*, and *The Christian Outlook*, his volumes of collected sermons, and his novel, *Norwood*, Beecher appealed to the "common man" who represented the American middle class.

This synthesis of religion and culture was exemplified best in his popular novel, *Norwood*; or, *Village Life in New England*.[59] In 1865, Robert Bonner, publisher of the *Ledger*, offered Beecher a contract for a novel which would be serialized in his paper. Although conscious that he was not a novelist, the preacher eventually accepted Bonner's offer.[60] The *Ledger's* circulation of 275,000 a week, and an advance payment of $24,000, which

was the highest that Bonner had ever paid, were the incentives in this decision.[61] Regardless of motivations, *Norwood* became a popular novel which increased the circulation of the *Ledger* to 300,000 readers (which would be equivalent to over a million modern readers).[62] *Norwood* also brought Beecher to the attention of the vast novel-reading audience of middle-class American women in the 1860s[63] for this literary exercise, moral and religious passion combined with aesthetic discernment and the familiar details of a genre painting.[64] Beecher acknowledged that average characters in their daily activities would have the most appeal to the popular literary audience of his day, that is, to middle-class women. His story was no fantasy or morality tale, but a fiction based on the truths of everyday life.

The plot of *Norwood* involved the romances that occurred between the virtuous, accomplished, and socially responsible sons and daughters of Norwood's citizens. The novel's theme reflected the contemporary interpretation of woman as the agent for the higher values, as the "transformer" for Christianity. "These two, the man of philosophy and theology, and the woman of nature and simple truth, are to act upon each other and she is to triumph."[65] Norwood was an interesting village, full of local color and characters, but without a low social class or the economic and moral problems they experience. The major intrusion of "evil" was the Civil War which occurred past the novel's midpoint.

The romantic heroine, Rose Wentworth, was the daughter of the village doctor and local philosopher, Dr. Reuben Wentworth. Interested in the relationship between religion and science, specifically the natural sciences of botany and human development indicated Beecher's own position. As a romantic, the village physician argued adamantly that God was symbolically present in nature. His descriptions of nature, like Beecher's sermons and newspaper columns, echoed the Christian Romanticism of Coleridge's American theological disciples such as Bushnell, Marsh, and Stowe, who saw nature as a symbol of God's grace and revelation. Regular debates among the pseudo-philosopher of a country doctor, the orthodox Calvinist minister Dr. Buell, and the rationalist and skeptic Lawyer Bacon gave voice to the author's concerns.[66]

Nurtured on his theological interpretation of the human person, Rose was her father's daughter--the perfect example of Bushnell's *Christian Nurture*. She was raised in a loving family environment and clearly never knew a day when she was not a Christian.[67] However, the young woman's parents and their practice of "Christian nurture" concerned Agate Bissell a traditional New England Calvinist. Distraught that Rose had not yet experienced her "conversion," Bissell debated the issue of nurture versus conversion with Mrs. Pearl Marble as she reported her close examination of

Rose's spiritual experiences.[68] The conversation between these two women offered the former little comfort in her concern for Rose's soul, but it did allow for Beecher's arguments against the traditional doctrines of conversion and the child as fundamentally sinful. The proof of Bushnell's "Christian nurture" was found in the compassionate Christian the young woman became as the novel unfolded. The father's discussions with his daughter allowed Beecher a forum for his interpretation of religion and the human person. For example, Wentworth engaged in a Sabbath afternoon conversation with his wife and children and responded to his wife's inquiry as to the nature and the meaning of the Sabbath.[69] Although concerned with the ecclesiastical institutions but not the rituals of the Christian tradition, such as the keeping of the Sabbath, the pseudo-philosopher did not consider earlier periods of Christianity as the ideal. Although he admired the architecture, symbolism, and spirituality of medieval cathedrals, he decried (as did Beecher) his contemporaries who sought to design American cathedrals from medieval models. The art of the period, like its interpretation of God and of the human person, must reflect the contemporary moment, and therefore the appropriate inward spirit of the particular age.[70] Beecher's goal was the "living of the Christian life" in the here and now world not in the retrieval of a past "ideal of church architecture" nor a rigid adherence to a religious ritual that no longer had meaning and value in the contemporary situation.

Norwood's romantic hero, Barton Cathcart, was not a child of "Christian nurture."[71] In fact, part of the novel's plot revolved around his becoming "worthy" of Rose, that is to say, relinquishing his doubts about God and Christianity. He symbolized the spiritual soul in those moments of doubt which were characteristic of the Christian Romantic tenet of unfolding revelation. In a dramatic episode Barton admitted to Rose's father his spiritual difficulties and how the elder man's personal model brought him to God. "I am almost certain, Doctor, that but for your help I should have made a shipwreck of my faith." Barton confessed, "under your help, I found the great truths of the Bible indicated and corroborated in Nature, I was wonderfully strengthened. Indeed, I consider that the turning point in my history."[72] Despite the traditional romantic convention of a lovers' misunderstanding due to a lost letter, and the intervention of the Civil War in which Barton was wounded and presumed dead, *Norwood* concluded with the marriage of the young couple in her father's garden.

The counterplot of *Norwood* was Beecher's presentation of the tenets of Christian Romanticism--the village doctor's verbal debates with Dr. Buell and Lawyer Bacon provided a forum concerning the nature of the child,[73] the relationship between religion and science,[74] the symbolic interpretation

of nature, the authority of sacred scripture, and the developmental nature of the human mind.[75] Wentworth indicated both an awareness of and response to the contemporary scientific and theological controversies aroused by the publication of Charles Darwin's *Origin of the Species*; Ferdinand Christian Baur's *Paul the Apostle of Jesus Christ*; and David Friedrich Strauss's *A New Life of Jesus*[76]. These three controversial texts were the topics of heated debates in academic circles in both Europe and America.[77] At the same time, middle-class Americans were alerted to these controversial texts and theories in sermons and from newspapers and magazines articles. Darwin's theory incited a faith crisis by questioning the divine nature of the human person, the authority of sacred scripture, and God's creative role in history. Baur's text was the foundation for modern scriptural scholarship which examined sacred scripture not as definitive revelation but as a literary, albeit inspired, text. By questioning the meaning of the divine nature of Jesus as the Christ and by studying the historical evidence about Jesus of Nazareth, Strauss's book was one of the first textual quests for the historical Jesus. The eventual Liberal Protestant identification of Jesus as the moral teacher was formulated in response to Strauss.

In other conversations with Dr. Buell, Wentworth expounded his understanding of the human mind[78] including the discrimination of levels of truth, divisions of the human mind, and the role of sense perception in a manner reminiscent of Coleridge's discussions of reason and understanding.[79] To be fully human and a Christian required a merger of heart and mind, that is the affections with the intellect. In this way, the romantic emphasis upon feeling, i.e., "the heart", and the sentimental aspects of religious feelings was qualified as necessary and fundamental.[80] Wentworth declared, "Imagination is the very marrow of faith."[81] For without the imaginative faculty which corresponded in this scheme of things to the feelings, sense perceptions, and intuition, the human person and the quality of his or her work suffered. The lack of an experiential base created a theology without human feeling or a poetry without spiritual authenticity.[82]

The integration of the aesthetic and the religious was essential to human existence for throughout his discourses, Wentworth, like Beecher, employed metaphors from nature and from art to illustrate and to clarify his theology and philosophy. During a family prayer and scripture session, for example, Rose raised the question of the appropriate mourning rites for her brother, Arthur. Her father fused the visual with the verbal in his response citing the example of a painting of the white garbed angels lamenting the dead Christ.[83]

Thus the beautiful merged with the Christian as the expression and vehicle for experiencing the truths of faith. The importance of art and the

artist for the Christian life were affirmed in Beecher's novel through the character of Rose's rejected suitor, Frank Esel, an aspiring artist. Through the literary conventions of letters and diaries as well as dialogues between father and daughter, Esel's presence provided a forum for the delineation of the role of the artist as a moral teacher, and for the appropriate relationship between Christianity and art.[84]

Whether the mode of artistic expression was verbal or visual, Beecher advocated the development of a careful and attentive reader. Although employing the then popular literary genre of the sentimental romance, his goal for *Norwood* as for all of his writings was to inspire Christian faith and moral action in his readers; i.e., the living of the Christian life through Christian Romanticism. In the Preface to the 1867 edition of *Norwood*, he wrote,

> By interesting my readers, if I could, in the ordinary experiences of daily life among the common people, not so much by dramatic skill as by a subtle sympathy with Nature, and by a certain largeness of moral feeling, I hoped to inspire a pleasure which, if it did not rise very high, might, on that account, perhaps, continue the longer. I had rather know that one returned again and again to parts of this most leisurely narrative, than that he devoured it all in a single passionate hour, and then turned away from it sated and forgetful.[85]

The careful and attentive reader would be transformed in the process of reading. Within Beecher's oeuvre, the analogy can be made of a similar transformative experience for the careful "reader" of nature or of a work of art.

At the same time, Beecher knew his audience and carefully constructed his texts to meet both their interest and his pastoral purposes. For example, *Lectures to Young Men* advocated a "manly" Christianity, and was addressed primarily to the sons of the American West. What better appeal could Beecher offer to such an audience than a Christianity which was by act and belief characterized as "manly"? Twenty years later when he wrote *Norwood*, Beecher ever cognizant of his audience, packaged a series of theological treatises within a novel full of sentimental nostalgia and romance for the then predominant reading audience of middle-class American women. While a comparison of these two texts offered a study in Beecher's theological development, it also revealed his ability to discern and to articulate the concerns and the values prevalent in the contemporary middle-class culture. The transition between *Lectures to Young Men* and *Norwood* indicated the development of Christian Romanticism as a theological expression of the American middle class. Simultaneously, this transition reflected the societal

shifts in middle-class values away from a male-dominated domestic order to a feminine domesticity. At the forefront of this transition stood Henry Ward Beecher--Christian Romantic preacher to the nineteenth-century American middle class.

Beecher, Bushnell, and Christian Romanticism in Antebellum America

As representative Christian Romantics, Horace Bushnell and Henry Ward Beecher shared a common bond in the romantic impulse while diverging in its expression. Bushnell emphasized a careful articulation of Christian Romanticism, while Beecher favored a personal encounter with his congregation. Bushnell denied the rationale and the method of revivalism; while Beecher modified the method and principles of revivalism appropriating them to the needs of his congregation. Beecher the optimist on issues of social reform stood in marked contrast to Bushnell the pessimist.[86]

Nevertheless, they shared the common principles that they came to understand as the core of Christian Romanticism. These principles included the centrality of God's love, faith in a merciful God, a Christocentric theology grounded in the revelation of a personal Christ, the intuitive nature of religion, an appeal to experience, a stress on human consciousness, and the centrality of the family and education as spiritual vehicles. These principles can be seen as modifications of the earlier forms of American Protestantism amended as much by societal and cultural changes as by the emergence of romantic philosophy.

The common foundation that united Beecher and Bushnell was the personal belief in the importance of environment which was domestic, geographic, and ecclesiastic. Their common theological interest in the development of the domestic aspects of family prayer, bible readings, and Christian nurture merged with their common cultural interest in the new role of middle-class women, the idealization of childhood, and the development of educational institutions. As Glenna Mathews suggested, where Bushnell avowed the importance of the nurture of children, Beecher stressed the conjugal relationship.[87] Their common interest in the environment spread to the geographic area outside of the domestic and ecclesiastical spheres to "America." Both men became avid environmentalists decrying the over-development of the cities and the evils of industrialization.

Bushnell throughout his theological treatises and Beecher throughout his popular articulations reshaped the three basic tenets of Christian Romanticism in a manner and mode appropriate to the religious and cultural concerns of the middle-class congregations that were their audiences in antebellum America. These three basic tenets of Christian Romanticism were

a Christianity based on God's gift of love, a natural world as a reflection of God's immutable laws, and the family as the ideal instrument for fostering true Protestantism. In its leading theological mind and pastoral voice, Christian Romanticism found individuals whose distinct gifts and personalities suited their respective tasks. Both Beecher and Bushnell stood firm in their mediation of the Protestant Christian message to the needs and concerns of mid-nineteenth-century America.

ENDNOTES

1. Sydney Ahlstrom referred to Coleridge as a "powerful interpreter and champion of the spiritual life. " Ahlstrom referred to Coleridge as the British Schleiermacher and to Horace Bushnell as the American Schleiermacher in Ahlstrom, *A Religious History of the American People* (New Haven: Yale University Press, 1965), p. 594. As Perry Miller noted, however, the Transcendentalist interpretation of Coleridge's texts was not seen as appropriate or fair to Coleridge by other nineteenth-century American interpreters beside the Christian Romantics who read Coleridge as a churchman and a theologian. See Perry Miller, "American Religious Freedom," in *Nature's Nation* (Cambridge: Belknap Press of Harvard University Press, 1967), p. 158.

It was, of course, the nineteenth-century German theologian, Friedrich Schleiermacher, whose work changed the course of the Protestant tradition by assimilating the ideals of Romantic philosophy into Christian theology. Schleiermacher's writings, especially his essay on the Trinity as translated by Moses Stuart, were influential upon Bushnell, as well as upon numerous nineteenth and twentieth-century American theologians.

2. The influence of Coleridge's texts on the artistic community and the development of an American aesthetic should also be noted. For example, Neil Harris states that "A survey of any mid-century American periodicals with an interest in the fine arts, like *The North American Review, The Christian Examiner* and *The Atlantic Monthly*, revealed the influence of Ruskin, Hegel, Cousin and Coleridge." Neil Harris, *The Artist in American Society. The Formative Years, 1790-1860* (Chicago: University of Chicago Press, 1982 [1966]), Note #1, p. 369. See also "Introduction," *The Romantic Vision in America* (Dallas: Dallas Museum of Fine Arts, 1971), exhibition catalogue, no pagination.

3. Marsh's preliminary essay for *Aids to Reflection* was retained in its entirety in the Shedd edition. The perduring influence of Coleridge's *Aids to Reflection* on American intellectual and religious thought is attested to by the American philosopher, John Dewey. In his "Introduction" to Coleridge's *American Disciples*, John Duffy twice quoted statements from Dewey attesting to the influence of Coleridge's *Aids to Reflection*, and Marsh's "Preliminary essay," upon Dewey's own thought. For example, Duffy recounted Herbert Schneider's recollection that upon presenting Dewey with a copy of *Aids to Reflection* at a birthday party late in Dewey's life, he responded to Schneider's inquiry as to whether or not Coleridge's text reminded him of anything by saying, "Yes, I remember very well that this was our spiritual emancipation in Vermont...This *Aids to Reflection*, in Marsh's edition, was my first bible...I never did change my religious views." Coleridge's *American Disciples. The Selected Correspondence of James Marsh* ed. John J. Duffy (Amherst: University of Massachusetts Press, 1973), p. 30; Dewey's statement as quoted from Corliss Lamont, *Dialogue on John Dewey* (New York, 1959), pp. 15-16.

Shedd's edition is only currently being superseded by the complete collection of Coleridge's texts being published under the general editorship of Katharine Coburn as part of the Bollingen Series through Princeton University Press. To date, eight of a projected sixteen titled volumes have been published.

4. See Coleridge's *American Disciples: The Selected Correspondence of James Marsh* ed. John J. Duffy (Amherst: University of Massachusetts Press, 1973), p. 18. In turn, Duffy referred his reader to Van Wyck Brooks, *The Flowering of New England* (New York: np, 1952), pp. 117-21.

5. Noah Porter, Jr. "Coleridge and His American Disciples," *Bibliotheca Sacra and Theological Review* 4 (1847): 117-71, see esp. pp. 163-71. In fact, Marsh's correspondence with Thomas Porter Smith of Paris, Kentucky; Nathaniel S. Harris of West Point, New York; N. Frank Cabell from Bremo, Virginia; and James M. Mathews

and Charles Hodge concerning the convention of clergyman and educators which gathered to discuss the establishment of a university in the city of New York in 1830, bespoke the initial geographic range of Coleridge's thought on the American scene.

6. Samuel Taylor Coleridge, *Aids to Reflection*, (Port Washington, N.Y./London: Kennikat Press, 1971), p. xvi. This is a facsimile edition of the 1829 American edition with James Marsh's preliminary essay. All references to *Aids to Reflection* throughout this text refer to this edition.

7. Ibid., p. 201.

8. Ibid., p. 201.

9. The most recent book-length biography of Horace Bushnell is Barbara Cross's *Horace Bushnell: Minister to a Changing America* (Chicago: University if Chicago Press, 1958). Her text is however as much a social history of the nineteenth-century American Protestant middle class as it is a biography of Horace Bushnell. The standard sources for biographical information about Bushnell are Theodore H. Munger, *Horace Bushnell, Preacher and Theologian* (Boston: Houghton, Mifflin and Company, 1899); and Mary Bushnell Cheney, *The Life and Letters of Horace Bushnell* (New York: Harper and Brothers, Publishers, 1880).

10. There were three texts published by Horace Bushnell on the topic of *Christian Nurture*. First was the pamphlet, *Discourses on Christian Nurture*, which was published by the Massachusetts Sabbath-School Society in 1846. This text ran approximately 64 pages. After the initial furor incited by that publication, Bushnell defended himself by expanding that pamphlet into a book-length discussion, *Views of Christian Nurture and of Subjects Adjacent Thereto*, published by Edwin Hunt of Hartford in 1847. This text ran approximately 122 pages. In 1861, Bushnell revised and expanded his original two essays into a lengthy book, *Christian Nurture*, published by Charles Scribner's Sons. This final version ran approximately 407 pages. It was this latter revision which is best known by modern students of Bushnell.

　　Since a part of my concern in this research has been Bushnell's response to the cultural shifts in antebellum America as well as the influence of Coleridge's thought on American religious and cultural history, I have used facsimile editions of the 1847 and the 1861 texts for my analysis. All references to *Views of Christian Nurture* are selected from Horace Bushnell, *Views of Christian Nurture and of Subjects Adjacent Thereof*, introduction by Philip B. Eppard (Delmar, N.Y.: Scholars' Facsimile and Reprints, 1975 [1847]). All references to *Christian Nurture* are excerpted from Horace Bushnell, *Christian Nurture*, introduction by John M. Mulder (Grand Rapids, Michigan: Baker Book House, 1979 [1861]).

11. For example, Claude Welch, *Protestant Thought in the Nineteenth Century, Volume I: 1799-1870* (New Haven: Yale University Press, 1974 [1972]), pp. 258-68.

12. David L. Smith, *Symbolism and Growth in the Religious Thought of Horace Bushnell* (Chico: Scholars Press, 1983), p. 22-25. On Bushnell's intellectual and theological debts to Coleridge, see Munger, *Horace Bushnell, Preacher and Theologian*, p. 47. In his text, Munger described the initial problems Bushnell experienced in reading *Aids to Reflection*, and how Bushnell chanced upon his copy for his dramatic second reading of *Aids to Reflection*, see pp. 45-47. See also Cheney, *Life and Letters of Horace Bushnell*, pp. 207-9, 499.

13. Careful analysis of Bushnell's theory of symbol and its relationship to the work of Coleridge has been made by other scholars, see for example Cherry, *Nature and Religious Imagination*, esp. pp. 173-87; and Smith, *Symbolism and Growth*.

　　Since no attention has been given to the relationship between Bushnell's theory of the child and of Christian nurture to Coleridge's theory of education and of the child, I have

directed my attention to that issue. Additionally, an in-depth analysis of theories of symbol and aesthetic discernment turn the reader's attention towards a more philosophical and theological discussion, whereas an examination of the child and education maintain the cultural history direction of this study.

14. For example, see Cross, *Horace Bushnell*, pp. 52-72; Cheney, *Life and Letters of Horace Bushnell*, pp. 178-83; Munger, *Horace Bushnell, Preacher and Theologian*, pp. 67ff.; or Smith, Symbolism and Growth, pp. 141-44.

15. Bushnell, *Views of Christian Nurture*, p. 16.

16. Ibid., p. 10.

17. Ibid., p. 6.

18. Additionally, Bushnell would have had the opportunity to study or hear about Coleridge's ideas during his two trips to England ass part of his "rest cures" in Europe.

19. Samuel Taylor Coleridge, *Miscellaneous Criticism* ed. Thomas Middleton Raysor (Cambridge: Harvard University Press, 1936). Samuel Taylor Coleridge, *Shakespearean Criticism*, 2 volumes, ed. Thomas Middleton Raysor (Cambridge University Press, 1930).

20. Judith Plotz, "The Perpetual Messiah: Romanticism, Childhood, and the Paradoxes of Human Development" in *Regulated Children/Liberated Children*, pp. 63-95.

21. Coleridge, "The Education of Young Children," *The Portable Coleridge*, p. 401.

22. Kathryn Gill Cook, "'A Past Always Present' Coleridge on Human Development and Education." Unpublished Ph.D. Dissertation, The George Washington University, 1983. Of particular interest for my purposes was Chapter VI: "The Total Soul Energizing, Unique and Unific!", pp. 142-76.

23. Coleridge, *Shakespearean Criticism, Volume II*, p. 195.

24. Bushnell, *Views of Christian Nurture*, p. 21.

25. Ibid., p. 22.

26. Ibid., p. 28.

27. Ibid., pp. 27-29.

28. Ibid., p. 32.

29. Ibid., p. 15.

30.. Ibid., p. 63.

31. Bushnell, *Christian Nurture*, pp. 236-7.

32. Ibid., p. 380.

33. Ibid., p. 406.

34. As cited in the "Introduction," *Views of Christian Nurture*, np.

35. *Christian Nurture*, p. xxxii.

36. The reader is referred to the chronology of the varied editions of these texts in endnote #16 of this chapter.

37. Cheney, *Life and Letters of Horace Bushnell*, p. 68.

38. The most detailed bibliography of Bushnell's address, letters, and sermons as well his articles and books is found in James O. Duke, *Horace Bushnell. On the Vitality of Biblical Language* (Chico: Scholars Press, 1984), pp. 95-104. A cursory reading of these

lists indicate the plethora of cultural and social topics that Bushnell addressed. All the following references to addresses and sermons are carefully indexed in Duke.

39. See for example, "Barbarism the First Danger," (1847), or "Common Schools," (1853).

40.For a feminist interpretation and critique of Bushnell's statements on the role of women and on women's suffrage, see Douglas, *The Feminization of American Culture.*

41. For example, see Horace Bushnell, *Christ and His Salvation: In Sermons Variously Related Thereto* (New York: Charles Scribner, 1864); or idem., *The Vicarious Sacrifice, Grounded in Principles of Universal Obligation* (New York: Charles Scribner, 1866 [c.1865]).

42. The most recent book-length study of Henry Ward Beecher is *Henry Ward Beecher, Spokesman for a Middle-Class America* by Clifford E. Clark, Jr. (Chicago: University of Illinois Press, 1978). As with Cross's biography of Bushnell, Clark's text also emphasized the social history of what he called a middle-class Victorian America. Recent studies of the Beecher family include *Chariot of Fire: Religion and the Beecher Family* by Marie Caskey (New Haven: Yale University Press, 1978), and *The Beechers: An American Family in the Nineteenth Century* by Milton Rugoff (New York: Harper and Row, 1981).

43. Beecher fused "Christian" with "American" in a manner prophetic of Ralph Henry Gabriel's concept of the American Democratic Faith and Robert Bellah's American Civil Religion. Ralph Henry Gabriel, *The Course of American Democratic Thought* (New York: Ronald Press, 1956 [1940]); or, Robert Bellah, *The Broken Covenant* (New York: Harper and Row, 1975).

44. See for example, Perry Miller, *Errand into the Wilderness* (Cambridge: Belknap Press of Harvard University Press, 1978 [1956]); William B. Clebsch, *From Sacred to Profane America* (Chico: Scholars' Press, 1981 [1968]); or Bellah, *The Broken Covenant.*

45. William McLoughlin argued for the orthodoxy of Beecher's *Lectures to Young Men.* McLoughlin saw Beecher as being within the tradition of his father, Lyman Beecher, at the time the lectures were originally presented and published. In contrast, McLoughlin interpreted Beecher's novel, *Norwood,* as the key work in Beecher's corpus. Although I agree with McLoughlin's assessment of *Norwood,* I do not find his analysis of *Lectures to Young Men* as appropriate. See William C. McLoughlin, *The Meaning of Henry Ward Beecher* (New York: Alfred A. Knopf, 1970), pp. xi-xii; 20-27; and 55-83.

46. Henry Ward Beecher, *Lectures to Young Men on Various Important Subjects* (New York: J.B. Ford and Company, 1873 [1847]), p. 27.

47. Ibid., p. 73.

48. Ibid., p. 190.

49. Ibid., p. 208.

50. Ibid., p. 211.

51. Ibid., p. 213.

52. Ibid., pp. 8; 202-5.

53. Ibid., p. 217.

54. Ibid., "Publisher's Notice," np.

55. Ibid., p. 14.

56. Ibid., p. xviii.

57. Note Lyman Beecher's support of Bushnell during *Christian Nurture* debate as reported in a letter to Rev. A.S. Chesebrough, August 29, 1849, and reprinted in Cheney, *Life and Letters of Horace Bushnell*, p. 225.

58. Ibid., p. 81.

59. McLoughlin asserted that Beecher's *Norwood* was his central and mature theological text. See McLoughlin, *The Meaning of Henry Ward Beecher*, esp. pp. 55-83. For an alternate interpretation of *Norwood* in terms of the development of American aesthetic tastes, see Harris, *The Artist in American Society*, pp. 310-2.

60. Henry Ward Beecher brushed off the negative criticisms and reviews of Norwood by responding that it proved he had not ghost-written his sister Harriet's much acclaimed novel, *Uncle Tom's Cabin*.

61. See Caskey, *Chariots of Fire*, p. 232; Clark, *Henry Ward Beecher*, p. 183; J.C. Derby, *Fifty Years Among Authors, Books and Publishers* (New York: G.W. Carleton, 1884), pp. 203, 206-7, 470-1; Douglas, *The Feminization of American Culture*, pp. 289-93; McLoughlin, *The Meaning of Henry Ward Beecher*, pp. 55ff.; Fred Lewis Pattee, *The Feminine Fifties* (Port Washington: Kennikat Press, 1966 [1940]), p. 180; Rugoff, *The Beechers, Portrait of an American Family*, pp. 397-8; and Henry Nash Smith, *Democracy and the American Novel* (New York: Oxford University Press, 1978), pp. 58-59, for descriptions of the terms of the Bonner-Beecher deal for *Norwood*.

62. Smith, *Democracy and the Novel*, p. 57.

63. See McLoughlin, *The Meaning of Henry Ward Beecher*, p. 61. See also Douglas, *The Feminization of American Culture*, esp. pp. 293-8. Beecher's novel was published in book form in at least six American editions in 1868, 1874, 1880 (with illustrations), 1887 and 1895 plus the original newspaper serialization of 1867 and an English edition in 1867. A dramatic version was produced in New York and a burlesque in narrative form (*Gnaw-Wood*) went into two editions.

The reader is referred to the discussions of the publication history of *Norwood* available in Derby, *Fifty Years Among Authors, Books and Publishers*, pp. 203-7, 470-1; Douglas, *op. cit.*, pp. 289-3 ; Paxton Hibben, *Henry Ward Beecher: An American Portrait*, (New York: Doran Company, 1972), pp. 210-1, 220-1; and Smith, *Democracy and the Novel*, pp. 56-57. The only discussion of the theatrical productions and their popularity, or lack thereof, is found in Marvin Felheim, "Two Views of the Stage; Or, The Theory and Practice of Henry Ward Beecher," *New England Quarterly* 25 (1952): 314-26. Additionally, passages from *Norwood* were read at and entered into the transcript [and therefore the newspaper reports] of Beecher's adultery trial in 1875 as the alleged adultery between Henry Ward Beecher and Elizabeth Tilton took place during the time that Beecher wrote *Norwood*. For an analysis of the relationship (symbolic, metaphoric, and actual) between Beecher's writing of *Norwood* and his relationship with Mrs. Tilton, see Douglas, *The Feminization of American Culture*, pp. 293-8.

A further note clarifies the use of the term "popular" in this discussion. Beecher's *Norwood* in its book form is listed among the "better sellers for 1868" in Frank Luther Mott, *Golden Multitudes: The Story of Best Sellers in the United States* (New York: Macmillan Company, 1947), p. 321. Better sellers by Mott's criteria were "the runner-ups believed not to have reached the total sales required for the over-all best sellers," (p. 315). However, the criteria for "best-seller" was "a total sale equal to one per cent of the population of continental United States for the decade in which it was published," (p. 303). The sales for a "best seller" in 1868 would have been sales of 300,000 copies. Best sellers for 1868 were Louisa May Alcott's *Little Women* (Boston: Roberts Brothers) and Wilkie Collins' *The Moonstone* (New York: Harper Brothers), (p. 309). The better sellers for 1868 were in order of sales Beecher's *Norwood*; Elizabeth Stuart Phelps Ward, *The Gates Ajar*; Edmund Yates, *The Black Sheep*; and Matthew Hale Smith, *Sunshine and*

Shadow in New York. (p. 321). None of these figures reflected the readership of the *Ledger* serialization of *Norwood*.

64. Henry Ward Beecher, *Norwood*; or, *Village Life in New England* (New York: J.P. Ford, 1887 [1867]), p. v.

65. Ibid., p. xi.

66. Ibid., p. 55.

67. Ibid., p. 77.

68. Ibid., pp. 116-7.

69. Ibid., p. 140.

70. Ibid., p. 322.

71. Note the letter from Dr. Wentworth to Barton Cathcart in which the themes and advice from Beecher's *Lectures to Young Men on Various Subjects* were reiterated, see Beecher, Norwood, p. 183.

72. Beecher, *Norwood*, p. 375. For the full text of this conversation between Barton and Dr. Wentworth, see pp. 374-8.

73. Ibid., p. 58.

74. For Beecher and Bushnell, the relationship between religion and science meant the relationship between Christian Romanticism and the "natural sciences," i.e., botany and human development. For the American landscape painters like Thomas Cole and Frederic Edwin Church who had an analogous interest in religion and science that translated as the relationship between Christian Romanticism and geology.

75. Beecher, *Norwood*, pp. 59-60.

76. Darwin's *Origin of the Species* was published in 1859; Baur's *Paul the Apostle of Jesus Christ* in 1866 with an English translation in 1875; and Strauss's *A New Life of Jesus* in 1835 with an English translation in 1865. Although the dates of the English translations of the texts of Baur and Strauss postdate the formative period of Beecher's Christian Romantic theology, these texts were so controversial that he would have been aware of the major premises, if not the intricacy of the individual arguments, of each theologian.

77. These three books and their critiques of orthodox Protestantism merged with the Christian Romanticism of Beecher and Bushnell to give rise to the Liberal Protestantism and the Social Gospel of the latter half of the nineteenth century.

78. Beecher, *Norwood*, p. 52.

79. Ibid., for example, p. 57.

80. Ibid., p. 56.

81. Ibid., p. 52.

82. Ibid., p. 56.

83. Ibid., p. 430.

84. The reader is referred to the section which concludes the first section of the second chapter, "The Creation of a Christian Romantic Culture: The Clergy, An American Art, Nature and the Home," for an in-depth analysis of Henry Ward Beecher's position.

85. Beecher, *Norwood*, p. vi.

CHAPTER II

The Creation of a Christian Romantic Culture:
The Clergy, An American Art,
Nature and the Home

A reading of nineteenth-century American religious and art journals indicates the art critical, clerical, and popular attitudes toward art, especially the relationship between Christianity and art. In contrast, late eighteenth-century journals expressed an initial interest in the role of art in terms of cultural refinement and the use of leisure time.[1] By the middle of the nineteenth-century, however, the new direction appropriate to the romantic impulse then present in American Protestantism, shifted the central issues to the roles of art and artist in American society. Given Christian Romanticism's emphasis on the Christian life, clergymen explored the issues of the morality of art, the duty of the artist, and the national goal of an American art. The visual arts like the sentimental novels and popular magazines of nineteenth-century America advocated a particular middle-class life style.

The majority of the articles devoted to the arts appeared in two popular journals, the *Christian Examiner* and *The Crayon*. Liberal and Unitarian in its theological worldview, the *Christian Examiner* was a journal dedicated to religion especially in terms of its relation to cultural expressions. The first sustained effort at an art journal in America *The Crayon* was a forum for the aesthetic ideas of John Ruskin which were based as much upon a concern for morality as for artistic and religious integrity. Additional essays authored by artists, clergymen, critics, and scholars were included in such diverse publications as *Harper's New Monthly Magazine*; *The Illus-*

39

trated Magazine of Art; *The Churchman*; *Bulletin of American Art Union*; *Cosmopolitan Art Journal*; *Putnam's Monthly Magazine*; *North American Review*; and *Atlantic Monthly.*[2] Representatives of the popular sentiments of the spectrum of these journals, the *Christian Examiner* and *The Crayon* are the major sources for this analysis.

The major themes of the essays devoted to the arts proved to be more harmonious than diversified, and were premised upon an overall concern for the development and establishment of a distinctive American art comparable in style, technique, and spirit to that exemplified by the best in European art.[3] The time and effort which necessarily had placed on economic and political development could now be diverted to the arts. "That better day must come," G.F. Simon counseled when, "we shall finally turn to the tranquil contemplation of that picture which God has so long held before our eyes."[4] Art schools, professional artists's organizations, popular recognition of the artist, and enlightened patronage would be required in order to establish an "American" art.

The artist came to be regarded as a moral and social teacher whose fundamental orientation was spiritual, even if he was not ostensibly religious. "The artist is not necessarily a religious man," Simons wrote, "but he has the spirit from which all religion springs."[5] Nevertheless, the artist was believed to possess a vocation, inspiration, and sense of duty analogous to that of the clergyman. "Is there not something quite kindred between your profession and ours?" Rev. Samuel Osgood wrote to *The Crayon*. "Certainly, every artist ought to have a deep religious sensibility....every preacher ought to have something of an artist's taste and imagination in his composition...The two professions have been and will be vastly helped by closer intimacy."[6]

As with other aspects of American life in the period between 1820 and 1860, the artistic merged with the patriotic since the artist as an American had a "duty which he owes to his country, to come forth and educate the popular taste--come forth and be the interpreter of fine art as well as its cultivator."[7] The purpose of this "education", that is to say, the purpose of art in American society was multiple. Art gratified the human senses and in so doing elevated the primitive to the status of the cultured. The development of a culture signified the establishment of a national identity.

Art, according to the Rev. Orville Dewey, elevated the human spirit both in terms of national pride and religious assent, thus providing for constructive utilization of leisure time. "It is often said," he remarked, "that the arts cannot flourish in a republic." In responding to his own hypothesis, he argued that "it is precisely in a republic that they are wanted to complete the system of social influence."[8] Carefully orchestrated exposure to works

of art instilled morality and patriotism in viewers. Through the visual arts, then, Christianity and America came together in pursuit of an American identity. The common causes and concerns of the American middle class and of Christian Romantic ministers united in yet another common goal, the development of an "American" art.

The anonymous author of an untitled essay in *The Illustrated Magazine of Art* employed a series of theological metaphors to argue for the unity of art, religion, and America. "Let the nation, then, give us a true nationality, the church a holy brotherhood, and the family a free and close union of power and love, and American art will fulfil its destiny."[9] For such clergymen and art critics, the purpose of art was to "aid man in reading the works of God and transferring to his heart the thoughts that breathe in their substantial forms."[10]

These divine works of God to be read with diligence were found in nature, particularly the American landscape. The triadic relationship between God, nature, and art was the theological foundation for the development of American landscape painting. This Christian Romantic attitude towards Nature, symbol, and imagination formulated a particular spiritual receptivity for landscape painting among middle-class Americans. In an editorial, *The Crayon* clarified the importance of this triad noting that. "The reverence of nature is the first step to the reverence of Nature's God, and the love which Art requires is the elder sister of that which Religion demands."[11] As the visual metaphor of America's singular identity, the landscape was the distinguishing characteristic of "American" art. "There is American scenery to be depicted, American character to be portrayed, American history to be embodied...Let our own rocks and rivers, our wooded glens and mountains, our ocean and our coast, be reflected from the canvas, and let the genius of our country breathe its own life into the imperishable marble."[12]

This recognition of the landscape as the appropriate theme for American art and as the visual icon for American identity accorded with the general sentiments of the middle class. As Rev. Osgood asserted, "The eye for landscape painting is, by this constant intercourse with Nature, quite quick in Americans; and this form of Art is, perhaps, more highly appreciated than any other among us."[13] The articles in popular religious and art journals affirmed that landscape painting was the distinctive American art form. With regularity, these articles praised Washington Allston, Thomas Cole, and Frederic Edwin Church as the ideal American artists and their paintings as the epitomes to which American art aspired.[14]

American Clergymen and the History of Christian Art

These nineteenth-century journal articles authored by American clergymen evidenced a richer knowledge of art history and Christian iconography than might otherwise be anticipated by such twentieth-century investigators as William Gerdts who stated that "Given the Protestant heritage and temper in the United States, religious art figures less significantly among the concerns of our painters and correspondingly of the critics."[15] The evidence of the journal articles and ministers' travel diaries argued for the role and public consciousness of "religious art" in antebellum America. These artists, clergymen, critics, and connoisseurs were well versed in the history and iconography of Christian art because of the writings of the French writer Alexis-François Rio, the British art connoisseur Lord Lindsay, the art critic John Ruskin, and the British writer Anna Jameson who, as Lillian B. Miller has pointed out, "were the most important advocates in English for Italian Primitives."[16] Rio's *The Poetry of Christian Art* (1836) was the first book delineating the spiritual and cultural connections between Christianity and art, without regard to style or technique. Ruskin's *Modern Painters* and Mrs. Jameson's multi-volume, *The Poetry of Sacred and Legendary Art* and her *Handbook to the Public Galleries of Art in and Near London*, became "classics" for both cultured connoisseurs and sophisticated travelers, including American clergymen. Mrs. Jameson's ideas were also accessible to both American ministers and a middle-class audience given that her articles on Italian painters were published in *Penny Magazine* (1843), her reviews in the *Atheneum*, and a serialization of her *Sacred and Legendary Art* in the *Atheneum* (1845).[17] These publications laid a foundation upon which America's Christian Romantic clergy based a relationship between Christianity and art.

Lengthy treatises discussing the historical connections between Christianity and art illustrated the recognition and concern of American clergymen and art critics even though the inherent weaknesses of clergymen as art critics and of art critics as theologians were also evident. For example, many of the technical assessments of paintings made by clergymen indicated the superficiality of their art historical knowledge; and the attempted delineations between religion and theology by art critics were equally naive.[18] The alliance between art and religion was recognized and supported by Christian Romantic clergymen in other ways. As Rev. Osgood told *The Crayon*, "...if I may judge from my own personal friends, your journal has no heartier well-wishers than the educated clergymen of this country."[19] In

his analysis of clergy attitudes towards the visual arts, John Dillenberger indicated that there were "those who made an occasional statement about the arts, while still fundamentally ignoring them, and those for whom they were considered a part of the life of humanity."[20] Those clergy who fell into Dillenberger's second category--Cyrus A. Bartol, Henry Ward Beecher, George Washington Bethune, Horace Bushnell, Orville Dewey, Elias L. Magoon, Louis Legrand Noble, and Samuel Osgood--were Christian Romantics.

Through public speeches, newspaper articles, pamphlets, books, sermons, and their attendance at art galleries, these clergymen experienced and supported the development of American art. Most clergymen of this period, like their artistic counterparts, traveled to Europe and spent the greater part of their time looking at the artistic masterpieces of the European tradition, from paintings and sculptures to the great cathedrals. This first hand encounter with the "classical" tradition affirmed the importance of art for the development of an American culture and for the spiritual assent to Protestant Christianity. In typical fashion, these clergymen kept travel journals and diaries in which they recorded not only their meetings with leading religious and cultural figures, but also impressions of masterpiece paintings and the great cathedrals. Several consistent questions were argued in these clerical travel diaries: "the supremacy of nature or of art;" "the issue of Roman Catholicism and its world of art;" "a disagreement on specific cathedrals, about which there is more difference of opinion than on individual paintings;" the role of art as a Christian educator; the role of art in the church; and the supremacy of Raphael.[21]

Discussions of the supremacy of nature or of art revealed the fundamental romantic interest in the affective dimensions of the human person such as imagination and the heart, and the personal experience of spirituality. For some romantics, like the Emersonian Transcendentalists, such an experience was most fully realized through an encounter with nature; whereas for the Christian Romantics, an encounter with nature represented the symbolic mediation of God's grace. Such a symbolic mediation took the form of a work of art, especially a landscape painting, as well as the natural environment. The romantic interest in the organic relationship of the arts, and the connections between art and nature, were also evident. More importantly, the Christian Romantic interest in the landscape and its expression in art was attested to in these travel journals. Descriptions of the wonders of European nature were later refuted by these same clergymen whose discussions of the American landscape reaffirmed its singularity and the magnificence following their European experiences.

A second identifiable theme was a nineteenth-century variant of the traditional Protestant iconoclastic and anti-papist bias against the visual arts. As Peter Gardella has stated, "In the first half of the nineteenth century, American Protestants had almost no experience of ritual in worship or the adornment of churches."[22] At the same time, the majority of Americans had no direct or prolonged experience of Roman Catholic ritual, art, or architecture. America, as a nation characterized by the Protestant principle, had little indigenous Roman Catholic heritage or experience to draw upon. Instead, the "mystique" of Romanism and the idolatry of "Catholic art" was instilled in the minds and the hearts of the average nineteenth-century American. This discomfort with Romanism built upon the "Hebraistic imagination" which Perry Miller interpreted as "always be[ing] impressed upon" America's "submerged memory."[23] Furthermore, in this mid-nineteenth-century period, according to Lillian B. Miller, "American travelers to Italy--most of them Protestants--encountered artistic subject matter that troubled them: Catholic images on the one hand, and nude statuary on the other."[24] Given the simple fact that there was no American Roman Catholic heritage or monuments for these travelers to draw upon as reference points, they found themselves confronted, for the first time in Italy or France or Spain, with first-hand experiences of Roman Catholic art. Coincidentally, these same clergymen were lured into Roman Catholic Churches and attended Roman Catholic liturgies during their European sojourns.

Having recognized the role of the imagination and the human affections in religion, these clergymen needed to identify the appropriate role for the arts without encouraging what they deemed the distressing abuse of the visual arts prevalent in Roman Catholicism. The concern of the Christian Romantic clergymen was, then, to establish a meaningful venue for the visual arts in American Protestantism. One rationalization was to recognize that "Catholic art" was a historic expression of religious belief. A second was the analogy between a work of art and a sermon. "Art is nothing less than a preacher," Bartol wrote in his travel diary.[25] Orville Dewey commented that "Painting is a language, as truly as that which is heard from the pulpit."[26]

The greater portion of clerical comments on the arts dealt with the role of art and of the artist in American society rather than in church buildings. Nevertheless, occasional and thoughtful comments indicated a recognition of the visual arts in church building, and offered a plan for the style, placement, and commissioning of works of art in American churches. For example, Dewey recognized that in order "to place good paintings in all their churches ...any congregation should commence the leadership, by a collection in the

church, or by individual subscriptions, and when a sufficient sum is obtained to defray the expense of a painting, let the purchase be made by a judicious committee appointed for that purpose." After several generations, Dewey reasoned that "the country might at length be filled with the finest productions of the pencil" once "Our own artists would immediately feel the stimulus of the call."[27]

The lengthiest and most erudite clerical analyses of the historic relationship between Christianity and the arts concerned church architecture, especially the problem of the design and building of new churches.[28] The medieval cathedral, and its appropriateness or inappropriateness as an artistic, symbolic, cultural, or religious expression became a subject of discussion and reflection in many a travelling American clergyman's journal. For Christian Romantic clergymen, the medieval cathedral was not retrieved as a nostalgic expression of the ideal relationship between Christianity and culture, as it was for High Church Anglicans or Roman Catholics, rather they sought an architectural form appropriate to the cultural temper and architectural skill of their own day. After all, the God of Christian Romanticism was the God who acted in the history of the here and now world.

The pedagogical and evangelical functions of the visual arts were recognized by these American ministerial travelers. "What value and variety of instruction!" exclaimed the Rev. Cyrus A. Bartol of his experiences viewing the great Catholic art in Florentine and Roman museums. For Bartol and other like-minded clergymen, "Art" was "a fifth evangelist" which proclaimed "with her mute but mighty trumpet...the eternal lessons of truth and beauty."[29] Cognizant of the visual modality's potential, Bartol advocated the employment of the arts for the mutual benefit of American Protestantism and American culture, these two, for him, being interchangeable. Similarly, the Rev. Orville Dewey argued that the "fine arts have usually been the handmaids of virtue and religion."[30] The issue, then, became for these American clergymen to find an appropriate style and theme for the religious art of American Protestantism. Their initial answer may be seen in the works of "classic" art and the artists they praised in their texts and travel diaries.

More than any other "classic" artist singled out for praise was the Italian Renaissance master Raphael, specifically, the Raphael of "the dear Madonnas."[31] As Colleen McDannell noted, "paintings of the Madonna and child graced the walls of Protestant and Catholic homes" alike.[32] Raphael's various paintings of the Madonna and Child provided the primary source of these reproductions as well as the many prints and engravings, and in particular, his famous *Madonna of the Chair* (1510-1515: Pitti Palace, Florence) (fig. 4) became a "a barometer of mid-century taste."[33] Most major Amer-

ican painters, including Benjamin West and Washington Allston, not only admired but were influenced by Raphael. Known as "the American Raphael," West painted his *Portrait of Mrs. West and her son Raphael* (c. 1770: Utah Museum of Fine Arts, Salt Lake City) (fig. 5), modelled after the *Madonna of the Chair* as did other American artists of this period, including Charles Willson Peale and his son Rembrandt. Allston's series of paintings on the theme of contemplative young women are thought to have been influenced by his study of Raphael's paintings.[34] Exactly what engaged and transfixed these American artists and clergymen was not Raphael's style or artistic technique *per se* but rather his ability to present sentiment and sentimental-ism through visual idealization of motherhood. Witness the Rev. Cyrus A. Bartol's journal entry that "Mont Blanc may fall out of the memory, and the Pass of the Stelvio fade away; but the argument for religion...which was offered...in the great Madonnas of Raphael, cannot fail."[35]

Other images of Catholic art, such as the last supper, crucifixion, and adoration scenes, were both unfamiliar and uncomfortable to the American Protestant psyche. The images of the Madonna and Child, especially those by Raphael, could be appreciated, and admired, as they could be separated from their "Catholic" and "Romanist" roots.[36] In his popular mid-nineteenth century *Book of Raphael's Madonnas*, the connoisseur James P. Walker verbalized the commonly acknowledged belief that "the Madonnas were central to Raphael's achievement."[37] This achievement, which was also to be praised by Rio, Ruskin, and Mrs. Jameson in their texts on Christian art, was not so much stylistic or theological as aesthetic for Raphael's Madonnas were idealized depictions of the beauty of motherhood. Thus, American Prot-estant viewers could admire the presentation of a loving, gentle mother with her sweet child as distinct from the sacramental theology a Roman Catholic viewer attached to such an image. Raphael's Madonnas were admired by the Christian Romantic clergy, connoisseur, artist, and the American middle class for their sentiment which conformed to the tenets of domestic spirituality.

These themes reflected the general Christian Romantic interest in the role of art in society and the home, not in the church. Such an interest related logically to the fundamental Protestant bias against the visual modal-ity, and was indicative of the general cultural trend to which Christian Romanticism was both sympathetic and supportive--the living of the Christian life. In shifting the emphasis from the ritual and sacramental aspects of traditional religious practice to being a Christian, Christian Romanticism fostered the development of domestic religion and the centrality of the family as the vehicle for spiritual formation.[38] The emphasis on art in the home and of family visits to art galleries and natural landmarks (e.g.,

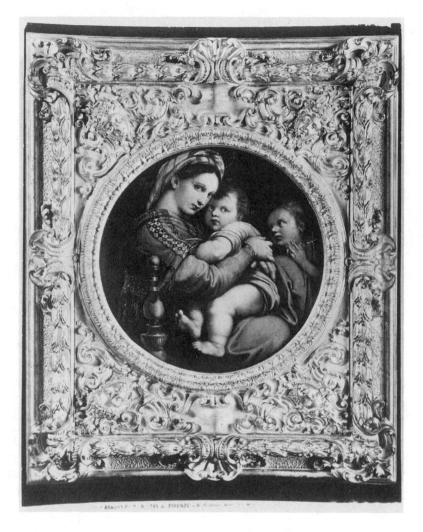

4. Raphael, *Madonna of the Chair*, 1510-1515. Oil on panel, 71 cm. diameter. Pitti Palace, Florence. Courtesy of Alinari/Art Resource, New York.

5. Benjamin West, *Portrait of Mrs. West and her Son Raphael*, © 1994. 1770. Oil on
canvas, 36 inch diameter. Utah Museum of Fine Arts, Salt Lake City. Gift of The
Merriner S. Eccles Foundation for The Merriner S. Eccles Collection of Masterworks,
Permanent Collection, Utah Museum of Fine Arts, University of Utah. (1982.002.003).
Courtesy of the Utah Museum of Fine Arts.

Niagara Falls), and architectural sites (e.g., St. Peter's Basilica, Rome) were logical consequences of this shift in religious centers from the church to the home.

Both Horace Bushnell and Henry Ward Beecher made trips to Europe during this period and kept extensive travel diaries.[39] In particular, Bushnell's carefully annotated five volumes of travel diaries from July 1845 to May 1846 feature his own illustrations and lengthy descriptions of his impressions of artistic masterpieces and liturgical environments. "The great day, Christmas!...we arrived at St. Peter's...At the moment when the host was consecrated...a great part of the assembly went down in an instant, to adore the body and the blood...As I looked upon it, at the close, considering how a simple life of goodness and humility in the flesh, as distinct from all this as thought can conceive, had yet power to set it all in motion, I felt a stronger sense of the sublimity of the cross."[40] His comments on the paintings of Raphael, affirmed his middle-class Christian Romantic values.[41] For Raphael's gift, according to the American minister, was the artist's ability to express only "what nature wants expressed, without the least exaggeration. The most delicate sentiment has its language."[42]

Contrary to Dillenberger's suggestion that Bushnell's comments "on the visual arts fall into the general pattern of travellers of the time,"[43] an analysis of these diaries in the larger context of the nineteenth-century American's published texts proved that they were more significant than the average clerical travel journal. The young Horace Bushnell who entered Yale University with a sense of cultural, linguistic, and spiritual insecurity would not have made any reference to the arts at all, let alone written lengthy entries and made detailed drawings, if he were not becoming sensitive to aesthetic values. Although much of his discussion took on an anti-papist tone, other passages testified to his growing recognition of visual images as symbols, and therefore as a religious language, specifically in terms of the role of aesthetic discernment in the development of moral action and spirituality. The one similarity that Dillenberger found between Bushnell's travel journals and those of other American clergymen, that of language, was particularly illuminating since the young student from a simple country family had sought a language that would serve as a source of a communal identity among the more established and cultivated Americans to whom he wished to minister. His European trips and travel diaries evidenced the development of both an acceptable and appropriate language and societal identity.

Ministerial Collections in Antebellum America

During this period, clergymen formed art collections which were more than a personal gathering of prints, engravings, and small paintings, and assumed the size and scope of important private collections. Elias L. Magoon, for example, a Baptist clergyman, who served as Chairman of the Committee on the Art Gallery for Vassar College, formed a collection that became the nucleus of the Vassar College Art Gallery in 1864.[44] Magoon's collection of landscape paintings by the Hudson River School and later American painters, his collection represented the sentiments expressed by other Christian Romantic clergymen. His collection, ostensibly entitled "American Originality in Art," this clergyman-collector acknowledged the progress of human civilization from the Old to the New World as well as the divine inspiration in art and the symbolic relationship between art and nature.[45] Magoon collected paintings by Frederic Edwin Church, Thomas Cole, Jasper Cropsey, Thomas Doughty, Asher Brown Durand, Sanford Gifford, George Inness, and John Frederick Kensett.[46]

Henry Ward Beecher's collection of original oil paintings, watercolors, prints, engravings, etchings, and drawings which included works by George Inness, Eastman Johnson, Rembrandt, and Turner. was exhibited at the American Art Association in 1887 just prior to the sale of his estate.[47] Like Magoon, Beecher collected works of art for educational as well as aesthetic purposes. His son and son-in-law described Beecher's collection and his pattern of collecting as stemming from his "own love of learning and of the beautiful" as well as his concern "for the training of the family." His choices were made "not with the zeal of a collector, who seeks the rare merely for its rarity, but because the thing itself was beautiful, or illustrated some type of period of art."[48]

In contrast to these clergy collections, Thomas Jefferson Bryan and James Jackson Jarves established specialized collections of "Christian art." The aesthetic tastes of these laymen-collectors extended beyond the mainstream of nineteenth-century American collectors.[49] Consisting of over three-hundred works of art from the thirteenth to the eighteenth centuries, Bryan's Gallery of Christian Art which originally could be viewed for an admission fee of twenty-five cents at his New York City home became part of The New-York Historical Society in 1866.[50] As unappreciated as Bryan's Gallery of Christian Art, the James Jackson Jarves Collection which "illustrate[d] the History of Painting from AD 1200 to the Best Periods of Italian Art," (fig. 6). As unappreciated as Bryan's Collection by both critics and the

public, the Jarves Collection was purchased by Yale University Art Gallery in 1864.[51]

Although the focus of these two collections, traditional Christian art, was appropriate to the contemporary discussions of the relationship between Christianity and art, the reality of the works in the collections led to critical and public disapproval. As Lillian B. Miller noted, "In the 1860's,...Catholic religious art such as was to be found in Bryan's and Jarves' collections either frightened, confused, or bored the general American public, and held little for collectors." The average middle-class American, who might have found a Raphael *Madonna and Child* accessible, "sought [rather] to experience religious emotions" from the "nationalistic and spiritual meaning" attached to American landscape painting.[52] Although the collections of Bryan and Jarves were without doubt created with a more discerning aesthetic and art historical eye than those of Magoon and Beecher, the latter collections like the clergymen who established them reflected mainstream nineteenth-century middle-class American tastes. The emphasis on the development of an American art, recognition of the originality of American landscape painting, and integration of these works within the domestic and familial spheres (and therefore as models for personal collections in the middle-class home) made the Beecher and Magoon Collections appropriate to middle-class American Christian Romanticism.

Henry Ward Beecher on Art and Christianity

Characteristically Henry Ward Beecher's attitudes towards art and Christianity represented the popular synthesis of clerical and artistic dispositions between 1820 and 1860. Gifted in his ability to discern philosophical and theological ideas, and to relate them in a language accessible to the general cultural milieu of middle-class Americans, Beecher discussed art in his regular newspaper columns and later, reprinted in the collections known as *The Star Papers* and *Eyes and Ears*; and in his novel, *Norwood*. Fundamental and necessary elements to human existence, nature and art were God's gifts to human beings which once properly understood brought humanity closer to spiritual communion with God. Beecher's understanding of the artist was reminiscent of Coleridge's understanding of genius. The artist "teaches men by opening through imitation the message of deeds, events, or objects, so that they rise from the senses, where before they had exclusively presented themselves, and speak to the higher feelings."[53]

6. Sassetta(?) or "Osservanza Master" (Sienese School), *St. Anthony Tempted by the Devil in the Shape of a Woman*, 15th century. Egg tempera on panel, 14 7/8 x 15 13/16 inches. Yale University Art Gallery, New Haven. University Purchase from James Jackson Jarves. (1871.57).

In keeping with contemporary attitudes towards arts and crafts, Beecher distinguished between two artistic types: artisans who pleased the public, and artists who presented the vision of the spiritual beauty of the world.[54] The artist had been given special gifts from God which he must use for the betterment of the human condition.[55] As a moral and spiritual teacher, the artist, operated in a fashion analogous to the clergyman. "You can seek the moral benefit of society by your art, as readily as by sermons, and probably with far greater success," Wentworth advised Esel. "But your profession is, Christianly considered, the education of the community by the ministration of Beauty."[56] After all, Beecher affirmed with a Christian Romantic faith in a God who acts in history, "Art is a pictorial language. It must discourse in every age of the things which belong to that age, as to the purposes which a Divine Providence is developing in any period of time."[57]

The proper purpose of art in society, Beecher continued, was to serve the people and, in order to attain this end, "Art was called down from great ceilings and vast walls, from churches and palaces, because the citizen was building his house, and it is a higher function for Art to serve the whole citizenship than to serve their rulers."[58] Commensurate with the changing social role of middle-class women and children, and the developments within the domestic sphere, the preacher-author argued for an art which revealed and taught spiritual truths in a style and manner appropriate for display in the home for "there is a whole realm of household life, of moral life, of common occupation, which, as yet, has been imperfectly served or expressed."[59]

Art and the artist had more than a spiritual vocation to fulfill: they had a social and moral responsibility as well. "Why should there not be drawing-classes among the poor as well as sewing-classes, reading-classes, singing-classes, etc.?" Dr. Wentworth asked Esel.[60] Such a recognition of the social and moral responsibility of the artist reflected Christian Romanticism's connection to the benevolent associations of the Second Great Awakening just as the philosopher-physician summarized the fusion of the religious and the cultural in the process of living the Christian life.

> All this is a part of the work of true benevolence. If you would teach within the church, you must seek ordination at the hands of man. But whose heart soever God has touched with a spirit of benevolence is ordained to go forth into society and preach the gospel to every· creature, each man speaking in the language of his own business![61]

Art taught through the pictorial language of images and symbols which affected the human sensibilities, and art awakened the imagination and

intellect. Following Coleridge, Beecher argued that an experience of the beautiful revealed truth and resulted in good action. "In these higher moods of feeling there is institutional moral instruction, to the analysis of which the intellect comes afterward with slow steps."[62] The work of art then incited an initial emotional response which would be completed by intellectual assent and then by action.

Like the developmental process of conversion experienced by Coleridge and Bushnell, Beecher advocated a similar process for intellectual and spiritual conversion which was enhanced by the experience of art. However, the basic encounter of spiritual communion was an inward feeling of love which for Beecher was specifically maternal love. Thus he recognized both the spiritual significance of the maternal role in the family, and the Christian Romantic interpretation of Jesus as the Christ. Even though the work of art was a symbolic mediation for the universal expression of Christian love, could neither save or sanctify. The subject of the painting was not the relevant issue but the spiritual vocation and authenticity of the artist was for the spiritual truth which stood behind the painted image transcended all obstacles of human fallibility and ineptitude. Beecher's description of an engraving of Leonardo da Vinci's Madonna (*La Vierge au Bas-Relief*) merged his understanding of art as symbolic mediation with the contemporary middle-class American interest in the maternal vocation, for even, "in Protestant America, the picture, if less reverenced, would be much loved as at the day and in the land where it was painted. For it is still a mother with children."[63]

The art which touched the human soul was that which like Beecher's novel, *Norwood*, or Bushnell's treatise, *Views of Christian Nurture*, concentrated on the themes relevant to the average person. With a Christian Romantic sensibility to nature, then, a painting of the American landscape fulfilled both the spiritual vocation of the artist and the office of art among the people. After all, Beecher advocated, "It is the end of art to inoculate men with the love of nature."[64]

Antebellum Interpretations of Nature: America as the Garden of Eden

The quest for a national identity and the gradual spread of romanticism were inextricably united in nineteenth-century America. The answer to the question, "What does it mean to be an American?" resulted in an attempt to establish a cultural cohesiveness for the varied geographic regions of the United States and involved a quest for credibility as well as for a "culture." As Roderick Nash suggested, "Creation of a distinctive culture was thought

to be the mark of true nationhood."[65] This search for an iconography and mythology that identified and authenticated the singularity of the American experience was premised on the recognition of the American wilderness. The transformation of the Wilderness into Nature, and of the Virgin Land into the Garden of Eden, issued from the artistic and religious interpretations. American artists and theologians recognized the appropriateness of the land-scape as that singular characteristic which defined "America."

For nineteenth-century artists, the "American" landscape had visual distinctions from the "European" landscape while for theologians, the "American" landscape affirmed, or in some cases, re-affirmed, America's special place in God's universal plan. "God has promised us a renowned existence, if we will but deserve it," James Brook wrote in the *Knickerbocker.*[66] However, a specific goal was carefully noted throughout this essay, "My only object has been to awaken in the young American a love <u>for his own land,</u>--to fix his eyes and his thoughts <u>here.</u>" This concern for the development of the full person, not just the pragmatic and scientific aspects was paralleled by a concern that too many young Americans admired and traveled to Europe instead of their own country. Brook reiterated, "Home, <u>home,</u> HOME,--is the sentiment that we need to cherish. Our country must be our idols, if idols we have."[67]

The nineteenth-century interest in the wilderness was a variation of the Puritan understanding of their "errand into the wilderness" which was the basic premise that the American landscape was created by God as a gift to this specially chosen group of peoples. In the nineteenth century, however, modifications premised upon the transformation of the Wilderness into the Garden became a dominant theological theme and parodied the scriptural model of the old Israelites who moved through the Wilderness into Paradise, whereas the new Israelites transformed the Wilderness into Paradise. Such a contrast between the Primordial Wilderness and the Garden of Eden reflected both states of nature and states of mind. The dichotomy of the wilderness and the garden reflected the scriptural interpretation of the wrath and the grace of God for the former was the realm of punishment which provoked fear, while the latter was the site of providence which inspired serenity. The traditional scriptural ambiguity of the Hebraic experience as God's chosen people was evident in this dialectic of wilderness and garden.[68]

The Wilderness had both positive and negative connotations. The Primordial Wilderness was a place of refuge from the evils and ills of civilization--a place where persecutions did not exist and thus the goal of the immigrant experiences of the Jews. In this positive reading of the wilderness,

it was contrasted to the desert which was the realm of emptiness and despair. In certain interpretations within the American context in the nineteenth century, the term, Primordial Wilderness, was used in a positive manner and connected with the ideas of Youth, Freedom, Individual Regeneration, and Mission. In its negative reading, the wilderness was the unredeemable wasteland which was the location for the punitive or purgative preparation for Christian salvation. Mircea Eliade suggested that, "Christianity is ruled by a longing for Paradise;" and American Christianity, especially in its antebellum variations, was no exception. Eliade defined this "nostalgia for Paradise" as "the desire to recover the state of freedom and beatitude before 'the Fall,' the will to restore communication between Earth and Heaven."[69] Paradise and the Garden were synonymous as physical and metaphysical realities in the American mind. As the place of protection and nurture, and of contemplative retreat, the Garden reflected one's inner nature or ground of being the reality of God's special blessing.

In newspaper and magazine articles, including the essays by Brook and Cole, as well as in books, pamphlets, lyceum lectures, and sermons, the Garden of Eden became a metaphor for the American Wilderness, and eventually for the American Frontier. In this way, America in its virginal state of aweful beauty and union with God stood in opposition to the antiquity of Europe. America was not interpreted as a continuation of Europe and of the European tradition, but as a singular state of nature replete with spiritual significance. This generalized religious reading of the American landscape was affirmed by the growing nineteenth-century interest in the sciences of botany and geology. The geological investigations of Asa Gray and Benjamin Silliman among others came to influence the emergent "American" literary and artistic traditions and American Protestantism, as well as the general culture.[70]

With the identification of America as the Garden of Eden by the explorations and the settlements of the West, the idea of the "Frontier" became empowered in the American mind by its parallels to the Garden of Eden. These were psychological as well as geographical states for the Frontier was as much a state of mind as a place in nature just as the Garden of Eden was their natural place for Adam and Eve, so the Frontier was a state of bewilderment and refuge to the settlers. Thus, the American as pathfinder, pioneer, settler, frontiersman, immigrant, and Indian became identified in the mid-nineteenth-century mind with Adam.

This identification of America as the Garden of Eden earned additional significance with the development of a variety of Utopian communities which sought to build the perfect society on that site each claimed was the

"Garden of Eden." The establishment of Brook Farm, New Harmony, Oneida, and Hopedale signified this identification of the Utopian ideal within the American experience. At this time, several perfectionist style cults established their idealized communities on the locations selected by God and identified as the Garden of Eden. Mormonism was the predominate example of these mid-nineteenth-century cults which might be described as religious communities that fused the frontier image with a specific understanding of the theology of salvation for "America." Charles I. Sanford summarized that attitude:

> As a framework for interpreting historical events, the myth of the Garden of Eden helps to rescue man from the terrors of his swift-passing and often painful existence on earth by reconciling the transitory and the eternal. It becomes a powerful fulcrum for historical change, however, when a "chosen people" convert it into a rationale for temporal status, independence, power. The chosen people try to make historical events conform to their image of a temporal future which holds for them an earthly paradise. They tend to regard this earthly paradise as a type of the original Eden.[71]

In his survey of American literature from 1820 to 1860, R.W.B. Lewis indicated a similar attitude towards America as the Garden of Eden.[72] This romantic feeling for the new nation of Nature in Paradisaic innocence was identified in the writings of James Fenimore Cooper and Walt Whitman. However, in the writings of Nathaniel Hawthorne and Herman Melville, a new sense of the fall of humanity and nature in the American Paradise. Hawthorne and Melville, presented an alternative voice to Christian Romanticism, for romanticism altered only their understanding of nature; whereas for the Christian Romantics, romanticism re-interpreted the meaning of both Nature and the human person.

Historian David W. Noble suggested that all major American novelists were in fact "public philosophers who continually test[ed] the national faith in an American Adam."[73] In his analysis of nineteenth-century American literature, he concluded that the American experience, particularly the contemporary interpretations of America as the new Garden of Eden and the American as the new Adam, resulted in the novelist's confrontation and criticism of "the central myth of our civilization--the transcendence of time."[74] The metaphor of the Garden of Eden allowed for the transcendence of time since in the Garden there was no history, no time, no evil, and no death until Adam ate of the apple offered to him by Eve. The ideal world, then, which "America" symbolized was a world without time, history, evil, or death. Rather, it was a world of possibilities, protection, and God's grace. As the traditional Calvinist doctrine of election became secularized in the

American experience into manifest destiny and the American became symbolically converted into the new Adam, the retrieval of the myth of the Garden of Eden in antebellum America transformed the Wilderness into Nature. The interpretations of Nature were dependent upon the influence of romantic thought on the varied and prevailing theological perspectives. A comparison between the Emersonian Transcendentalist and the Christian Romantic position clarifies not only the theological differences separating them, but also the ways in which America assumed the symbolism of the Garden of Eden.

For the Emersonian Transcendentalist, Nature was sacred so an encounter with Nature became communion with the divine. The unceasing revelations available through Nature were understood as God's self-manifestations. These encounters emphasized the qualities of timelessness, awe, and wonder. In this way, the Emersonian Transcendentalist position reflected what Noble identified as the central American myth, "the transcendence of time." Therefore, Nature, i.e., the American landscape, became ahistorical and permeated with a sense of neutrality and eternality. The American Luminists painted landscapes which were sympathetic visualizations of this interpretation of Nature.[75] In their attempt to present timelessness and ahistoricity, luminist paintings depicted images of photographic neutrality in which the smooth crystalline surfaces of the paintings emphasized the impersonal detachment of the artist from the subject. Such a visual concentration on the universal qualities of time and space was characterized by the planar emphasis on the horizon. The aesthetic concept of "the beautiful" was appropriate to the gentle, regular beauty described by the Emersonian Transcendentalists and the American Luminists. In harmony with the supposed morality and beneficence of Nature, "the beautiful" was the philosophic description of a cultivated nature found in the paintings of Martin Johnson Heade and John Frederick Kensett and in the philosophy of an Emerson. The perspective of Nature presented by the Emersonian Transcendentalists and the American Luminists was one of the Garden of Eden at its original moment of creation.

To Christian Romanticism, however, Nature was symbolic of the presence and grace of God on earth. Nature was permeated with historicity, awe, and fear. An experience of the grandeur and the power of Nature resulted in a recognition of human limitations and finitude. At the same time, Nature was experienced as beautiful because it was infused with God's grace. The fundamental orientation of Christian Romanticism toward a symbolic interpretation of Nature allowed for a dichotomous relationship to Nature as both Garden and Wilderness. Nature was the Paradise Garden

regained and the dramatic setting for the working out of God's universal plan. Nature made possible the positive experience of God's grace and love, and the negative experience of God's wrath. In either case, Nature was America and America was the Garden of Eden regained--to be regained, however, was not to be original. The emphasis here was not on the original and therefore innocent state of Adam and Eve in the Garden but on the possibility of the Garden regained through the innocence and faith of childhood.

In Christian Romanticism, Nature was the realm of "the child in the Garden." Bushnell's theological interest in the establishment of a theology of Christian Nurture, premised as much on social and cultural changes as on theological interpretation, found a visual icon in the image of the child in the garden. The spiritual domesticity and Christian nurture preached by Christian Romanticism found its way into these visualizations of mothers and children in the American landscape; thus, the visual became a form of Christian rhetoric.

The idealization of childhood had multiple influences upon the development of the theology and the practice of American Christian Romanticism. The Romantic emphases on development, growth, and organicism found their best expressions in the child and the artist. "[T]o this universe of process and change only the child and the artist are native," Judith Plotz advised, "the artist by his chosen task of embodying meaning in symbols, the child by his inborn necessity for growth."[76] The child in perfect completion and the artist in spiritual vocation became for the Romantics the symbolic redeemers of humanity. The child symbolized the potential for human redemption, and the artist human maturity. Plotz summarized the Romantic interpretation of the artist: "The person able to retain his childhood powers of perception while acquiring the adult's intellect and moral awareness is the artist--and the best kind of mature adult."[77] This philosophic and theological emphasis on the redemptive role of the child and of childhood merged with the general cultural attitude towards a positive interpretation of youth. Any heightened or re-interpreted value such as that placed upon childhood necessarily resulted in changes in the sphere of daily activities; specifically in terms of a re-definition of childhood, the concurrent societal values of motherhood and education were affected. Christian Romanticism's theology of Christian Nurture and of Nature with the child in the Garden addressed these issues.

The aesthetic concept of "the sublime" was appropriate to Christian Romanticism's approach to Nature. The blind forces of Nature which could be both amoral and moral in their actions and presentation were visually

reflective of Christian Romanticism's dichotomous interpretation. "The sub-lime" was simultaneously a return to the primitive powers of the wilderness and a presentation of God acting in history and through nature. In the paintings of artists sympathetic to Christian Romanticism, specifically Allston, Cole, and Church, the sublime became both embodiment of and stage for a Christian rhetoric.

The Aesthetics of the Christian Romantic Home

This visual rhetoric found its way into the homes of middle-class America through prints, engravings, and gift books. Cole's paintings, especially *The Voyage of Life*, were a common and popular source for the prints which hung on the living room walls of middle-class American homes.[78] With its integrated theme of Christian pilgrimage and the American landscape, Cole's series fulfilled the aesthetic and moral concerns of middle-class American homes.[79]

In the larger realm of prints and engravings in antebellum middle-class homes, the themes of these prints focused on acceptable scriptural topics, such as the New Testament themes of the Resurrection, the Supper at Emmaus, and the Madonna and Child as well as genre and landscape themes.[80] The print, since it was designed to adorn the walls within a home instead of a public space like a church or civic building, had a pedagogical and spiritual impact on its viewers. As Rev. Henry W. Bellows wrote to his colleague, Rev. Abbott, on November 7, 1855, "...in respect of the moral influence of art, the character of the stock in our Print shops is of more importance than the nature and promise of native Art in our National Academies of Design."[81]

The gift book was another vehicle for the development of middle-class values in antebellum America.[82] Originally designed to educate young female minds morally and spiritually, gift books are an importary record of antebellum cultural history. On average, each volume of the different gift books reproduced 8 to 12 full page engravings which emphasized the Amer-ican scene and the American way of life. In particular, the *Home Book of the Picturesque* (1852) and *Home Authors and Home Artists* (1851)[83] reflected this interest in Nature, art, and an American identity.

The paintings of Allston and Cole were popular sources for gift book engravings. In fact, five of Cole's landscape paintings were engraved for *The Token* to bring its readers a sense of the beauty of the American landscape. Similarly, Allston's works were engraved for the two most popular gift books, *The Atlantic Souvenir* and *The Token*. Like the prints by Kellogg,

these gift book engravings focused on the timeless and sentimental themes of family life and of mountain scenery as such subjects were accessible and familiar to the average reader, i.e., middle-class Americans.

The gift book was an ornament for the parlor table which was intended to cultivate refinement in its readers and served as an "amenity" in a Christian home. This middle-class interest in and propensity towards both prints and engravings and giftbooks reflected the Protestant bias towards those media of visual presentations and away from painting and sculpture. Thematically and technically, Protestant artists, from Albrecht Dürer and Rembrandt van Rijn into the nineteenth century, excelled in the presentation of religious and genre themes throughout the varied media of prints, engravings, and book illustrations. Therefore, the artistic heritage to which the nineteenth-century American middle class was the heir was one in which American artists came to excel through prints, engravings, and illustrations for gift books and annuals. On another level, the gift book reflected the fusion of the middle-class values of domesticity, Christian nurture, and education integral to the culture-at-large. Prints and gift books made accessible to the average American and therefore to the average child, visual interpretations of America's singular and unique characteristic, the landscape. By means of these pedestrian vehicles, "America" was transformed from the Wilderness into Nature, and from Nature into the Garden.

Sacvan Bercovitch described the practical results of this retrieval and re-interpretation of America as the Garden of Eden, and its significance for the development of nineteenth-century landscape painting. For "nothing more clearly shows the sustained power of the myth than its capacity to accommodate new forms." Bercovitch continued

> By the mid-nineteenth century, for example, nature was supplanting scripture as the source of prophecy; but the effect was to reinforce familiar patterns. Scripture and Nature were seen as complementary. They were the Old and New Testaments, as it were, of the American way. The Bible had foretold America, the New World landscape radiated the types of things to come. It was a second Genesis and Apocalypse combined, a new cosmic author-ity for the nation of the future. This was the principle of landscape painting throughout the period. The enormous canvasses of the romantics and the luminists comprise nothing less than a national iconography: crosses in the western sky, forests and plains graced with baptismal founts, pioneers, directing caravans through mountain passes like Moses pointing the way to Canaan. As Frederic Church said of his most popular work, he wanted Niagara to speak through him, so that viewers would hear for themselves its prophecy of the American Jerusalem.[84]

The search for a visual icon for the new nation resulted in a turn to the landscape, and of the ultimate identification of America with the Garden of Eden. The integration of the Judeo-Christian scriptural tradition with the cultural consciousness of "America" found affirmation in the gradual spread of romanticism. The artistic and religious expressions of kinetic nature resulted in the two distinct interpretations of Emersonian Transcendentalism and Christian Romanticism. The common bond between these was the undeniable conviction that "America" had been singled out by God for a unique destiny.

ENDNOTES

1. John Dillenberger, *The Visual Arts and Christianity in America. From the Colonial Period to the Present* (New York: Crossroad Publishing, 1988 [1986]), Chapter 4, "Religious Journals and the Visual Arts," pp. 57-70. I am indebted to the preliminary studies of the relationship between clergymen and artists in nineteenth-century America by John Dillenberger and Neil Harris. Although my own reading of the primary source materials is not in total agreement with either Dillenberger or Harris, we share the basic premise that there was a stronger alliance between these two groups than has previously been acknowledged. My analysis of this relationship as manifested through journal articles, travel diaries, and newspaper articles is not exhaustive but suggestive. See Neil Harris, *The Artist in American Society. The Formative Years*, 1790-1860 (Chicago: University of Chicago Press, 1982 [1966]); esp. Chapter 12, "The Final Tribute," pp. 300-6.

2. Beyond the primary texts cited in my bibliography; see Dillenberger, *The Visual Arts and Christianity in America*, pp. 174-81; and Harris, *The Artist in American Society*, pp. 408-2.

3. With regularity in both art and religious journals, the predominant epitome of artistic and spiritual expression was the work of the Italian Renaissance painter, Raphael. This American fondness for Raphael was no doubt related to the emergence in the antebellum period of the domestic spirituality common to Christian Romanticism. For a study of Raphael's place in the development of American aesthetics, American art collections, and American cultural history; see David Alan Brown, *Raphael and America* (Washington, D.C.: The National Gallery of Art, 1983), exhibition catalogue.

4. G.F. Simons, "Prospects of Art in this Country," *Christian Examiner* 25 (January 1839): 320.

5. Ibid., 320.

6. Rev. Samuel Osgood, "Art in its Relation to American Life," *The Crayon* 2.3 (July 1855): 54.

7. "American Art," *The Illustrated Magazine of Art* 3 (1854): 212.

8. Orville Dewey, The Old World and The New; Or, *A Journal of Reflections and Observations Made on a Tour in Europe.* (New York: Harper and Brothers, 1836), Volume I, pp. 190, 192.

9. *The Illustrated Magazine of Art*, p. 216.

10. *The Illustrated Magazine of Art*, p. 212.

11. Editorial, "The Creed of Art," *The Crayon* 2.21 (November 1855): 319.

12. R.C.W., "American Art and Art Unions," *Christian Examiner* 48 (March 1850): 223.

13. Osgood, "Art in its Relation to American Life," p. 54.

14. For example, see *The Illustrated Magazine of Art*, 215; Simons, "Prospects of Art in this Country," 313-4; R.C.W., "American Artists and Art Union", 209; and "The Art of America and 'The Old Masters'", *Christian Examiner* 73 (1862): 68-69.

15. For example, see the editorials, "Christianity and the Formative Arts" in *The Crayon* 6.11 (November 1859): 325-32, and 6.12 (December 1859): 357-67; or any of the reviews cited from the *Christian Examiner* in the bibliography. As an example of an artist's perspective and knowledge of this subject, see any of the following essays by Thomas

Cole, "A Letter to Critics on the Art of Painting," Knickerbocker, *New-York Monthly Magazine* 16 (1840); 230-3; "On Frescoes: A Letter to the *Churchman*," *Churchman* (October 31, 1846): 138; or "In Reply to J.C.H.: A Letter to the *Churchman*," *Churchman* (December 5, 1846), p. 158. All three essays have been reprinted in Thomas Cole, *The Collected Essays and Prose Sketches* ed. Marshall Tymn (St. Paul: The John Colet Press, 1980), pp. 58-74.

 William H. Gerdts and Mark Thistlewaithe, *Grand Illusions, History Painting in America* (Fort Worth: Amon Carter Museum, 1988), p. 97.

16. Lillian B. Miller, "'An Influence in the Air': Italian Art and American Taste in the Mid-Nineteenth Century" in Insight and Inspiration. *The Italian Presence in American Art: 1760-1860* ed. Irma B. Jaffee (New York: Fordham University Press, forthcoming). This citation is from the unpublished manuscript, p. 18. I am grateful to Dr. Miller for both allowing me to read and cite from her unpublished manuscript text, and also for introducing me to the works of Alexis-François Rio and Lord Lindsay.

17. Anna Brownell Murphy Jameson (1794-1860) was one of the first women writers on art. She authored two catalogues of London galleries, a widely influential account of Italian painting from the thirteenth to the sixteenth century, six volumes that comprise the first systematic study of Christian iconography, and journal and magazine articles. An advocate for women's education, Mrs. Jameson wrote books and lectured widely on behalf of improved employment and education for women.

 First recognized for *The Diary of an Ennuyé* (1826), Mrs. Jameson began her career as a serious critic who commanded respect in American, English, and German literary circles. Her earliest critical studies included *The Love of the Poets* (1829); *Memoirs of Celebrated Female Sovereigns* (1831); and *Characteristics of Women* (1832). Her meeting with Alexis-François Rio in 1841 in Paris changed the course of her career as she then began the research and writing of the first art historical studies on the history and symbolism of Christian art.

 Her guidebooks to London galleries, and her studies of Christian art were known to American readers, especially those clergymen and artists who traveled to Europe. Mrs. Jameson visited the United States in 1839 during which time she began a friendship and correspondence with Washington Allston. Many of her writings were published in American magazines, and most of her books saw at least one American edition during her lifetime.

 For additional information concerning Anna Brownell Jameson, see Clara Thomas, *Love and Work Enough: The Life of Anna Jameson* (Toronto: University of Toronto Press, 1978 [1968]).

18. The evidence provided by these journal articles confirmed the existence of a public concern in the role of the artist and of art in nineteenth-century middle-class culture and its appropriate relationship to Christian Romanticism.

19. Osgood, "Art in its Relation to American Life," p. 54.

20. Dillenberger, *The Visual Arts and Christianity in America*, p. 43. For the most in-depth analysis of nineteenth-century clergy views on the visual arts, the reader is referred to the third chapter of Dillenberger's text, pp. 39-56.

21. Ibid., p. 44. I have expanded Dillenberger's three themes to include the role of art as a Christian educator, the role of art in the church, and the supremacy of Raphael.

22. Peter Gardella, *Innocent Ecstasy. How Christianity Gave America an Ethic of Sexual Pleasure* (New York: Oxford University Press, 1985), p. 35.

23. Perry Miller, "The Garden of Eden and the Deacon's Meadow," *American Heritage* 7 (1955): 102.

24. Miller, "'An Influence in the Air'", ms. p. 5.

25. Cyrus A. Bartol, *Pictures of Europe Framed in Ideas* (Boston: Crosby Nichols & Co., 1856, 2nd ed.), p. 200.

26. Dewey, *The Old World and the New*, Volume I, p. 198.

27. Ibid., p. 198.

28. For example, see "Chapel and Church Architecture," *The Crayon* 6.10 (October 1859): 307-8; "Lectures on Church Building," *The Crayon* 5.5 (May 1859): 135-7; "Statement of the Trustees of Plymouth Church to Architects," *The Crayon* 6.5 (May 1859): 155-7; Henry Ward Beecher [ascribed to], "Henry Ward Beecher on Church Architecture," *The Crayon* 6.5 (May 1859): 154-5; Leopold Eidlitz, "Christian Architecture," *The Crayon* 5.2 (May 1858): 135-7; and A.D. White, "Architecture: Cathedral Builders and Medieval Sculptors," *The Crayon* 5.11 (November 1858): 320-1, as extracted from a report in *The New York Tribune*.

29. Ibid., p. 199.

30. Dewey, *The Old World and the New*, Volume I, p. 193.

31. John Pope-Hennessey, *Raphael* (New York: Harper and Row, 1970), pp. 175-221.

32. McDannell, *The Christian Home in Victorian America*, p. 154.

33. Brown, *Raphael and America*, p. 24.

34. Ibid., p. 21. Note that Brown's source for this discussion is Carol Troyen's entry on Allston's *Beatrice* in the Museum of Fine Arts, Boston, catalogue.

35. Bartol, *Pictures Framed in Ideas*, p. 204.

36. For example, the Spanish baroque artist, Murillo's famous *Madonna and Child* served as an illustration re-titled "The Christian Mother" for *Godey's Lady Book* 41 (1850): 67.

37. Brown, *Raphael and America*, pp. 16, 19-20.

38. For example, see McDannell, *The Christian Home in Victorian America*.

39. The originals of Bushnell's travel diaries are among The Horace Bushnell Papers, The Divinity School Library, Yale University; and are excerpted in Mary Bushnell Cheney, *Life and Letters of Horace Bushnell* (New York: Harper and Row Publishers, 1880). The original of Beecher's travel diaries are among The Henry Ward Beecher Papers, Sterling Memorial Library, Yale University; and are excerpted in William C. Beecher and Samuel Scoville, *A Biography of Henry Ward Beecher* (New York: Webster and Company, 1888).

40. Cheney, *Life and Letters of Horace Bushnell*, p. 157. Edited travel diary entry dated December 25, 1845.

41. In this way, Bushnell's aesthetic taste is within the mainline of middle-class American cultural attitudes of the mid-nineteenth century. See Brown, *Raphael and America*; and Lillian B. Miller, *Patrons and Patriotism*.

42. Cheney, *Life and Letters of Horace Bushnell*, p. 156.

43. Dillenberger, *The Visual Arts and Christianity in America*, p. 45.

44. Ibid., p. 49. For the history of the Vassar College Art Gallery, see "Historical Introduction," *Vassar College Art Gallery Catalogue* (Poughkeepsie: Vassar College Art Gallery, 1939), esp. pp. 11-12; and *Vassar College Art Gallery: Selections from the Permanent Collection* (Poughkeepsie: Vassar College Art Gallery, 1967). Both of these

sources reprint the "Report of the Committee on the Art Gallery of Vassar Female College, 1864" which was authored by Magoon.

In light of the cultural shifts fundamental to the development of Christian Romanticism such as the role of literacy and education of middle-class women, it is an interesting note that Magoon's Collection fostered the development of an Art Gallery and that he continued to support the future development of that collection and the art program at a college established in the mid-nineteenth century and dedicated to the education of women.

45. Magoon, "Report of the Committee on the Art Gallery of Vassar Female College, 1864," *Vassar College Art Gallery: Selections from the Permanent Collection*, p. xi.

46. For example, see the entries under "Nineteenth-Century Paintings," *Vassar College Art Gallery: Selections from the Permanent Collection*, pp. 35-42. The Magoon Collection is identified in modern indices of art galleries as the Magoon Collection of Hudson River School and other Nineteenth-Century American Paintings, Vassar Art Gallery.

47. *The Critic*, 203 (November 19, 1887): 264; and 204 (November 26, 1887): 276. For a description of Beecher's collection and its exhibition, see "The Beecher Collection," *The Critic*, 200 (October 29, 1887): 221-2.

48. Beecher and Scoville, *Henry Ward Beecher*, p. 646.

49. For a biographical and cultural history study of both collectors and their collections, see Lillian B. Miller, "'An Influence in the Air'", manuscript pp. 9-17, 17-27. See also, idem., *Patrons and Patriotism*, esp. p. 226.

50. Dillenberger, *The Visual Arts and Christianity*, p. 49; and Miller, *Patrons and Patriotism*, illustration caption opposite p. 97.

51. James Jackson Jarves [ascribed to], "Can We Have An Art Gallery?" *Christian Examiner* 72 (March 1862): 204. Miller, *Patrons and Patriotism*, p. 226.

52. Miller, "'An Influence in the Air'", p. 33.

53. Henry Ward Beecher, "Art Among the People," *Eyes and Ears* (Boston: Ticknor and Field, 1863), pp. 265-6.

54. Beecher's distinction between artist and artisan paralleled Coleridge's famous distinction between genius and talent in the *Biographia Literaria*.

55. Henry Ward Beecher, *Norwood; or, Village Life in New England* (New York: J.P. Ford, 1887 [1867]), p. 205.

56. Ibid., p. 302.

57. Beecher, "Art Among the People," p. 263.

58. Ibid., p. 265.

59. Ibid., p. 265.

60. Beecher, *Norwood*, p. 302.

61. Ibid., p. 303.

62. Henry Ward Beecher, "Impressions," Star Papers; *Or Experiences of Art and Nature* (New York: Ford and Company, 1873 [1855]), pp. 63-4.

63. Beecher, "The Office of Art," *Eyes and Ears*, p. 228.

64. Beecher, "A Discourse of Flowers," *Star Papers*, p. 94.

65. Roderick Nash, *Wilderness and the American Mind* (New Haven: Yale University Press 1982 [1967]), p. 67.

66. James Brook, "Our Own Country," *Knickerbocker, New-York Monthly Magazine* 5 (1835): 46-55. The publication of Brook's essay preceded the 1836 publications of Thomas Cole's "Essay on American Scenery" and Ralph Waldo Emerson's "Nature." Brook's essay was cited by Perry Miller as so appropriate to the nineteenth-century American view of nature "that it was reprinted over the whole country." Perry Miller, "The Romantic Dilemma in American Nationalism and the Concept of Nature," Nature's Nation (Cambridge: Belknap Press of Harvard University Press, 1967); p. 201.

67. Brook, "Our Own Country," 55.

68. See the following texts on this dichotomous relationship between wilderness and garden, and its specific application to the American Experience: Mircea Eliade, "American Paradise" in his The Quest. *History and Meaning in Religion*, (Chicago: University of Chicago Press, 1975 [1969]), pp. 94-5; Charles L. Sanford, The Quest for Paradise. *Europe and the American Moral Imagination*, (New York: AMS Press, 1979 [1961]); and George H. Williams, *Wilderness and Paradise in Christian Thought. The Biblical Experience of the Desert in the History of Christianity and The Paradise Theme in the Theological Idea of the University* (New York: Harper and Row, 1962).

69. Mircea Eliade, Myths, *Mysteries, and Dreams. The Encounter between Contemporary Faiths and Archaic Realities* (New York: Harper and Row, 1975 [1960]), p. 66.

70. Dennis R. Dean, "The Influence of Geology in American Literature and Thought" in *Two Hundred Years of Geology in America* ed. Cecil J. Schneer (Hanover: University of New Hampshire Press, 1979), p. 293.

71. Sanford, *The Quest for Paradise*, p. 27.

72. R.W.B. Lewis, *The American Adam: Innocence, Tragedy, and Tradition in the Nineteenth-Century* (Chicago: University of Chicago Press, 1968 [1955]).

73. David W. Noble, *The Eternal Adam and The New World Garden. The Central Question in the American Novel Since 1830* (New York: George Braziller, 1968), p. 5.

74. Ibid., p. xi.

75. For the classic description of American Luminism and its relationship to Emersonian Transcendentalism, see Barbara Novak, *Nature and Culture, American Landscape and Painting, 1825-1875* (New York: Oxford University Press, 1980).

76. Judith Plotz, "The Perpetual Messiah: Romanticism, Childhood, and the Paradoxes of Human Development" in *Regulated Children/Liberated Children* ed. Barbara Finkelstein (New York: Psychohistory Press, 1979), p. 66.

77. Ibid., p. 69.

78. The paintings of Thomas Cole, including landscapes and serial panoramas, were made into prints and engravings both in his lifetime and after his death. The two most successful engravers of Cole's works were James Smillie and Timothy Cole (no relation). Replicas of Cole's paintings were circulated among the many art centers of nineteenth-century America.

For the fullest description of the engravings of Cole and their role in understanding nineteenth-century cultural attitudes, see Doug Adams, "Environmental Concerns and Ironic Views of American Expansionism Portrayed in Thomas Cole's Religious Paintings" in *Environment and Vision: Transforming the Christian Creation Tradition* ed. Philip N. Joranson and Ken Butigan (Santa Fe: Bear Press, 1984); pp. 296-305. For a description of the engravings of Cole's *Voyage of Life*, see Paul D. Schweizer, "'So exquisite a

transcript': James Smillie's Engravings after Thomas Cole's *Voyage of Life,*" *Imprint* 11.2 (1986): 2-13, and 12.1 (1987): 13-24.

79. For the history of Cole's *The Voyage of Life* and the ensuing prints of the series, see Chapter 4: "The Garden Regained: Thomas Cole and Landscape Painting as Christian Romantic Rhetoric."

80. Perry Miller, "The Garden of Eden and the Deacon's Meadow," *American Heritage,* pp. 61, 102.

81. Gorham D. Abbott Collection, Hawthorne-Longfellow Library, Bowdoin College, as cited in Schweizer, II, p. 18.

82. See also Katherine Ann Martinez, "The Life and Career of John Sartain (1808-1897). A Nineteenth-Century Philadelphia Printmaker." Unpublished Ph.D. dissertation, The George Washington University, 1986.

83. This latter text was revised and re-issued as (and more appropriately for the purposes of this study) *Home Book of the Landscape* in 1867.

84. Sacvan Bercovitch, "The Biblical Basis of the American Myth" in *The Bible in American Arts and Letters* ed. Giles B. Gunn (Philadelphia and Chico: Fortress Press and Scholars Press, 1984), pp. 224-5.

CHAPTER III

Entry into the Garden:
Washington Allston and the Emergence of a
Christian Romantic Aesthetic
in American Art

Rome in the early nineteenth century was haven to many artists and writers, and became so also to Washington Allston[1]. For four years (1804-1808), the young American artist studied the masterpieces of Renaissance art in Rome, and conversed with other expatriate artists and writers including Horatio Greenough and Washington Irving. In late December 1805 or early January 1806, the young American artist met the British poet and philosopher, Samuel Taylor Coleridge.[2] Impressed by the romantic sensitivity to nature expressed in Allston's painting, *Swiss Landskip* [sic], the British poet arranged to meet the artist with whom he formed a close and intimate friendship[3]--becoming constant companions in Rome and travelling together during Coleridge's five-and-a-half month sojourn in Italy.

"To no other man do I owe so much intellectually as to Mr. Coleridge, with whom I became acquainted in Rome, and who has honored me with his friendship for more than five and twenty years," wrote the painter.[4] Although there is no documentation as to exactly what they discussed during their time in Rome, it can be ascertained that the issues of creativity, imagination, artistic originality, human finitude, and religion were raised.[5] Many of the issues Allston voiced in what was to become the first American

art treatise, his *Lectures on Art*, were formulated from the unique experience of having Coleridge as friend, confidante, and conversation partner. Clearly, the British thinker's interest in aesthetic questions increased as a result of this relationship; while the American artist learned about the German Romantic philosophy with which Coleridge was so involved. While in Rome, the young American painter became acquainted with other artists conversant with German Romanticism including Canova, Thorwaldsen, and Gottlieb Schick.[6]

The close ties of friendship between Allston and Coleridge were tested by the former's marriage to Ann Channing Allston in 1811.[7] Dependent upon their friendship, it was to Coleridge that Allston turned upon his wife's death in 1815. In the depths of his despondency, the artist was tormented by nightmares and sleepless nights. Later that same year, the poet wrote "I know what consolation it has been to me, that YOU have in every sense the consolations & the undoubting Hopes, of a Christian."[8] From these experiences of his own finitude and grief, Allston's religious faith was revived, as much by his own energies as by Coleridge's spiritual counsel which involved the artist in the poet's world.[9] During this time, *Aids to Reflection* which would become so influential on the development of both forms of American Transcendentalism as well as on Christian Romanticism was in the "idea" stage. The poet's counsel and perception of the artist's spiritual re-birth played a role in this formative text. Nevertheless, the philosophies and theologies of both the artist and the poet would maintain distinctions from those of the American Transcendentalists, both Christian and Emersonian, which emerged from the American Romanticism they inspired. Both men, though characterized as romantics, retained their fundamental conviction of human fallibility and of human dependence upon God in contrast to the Transcendentalist tenets of individualism and human perfection.

Allston's religious life began within the Episcopal church, although his family had ties to the dissenting tradition.[10] His own commitment to any particular form of Christianity can at best be described as "loose."[11] The primary documentation to his spiritual life was found in Elizabeth Palmer Peabody's essay, "Last Evening with Allston."[12] Approximately three weeks before his death, the artist met with the female educator to discuss issues pertinent to art and the development of an artistic tradition in Boston. Early in the conversation he revealed his "profoundly religious" nature to her; "with him," she reported, "as with Michael Angelo, *salvation* was the ultimate art of humanity."[13] In their discussion of spiritual matters, she

added "I had never seen the artist when he revealed so much of his personal experience of religion as on this evening."[14]

Allston described not only his spirituality through a discussion of human finitude and the power of God's love, but also how he came to know the presence of God's grace. "He said that when he was in England (either just before or just after his residence in Italy,--I forget which it was), the question came to him, and 'would not be put by,' Is the memory our spiritual body?"[15] Such a concern would, of course, correspond in time with the artist's relationship with Coleridge when questions of human finitude and spiritual meaning were in the forefront of their conversations. Peabody was not clear as to whether or not this question occurred during the first or second trip to Europe. Although he only visited Italy during his first European tour, Peabody's imprecision as to when the artist experienced this spiritual questioning is open to interpretation. Based upon the evidence of the spiritual nadir after the death of his first wife and his eventual return to the Episcopal Church, this experience must have occurred after the death of Ann Channing Allston.[16] Allston clarified that through this experience he came to know that the fundamental limitations of human finitude could be overcome by the Christian faith evidenced by both his poem, "The Atonement," and his re-confirmation in the Episcopal Church.[17] Christian Romantic themes such as human finitude and guilt, God's infinite power, the glory of the cross, and the wonder of the resurrection wove in and through his poetry and paintings. After his Christian reaffirmation, the artist painted scriptural subject matter which corresponded to these theological themes including his lengthy preoccupation with *Belshazzar's Feast* (1817-43; Detroit Institute of Art, Detroit) which emphasized human finitude, divine judgment, and divine intervention in human history.[18]

Allston's painting of *The Dead Man Restored to Life by Touching the Bones of Elisha* (1813: Pennsylvania Academy of the Fine Arts, Philadelphia)[19] was based upon an obscure scriptural passage of a miraculous resurrection from II Kings 13:20-21. A common theme in the repertory of contemporary British art, it was also appropriate for the young American's continued interest in the sublime, especially for the viewer's experience of awe, wonder, and mystery. The miraculous and effective action of resurrection both within and outside of the frame of the painting indicated his religious preoccupations. Exhibited at the British Institution's Exhibition in 1814, it was presumed that the British Institution would purchase this painting, but the anticipated transaction never occurred.[20] Although never acknowledged by the artist, Coleridge was convinced that anti-American prejudice was the true motive in the Institution's actions.[21] In the summer

of 1815, James McMurtie, a businessman and art collector from Philadelphia, convinced of the significance of *The Dead Man Restored*, arranged to take the canvas to America to sell to the Pennsylvania Academy of the Fine Arts. In March 1816, when the painting arrived in Philadelphia, the Academy's Board of Directors voted to purchase *The Dead Man Restored* at Allston's requested price. In order to meet the necessary payments which totaled $3,500.00, the Academy offered a subscription of $20.00 to its "friends." Although the payments were drawn out over a period of eighteen months, Allston was pleased with the patronage of his fellow countrymen which supported his decision to return to America in 1818 with his artistic reputation established by *The Dead Man Restored*.[22]

Allston became a primary voice in the transfer of the romantic sensibility to the cultured circles of Boston where he was revered as the great "American" artist, who unlike Benjamin West, had chosen to return to America to paint and to teach.[23] Until his death in 1843, he participated actively in Boston's and Cambridge's cultural life, as friend, mentor, and associate of Henry Wadsworth Longfellow, Horatio Greenough, Richard Henry Dana, Margaret Fuller, Oliver Wendell Holmes, Elizabeth Palmer Peabody, William Ellery Channing, Ralph Waldo Emerson, and James Marsh.[24]

Washington Allston's paintings represented the introduction of the romantic aesthetic into American art just as his transfer of the visual rhetoric of grand manner history painting to historical landscape painting signified the emergence of the landscape tradition in American art. These landscape paintings were transitional works reflective of one style of painting that was diminishing in popularity, and formative of a second style of painting then emerging into the forefront of American art. Through the efforts of Benjamin West, especially his Escape of Lot and His Family from the *Destruction of Sodom and Gomorrah* (1810: The Detroit Institute of Arts, Detroit), the level of the critical appreciation of landscape painting was raised. By 1817, the thematic category of "Historical Landscape" had gained both critical and public recognition.[25] During the winter of 1817-1818, Allston painted his only effort to merge historical landscape with a scriptural theme in *Elijah in the Desert* (1817-1818: Museum of Fine Arts, Boston), (fig. 7).

In historical landscape paintings, the figures were secondary in presentation and purpose as the landscape took on the mood and characteristics of historical subject matter, thereby becoming the predominant elements of the painting.[26] In *Elijah in the Desert*, Allston presented the image of a solitary figure superimposed upon a landscape in a fashion similar to a theatrical setting.[27] The basic elements of this painting--the solitary figure

7. Washington Allston, *Elijah in the Desert*, 1817-1818. Oil on canvas, 48 3/4 x 72 1/2 inches (123.8 x 184.2 cm.). Museum of Fine Arts, Boston. Gift of Mrs. Samuel Hooper and Miss Alice Hooper. (70.1). Courtesy, Museum of Fine Arts, Boston.

in prayer, single dead tree with a bird, and a historicized landscape--became
common in Thomas Cole's work. However, Allston's presentation was aus-
tere and severe, and lacking in Cole's dialectical aura of awe and terror. As
opposed to the young painter's empathetic union of nature and humanity, the
elder artist presented an image of the division between nature and humanity
signifying Elijah's role as a visual metaphor of penitence and God's
judgment.

Painted after his return to Boston, Allston's next attempt at landscape,
Moonlit Landscape (1819: Museum of Fine Arts, Boston) (fig. 8), was an
inhabited landscape in which the figures were united with the landscape as
the family group in the foreground of the painting stopped to greet or per-
haps question the approaching horseman. The pyramidal form of the family
and the horseman was harmonious with the rest of the painting just as the
simplicity of the composition which was divided between a foreground of
earth, a middle ground of water, and a background of mountain and sky
enhanced it's experiential tone.[28] Such painting affected both the viewer's
sense of sight and sense of intellectual and moral life.

As one of the landscapes on view in the 1839 exhibition, *Moonlight*
fell within Margaret Fuller's general comment:

> *The Landscapes*....he exhibit[s] the attributes of the master;
> a power of sympathy, which gives each landscape a per-
> fectly individual character. Here the painter is merged in his
> theme, and these pictures affect us as parts of nature....The
> soul of the painter is in these landscapes, but not his
> character. Is not that the highest art? Nature and the soul
> combined.[29]

The composition, radiant light (which verged upon luminism), and prevalent
mood of Allston's painting was akin to the reverie landscapes of the German
Romantic painter, Caspar David Friedrich (1774-1840).[30] Although the two
painters never met nor were aware of the other's work, the bonds which
linked them were a common empathy to aesthetic and theological currents
for the American was familiar with the German Romantic tradition from the
German expatriate artists who frequented the Caffé Greco in Rome, and from
Coleridge.

Although far advanced in atmospheric and coloristic technique for its
time, *Moonlit Landscape* was a popular landscape painting which would later
be engraved by George B. Ellis for reproduction in the gift book, *The
Atlantic Souvenir* (1828).[31] At first glance, a narrative theme was suggested
through the familial trio and the horseman in the foreground but after careful

8. Washington Allston, *Moonlit Landscape*, 1819. Oil on canvas, 24 x 35 inches (61 x 88.9 cm.). Museum of Fine Arts, Boston. Gift of William Sturgis Bigelow. (21.1429). Courtesy, Museum of Fine Arts, Boston.

contemplation, the painting was seen as story-less and the individual lyrically perfect, to be translated into this of words, without doing them injury."[32]

These two paintings represented Allston's transition from history painting to historical landscape for in *Elijah*, the solitary contemplative figure was superimposed upon a stage setting while in *Moonlit Landscape*, the figures were so integrated with the landscape that their presence was not immediately recognized. A contemplative mood was established by the artist who engaged the attention of his viewer thereby affecting her intellectual and moral life. The transition evident in Allston's paintings was the foundation for the development of landscape painting by Cole and the Hudson River School.

After his return to Boston, Allston became involved with the Episcopal congregation that eventually became St. Paul's Episcopal Church in 1820, his name being the twenty-fifth entry in the original Register of Communicants for St. Paul's Church.[33] On April 8, 1821, Allston was confirmed in the Episcopal tradition by the Right Rev. Alexander Griswold, Bishop of the Diocese, at St. Paul's Church.[34] This Episcopal congregation included many of the artist's friends and patrons, such as Henry Pickering and David Sears, both of whom served on various committees and were patrons of the church.[35] From its beginnings, this congregation was by self-definition, "evangelical in spirit, doctrinally sound, yet liberal and intellectually lively in thought."[36] Among its founding members, St. Paul's counted not only Allston, Pickering, and Sears but Daniel Webster and other young Boston lawyers. St. Paul's was at the center of the movement which "flowered" in the establishment of the Episcopal Divinity School in Cambridge.[37] The artist maintained a relationship with St. Paul's until his death despite his move to Cambridgeport in 1830.[38]

As expressions of his religious convictions and the romantic ethos, Allston's later paintings, "delicate, dreamlike and graceful fantasies," became the first paintings appropriate to the emergent American literary taste represented by Hawthorne and Longfellow. Edgar Richardson noted, with the dying out of Calvinism "the most sensitive and thoughtful minds were searching for a new outlook on life, not less than ideal but gentler and more gracious."[39] The artist's Christian Romanticism colored his completed paintings and influenced his subject matter including his distinctive style of imaging woman, which like his presentation of historical landscape painting, introduced a new theme into American art.[40] A formative influence upon later American artists and recognized by contemporary critics for its singularity, Allston's interpretation of woman symbolized the cultural transformations occurring in antebellum middle-class America.[41] For example,

Beatrice (c. 1816-1819: Museum of Fine Arts, Boston) (fig. 9) and *The Valentine* (1809-1811: Private Collection) had a profound effect upon the sixteen-year-old Margaret Fuller who later wrote that

> The calm and meditative cast of these pictures, the ideal beauty that shone <u>through</u> rather than <u>in</u> them, and the harmony of colouring were as unlike anything else I saw...I seemed to recognise in painting that self-possessed elegance, that transparent depth, which I most admired in literature.[42]

These paintings of women as Fuller so astutely recognized were distinctively different from those painted by other American artists such as Copley, Charles Willson Peale, or Gilbert Stuart. Where the latter emphasized clarity of light and line, and representational identity with the sitter, Allston strove for a softness of light and line, and an idealization of the subject. "The excellence of these pictures is subjective and even feminine," Fuller wrote. "They tell us the painter's ideal of character."[43] Interested in portraiture as a means of conveying psychology rather than a depiction of a particular sitter, Allston's smaller paintings of female images were recognized in his own lifetime as a fusion of his idealizations of identifiable women with his extrapolations of what his contemporaries perceived were the elemental essences of the feminine nature. Emphasizing the essential character of woman through the subtlety of color, light, and line, his presentation of a partial figure and a minimum of accessories directed the viewer's attention to the female mind and heart.[44]

Whether Allston strove to present images of spirituality, domesticity, or literacy in his paintings of women, the one common denominator in these works of art was the constant representation of the aura of repose which signified the activity of the human mind as their otherwise active intellects were receptive to the internal or external inspiration which was necessary to bring their ideas to life.[45] The image of solitary and silent contemplation, related to the experience of Christian meditation and prayer so well known to Allston, was appropriate for his feminine images of spirituality, such as *Beatrice*. The cultural implications of a receptive and passive female figure were also obvious, especially in a patriarchal society, whereas the artist's picturations of spiritual domesticity like *Mother Watching Her Sleeping Child* (1814: Private Collection), or of female literacy such as *The Valentine* placed women outside the contemporary mainstream and into more creative postures.[46]

Upon his return to Boston in October 1818, Allston was preoccupied with renewing acquaintances and friendships. After he had re-established himself in Boston, he began to paint again and among the works in his first group of finished paintings were *Beatrice* and *Miriam the Prophetess* (1821: The William A. Farnsworth Library and Art Museum, Rockland) (fig. 10).[47] Both of these feminine images of spirituality were commissioned works-- *Beatrice* for Theodore Lyman, and *Miriam* for David Sears--which form a complementary pair signifying the duality of spirituality: silent contemplation and joyous praise.

Inspired by the recent translation of Dante by Henry Francis Cary, Allston's *Beatrice* (fig. 8) was one of his most popular images of woman.[48] Building upon the revival of interest in Dante's text and the Romantic admiration for the medieval poet, the artist's choice of Beatrice was as much a vehicle of contemporary spirituality as she was the portrayal of a literary figure. Not the glorification of ideal beauty, but a presentation of the essence of female spirituality, *Beatrice* was calm, resigned, and engaged in thought while her elegant fingers were entwined around cross and chain. As Huntington noted, both the graceful gesture and elegance of her fingers "show the nature of the feeling which occupies her mind; engrossing but tranquil."[49] This Beatrice was physically and spiritually in contact with the source and meaning of Christianity: the salvation of the cross. In her commentary on Allston's paintings, Anna B. Jameson wrote "This most lovely picture [*Beatrice*] struck me more the second time I saw it than the first; the hand holding the cross, painted with exceeding truth and delicacy."[50] The contemplative nature of the painting induced meditation within the viewer. Rather than being a portrait or narrative painting which permitted a "quick read," Allston's images of women like *Beatrice* demanded the engagement of its viewers. The artist intended that his paintings would inspire the intellectual and moral life of the viewer through the subtlety of human sensibilities rather than a dramatic and bold gesture.

In her analysis of *Beatrice*, Elizabeth Palmer Peabody remarked, "This is the very Beatrice of Dante:--celestial wisdom embodied in nature's masterpiece."[51] According to Peabody, when the viewer's mind was as receptive as Beatrice's, the spiritual qualities that Allston portrayed in his painting were transferred to the viewer's moral sensibility. Peabody also suggested that the painting argued for the establishment of a domestic as well as a Christian spirituality.[52] Allston's development of the iconography of the "dreaming figure of a woman, very quietly painted" had multiple cultural connections as initially perceived by his contemporary female critics, that is, Fuller, Jameson, and Peabody.[53] *Beatrice* represented not only

9. Washington Allston, *Beatrice*, © 1994. 1816-1819. Oil on canvas, 31 1/4 x 25 1/4 (76.8 x 64.1 cm.). Museum of Fine Arts, Boston. Anonymous Gift. (59.778). Courtesy, Museum of Fine Arts, Boston.

Christian contemplation and feminine intuition but spiritual domesticity--all
Christian Romantic tenets.

In 1820, Allston painted *Miriam the Prophetess* (fig. 10) for David
Sears whose wife was named Miriam. Although the artist deemed *Miriam* as
one of his finest works, the critical response to the painting was mixed as
exemplified by Margaret Fuller who admired its theme but felt that it failed
to satisfy the viewer's expectations noting that the figure was not integrated
with the landscape and that the absent foreground emphasized the viewer's
immediate entry into the picture plane. Nevertheless, Fuller wrote a lengthy
commentary on *Miriam* in which she praised the noble character of women
of action as much as she described Allston's painting. In fact, Fuller's
description was the exact response which the artist sought--a response that
involved the viewer's intellectual and moral sensibility--*Miriam* was the
successful portrayal of the nobility of the Jewish woman and of God's
triumph over idolatry.

Generally, the critics and public praised *Miriam* as the artist's former
student, Susan Clarke suggested, "The magnetism of the artist at the moment
of conception powerfully seizes the beholder."[54] Although Allston's
employment of a female figure to advocate spirituality was not new, his
formulation was in its fusion of romantic ideals, the changing status of
middle-class women, and Christian Romanticism.

In 1816, the artist sent his friend and patron, James McMurtie, a
painting originally entitled, "The Virgin and Child."[55] Later re-titled *A
Mother Watching Her Sleeping Child*, Allston recognized the popular quality
of his secular presentation of a religious theme. "I wish you not to consider
it now as the 'Virgin and Child,' but simply as a mother watching her
sleeping offspring." He wrote McMurtie, "A 'Madonna' should be youthful;
but my mother is a matron."[56] Among the works on view in the Exhibition
of 1839, this painting received mixed reviews. Margaret Fuller commented,
"A lovely little picture. But there is to my taste an air of got up naivete and
delicacy in it."[57] Mrs. Jameson found, The beautiful little picture of the
'Mother and Child'...charming;" but went on to comment that as the painter
had said himself, "the mother was too matronly for a madonna."[58] *Mother
Watching Her Sleeping Child* became one of Allston's most discussed and
widely exhibited paintings, perhaps because the visual relationship to
Renaissance interpretations of the Madonna and Child was obvious to
contemporary audiences both in London and in Boston. Mariana G. van
consider it now as the 'Virgin and Child,' but simply as a mother watching
her sleeping offspring." He wrote McMurtie, "A 'Madonna' should be

10. Washington Allston, *Miriam the Prophetess*, 1821. Oil on canvas, 65 x 48 1/2 inches. Collection of The William A. Farnsworth Library and Art Museum, Rockland.

youthful; but my mother is a matron."[59] Among the works on view in the Exhibition of 1839, this painting received mixed reviews. Margaret Fuller commented, "A lovely little picture. But there is to my taste an air of got up naivete and delicacy in it."[60] Mrs. Jameson found, The beautiful little picture of the 'Mother and Child'...charming;" but went on to comment that as the painter had said himself, "the mother was too matronly for a madonna."[61] *Mother Watching Her Sleeping Child* became one of Allston's most discussed and widely exhibited paintings, perhaps because the visual relationship to Renaissance interpretations of the Madonna and Child was obvious to contemporary audiences both in London and in Boston. Mariana G. van Rensselaer praised this little painting as evidence of Allston's "colouristic gift" which derived from but did not imitate the Venetian color school.[62] His greatest debt, in her view, for both the figure and pose of the Madonna was to Michelangelo rather than to Raphael even though Raphael's art was held in a higher esteem in the nineteenth century.

In 1828, Allston painted and exhibited a variant of this motif which was purchased by the Boston Athenaeum in 1829.[63] Although the painting itself was lost, Seth Cheney engraved it for the 1836 edition of the gift book, *The Token*, an annual publication for women which made this image of domesticity accessible to middle-class America, not just to Bostonians. In both versions, the painter sought to humanize the sacred thereby making it more accessible, thus, portraying the mother not as the youthful virgin of a Raphael or a Perugino, but as a more "matronly" figure. The child had no halo nor was he distinguished by a star in the sky or a retinue of adoring kings and shepherds. Rather, this scene of simple domesticity of a typical mother and child emphasized on the mother as the prime nurturer.

In his *Family Group* (1835: Boston University, Boston), Allston seated the mother and child in the left foreground while relegating the father to the right background where he was almost lost in the darkness of the shadows. Thus, the mother and child dominated the composition while the radiant light distinguished their forms in opposition to the shadows's obliteration of the father. Therefore, the primary relationship was that which existed between mother and child: she was the nurturer, physically and spiritually as typified by Christian Romanticism's emerging domestic spirituality.

The third mode in which Allston painted his images of woman was in the act of engaged reading.[64] The motif of women reading was not original to this particular American artist; the iconography of woman as reader existed in Christian art in presentations of the Virgin Annunciate and the Repentant Magdalene. A small painting, *The Valentine*, according to Flagg, was based upon "a pencil drawing of his wife," Ann Channing Allston.[65]

Margaret Fuller's engagement with this image was appropriate to her unconscious identification with the simply dressed woman with dark hair portrayed in the act of concentrated reading. In his analysis of the 1839 exhibition, Huntington reported that "Very different [from Rosalia] is the lady reading '*The Valentine*.' Her interest is perhaps deeper than that of Rosalie, but she comprehends it."[66] Oliver Wendell Holmes also noted the enchanting and engaging quality of "The 'Valentine' lady has far less of the ideal, and far more of breathing life about her than 'Rosalie'; it is a real woman, and not a poetical vision."[67] Although these male critics may have understood Allston's theme, they misunderstood his purpose.

In his paintings of engaged readers, Allston provided a visual argument for female literacy, and turned his viewer's attention away from woman as sex object to woman as intellectual being. Having been to Paris in 1804 to study the art on display in the Louvre, Allston was familiar with the eighteenth-century French tradition of woman as reader, especially in the work of Jean-Honoré Fragonard, to re-formulate this image into a romantic one.[68] In contrast to both the sacred images of Christian art in which the female reader was interrupted in her reading by a divine messenger, or the secular images of French art in which the female reader was an object of sensuality, Allston's women readers were engaged in the act of reading as images of literacy. A comparison between *The Valentine* and Fragonard's *A Young Girl Reading* (c. 1776; National Gallery of Art, Washington, D.C.) (fig. 11) clarifies Allston's purpose.

In both paintings, the viewer is presented with a half-figure view of a single female figure engaged in the act of reading. Fragonard's young slender woman read a book whereas Allston's more physically mature figure read a letter. Fragonard's painting was part of a series which represented young women in moments of solitude and relaxation, either reading a *billet-doux*, turning the pages of a book, or seated at a dressing table. These young women were lost in the world of their own thoughts and as such became objects for male fantasies. The book, the *billet-doux*, and the dressing table functioned merely as props, not as sources of "intellectual" engagement. Allston's painting was a single work unconnected to a formal series of paintings, although as Flagg indicated, it was connected to a pencil sketch of Ann Channing Allston. The key distinction between the traditional French image and Allston's new iconography was simple--Allston's reader was engaged by her text, be it a letter of any type including a *billet-doux* or a book.

Both artists employed a similar palette of yellows and browns in their paintings. Fragonard's reader was presented in a profile pose which empha-

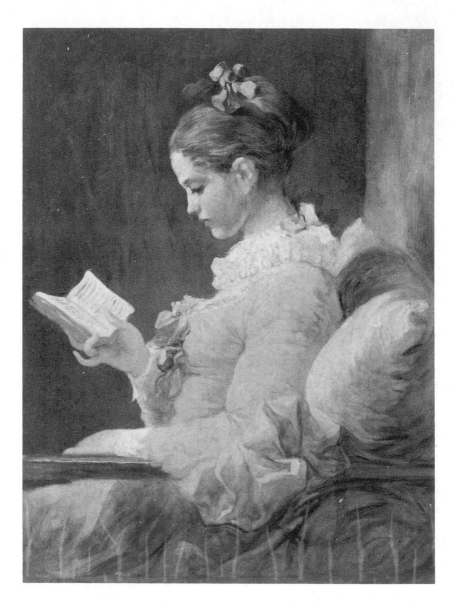

11. Jean Honoré Fragonard, *A Young Girl Reading*, © 1994. 1776. Oil on canvas, 32 x
25 1/2 (.8111 x .648). National Gallery of Art, Washington, D.C. Gift of Mrs. Mellon
Bruce in memory of her father, Andrew W. Mellon. (1961.16.1 [1653]/PA). © National
Gallery of Art, Washington, D.C.

sized through his loosely swirling brushstrokes of the clear and warm of the artist's colors and the tactile lushness of the silken fabric of her dress, her bows, and her pillow, the sitter as an object of female sensuality. The clothing and pose of Fragonard's figure followed the renaissance tradition of presentation of a wealthy patron's wife or mistress. As Edwin Mullins noted in his study of the female figure in western art, this profile presentation of an elegantly dressed female figure,

> is more complimentary to the man who owns her if she dresses beautifully so that other men will envy him, and dresses expensively so that other women will envy her for being his property.[69]

By contrast, Allston's reader was plainly, almost matronly, dressed, and the softness of both his brush and his use of muddier and thereby cooler tones, light, and line conformed to his presentation of the essence of woman and her intellectual engagement. One of Allston's most popular paintings, *The Valentine* was engraved by James Longacre in 1831 as an illustration for *The Common-Place Book of Romantic Tales*. However, the engraver added a significant detail: Allston's reader wears a cross and a chain similar to his Beatrice. This detail was as much the engraver's admiring response to *Beatrice* as a reflection of his own spirituality.

The late nineteenth-century Boston artists, William Morris Hunt, George Fuller, and William Babcock, were the heirs of Allston's images of women. *The Valentine* was the beginning of a painted series of women reading letters and books that continued throughout the nineteenth century. These female readers symbolized the growing audience of literate middle-class women in antebellum America. *The Valentine* was only one, albeit aesthetically the finest, example of Allston's images of woman as reader. His other paintings in this genre included his portrait of *Ann Channing Allston* (1809-1811: Henry Channing Rivers); *Contemplation* (1817-1818: Lord Egremont, Petworth House, Sussex); and *A Roman Lady Reading* (1821: The Newark Museum, Newark) (fig. 12). Mariana van Rensselaer perceptively described the painter's series of women readers whose "whole figure is reading. A vital intelligence seems to pass from the eyes to the book."[70] For Allston, the image of woman as reader was the idealization of the romantic principle of subjectivity and the interior life of the mind. His innovative presentation of the primary right of women to an intellectual life signified the cultural shift to female literacy in antebellum America.

12. Washington Allston, *A Roman Lady Reading*, 1821. Oil on canvas, 30 x 25 inches. Collection of The Newark Museum. Purchase 1965 The Membership Endowment Fund. (65.35).

At the same that Allston was able to re-interpret the image of woman in American art, he was unable to re-present the central image of traditional Christian art. His own faith experience impressed upon the artist the singularity of Christ's divinity which could not be described in human terms but only revealed in the fullness of time. In response to an inquiry as to the lack of Christological themes in his paintings, Allston responded out of both a spiritual and an artistic concern. "I have not done so because of my convictions concerning the nature, the mission, and the character of the Saviour," he replied. "I should fail if I attempted it. I could not make him a study for art."[71]

This recognition of the divinity of Christ motivated Allston to refuse McMurtie's commission for a painting from the artist's earlier sketch of "Christ Healing." "I may here observe that the universal failure of all painters, ancient and modern, in their attempts to give even a tolerable idea of the Saviour, has now determined me never to attempt it," the artist wrote his patron. "Besides, I think His character too holy and sacred to be attempted by the pencil."[72] A decade later, in correspondence with fellow artist, John F. Cogdell, Allston re-affirmed his decision not to attempt an image of the Christ by noting that West "has only added one to the uniform failures of all his predecessors...it is one which I have long since resolved never to attempt."[73] This artistic restraint did not hinder Allston's interest in and presentation of scriptural themes which increased after his return to the Episcopal tradition.[74]

During the spring of 1817, the artist began the first studies for what was to be his "great" painting, *Belshazzar's Feast*, a theme much admired for its scriptural inspiration and its historic narrative quality including his admiration for Rembrandt who had painted a version of *Belshazzar's Feast* in 1635. Additionally, this theme nurtured the artist's interest in the sublime concepts of awe, wonder, and mystery. Returning to Boston in the autumn of 1818, Allston advised McMurtie that the painting was "considerably advanced...I purpose finishing it here," he wrote; "all the laborious part is over, but there remains still about six or eight months' work to do to it."[75]

Without enough funds for his immediate living expenses let alone for the protracted period necessary for the completion of *Belshazzar's Feast*, the "great" painting remained a rolled up canvas in the artist's studio as he accepted portrait commissions and completed small paintings for immediate sale during his first two years in Boston. As a remedy to the artist's financial distress, a group of ten Boston gentlemen formed the Allston Trust, each of the donors giving $1,000.00 for the purchase of the completed painting. Three members of the group directed the Allston Trust, and the artist was

allowed to draw funds for his living expenses until the painting was completed. Like Allston's painting, the Trust, was well intended, but nevertheless "burdened the artist with an impossible task."[76] *Belshazzar's Feast* remained unfinished at the artist's death in 1843 while no single explanation resolved the art historical problem of the painting's "unfinished-ness," current scholarship suggests an unsettled personal identity as the root of his inability to finish *Belshazzar's Feast,* while earlier theories included a loss of interest in the project following Stuart's severe criticism and a general change in Allston's artistic direction upon his return to Boston in 1818.[77]

With his second marriage, Allston began to attend the services of the newly established Shepard Congregational Society with his wife, Martha Remington Dana, although he had earlier joined St. Paul's Episcopal Church. He attended services regularly at The Shepard Congregational Society, but there is no official record of either formal membership in or conversion to Congregationalism.[78] The Society's records state that "Washington Allston Esq. was in sentiment and membership an Episcopalian, but for many years a constant worshiper and communicant with this Church."[79] In fact, Flagg reported that in response to criticism, the artist retorted that he wanted to "enlarge" his critics' "views of religion; I am neither an Episcopalian nor a Congregationalist, I endeavor to be a Christian."[80]

The Dana Family had a longstanding relationship with the First Parish of Cambridge.[81] In 1829, a theological controversy within the parish over Abiel Holmes's refusal to allow the exchange of pulpits with "liberal" preachers resulted in the division of the parish and the congregation.[82] In this particular instance, "liberal" was synonymous with Unitarian, especially Unitarian with a Transcendentalist cast. The Shepard Congregational Society, in breaking off from the First Parish of Cambridge, interpreted itself as the "Orthodox" Church, that is, trinitarian. The Dana Family, including Washington Allston, supported the establishment of the new congregation. In fact, the first meeting house of the newly formed society was built upon land donated by Miss Sarah Ann Dana. Although the artist was reputed to have been the architect of this first meeting house in 1830, the actual architect was Horatio Greenough's brother, Henry, who sought the artist's support and comments upon the project.[83]

Between 1830 and 1833, Allston was involved in a series of delicate negotiations in response to an invitation to paint a panel for the rotunda of the Capitol Building in Washington. As the Chairman of the Committee of the House of Representatives on Public Buildings, the Rev. Gulian C. Verplanck, former Professor of Revealed Religion at the Episcopalian

General Theological Seminary in New York, hoped to have the famed artist paint two of the four panels planned for that space. Although honored by Verplanck's invitation and the Congressional request, Allston declined the commission as his interest was in painting a scriptural rather than a historical theme and in completing the unfinished *Belshazzar's Feast*.[84]

In point of fact, Allston's commitment to the role of the artist as that of moral teacher motivated his negotiations for the Capitol Rotunda panels with Verplanck. Advising the Congressional Committee of his lack of interest in their request for an illustration of a battle-scene from American history, he suggested a theme from Scripture noting, "But I fear this is a forlorn hope. Yet why should it be? This is a Christian land, and the Scriptures belong to no country, but to man...Should the Government allow me to select a subject from them, I need not say with what delight I should accept the commission."[85] Had the Congressional Committee accepted Allston's suggestion, he had prepared what he deemed the appropriate scriptural theme for the Capitol Rotunda, "the three Marys at the tomb of the Saviour, the angel sitting on a stone before the mouth of the sepulchre."[86] Again, the artist's interest in the themes of human finitude and divine intervention in human history conjoined in this scriptural image of the Resurrection. Needless to say, the Congressional Committee denied this request, and he in turn rejected their commission.

These negotiations were renewed in 1836 through the joint efforts of Verplanck, Jarvis, and John Quincy Adams.[87] Again Allston declined the request, re-stating his original reason that the total dedication of his time and energy was required for the completion of *Belshazzar's Feast*. In a personal letter which accompanied his formal letter declining the commission, the painter wrote Jarvis that it was only "After the maturest deliberation" that he made his decision. It was "the only course," he went on to say, "for the remembrance of what I have suffered for the last ten years, I might be tempted to accept the commission...But the past is too fresh in my mind to allow me hazard my peace by entering into any engagement of so public a nature."[88]

Washington Allston's reputation extended beyond his role as America's premier painter to his writing. His short essays and poems were published in several of the leading annuals and gift books, including *The Boston Book*, *The Charleston Book*, and *The Wreath of Beauty*.[89] In 1813, he published a book of his poetry, *Sylphs of the Seasons*. His interest in the arts of poetry, prose, and painting evidenced the romantic interpretation of the organic unity of the arts. As with the works of other romantics, including Eugene Délacroix and Thomas Cole, Allston's written texts explicated his

visual images. In 1821, he prepared a serial story entitled "Monaldi" for publication in Richard H. Dana's *The Idle Man*.[90] Unfortunately, this periodical ceased publication prior to printing the artist's story, which he put away in a drawer and forgot about. The manuscript was rescued from oblivion by the efforts of his friends and published as a novel in 1841.[91]

Like Henry Ward Beecher, Allston was an aficionado of the novel. However, unlike the cleric, the artist studied the genre with some care. His attempt at writing a novel for serialization, like Beecher's later presentation of *Norwood*, indicated the painter's recognition of the influence of the written word as well as the visual image. One contemporary literary critic, Cornelius Conway Felton, then President of Harvard University, wrote that *Monaldi* was "a work of high genius, of rare beauty, and of a moral purity and religious elevation which distinguishes it from most literary works of the age."[92] In it's own time, *Monaldi* was recognized as a moral lesson presented in a form and style of verse indicative of an artist not a writer. In her critique, Mrs. Jameson remarked that although she found the story "ill-constructed," *Monaldi* "contained some powerful descriptions, and some passages relative to pictures and to art such as only a painter-poet could have written."[93]

Like Coleridge's contemporary texts and Beecher's later *Norwood*, Allston's *Monaldi* was written in a romantic subjective style which allowed the reader immediate empathy. As Flagg suggested, the text contained sufficient common human experiences that the reader could leisurely journey through *Monaldi* for both emotional and moral enlightenment. However, like the texts of Coleridge and Beecher, the artist's novel taught moral lessons as well as Christian Romantic principles within the context of a romantic literary genre. Like Coleridge's *Biographia* and *Aids to Reflection* and Beecher's *Norwood*, this novel was a spiritual autobiography written in a style more accessible to the average reader than a theological treatise.

Monaldi, a story of love destroyed by jealousy, revolved around the relationship between two artists, Monaldi and Maldura. As the story opened, the hero, Monaldi, was the younger and lesser known artist, Maldura the more famous and respected. The two artists represented the duality of action and contemplation. The young hero eventually became the leading painter of Italy and, later, captured the heart of the beautiful Rosalia whose hand in marriage had been sought by the elder artist. Racked with professional envy and personal jealousy, Maldura swore revenge against the younger artist. In a plot which bore a resemblance to Shakespeare's *Othello*, this Italian villain planted the seeds of jealousy in the hero's mind, thereby, provoking an

attempt on his innocent wife's life. Unlike Shakespeare's tragedy, this morality tale had a romantic twist: during the attempted murder of Rosalia, Monaldi recognized her innocence and tried to save her from the wound he had inflicted in her throat. The virtuous wife survived the attack by her husband who, in turn, became insane and died at the end of the tale. In a state of guilt and despair, Maldura recognized his own evil, repented of his jealousy, and confessed all to the ailing young artist, thereby, precipitating his mental breakdown. The elder painter ended his days in prayerful repentance as an exemplary member of a monastery.

Interspersed with Romantic and Christian themes and sub-themes, the tale betrayed Allston's own continued preference for the inner life of the romantic. The author advised his readers that each individual had a "sanctuary" in one's heart "where we can retire unobserved, and feel ourselves distinct," and the sanctuary of the heart was a woman's most prized and purest possession.[94] Rosalia was Allston's ideal woman: beautiful in form and also in heart. During his initial suspicion and inquiry into her possible adultery, Monaldi recognized Rosalia's innocence and declared, "Oh, how beautiful is Truth when it looks out from the eyes of a pure woman! Such, if ever visible, should be its image--the present shadowing of that hallowed harmony which the soul shall hereafter know in substance."[95]

Later, when recovering from her wound, Rosalia continued to attend to her demented husband, Allston described her feminine heart as her outstanding virtue,

> "Oh, woman, when thy heart is pure, and thy love true, what is there in nature to match thee! Though he whom thou lovest become maimed, wasted by disease, or blanked by madness, yet wilt thou cling to him, and see in the ruin only that image which he first left in thy heart."[96]

The development of the character of Rosalia corresponded in time with Allston's involvement in the painting of his most significant picturizations of woman including *Beatrice* and *Miriam the Prophetess*. In Rosalia, Allston created a verbal counterpart to his visual images of woman whose feminine character symbolized the spiritual dimension to human experience. Truth, beauty, wisdom, and the sanctuary of the heart were personified in such an ideal woman.

On the other hand, evil was realized in the masculine character of Maldura who both in his words and deeds sought to disrupt the lives of others. Where the heart that had been touched by "RELIGION" was empowered for moral harmony, that tinged with evil was only capable of moral disharmony.[97] However, once Maldura recognized his evil actions he

became repentant and, thereby, a symbol of Christian conversion as his heart turned from evil to good. After his complete confession to Monaldi of both his envy and his jealousy, as well as his evil deeds, the elder artist sought God's forgiveness.[98] Nevertheless, it was Monaldi's own death which clarified the moral lessons of Christian prayer and the meaning of death in the promise of the resurrection. Confronting the possibility of her own death, Rosalia told her husband, "Think of my hopes--of my blessed change. Oh, no--death has no sting for a christian."[99] Such a theme resounded throughout the younger painter's deathbed scene which concluded the tale. The anonymous visitor ended the tale with the reflection that Monaldi's death was "not the mere crumbling of a mortal body...its passage to dust--but a revelation--touching our highest instinct, and giving it evidence of the invisible world."[100]

Begun as a tale of two painters, *Monaldi* was transformed into a romantic tale of love and jealousy, and concluded as a morality tale. In his novel as in his paintings including *Beatrice*; *Jeremiah Dictating His Prophecy of the Destruction of Jerusalem to Baruch the Scribe* (1820: Yale University Art Gallery, New Haven); Saul and the *Witch of Endor* (1820: Amherst College, Amherst); and *Miriam the Prophetess* from the same period, Allston was concerned with themes of memory, reverie, judgment, repentance, prayer, Christian faith, and the artistic imagination. Subliminal feelings of guilt and despair over the death of Ann Channing Allston, including his memories of her care during his convalescence in Bristol, were involved in his presentation of the relationship between Rosalia and Monaldi. The author's own experience of finitude and, later, of spiritual re-affirmation were also evidenced in his "tale."

At his death, Washington Allston left his two major projects unfinished: *Belshazzar's Feast* and *Lectures on Art*. In 1850, Richard H. Dana published an edited version of the treatise on art which Nathalia Wright identified as the first published American art treatise,[101] and as "the only treatise on art in English during the Romantic period which is based upon the German idealist philosophy pervading the Romantic movement."[102] Allston labored over the writing of these lectures for over ten years, although as Elizabeth Johns suggested, the ideas presented in the lectures had been gestating since the time he knew Coleridge in Rome.[103] Dana reported that after his second marriage and his move to Cambridgeport, the artist "began the preparation of a course of lectures on Art....Four of these he completed. Rough drafts of two others were found among his papers."[104] Nevertheless, he read excerpts from these lectures to several of his friends, including Professors Longfellow and Cornelius Conway Felton.[105] The content of the

lectures was evidently well known among the art and literary circles of Boston prior to their posthumous publication.

The four completed lectures dealt with the fundamental issues of artistic creativity, imagination, God, Nature, and art; and evidenced an empathy with Coleridge's ideas and positions.[106] In the theories of the philosopher-poet, the artist found the explanation for his experience of the world and of art. In his lectures, Allston put his thoughts to paper and worked out the applicability of romantic philosophy to the purpose and nature of art. This presentation was based upon his answer to the epistemological question, that is how the human person comes to know for knowing was predicated upon ideas.[107] In an echo of Coleridge's theory of imagination, Allston argued that "Ideas are of two kinds; which we shall distinguish by the terms primary and secondary: the first being the manifestation of objective realities; the second, that of the reflex product, so to speak, of the mental constitution."[108] Through the apprehension of ideas human beings came to know while the quality and kind of the idea allowed for its influence on the moral development of the individual person. God devised and implanted the power of reason in the human person, thus distinguishing human beings from all other creatures.[109] God also gave human beings "that imaginative faculty whereby his exalted creature, made in his image, might mould at will, from his most marvelous world, yet unborn forms, even forms of beauty, grandeur, and majesty, having all of truth but his own divine prerogative,--the mystery of Life."[110] Through this gift of the imaginative faculty, the artist created works of art. The primary characteristic of art was originality or the ability to project an image that awakened in the viewer an empathy of emotion and a universality of human experience. As in his novel and his paintings, Allston's central theme in his lectures was once again the interior life: the experience of reverie. As Richardson explained, the artist's use of the term and idea of "reverie" was appropriate to romanticism.[111]

The visual image was a more appropriate and adequate vehicle for moral instruction and values than the written text. The duty of the artist was the highest vocation--the artist was a moral teacher for "the calling of the Artist...is one of no common responsibility; and it well becomes him to consider at the threshold, whether he shall assume it for high and noble purposes, or for the low and licentious."[112] An artistic vocation was to be used only for the highest and most noble of purposes, and art was created for the moral instruction of the audience. During the time he was engaged in the actual writing of *Lectures on Art*, Allston completed nineteen paintings including *A Spanish Girl in Reverie*; *The Evening Hymn*; and *Rosalie* (1840: Private Collection). These images of women in moments of reverie to

Allston's theories on art by employing a dreamer or a mind in reverie as the key image explicating the central points of each lecture.

Just as his works of art were innovations in the development of romantic painting in America, so too Allston's written texts were influential in the romanticization of American aesthetics and literature. In *Monaldi* and *Lectures on Art*, he presented a literary and an intellectual excursion into the artistic imagination. Both works were premised upon the romantic principles of subjectivity, imagination, and the interior life of the mind. The unity of his ideas argued for the romantic ideal of the organic relation between the inner and the outer; in this case, the artistic and the philosophic. As a precursor of the sentimental novels of mid-nineteenth century America *Monaldi*, like Beecher's *Norwood*, taught moral lessons through the guise of a "romance," whereas its autobiographical references served as a form of spiritual autobiography. *Lectures on Art* spread Allston's interpretation of Coleridge's ideas into the artistic and literary circles of antebellum America. Art became the vehicle for the expression of his spiritual life, and a symbol for spiritual and moral development.

Like other artists and writers, Allston witnessed and proclaimed his religious faith not through public ecclesiastical activities but through the testimony of his work. For him, as for Coleridge, Christianity was not the product of ecclesiastical affiliation, creedal affirmation, or participation in ritual. Rather his conviction of Christianity as a process of living was witnessed by his last recorded words when he told his young niece, "God bless you! Go on to perfection, my child!"[113] In image, word, and deed, Allston professed his commitment to the truth of the Christian tradition after the death of his first wife when he re-affirmed his faith in the Episcopal Church, and his art became his expression of the Christian life. "In a strict sense, imagination does not create, it only sees the spiritual creations of God," he told Elizabeth Palmer Peabody.[114] Since the artist created images that symbolized God's presence, Allston reasoned, that the artist had the highest obligation and role in American society, and in the development of an American culture.

As an artist who returned first from European study and later from European artistic success to paint and to teach in America, Washington Allston became the model for "the American artist." He represented the introduction into American art of Coleridge's theories of romanticism, and combined this romantic aesthetic with his own spiritual experiences thereby advocating the Christian Romantic tenets of confession, human finitude, gradual conversion, unfolding revelation, judgment, and divine intervention in human history. Following his mother's death, Allston affirmed his

Christian Romanticism in his description of her role as both maternal nurturer and spiritual model.[115] His recognition of the organic unity between art and spirituality signified the emergence of a Christian Romantic aesthetic in antebellum America, and transformed his own style of visual presentations. His paintings formed the foundation for the establishment of the American tradition of landscape painting in the work of Thomas Cole and Frederic Edwin Church, and of the eventual development of a new style of portraiture especially in terms of the image of woman. Despite his own artistic failings and uncompleted masterworks, Allston's paintings were formative upon the cultural world of antebellum America.

As one of his most perceptive critics, Mariana G. van Rensselaer acknowedged,

> If his pictures can have no notable influence upon American art, his life and character had an immense and happy influence upon the reverence for, and appreciation of, art in America. What we needed fifty years ago was not so much a great artist as a great prophet and apostle and servant of art.[116]

In his artistic expression of Christian Romanticism, Washington Allston filled a critical role in the introduction and transformation of aesthetic and religious ideas in antebellum American culture.

ENDNOTES

1. The standard source for biographical material on Washington Allston is Edgar P. Richardson, Washington Allston. *The Biography of a Pioneer of American Art and a Study of Romantic Art in America* (New York: Thomas Crowell: 1967 [1948]). Other sources to be consulted are: William Dunlap, *History of the Rise and Progress of the Arts of Design in the United States. Volume I* (New York: Dover, 1969 [1834]); Jared B. Flagg, *The Life and Letters of Washington Allston* (New York: Benjamin Blom, 1969 [1892]); and William Gerdts and Theodore E. Stebbins, Jr., "A Man of Genius" *The Art of Washington Allston (1779-1843)* (Boston: Museum of Fine Arts, 1979), Exhibition catalogue. The most recent essay on the life of Allston is Phoebe Lloyd, "Washington Allston: American Martyr?" *Art in America* 72.3 (1984): 145-55, 177-9.

2. For a detailed discussion of the chronology of this friendship, see John R. Welsh, "An Anglo-American Friendship: Allston and Coleridge," *American Studies* 5.1 (1971): 81-91.

3. The painting to which Coleridge referred as *Swiss Landskip* was actually *Diana and her Nymphs in the Chase* (1805: Fogg Art Museum, Harvard University, Cambridge).

4. Flagg, *Life and Letters of Washington Allston*, p. 64.

5. The major documentation of the conversations and exchanges between Allston and Coleridge would have been the latter's own notes. Fearful that he was a target of Napoleon's anger, Coleridge departed Rome on the advice of the Pope who offered him a passport and immediate flight via Leghorn. In his hasty retreat, Coleridge threw his notes into the sea so any record of the evolution of Coleridge's *Biographia Literaria* including his tracts on art was lost. See Flagg, *Life and Letters of Washington Allston*, pp. 357-8. See also Henry T. Tuckerman, *Artist-Life*; or *Sketches of American Painters* (New York: D. Appleton & Co,m 1847), p. 50.

6. For a fuller discussion of Allston's Roman friendships, particularly in terms of the intellectual and artistic exchange with the German community in Rome; see William H. Gerdts, "Washington Allston and the German Romantic Classicists in Rome," *Art Quarterly* 32.2 (1969): 166-96.

7. Welsh, "An Anglo-American Friendship", p. 87.

8. Coleridge to Allston, letter dated October 25, 1815. Samuel Taylor Coleridge, *The Collected Letters, Volume 4* ed. Earl Leslie Griggs (Oxford: Clarendon Press, 1959), p. 607.

9. Flagg, *Life and Letters of Washington Allston*, p. 356.

10. Ibid., p. 2. In her study of Allston, Elizabeth Garrity Ellis notes that Allston was baptized an Episcopalian in South Carolina. See Elizabeth Garrity Ellis, "The 'Intellectual and Moral Made Visible': The 1839 Washington Allston Exhibition and Unitarian Taste in Boston," *Prospects* 10 (1985): 74.

11. Flagg, *Life and Letters of Washington Allston*, p. 113. For further inquiry into the early religious life of Allston from Jarvis's perspective, see George David Chase, "Some Washington Allston Correspondence," *The New England Quarterly* 16 (1943): 632-3.

12. Elizabeth Palmer Peabody, *Last Evening with Allston, and Other Papers* (Boston: D. Lothrop & Co., 1886), p. 5.
 Elizabeth Palmer Peabody (1804-1894) was an educator and writer, who belonged to the group of noted American authors who made Boston the literary capital of the 1800s. In 1820, Miss Peabody opened her own school in Lancaster, Massachusetts, and in 1822 she opened a second school in Boston where she taught for nine years. She

opened a bookshop in 1839 which became the gathering place for such writers as Ralph Waldo Emerson, Nathaniel Hawthorne, and Margaret Fuller. The Brook Farm project was planned at Miss Peabody's bookshop. Additionally, some of Fuller's and Hawthorne's works were first printed on the presses in the back of the bookshop. In 1860, she opened a kindergarten in Boston, and became a leader in the kindergarten movement in American education. Later, Miss Peabody acted as secretary to the Unitarian clergyman, William Ellery Channing, whose biography she wrote in 1880.

For additional information concerning Elizabeth Palmer Peabody's role in the cultural world of Boston, and her support of Allston, see Ellis, "The 'Intellectual and Moral Made Visible': The 1839 Washington Allston Exhibition and Unitarian Taste in Boston," esp. 60-69.

13. Peabody, *Last Evening with Allston* p. 5.

14. *Ibid.*, pp. 5-6. In his "Preface" to *Lectures on Art, and Poems*, Richard H. Dana confirmed Miss Peabody's recognition of Allston's reticence to discuss his personal spirituality. Although Dana reported that there was no doubt that these existed. See Dana's "Preface" to Washington Allston, *Lectures on Art, and Poems* ed. Richard H. Dana, Jr. (New York: Baker and Scribner, 1852), pp. vi-vii.

15. Peabody, *Last Evening with Allston*, p. 6.

16. Richard Henry Dana testified to the conviction that in his grief over Ann's death, Allston turned to religion for solace. In a letter to the artist's London servant, Dana inquired "From what occasionally dropt from him, I presume that you know more about his religious state of mind while in London, than any other man, and more about the time and the circumstances which, under God, made him a devoted Christian." Richard Henry Dana to Thomas Brown, letter dated August 15, 1843, Dana Family Papers, Massachusetts Historical Society, Boston. This unopened letter was returned to Dana by Collins.

17. Peabody, *Last Evening with Allston*, pp. 7-8.

18. *Rebecca at the Well* (1816: Fogg Museum of Art, Cambridge); *Jacob's Dream* (1817: Petworth); *Elijah in the Desert* (1818: Museum of Fine Arts, Boston); *Jeremiah Dictating His Prophecy of the Destruction of Jerusalem to Baruch the Scribe* (1820: Yale University Art Museum, New Haven); and *Miriam the Prophetess* (1821: The William A. Farnsworth Library and Art Museum, Rockland).

19. For the fullest discussion of this painting and its relationship to Allston's development as an artist, see Elizabeth Johns, "Washington Allston's *Dead Man Revived*," *The Art Bulletin* 61.1 (1979): 78-99.

20. As reported by Allston to Coleridge, see Johns, "Allston's *Dead Man Revived*," p. 93.

21. Coleridge, *The Collected Letters, Volume 4*, p. 534. Additional Coleridge correspondence attested to Allston's dearth of British patronage, see Coleridge to Wordsworth, letter dated May 30, 1815:

> Allston, lives at 8, Buckingham Place, Fitzroy Square--He
> has lost his wife--& been most unkindly treated--& most
> unfortunate--I hope, you will call on him.--Good God! to
> think of such a Grub as Daw[e] with more than he can do--
> and such a Genius as Allston, without a Single Patron!

22. See the letter dated April (n.d.), 1816 from Allston to Morse, as cited in Johns, "Allston's *Dead Man Revived*", p. 96. The text is excerpted from S.F.B. Morse, Samuel F.B. *Morse: His Letters and Journals. Volume I* ed. E.L. Morse (New York: 1914), p. 199.

23. Diana Strazdes, "Washington Allston" in Theodore E. Stebbins, Jr., Carol Troyes, and Trevor J. Fairbrother, *A New World: Masterpieces of American Painting, 1760-1910* (Boston: Museum of Fine Arts, 1983), exhibition catalogue, p. 214.

24. Abraham A. Davidson, *The Eccentrics and Other American Visionary Painters* (New York: E.P. Dutton, 1978), p. 12.

25. Three unconnected but significant events--the King of France's declaration that landscape was a class of painting to be encouraged, Turner's transfer of his own designation at the Royal Academy from "landscape" to "historical landscape" painter, and John R. Martin's appointment as "Historical Landscape Painter" to Prince Leopold and Princess Charlotte--signified the growing acceptance of landscape painting.

26. For a recent study of the history of history painting in America, see Gerdts and Thistlewaite, *Grand Illusions, History Painting in America*. For specific reference to Allston, see pp. 21-22, 26, 30, 31, 62-63, 80-81, 84, 85 & 87.

27. Allston exhibited *Elijah in the Desert* and *Uriel in the Sun* (1817: Mugar Memorial Library, Boston University, Boston) at the British Institution in 1818. The latter painting was a success, critically and financially, whereas *Elijah* remained unsold at the end of the exhibition. It was the one finished painting that Allston brought with him when he returned to Boston in 1818. On loan to his friend and patron, Isaac Davis, *Elijah* captured the eye of Davis's guest Henry Labouchere [later Lord Taunton], who purchased the painting for $1,000.00 in 1827. *Elijah* returned to England to enter one of the finest collections of master paintings formed in the nineteenth century. After the death of Lord Taunton in 1870, *Elijah* was shown at the Royal Academy, and was eventually purchased by Mrs. Samuel Hooper of Boston. Allston's painting not only was to return to his adopted city, but became the first acquisition of the newly established Museum of Fine Arts.

28. Parts of the elements of *Moonlight* were based upon Allston's drawings of actual landscape settings. For a complete analysis of the relationship between Allston's drawings and paintings see Theodore E. Stebbins, Jr., "The Drawings of Washington Allston" in *"A Man of Genius." Washington Allston, 1779-1843*, p. 214.

29. Sarah Margaret Fuller, "A Record of Impressions Produced by the Exhibition of Mr. Allston's Pictures in the Summer of 1839," *The Dial* I.1 (1840): 83.

30. The most comprehensive study suggesting the common empathies between American painters and Caspar David Friedrich was Robert Rosenblum, *Modern Painting and the Northern Romantic Tradition, Friedrich to Rothko* (New York: Harper and Row, 1975).

31. Richardson, *Washington Allston*, p. 145. See also *The Atlantic Souvenir*, 1828 issue, p. 83.

32. Fuller, "A Record of Impressions," p. 83.

33. *A Register of Communicants in the Parish of St. Paul's Church, Boston, from the Consecration of the Church, June 30, 1820, arranged as nearly as possible according to the times of their admissions, under the successive Rectorships of the Church; the record in the Volume being begun by its third Rector, Rev. John Seely Stone, AM.* Entry #25, p. 1. Archives, Episcopal Diocese of Massachusetts, Boston.

34. Ibid., Entry #1, p. 23. This date coincided with Easter Sunday. Elizabeth Garrity Ellis noted that there was no entry for either a baptism or confirmation of Washington Allston in the Archives, Diocese of London. Ellis, "The 'Intellectual and Moral Made Visible'": 74.

35. Katherine Powers, *The Cathedral Church of St. Paul, 1912-1987. An Anniversary History*. Pamphlet, nd., p. 6.

36. George L. Blackmun, *St. Paul's Cathedral. A Center for Mission of the Episcopal Diocese of Massachusetts*. Pamphlet, nd., p. 2.

37. *A Brief History of St. Paul's Cathedral.* Pamphlet, nd., p. 8.

38. Allston's name appeared on several parish registers and communants lists through the period of 1830 to 1843, with his residence as Cambridgeport. For example, see "Burials," Entry #32, p. 5, stated that Washington Allston died from a disease of the heart in Cambridge in July, 1843 and that the Rector of St. Paul's, Alexander Hamilton Vinton, presided at the grave site rites. *A Catalogue of the Proprietors and Parishioners of St. Paul's Church, Boston, 1820-1875*, p. 6, indicated that Washington Allston was a communicant of St. Paul's, that he was married to Martha Remington and removed to Cambridge. Archives, Episcopal Diocese of Massachusetts, Boston.

39. Richardson, *Washington Allston, 1779-1843*, p. 5.

40. The leading female art historians and critics of the nineteenth century all commented upon Allston's positive way of re-presenting women: Margaret Fuller; Elizabeth Palmer Peabody; Anna Brownell Jameson; Clara Erskine Clement; and Mariana G. van Rensselaer. For further evidence of Mrs. Jameson's admiration for Allston, see her unpublished letters in the collection of The Houghton Library, Harvard University, Cambridge.

41. John Quincy Adams, then the American minister to Great Britain, made multiple entries in his diary of his admiration for Allston's *Beatrix*, *Mother and Child*, and *Rebecca*. See Gerdts, "Paintings of Washington Allston," p. 90.

42. Ibid., p. 74.

43. Ibid, p. 79.

44. For example, see Oliver Wendell Holmes, "The Allston Exhibition," *North American Review* 50 (1840): 378.

45. William Ware, *Lectures on the Work and Genius of Washington Allston* (Boston: Phillips, Sampson and Company, 1852), p. 72.

46. Three of Allston's images of women were engraved in his own lifetime as illustrations for popular gifts books: *The Valentine* was engraved by Longacre for the 1828 issue of *The Atlantic Souvenir*, p. 3; *Beatrice* was engraved by John Cheney for the 1836 issue of *The Token*, p. 105; and *The Mother* was engraved by S.W. Cheney for the 1837 issue of *The Token*, p, 145. Allston was pleased with the quality of Cheney's engravings and the artist was therefore happy to grant permission for Cheney's engraving of *Beatrice*. Washington Allston to Charles Bowen, letter dated November 7, 1834, Washington Allston Papers, Massachusetts Historical Society, Boston.

47. Allston to Collins; letter dated May 18, 1821. The Dana Papers, Massachusetts Historical Society as cited in Richardson, *Washington Allston*, p. 139.

48. Richardson, *Washington Allston*, p. 207. For an additional interpretation of Allston's *Beatrice*, see Ellis, "The 'Intellectual and Moral Made Visible'": 63-67.

49. Huntington, "The Allston Exhibition": 171-172.

50. Anna B. Jameson, "Memoir of Washington Allston, and His Axioms on Art" in *emoirs and Essays illustrative of art, literature, and social morals* (London: Richard Bentley, 1846),p. 203.

51. Peabody, "Remarks on Allston's Paintings" in her *Last Evening with Allston*, p. 15.

52. Ibid., p. 15.

53. Richardson, *Washington Allston*, p. 141.

54. Sarah Clarke, "Our First Great Painter, and his Works," *The Atlantic Monthly 15* (1865): 133.

55. Allston to McMurtie; letter dated June 13, 1816. Flagg, *Life and Letters of Washington Allston*, p. 121.

56. Allston to McMurtie; letter dated October 25, 1816. Ibid., pp. 123-4.

57. Fuller, "A Record of Impressions," p. 82.

58. Jameson, *Memoirs*, p. 178.

59. Allston to McMurtie; letter dated October 25, 1816. Ibid., pp. 123-4.

60. Fuller, "A Record of Impressions," p. 82.

61. Jameson, *Memoirs*, p. 178.

62. Mariana G. van Rensselaer, "Washington Allston," *The Magazine of Art* (1860): 148.

63. Richardson, *Washington Allston*, p. 148. See Miller, *Patrons and Patriotism*, p. 118; this painting was included in the list which reflected contemporary aesthetic taste in the Boston of 1828/1829. See also Mabel Munson Swan, *The Athaeneum Gallery, 1827-1873. The Boston Athaeneum as an Early Patron of Art* (Boston: The Boston Athaeneum, 1940), for details of both the purchase and sale of Allston's painting, *Mother and Child*; pp. 118, 127.

64. I was introduced to the iconography of the woman as reader by Leo Steinberg, Benjamin Franklin Professor of the History of Art, University of Pennsylvania. In his slide-illustrated lecture, "Woman with Book, or The Interrupted Reading (How Men Have Perceived Female Readers from the 14th Century to Modern Advertising)," Professor Steinberg analyzed the origins of this iconography in the Virgin Annunciate and the Penitent Magdalene. He also suggested that a third paradigm for the iconography of "reading no more" is the image of Paolo and Francesca from the *Divina Commedia*.

 As I remember Professor Steinberg's presentation, I was struck by his argument that reading woman could be interrupted, i.e., the Virgin by the Angel Gabriel, whereas reading men were protected from interruption by their wives or colleagues. The cultural implication being clear: that reading, i.e., intellectual activity, was a secondary act for a woman but a primary one for a man.

 My analysis of Allston's paintings of reading women as images of literacy is based upon my understanding of Professor Steinberg's presentation. Unfortunately, his lecture remains unpublished so that I am dependent upon my notes and memory of it. Nevertheless, I am of the opinion that both Professor Steinberg's thesis of the iconography of woman as reader and its applicability to Allston's paintings are appropriate.

65. Flagg, *Life and Letters of Washington Allston*, p. 82.

66. Huntington, "The Allston Exhibition," 171.

67. Holmes, " The Allston Exhibition," 378.

68. In her study of the sentimental novel in colonial America, Cathy N. Davidson included an illustration of a lithograph entitled *La Lecture*. The caption for this illustration, (fig. 11), reads as follows:

> This lithograph, *La Lecture* (Boston: c. 1830), was probably
> copied from a French print. Note the rapt attention of the
> female reader as she reads her book (which is the size of a

typical early American novel.) By the nineteenth century, a
book became a symbol of status, especially among
fashionable young women such as portrayed here.
See Davidson, *Revolution and the Word. The Rise of the Novel in America* (New York:
Oxford University Press, 1986), p. 124. Davidson credited "a French print" not Allston
as the source for the image of woman as reader.

My attention was called to the development of the iconography of woman as
reader in eighteenth-century French art by Maureen Kallet. I am grateful for her
observation.

69. Edwin Mullins, *The Painted Witch. Female Body/Male Art* (London: Martin Secker
and Warburg Ltd., 1985), p. 106.

70. Rensselaer, "Washington Allston," p. 133.

71. W.C., "Washington Allston," *The Christian World*, July 22, 1843, np. Washington
Allston Papers, Newspaper Clippings File, Massachusetts Historical Society, Boston.

72. Allston to McMurtie, letter dated June 13, 1816. Flagg, *Life and Letters of
Washington Allston*, p. 120. Full transcript of this letters is on pp. 119-21. Note that the
date of this letter and its subject matter confirm my interpretation that the religious
experience Allston described to Miss Peabody occurred after the death of Ann Channing
Allston and precipitated his return to active practice within the Episcopal Church.

73. Allston to Cogdell, letter dated December 21, 1828. Cited in Dillenberger, *The Visual
Arts and Christianity in America*, p. 142.

74. Dillenberger, *The Visual Arts and Christianity in America*, p. 136.

75. Allston to McMurtie, letter dated November 7, 1818. Flagg, *Life and Letters of
Washington Allston*, p. 144.

76. Lillian B. Miller, *Patrons and Patriotism*, p. 146.

77. For the most current discussion of the reasons for the "unfinished" painting, see
Lloyd, "Washington Allston: American Martyr?" For the most recent and comprehensive
analysis of the history, iconography, and meaning of *Belshazzar's Feast*, see David
Bjelajac, *Millenial Desire and the Apocalyptic Vision of Washington Allston* (Washington,
D.C.: Smithsonian Institution Press, 1988). For an alternate discussion of the history and
iconography of the *Belshazzar's Feast*, see William Gerdts, "Allston's 'Belshazzar's
Feast'," *Art in America* 61.2 (1973): 59-66; and idem., "'Belshazzar's Feast': 'That is his
Shroud'," *Art in America* 61.3 (1973): 58-65.

78. Elizabeth Palmer Peabody reported that "Allston was an Episcopalian by birth and
education, and he had never formally left that branch of the Church, as he once told me;
but he attended the ministrations of a Congregationalist." Peabody, *Last Evening with
Allston*, p. 17. The artist's name appeared irregularity throughout the parish records for
The Shepard Congregational Society, and always within the context of the Dana Family.

79. *Typed Records of the First Church Congregational, Rev. John A. Albro, Pastor, 1835-
1865* transcribed by Stephen P. Sharples, 1910, p. 2.

80. Flagg, *Life and Letters of Washington Allston*, pp. 245-6.

81. Several members of the Dana Family were listed among the earliest members of the
First Church Cambridge which was organized in 1792. Archival Records, First Church
of Cambridge, Congregational. Calvin E. Stowe was admitted to full communion at The
Shepard Congregational Society on November 5, 1830 by Rev. Holmes. See Sharples,
Records of the Church of Christ, p. 464.

82. Varied descriptions of this controversy were found among the archival records at The First Church of Cambridge, Congregational. For example, Alexander McKenzie, *Lectures on The History of the First Church in Cambridge* (Boston: Congregational Publishing Society, 1873).

83. For the misattribution of the architectural design to Allston, see Ibid., p. 223. The attribution of the design to Henry Greenough was substantiated by evidence on file at The Cambridge Historical Commission, see the Washington Allston Architectural Records File and the First Church of Cambridge, Congregational, Architectural Records File.

84. Flagg, *Life and Letters of Washington Allston*, pp. 233-9.

85. Allston to Verplanck, letter dated March 1, 1830. Ibid., p. 233. The full transcript of this letter is found on pp. 230-4. Note that Allston's motives in this suggestion to Verplanck might have been ambiguous. No doubt the artist recognized that a scriptural theme would prove unacceptable to the Congressional Committee, although as Dillenberger pointed out religious subject matter such as *The Baptism of Pocahontas* or *Embarkation of the Pilgrims* was acceptable to both the Congressional Committee and the American people. Dillenberger, *The Visual Arts and Christianity*, p. 111.

86. Allston to Verplanck, letter dated March 1, 1830. Flagg, *Life and Letters of Washington Allston*, p. 233.

87. Ibid., pp. 287-91.

88. Allston to Jarvis, letter dated February 3, 1837. Chase, "Some Washington Allston Correspondence," 629.

89. Allston published poetry and prose in three issues of *The Boston Book. Being Specimens of Metropolitan Literary Occasional and Periodical* ed. Henry T. Tuckerman; "The Paint King" in the 1836 issue, pp. 70-75; "Greenough's Group of the Angel and Child" and "Rosalie" in the 1837 issue, pp. 27-30 and 316-7 respectively; and, "America to Great Britain" in the 1838 issue, pp. 265-6. In *The Charleston Book. A Miscellany in Prose and Verse*, Allston published two poems in the 1845 issue, "Rosalie", and "The Tuscan Maid," pp. 13-14 and 304-5 respectively. "Rosalie" was re-printed in the 1864 issue of *The Wreath of Beauty*, pp. 61-62.

90. Elizabeth Johns, "Washington Allston's Library," *The American Art Journal* 7.2. (1975): 33.

91. Allston to Cogdell, letter dated November 14, 1841. Flagg, *Life and Letters of Washington Allston*, pp. 312-3.

92. From Felton's review of *Monaldi* in *North American Review* as cited in Flagg, *Life and Letters of Washington Allston*, p. 416.

93. Jameson, *Memoirs*, pp. 183-4.

94. Ibid., p. 93.

95. Ibid., pp. 165-6.

96. Ibid, p. 243.

97. Ibid., p. 203.

98. Ibid., pp. 216; 222-38.

99. Ibid., p. 187.

100. Ibid., p. 253.

101. Contemporary to the period of the writing of Allston's *Lectures on Art* was Rembrandt Peale's "Lecture on the Fine Arts" which was delivered on January 3, 1839. Peale's text, which dealt with his personal philosophy of art, an overview of western art history, and a call to support native artists, was never published. Fragments of this lecture were included in essays later published in the *Crayon* and elsewhere. For a bibliography of the writings, both published and unpublished, of Rembrandt Peale, see Carol Eaton Hevner and Lillian B. Miller, *Rembrandt Peale, 1778-1860. A Life in the Arts* (Philadelphia: The Historical Society of Pennsylvania, 1985), exhibition catalogue.

102. Nathalia Wright, "Introduction," Allston, *Lectures on Art and Poems, and Monaldi*, p. xiii.

103. See Johns, "Washington Allston: Method, Imagination, and Reality"; Regina Soria, "Washington Allston's Lectures on Art: The First American Art Treatise," *The Journal of Aesthetics and Art Criticism* 18.3 (1960): 329-44; and Welsh, "An Anglo-American Friendship: Allston and Coleridge," 90-91.

104. Dana, "Introduction," Allston, *Lectures on Art, and Poems*, p. viii.

105. Cornelius Conway Felton, "Allston's *Poems and Lectures on Art*," *North American Review* 71 (1850): 156.

106. Johns, "Method, Imagination, and Reality," p. 2. My own reading of Allston's texts was in agreement with Johns. For an alternate interpretation which argued for Allston's own origination of these ideas and theories, and therefore minimal dependence upon Coleridge; see Regina Soria, "Washington Allston's Lectures on Art: The First American Art Treatise," 329-44.

107. Allston, *Lectures on Art*, p. 3.

108. Ibid., p. 3. Coleridge's description of the primary and secondary imagination was found in the *Biographia Literaria*, p. 167.

109. Allston, *Lectures on Art*, p. 6.

110. Ibid., p. 13.

111. Edgar P. Richardson, "Allston and the Development of Romantic Color," *Art Quarterly* 7.1 (1944): 46.

112. Ibid., p. 110.

113. Peabody, *Last Evening with Allston*, p. 18. See also W.C., "Washington Allston."

114. Ibid., p. 4.

115. Flagg, *Life and Letters of Washington Allston*, p. 306.

116. Rensselaer, "Washington Allston," p. 150.

CHAPTER IV

The Garden Regained:
Thomas Cole and Landscape Painting
as Christian Romantic Rhetoric

With several of his landscape paintings from the 1820s and early 1830s engraved for reproductions in popular gift books, Thomas Cole's vision of the American landscape became familiar to middle-class American families.[1] According to Esther Seaver, "Any sentimental slant that such pictures [e.g., *Cole's View Near Fort Ticonderoga*] might have was quickly seized upon by the editors of the various Christmas annuals such as *The Talisman*, *The Chaplet* and *The Token*." These gift books

> published engravings of these paintings as "embellishments" to accompany sentimental stories, written for, if not by, anonymous ladies, and the ever present "sweet songs" of Lydia Sigourney. Several of Cole's pictures were reproduced for the first time in this way.[2]

During this same period, the artist's journal entries, poetry, and sketchbooks were replete with references from the Scriptures and to God including his 1827 sketchbook which contained several sketches for paintings with religious themes and several entries for "Subjects of Pictures," the first two subjects being "Preaching in the Wilderness/as is seen in the Western Country," and "Camp Meeting at Night/a fine light and moonlight."[3] Four pages depicted sketches of a glowing cross in the landscape in a variety of

compositional arrangements.[4] Like a writer's outline, these visual fragments indicated the artist's thematic interests which came to fruition during the 1840s in such paintings as *The Cross in the Wilderness* (1845: Louvre, Paris) (fig. 25) and *The Mountain Ford* (1836: The Metropolitan Museum of Art, New York) (fig. 21). Cole's interest in the cross and the landscape reflected the cross-centered spirituality and kinetic nature of Christian Romanticism.

"Essay on American Scenery," a provocative statement of America as the Garden of Eden regained, was first delivered by the young painter before the National Academy of Design on May 16, 1835, and first published in *American Monthly Magazine* in 1836.[5] His Christian Romantic perspective on America, art, nature, and religion was immediately popular with his audience. At the beginning, he acknowledged that his "almost illimitable subject--American scenery," had both spiritual and geographic significance.[6] Seeking to bring the singularity of the American landscape to the attention of the average American, Cole supported a national identity shaped by the establishment of both "American taste" and "American art." His search was a quest for an American culture; and, for Cole, culture translated into "the arts."[7] For the painter and the poet alike nature was a source of inspiration and spiritual sublimity. Like the works of literary and visual art, American scenery could smooth the rough edges of mercantile and pragmatic Americans. The young landscape painter decried the economic orientation of America and appealed for the cultural refinement available through nature and art.[8]

In contrast to the earlier Calvinist perspective dominant in American culture, Cole argued that the arts and nature did not evoke simple sensual delight, but profound spiritual truth.[9] Therefore a spiritual encounter with nature, particularly with cultivated nature, transformed one's manner not just in daily business activities but also within the domestic environment. For cultivated nature, the artist advised:

> encompasses our homes...And it is here that taste, which is the perception of the beautiful, and the knowledge of the principles on which nature works, can be applied, and our dwelling-places made fitting for refined and intellectual beings.[10]

The individual who encountered the spiritual sublimity of the American scenery retained the memory and effects of that experience even after the return to the turmoil of the city. Spiritual encounter with the American scenery would lead one towards just action in this world, for such experience was more accessible in the virgin wilderness than in the antiquated landscape

of Europe.[11] Although the European landscape offered historical associations, the American landscape held the promise of the future.[12]

Cole delineated five distinguishing attributes of the American scenery which formed his iconography of the American landscape. The first, perhaps the most obvious, was the mountain, which the painter described with a verbal eloquence equal to the visual eloquence of his paintings. American mountains were set apart from European mountains not by size, scale, or history, but by the beauty and transitoriness of their "gorgeous garb." The vision of an American mountain in its form and in its rainbow grandeur offered an experience of "the sublime melting into the beautiful, the savage tempered by the magnificent."[13]

His second attribute was water, in particular, the numerous small tranquil lakes to be found in America. Cole indicated that these could not be compared to European lakes, other than a similarity in size.[14] Along with the traditional religious symbolism of water, the serene ambience of American lakes as a metaphor for the Garden of Eden regained signified America as Paradise.[15]

Representative of the dynamic power of water, the waterfall was Cole's third attribute. Like the coincidence of opposites found in philosophic and religious traditions,[16] the waterfall combined two equal but simultaneously opposing forces. A waterfall was that "which in the same object at once presents to the mind the beautiful but apparently incongruous idea, of fixedness and motion--a single experience in which we perceive unceasing change and everlasting duration." Through its energy, the waterfall sounded the "voice of the landscape"[17] which reverberated throughout the mountains and rocky plains. The dichotomous experience of confronting the overwhelming beauty and power of the waterfall was symbolic of God who was simultaneously creator and judge. Having sketched throughout the countryside from Ohio to New Hampshire, Cole drew upon his experiences of magnificent waterfalls and rivers.

His fourth attribute was trees which were individualized symbols as well as anthropomorphic metaphors. In an 1826 entry in his journal, "Thoughts and Occurrences," on the CHARACTER OF TREES, Cole noted their "resemblance to human form."[18] Dismayed by the unwarranted destruction of the trees for a railroad then being built in Catskill, Cole wrote his poem, "On a Favorite Tree of the Artist Being Cut Down."[19] "They are cutting down all the trees in the beautiful valley on which I have looked so often with a loving eye."[20] Such "ravages of the axe"[21] resulted in a double threat as such wanton destruction did not simply nullify the singularity of America's national identity, but also eliminated the sign of the

covenant that God had offered "America." Spirituality fused with nationalism in this painter's concern for a national consciousness and the individual Christian soul.

Trees had distinctive physical characteristics and symbolism in accordance with their individual genus. Moreover, the condition of the tree had iconographic relevance to artistic themes. Blasted or gnarled trees signified the natural cycle of life and death, whereas tree stumps symbolized the presence of civilization. If trees were cut down so that a family could build a home, the painter felt necessary remorse. On the other hand, if the trees had been cut down for industrial economic expansion, the artist was outraged. Although simply alluded to in his essay, Cole's paintings and poetry evidenced denotation between elms, maples, pines, oaks, birches, beeches, planes, and hemlocks, and interest in their physical conditions and placements.[22]

His preference for autumnal scenes was related to both the actual and the symbolic changes in the trees. "There is one season when the American forest surpasses all the world in gorgeousness--that is the autumnal."[23] The transitoriness of the seasons symbolized the passages of human life and the reality of God's actions in human history. Rather than the "eternality" of springtime, Cole favored seasonal change. His interest in the "transitory moment" reflected a recognition of human finitude and his hope for re-entry into the Garden. The artist indicated that "Amid them the consequent associations are of God the creator--they are his undefiled works, and the mind is cast into the contemplation of eternal things."[24] Therefore, the destruction of the American scenery symbolized by the destruction of trees signified the closure of the gates of the Garden.

His fifth and final attribute was that "soul of all scenery," the sky. The magnificence of the American sky was delineated by its limitless horizon and the particularity of an American light. Even the most well-travelled observer had "to acknowledge that for variety and magnificence American skies were unsurpassed."[25]

Despite these distinguishing attributes, Cole categorized American scenery as "lacking" or "defective" in its "want of associations, such as arise amid the scenes of the old world."[26] The historical associations of European scenery were both detriments and affirmations, although historical associations, such as American Revolution, were found in America and endangered by industrial and commercial expansion. Affirming the metaphor of America as the Garden of Eden regained, an association with limitless future orientations, Cole defined the American scenery by its identification

with the future. The variety as well as the "natural majesty" of the American scenery distinguished it from its European counterpart.[27]

Clarifying his religio-nationalist belief in America as the Garden of Eden regained, Cole wrote: "Nature has spread for us a rich and delightful banquet. Shall we turn from it? We are still in Eden; the wall that shuts us out of the garden is our own ignorance and folly."[28] Committed to the undeniable conviction that "America" had been chosen by God for a unique and singular destiny, the artist interpreted the magnificence of the American landscape as the sign of this selection. The artistic turn to landscape painting coincided with a recognition of the changing social and religious values in antebellum America. Combined with the national search for a cultural icon, Cole's "new" style of painting found an eager audience. Although initially perceived as overtly secular images of the American landscape, his paintings were in fact effectively sacred presentations of America either as the Wilderness or as the Garden of Eden regained. In his art, Cole carefully controlled his use of either the wilderness or the garden metaphor in terms of his theme not aesthetic considerations. Such interpretation of "cultivated scenery" reflected Christian Romanticism's Garden of Eden regained; whereas his "wild scenery" was synonymous with scripture's wilderness. The painter's vacillation between the "cultivated" and the "wild" in his depictions of American scenery represented the traditional dichotomy of wilderness and garden.

Cole expanded his visual motifs beyond the iconography of his "Essay on American Scenery" to include the child in the garden, the cross, and radiant light. Human beings like Adam and Eve were fallible and finite creatures. The only way that Americans could re-enter the garden regained was through childhood innocence, but an adult could become a child again through the rebirth offered by Christian baptism. The experience of God's grace was premised upon a recognition of dependence upon and faith in God, and a recognition of human finitude was symbolized by the passage of time, i.e., the seasons. Not only site of God's symbolic presence but also of his actions in history, American scenery was the dramatic setting for God's universal plan.

Cole's recognition of the centrality of "light" in painting, and especially, the symbolic properties of light, was evidenced in his development of radiant light.[29] Artistic light fell into categories of experiential and phenomenological analyses. Problematically, such descriptions or generalizations were not mutually exclusive for that which was luminist was simultaneously radiant.[30] Cole's use of light which can be

described as radiant was distinctive from those of his contemporaries which can be characterized as either retinal or luminist light.

A natural light similar to that recorded through the techniques developed by Leonardo da Vinci during the Italian Renaissance,[31] retinal light was the mode of perception otherwise identified as the normative functioning of the human eye. Retinal light clarified what was seen through the conventional mode of light and shadow and reported common and recognizable phenomena such as times of days, events, and objects. Luminist light was a cool, planar, and reflected light that first was depicted in Dutch marine paintings and in the landscapes of Claude Lorraine. This style of painterly light was adapted by those American artists referred to by later art historians as Luminists.[32] On first view, luminist light appeared to be a convincing natural light. Upon prolonged examination, its unnatural qualities became apparent including the indeterminate light source, the oblique coolness and quiet, and the unnatural shadows or absence of shadows.[33]

Radiant light was simultaneously natural and unnatural in its effects within the painting and upon the viewer.[34] In its finest expressions, it was a soft, warm, and suffusing light expressed by a subtle combination of horizontal and halating strokes. This play of light and shadows with its clarification of details, contributed to a radiant light's sense of naturalness. At the same time, its unreal qualities created by the dialectical pull of linear and circular strokes, and the drama of chiaroscuro skies distinguished radiant light from both natural light and luminist light. The visual combination of a radiant light's linear and circular movements projected the sensation of emanation rather than the reflection of a luminist light or the refraction of a natural light. Radiant light has also been described as visionary light.

Radiant light suggested a sense that the light was coming through the canvas; that is to say, it was neither contained within the canvas as with a natural light nor reflected by the canvas as with a luminist light. Rather, a radiant light simultaneously advanced and receded through the painting. The canvas functioned as a planar midpoint between the radiant light and the viewer in whom developed the feelings that she could walk through the painting to something or a place beyond. In this way, the painting was a threshold experience: it acted as a visual symbol mediating between the viewer and what stood beyond the painting.[35] A theological reading of the effects of a radiant light suggested that the painter believed that something existed beyond the painting, the creative act of which the painting was perhaps merely an echo or imitation. Conversely, a luminist light gave the effect of a mirror reflection which is to say that the painting was spatially contained, that nothing stood beyond it, and that all the viewers saw were

their own reflections. A radiant light indicated the presence of a something or a someone "more."

Cole's use of radiant light separated him from other Hudson River School painters and the Luminists. In their use of luminist light and in their interpretation of God as immanent in Nature, the Luminists reflected Emersonian Transcendentalism. Their artistic goal was the transformation of the human within a one-to-one encounter with Nature. Cole, however, as a Christian Romantic, believed that God's presence was symbolically mediated through nature, that is to say that God stood beyond and behind Nature. Through an experience with nature, Cole became aware of the greatness of God and of the possibility of God's presence while he simultaneously recognized his own human limitations and finitude. Cole's radiant light functioned in a similar fashion, not being either a reflected image or an end-in-itself, but rather a beginning, an opening, to the sacred which inferred a continuum.

For Cole, human life was not limitless, rather, the contrary was true. He was not simply as Barbara Novak suggested that rare pessimist in the age of Emersonian optimism[36], but a Christian Romantic cognizant of his limitations and finitude, of his dependence upon God's salvific grace, and of God actions in human history. What was limitless for Cole was the possibility of God's grace and the mystery of his love experienced through Jesus as the Christ. The radiant light of Cole's paintings had as its referent not humanity but God. Cole built upon an acknowledged Christian tradition of understanding revelation as an experience of light and of this light as symbolic of the illumination of wisdom.[37] Given Cole's symbolic use of radiant light, the implications of Novak's suggestion that "the spirituality of light signals the newly Christianized sublime [in American landscape painting]"[38] became apparent. Cole used a radiant light in his canvases from the early 1830s until his death in 1848, these years during which he was formally associated with the Protestant Episcopal Church.[39] Cole's religious life began in his native England within the dissenting tradition.[40] His affiliation with any one church was never acknowledged nor has his family's religious affiliation during their first years in the United States been determined. However, once Cole became a resident of the city of Catskill, he established a tie with St. Luke's Episcopal Church.[41]

The Course of Empire: Scriptural Prophecy and Serial Panorama

Cole's first serial, *The Course of Empire* (1836: The New-York Historical Society, New York City) (figs. 13-17) was highly praised. In a

letter to the Rev. Louis Legrand Noble, James Fenimore Cooper echoed the sentiment of contemporary critics, artists, and middle-class Americans in his assessment of Cole's *The Course of Empire*. "Not only do I consider the Course of Empire the work of the highest genius this country has ever produced," Cooper said, "but I esteem it as one of the noblest works of art that has ever been wrought."[42] Cole's series of five paintings commissioned by Luman Reed in 1833,[43] was based on "a favorite subject that I [Cole] had been cherishing for several years in the faint hope" of a commission.[44] In his plan to fuse history and landscape painting, Cole initially proposed to paint five canvases, four of equal size and one larger one. The pictures would be arranged in a carefully planned presentation with the larger picture placed directly over the fireplace and the smaller pictures hung in pairs on either side. In the original plan Cole also intended to paint three small narrow paintings for the very top of the wall to indicate the position of the sun in relationship to the series from dawn to high noon to dusk. The series was a visualization of the theme of passages: time, seasons, and history.

The Course of Empire was exhibited to the public at The National Academy of Design from October 15 to December 15, 1836. Reed's son-in-law Theodore Allen advised the artist of the financial and popular success of the exhibition which netted the artist "nearly $1000 in cash and a <u>Million</u> in fame."[45] Unfortunately, Reed's premature death intervened in what might have been the more widespread success of this series for he had intended to have the series engraved. Nevertheless, the popular acclaim for the series spread Cole's fame by word of mouth, newspaper reports, and subsequent engravings of his landscape views.[46]

Long fascinated by the idea of the progress of human civilization, Cole frequently noted the subject in his journal entries, sketchbooks, and poetry.[47] Although the cycle of human civilization was neither original nor singular to Cole; he expanded the symbolism of the rise and fall of European civilizations by placing it in relation to America's manifest destiny of westward expansion. Cole's title even paraphrased Bishop George Berkeley's poem, "America: or The Muse's Refuge"--"Westward the Course of Empire takes it Way."[48] Cole painted the unresolved, central questions of antebellum culture such as American identity and Nature versus Civilization. The United States of the 1830s had experienced two generations of successful self-government and rising prosperity. National self-confidence was fed by technological advances and geographic expansion. Yet such optimism was tempered by a prophetic sense of impending doom: the desecration of nature for the advent of civilization would eventually lead to

moral and social decay as witnessed by the absence of trees in *The Consummation of Empire* and *Destruction*.

Although Cole's five paintings each portrayed an individual theme, the passage of the sun unified them into a whole. The first painting, *The Savage State* (1836) (fig. 13), represented the dawn; the second painting, *The Arcadian State* (1836) (fig. 14), the morning; the third (and largest) painting, *The Consummation of Empire* (1836) (fig. 15), high noon; the fourth painting, *Destruction* (1836) (fig. 16), the afternoon; and the fifth and final painting, *Desolation* (1836) (fig. 17), the dusk. The sun's journey paralleled humanity's journey from the savage to the civilized for the regular progression of the sun moved in a rhythmic pattern similar to history and by analogy to human life. Such a cyclic pattern was premised on the tenet of death and rebirth. However, those individuals like Cole who saw the United States as the Garden of Eden regained also recognized that the country was the "last" garden--the final opportunity of humanity for the establishment of a civilization under God's covenant. This interpretation reaffirmed belief in America's singular and manifest destiny which was why the painter became so outraged by the destruction of the "American scenery." While painting *The Course of Empire*, he presented his "Lecture on American Scenery." The rise and destruction of the civilization portrayed in the series' third and fourth paintings depicted the artist's fears for the future course of the nation. By the use of classical Greco-Roman architecture and costumes, he signified that the civilization which rose and fell in these paintings was not America. Symbolically, then, Cole implied that the progress of a civilization under the aegis of paganism was doomed to destruction; whereas one under the guidance of Christianity, as he interpreted America, might change the traditional "course of empire."

As with other landscape paintings of the period, Cole's *The Course of Empire* was a series of secular but effectively sacred paintings. Analogies between the five paintings and the scriptural passages of the deluge were suggested by a series of visual elements, the primary one being water.[49] In *The Savage State*, the water was a calm narrow strip placed along the horizon separating the savage wilderness in the foreground from the cloud-shrouded majestic mountain. In *The Arcadian State*, the calm lake became the focus that separated the pastoral foreground with its pagan temples from the majestic mountain. In *The Consummation of Empire*, the serene lake became a prominent central divide between the left and right sides of the canvas as the majestic mountain faded into the upper right corner. In *Destruction*, the waters becameturbulent as the natural elements of air, earth,

13. Thomas Cole, *The Course of Empire: The Savage State*, 1836. Oil on canvas, 39 1/4 x 63 inches. Collection The New-York Historical Society. (1858.1). Courtesy of The New-York Historical Society.

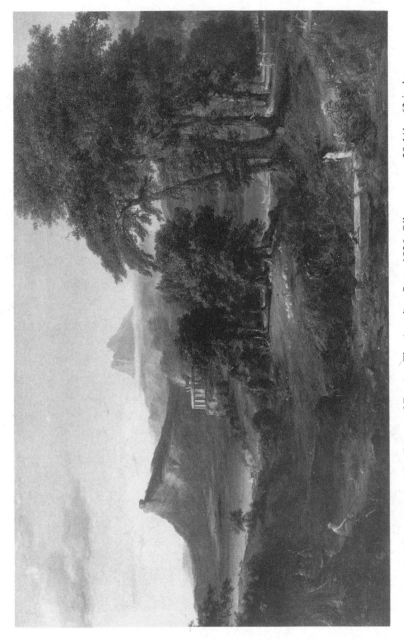

14. Thomas Cole, *The Course of Empire: The Arcadian State*, 1836. Oil on canvas, 39 1/4 x 63 inches. Collection The New-York Historical Society. (1858.2). Courtesy of The New-York Historical Society.

15. Thomas Cole, *The Course of Empire: Consummation of Empire*, 1836. Oil on canvas, 51 x 76 inches. Collection The New-York Historical Society. (1858.5). Courtesy of The New-York Historical Society.

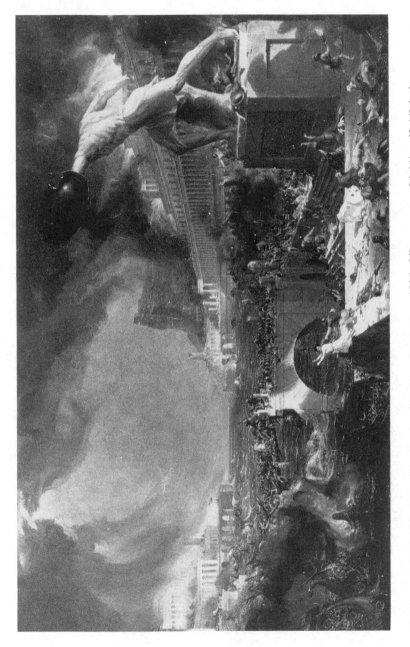

16. Thomas Cole, *The Course of Empire: Destruction*, 1836. Oil on canvas, 36 1/4 x 63 1/2 inches. Collection The New-York Historical Society. (1858.4). Courtesy of The New-York Historical Society.

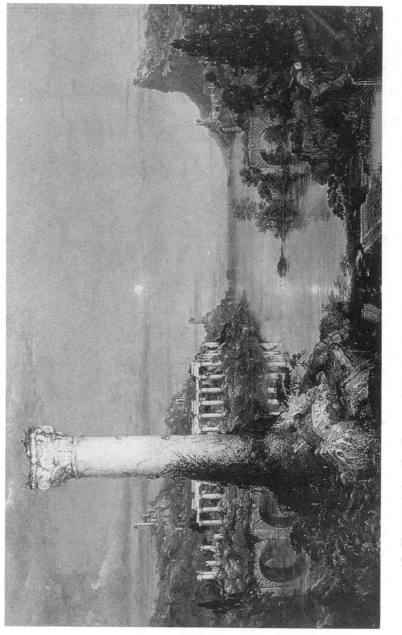

17. Thomas Cole, *The Course of Empire: Desolation*, 1836. Oil on canvas, 36 1/4 × 61 inches. Collection of The New-York Historical Society. (1858.3). Courtesy of The New-York Historical Society.

water, and fire united with the forces of destruction. In *Desolation*, the waters returned to the serenity appropriate after a storm or the deluge.

Another visual connector to the deluge was the absence and presence of animals. In *The Savage State*, the stags and deer were hunted animals. In *The Arcadian State*, the animals came under human domination as domesticated horses or sheep and goats are depicted with a shepherd. In both *The Consummation of Empire* and *Destruction*, domesticated horses with riders were present. However, in *Desolation*, the landscape was devoid of human figures but populated by birds--flying birds in the sky, a nesting heron on the crumbling pillar, ducks floating on the serene water, and a lone heron standing in the right foreground studying its reflection in the pool of water formed within the ruins. There were no birds present in the other four parts of *The Course of Empire*. Birds were symbolic of the end of the flood's destruction in the Genesis story.[50] When the dove "returned no more," Noah knew the earth was once again habitable. So Cole's scene of desolation visually echoed the scriptural image of the renewal of the earth. Such scriptural analogies furthered Cole's interpretation of America's singular destiny under God's covenant. For just as God formed a covenant with Noah and his sons after the earth was renewed, so God formed a covenant with America whose magnificent, virgin landscape was the sign of her unique identity. Europe was in a state of decay and populated by ruins. Selected by God as the site of the Garden of Eden regained, the American wilderness awaited transformation into Nature.

In *The Course of Empire*, Cole's visual rhetoric argued against the materialism and the ensuing decay brought about by industrialization's desecration of the landscape. For Cole, the artist was both prophet and moral teacher who voiced his concern for the survival of America through the visual image. As a pedagogical medium, art educated the public as to its moral responsibility and civic virtue. Cole's unannounced goal, implicit from his journal entries of 1835-1836, was the preservation of the covenant and the perpetuation of the nation. Art became for him the vehicle for elevating middle-class culture by tempering the utilitarian impulse to accumulate wealth. The refinement that art, especially landscape painting, afforded brought about a recognition of simplicity through the creation of sensitivity to Nature and by extension to natural law. No longer shut out by "our own ignorance and folly," Americans could re-enter the Garden.

The Landscape: The Secular as Effectively Sacred

Cole suspended work on *The Course of Empire* in the spring of 1836 in order to prepare a canvas for the exhibition at The National Academy of Design. In The Oxbow (*The Connecticut River near Northampton* (1836: The Metropolitan Museum of Art, New York) (fig. 18) Cole's purpose was to re-establish moral supremacy of America since scriptural authority affirmed America's mission. The scriptural story of the deluge was merely one example of God's justice symbolized by the destruction. America's singularity was guaranteed by a covenantal relationship with God. In that covenant, God was the greater partner who rendered justice as powerfully as blessings. Cole portrayed a landscape view of co-existent turmoil and serenity in which the sharp diagonal created by the Oxbow River divided the painting and brought the viewer into the midst of nature. With its series of dramatic dead trees, wild verdant backdrop of overgrown vegetation and trees, and tempestuous sky, the left hand side of the canvas emphasized the awesomeness of nature. Whereas a pastoral view of the American landscape on the right hand side offered a serenity conveyed through the bright sky and distant mountains.

An internal framing device, however, superseded the diagonal division of the river as the gnarled dead tree positioned on a sharp angle was complemented by a slanted umbrella and the artist's self-portrait. These two angular lines created a vortex which led the viewer's eye to the initially unassuming central mountain on which the carefully placed gouges on the central mountain which "spell the Hebrew letters *Noah*, and when the painting is viewed upside down they appear to spell the word *Shaddai*, which means 'the Almighty.'" *The Oxbow* was more than a simple landscape painting; it was a symbolic statement visualizing Cole's "fears for the stability of the country and of the vices of luxury and material lust overcoming the American people" that called for a return to their covenant with God.[51]

The artist's self-portrait was at the border between the natural and the pastoral as if he wished to balance the destructiveness of the wilderness with the creativity of the artist. His artistic experience of the American wilderness was as one "who looks on nature with a 'loving eye,' cannot move from his dwelling without the salutation of beauty; even in the city the deep blue sky and the drifting clouds appeal to him." For, he continued, "in gazing on the pure creations of the Almighty, he feels a calm religious tone steal through his mind, and when he has turned to mingle with his fellow men, the chords which have been struck in that sweet communion cease not to vibrate."[52]

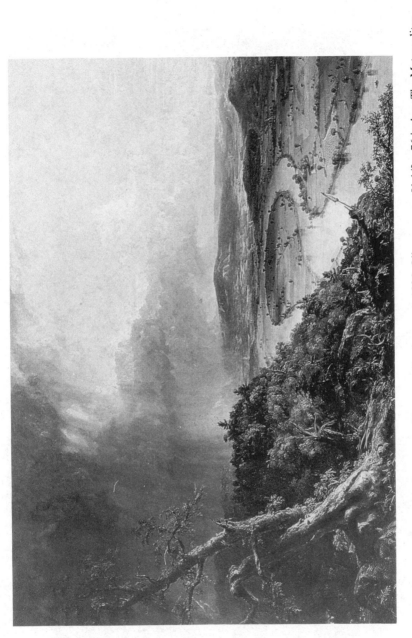

18. Thomas Cole, The Oxbow (*The Connecticut River near Northampton*), 1836. Oil on canvas, 51 1/2 x 76 inches. The Metropolitan Museum of Art. Gift of Mrs. Russell Sage, 1908. (08.228). Courtesy of The Metropolitan Museum of Art, New York.

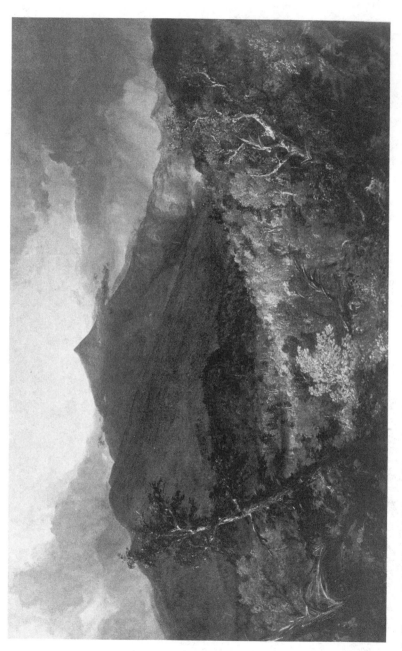

19. Thomas Cole, View of Schroon Mountain, Essex County, New York, *After a Storm*, 1838. Oil on canvas, 99.8 x 160.6 cm. © 1994. The Cleveland Museum of Art. Hinman B. Hurlbut Collection. (1335.17). Courtesy of The Cleveland Museum of Art.

Cole's expressions of this "sweet communion" with God through nature were his paintings of the American wilderness.

On first sight, View of Schroon Mountain, Essex County, New York, *After a Storm* (1838: The Cleveland Museum of Art, Cleveland) (fig. 19) appeared to be a romantic landscape painting. The internal presentation of time, drama, and movement, and Cole's identifiable visual motifs immediately distinguished it from being painted by a Hudson River School or Luminist artist. The internal framing device of the ubiquitous gnarled trees in the foreground created the familiar visual vortex which drew the viewer's eye to the central and distant mountain which was a place for inspiration and for prayer. Nature was symbolic of God's presence but not its equivalent.

> Prophets of old retired into the solitude of nature to wait the inspiration of heaven. It was on Mount Horeb that Elijah witnessed the mighty wind, the earthquake, and the fire; and heard the "still small voice"--that voice is YET heard among the mountains! St. John preached in the desert;--the wilderness is YET a fitting place to speak of God.[53]

In the Judeo-Christian tradition, the mountain was an accepted visual and verbal symbol for the presence of God. The pyramidal shape of the mountain had a visual reference to the traditional Christian employment of the triangular halo to distinguish God the Father and of the triangle to represent the Trinity. The multiple scriptural references to the mountain as a holy place were well known to Cole who regularly read the Scriptures.[54] Further evidence of Cole's scriptural knowledge was the multiple references in his journal and the themes of his religious paintings.[55] In his poem, "To Mount Washington" (1828) the poet-painter witnessed the symbolic relationship between God and majestic mountains.[56]

Mircea Eliade indicated that a common denominator of world religions was the symbolism of the "center". This center, which the historian of religions termed the *axis mundi*, is the geographical site singled out as a place of contact with the sacred.[57] For Eliade, "[t]he architectonic symbolism of the Center" consisted of "[t]he Sacred Mountain which "is situated at the center of the world," that "[e]very temple or residence...is a Sacred Mountain, thus becoming a Center," and the "*axis mundi*" which "is regarded as the meeting point of heaven, earth, and hell."[58] The central mountain of Cole's paintings was an *axis mundi*--a center of the world; a place consecrated to the communication between human beings and God.

The mountain was not God himself, but rather a symbol for his presence or of the place for communicating with him.[59]

Cole's consistent symbolism of a central mountain and aerial configuration of clouds combined with a knowledge of Christian art to permit alternate readings of his paintings. In Christianity, the image of Jesus as the Christ was a metaphor for the presence of God on earth. The Christian tradition allowed for a symbolic relationship between Jesus as the Christ and the holy mountain as a vehicle for communication with God. If this central majestic mountain signified Jesus as the Christ, the configuration of left and right characterized by the separation of light and darkness was related to the traditional iconography of the Last Judgment.[60] Traditionally, presentations of the Last Judgment were arranged with Christ as the Judge dividing the center of the composition between left and right, light and darkness, and the saved and the damned. Consistent throughout this artist's oeuvre, this compositional arrangement had visual connectors to the Last Judgment which signified his recognition of human finitude, and of a God who acted in history.[61]

In his "Essay on American Scenery", Cole described the inspiration for *The Notch of the White Mountain (Crawford's Notch)* (1839: National Gallery of Art, Washington, D.C.) (fig. 20) as the site where "he sees the sublime melting into the beautiful, the savage tempered by the magnificent."[62] The movement created by the sharp diagonals of the gnarled trees drew the viewer's eye forward into the central vortex of the painting created by the two small but contrasting mountains directly toward the majestic mountain peak. This artistic tendency to lead towards a single orientation point subordinated some of the elements of the painting to the others visually reflected a hierarchical system.[63] The large panorama and wide vista of the American landscape was then neither panoramic nor wide. Rather, it was a carefully composed series of visual connectors from the foreground of fallen branches and tree stumps to the internal framing of the gnarled trees and hills which led the viewer's eye toward the majestic mountain. The recurrent view of "majestic mountain peaks" to which he carefully directed the viewer's eye had scriptural referents. The central mountain indicated both the presence of God and the revelation of his activities in human history.[64] At the same time, the artist established use of an internal framing device and the hierarchical structure created by his controlled composition signified his belief in human limitations and finitude.

The Notch of the White Mountains (Crawford Notch) presented Cole's dichotomy of right and left configurations. The left side suffered under a tempestuous sky and the left hill was composed of barren rocks and autum-

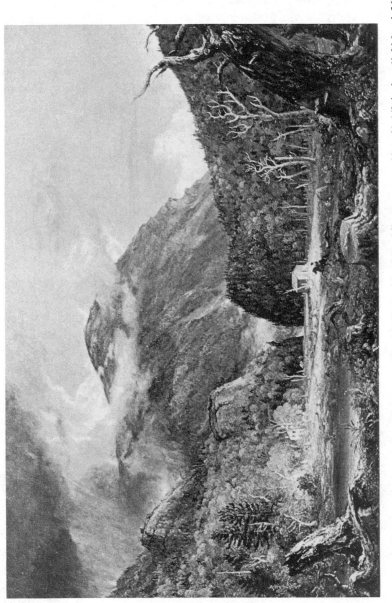

20. Thomas Cole, *The Notch of the White Mountains (Crawford Notch)*, 1840. Oil on canvas, 40 x 61 1/2 inches (1.016 x 1.560). National Gallery of Art, Washington, D.C. Andrew W. Mellon Fund. (1967.8.1[2328]/PA). © 1994 National Gallery of Art, Washington, D.C.

nal trees, whereas, the right side of the painting basked in a radiant light and the right hill was resplendent with autumnal vegetation. The obvious signs of civilization such as the house and the stagecoach were on the left side of the painting. However, the deserted barn and horse with rider were on the right side of the painting.

The majority of tree stumps which visually littered the painting from the foreground to the background related both to the painter's poetry and to the symbolism of the tree stump which represented Cole's cry of environmental concern at the destruction of the American wilderness.[65] The virgin wilderness of the Garden of Eden regained was threatened by civilization. The painted tree stump like Cole's poems represented his concern for the destruction of the environment. In *The Notch of the White Mountains*, there was a sense of awe mixed with nostalgia: awe for the majesty and splendor of the American wilderness, nostalgia for what America was and would never be again--a virgin wilderness.

Thus Cole's line, "We are still in Eden; the wall that shuts us out of the garden is our own ignorance and folly,"[66] could be read like his secular landscape paintings: that the majesty of the American virgin wilderness was singular in the decaying world of western civilization to which it offered a new salvific opportunity. All was lost through "our own ignorance and folly", which was civilization; that is, specifically that form of civilization which destroyed the virgin wilderness for materialistic gain and moral decay and thus "shuts us out of the garden."

Never unaware of the "threat of civilization" to his beloved American scenery, Cole saw also its impending threat to the religious and moral integrity of America. In this recognition of the "ills of the "city," the artist evidenced his Christian Romantic bias for Nature. "And to this cultivated state our western world is fast approaching" he wrote,

> but nature is still predominant, and there are those who regret that with improvements of cultivation the sublimity of the wilderness should pass away; for those scenes of solitude from which the hand of nature have never been lifted, affect the mind with a more deep toned emotion than aught which the hand of man has touched. Amid them the consequent associations are of God the creator--they are his undefiled works, and the mind is cast into the contemplation of eternal things.[67]

The loss of the American scenery threatened the universal prophetic design of which America was the final embodiment, Europe having descended into moral decay. To paint the American landscape was for Cole an exercise in

defining his own "American" identity and an attempt to call America to witness her universal prophetic destiny.

The use of the strong visual contrasts of the majesty and violence of nature with that of human beings suggested such an interpretation. The painter's basic artistic dichotomies became clearer the more one viewed his work. In *The Notch of the White Mountains (Crawford Notch)*, the landscape was simultaneously aweful and nostalgic, natural and domesticated, violent and serene, and autumnal and verdant. Throughout this painting, Cole's radiant light heightened the viewer's senses; as such his art was appropriately termed "visionary."[68]

However neither as a painter nor as a poet was Cole single-minded in his understanding of his American identity or of the meaning of "America." He was caught in those consistent and ever-present antinomies fundamental to the American consciousness. Just as he testified to the singularity of the American scenery, he decried the progressive societal decay which threatened that scenery's existence. Yet he also recognized the fundamental drive for human progress and the advent of civilization. He advocated an appropriate relationship between nature and humanity which supported the prophetic destiny of the American scenery. In his unpublished "Lecture on Art," Cole suggested that relationship as,

> Presented in Art the world blooms again in something of its pristine glory; Man "fearfully and wonderfully made" walks majestical as the first Adam and Woman moves as Eve in loveliness and grace. Through Art ideal beauty takes possession of the mind; hallows and elevates it above the sordid and the vulgar, and though it may not sanctify the heart, it renders it susceptible to religious expression.[69]

In all his landscape paintings, Cole created a series of antinomies which raised the fundamental issue of whether or not the theme and the intent of the painting was secular or sacred. Although the distinct division of the secular and the sacred themes were not as simple as they first appear, his merger of the sacred with the secular was the important element. The reference to "our ignorance and folly" implied the Emersonian Transcendentalist's rejection of finitude and guilt, and the acceptance of humanity's limitless potential which resulted in a personal independence which liberated one from dependence upon God. Such a blindness to fundamental human nature, that is, finitude and guilt, led to the acceptance of moral decay resulting in materialism which obstructed personal salvation and deterred America's

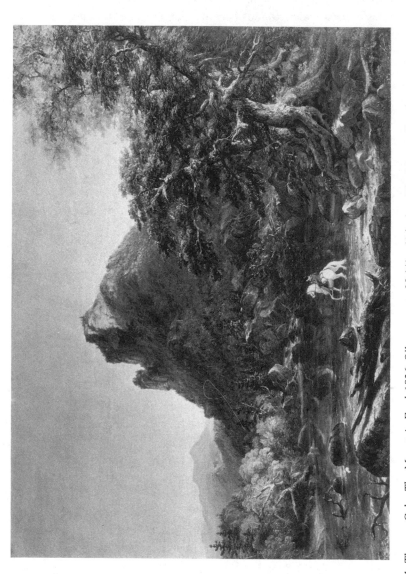

21. Thomas Cole, *The Mountain Ford*, 1836. Oil on canvas, 28 1/4 x 40 inches. The Metropolitan Museum of Art, New York. Bequest of Maria De Witt Jessup, 1915. (15.30.63). Courtesy of The Metropolitan Museum of Art, New York.

sacred destiny. For Cole, then, the secular was not purely secular but commingled with the sacred which was identified through the secular.

In *The Mountain Ford* (fig. 21) Cole painted the sacred character of the American landscape. The viewer's eye was led through the diagonal from the lower right hand corner past the gnarled tree to the horse and rider. From that point, the viewer's eye conjoined with the rider's upward gaze towards the source of radiant light. In the upper left corner, Cole painted a cross and two persons kneeling in prayer on the rocky ledge denoting a recognition ofthe presence of God and therefore of salvation in the American wilderness. Cognizant of human finitude and the need for salvific grace, Cole believed that the sign of that salvation was the cross.

In this painting of the Garden of Eden regained, a single horse and rider were overcome not by the majesty of nature but by the miracle of the Christian symbol of salvation. Cole's horse and rider visually connected to the traditional Christian symbolism of the quest for the Holy Grail by the crusader/knight who was also symbolic of salvation. One of the most popular depictions of this theme was Albrecht Dürer's print, *Knight, Death and the Devil* (1517: National Gallery of Art, Washington, D.C.) (fig. 22).[70] In all probability, Cole was familiar with Dürer's print or at least with the theme of the Christian knight. American ministers suggested analogies between the Christian knight, the quest for the Holy Grail, and the freedom of Jerusalem with the American pioneers, manifest destiny, and America as the new Jerusalem. Like Cole's rider, the viewer recognized human finitude in the contrast to the limitlessness of God's salvific grace.

The Landscape: Vision of Spiritual Domesticity

In his domesticated landscape paintings, Cole reflected societal transformations while retaining his basic iconography and contrived composition as in *The Hunter's Return* (1845: Amon Carter Museum, Fort Worth) (fig. 23).[71] In the clearing, the settlers's home is placed directly under the majestic mountain, while he left side of the canvas is forested with gnarled trees and stumps. The hunters with their dead prey cross the central boundary from the wilderness into the garden. The cleared land in the right corner becomes a small farm with the house encircled by a series of tree stumps. Two female figures dominate the area directly in front of the house. One woman holds forth a small child to greet the returning hunters while the other woman waits within the doorway. These figures with the children signify women's centrality in the American family. They are the nurturers in charge of child-raising, family piety, and the domestic sphere.

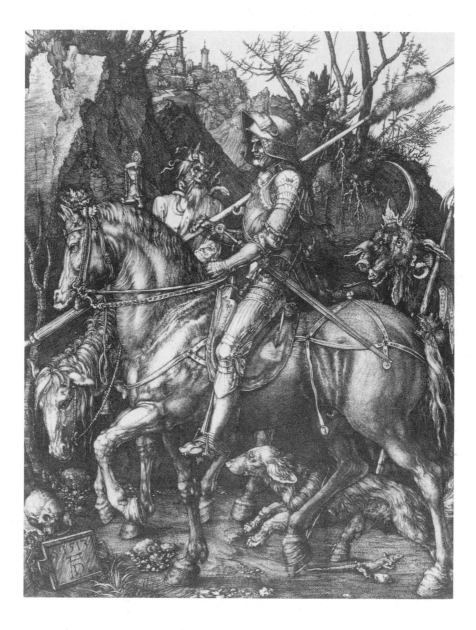

22. Albrecht Dürer, *Knight, Death, and the Devil*, 1513. Engraving (Meder 74), .246 x .188. National Gallery of Art, Washington, D.C. Gift of W.G. Russell Allen. © 1994 National Gallery of Art, Washington, D.C.

23. Thomas Cole, *The Hunter's Return*, 1845. Oil on canvas, 40 1/8 x 61 1/2 inches. Amon Carter Museum, Fort Worth. (1983.156). Courtesy of the Amon Carter Museum of Art, Fort Worth.

Immediately acknowledged as a representation of "American life" Henry T. Tuckerman noted that "It is altogether a beautiful and most authentic illustration of American life and nature."[72] The initial popularity of Cole's domesticated landscapes is due to the larger figures and a recognizable narrative. The painter's consistent use of diminutive figures was regularly attributed to his general weakness in figures even though such small figures symbolized "the children in the Garden."[73] The pioneers and settlers who cleared the virgin wilderness in order to build homes and farms were not the "enemies of the American scenery" against whom Cole raged. Rather, his images of domesticated landscapes presented the settlers ascoming under the grace of the majestic mountain as the children in the Garden regained, whereas the industrialists, railroad men, and manufacturers were the desecrators of that Garden.[74] This "collateral material" in his landscape paintings, no matter what genre, caused the viewer to return for successive examinations. The collateral material in *The Hunter's Return* had both secular and sacred references. The cross forms depicted in the clear-home. The domestic virtues of thrift, cleanliness, and Christian nurture signified by the careful details such as the laundry drying in the sun and the tiny household objects projected an aura of domestic religiosity premised upon the Calvinist ethic promoted by Christian Romantic ministers.

Parry clarified the effectively sacred tenor in the relationship between Cole's *The Return* (1837: The Corcoran Gallery of Art, Washington, D.C.) (fig. 24) and *The Hunter's Return*. The common theme of both paintings was signified by the word "return" which was a familiar theme in Cole's painting and poetry. The traditional Christian practices of ritual processions and pilgrimages became transformed in nineteenth-century Christian Romanticism into the conduct of the Christian life. These domesticated landscapes were filled with departures or returns of the family's patriarchal figure, thereby acknowledging the significance of the matriarch for the family's daily conduct of the Christian life. Since both processions moved horizontally from left to right the specific "returns" imaged in these two paintings corresponded to the western pattern of literacy and therefore heightened the visual narrative. Given the internal configurations of each painting, the processions moved from the wilderness into the garden. In *The Return*, the procession brought the body of the deceased knight to the ecclesiastical building for the rite of Christian burial. In a parallel movement, the procession in *The Hunter's Return* brought the body glass windows, back porch, and side fence indicated that this was a Christian of the slaughtered deer to the familial residence for human sustenance. The holy altar of *The Return* was replaced

24. Thomas Cole, *The Return*, 1837. Oil on canvas, 39 3/4 x 63 inches (100.97 x 160.02 cm.). The Corcoran Gallery of Art. Gift of William Wilson Corcoran in the collection of The Corcoran Gallery of Art, Washington, D.C. (69.3) Courtesy of The Corcoran Gallery of Art.

by the domestic altar of *The Hunter's Return* as the sanctity of the ecclesi-
astical edifice was transferred to the domestic domicile.[75]

There was also a commonality to the presence in both paintings of a
figure standing in the front of each building to greet, and ostensibly to bless,
the approaching procession with its sacrificial offering. In *The Return*, an old
druid stood before the church with his right hand raised in blessing and his
left hand holding his staff of authority. In *The Hunter's Return*, the hunter's
wife stood before the house holding forth her infant child as a sign of
greeting. The pose of these two figures, the druid and the wife, were iden-
tical as was their placement in the two paintings. Just as the druid signified
the indigenous nature worship which was fulfilled in Christianity, so the
wife/mother was the symbol of the domestic spirituality of middle-class A-
merica. Cole's two paintings suggested the translation from sacred ritual to
spiritual domesticity which was central to Christian Romanticism.

The Landscape: The Christianization of the Wilderness

Cole's *The Cross in the Wilderness* (fig. 25), categorized as a religious
landscape, visualized the cross-centered spirituality and the conduct of a
Christian life that was fundamental to Christian Romanticism.[76] With the
inscription in the upper left corner, Cole acknowledged that the source of the
painting's theme was Felicia Hemans' poem, "The Cross in the Wilder-
ness."[77] The emphasis in both the painting and the poem was the cross-
centered spirituality which was central to Christian Romanticism. Cole's
interest in the cross in the landscape was noted as early as his 1827 sketch-
book and continued through his last, unfinished series, *The Cross and the
World* (1848).[78] In *The Cross in the Wilderness*, the solitary Indian in the
landscape signified the passing of the frontier, the settlement and civilization
of the virgin wilderness. For the Christian Romantic, however, the Indian
like the pioneer, the settler, and the frontiersman was a symbol for the
American Adam--that innocent youth who resided in the Garden regained.
The solitary Indian contemplating a cross visualized the missionary impulse
of Christian Romanticism.

In a similar vein, Cole's poetry evidenced his spirituality as in his
poem, "The Vision of Life" (1825), an early attempt to put scripture into
verse,[79] described the Expulsion from the Garden of Eden. Cole's fas-
cination with the expulsion was also evident in his 1827 sketchbook and
ultimately in two major paintings, The Expulsion from the *Garden of Eden*
and *Expulsion: Moonlight and Fire* (1829: Thyssen-Bornemisza Collection,

25. Thomas Cole, *The Cross in the Wilderness*, 1845. Oil on canvas, 0,610 x 0,617 (0,61 diameter). Louvre, Paris. (R.F. 1975-9). Courtesy of Giraudon/Art Resource, New York.

Lugano). In his poem, the artist described the experience of the expelled American Adam who looked with longing upon the beauty of the American wilderness and declared:

> Eager I gazed--What heavenly scenes were there!
> Over the rocks, the rugged barren hills,
> The deep black pools, the furious cataracts,
> Distance had spread a veil of tender beauty.[80]

The familiar themes of human finitude, spiritual pilgrimage, faith in God, resurrection, mother-child relationships, guardian angels, God's mountain, the symbolic properties of nature, and the stages of life ran throughout Cole's poetry such as "Hope and Trust Spring from the Contemplation of the Works of God," and "Life's Pilgrimage." His 1848 poem, "The Cross," was a summation of his Christian Romantic spirituality.[81] The journey to faith and in faith was not an easy one in a newly industrialized society, but the reality of one's faith made the perilous pilgrimage worthwhile:

> O Sacred symbol of our Faith!
> Despised in this dark day
> By those who leave the narrow path
> To seek an easier way.[82]

Cole described a cross-centered spirituality analogous to that which he painted in *The Cross in the Wilderness*.

> Brighter and brighter grows the cross
> The mountain-tops are gold
> And o'er death's valley far across
> The gorgeous light is rolled.[83]

Cole's deepening spirituality was evidenced by his paintings, journals, poems, sketchbooks, and published texts indicated his developing and deepening spirituality. Like Coleridge, Allston, Bushnell, and Beecher, the landscape painter never underwent a dramatic and singular conversion experience. Rather, he experienced a gradual unfolding of his faith which found expression throughout his painting and his poetry. As he matured, Cole's innate Christian Romantic spirituality was publicly witnessed in his work.

The Voyage of Life: The Artist's Journey to Faith

On September 11, 1839, a fire destroyed St. Luke's Episcopal Church in Catskill and the sudden need for a new building initiated Cole's more public involvement with St. Luke's Church. His design for the new church was adopted on March 6, 1840,[84] and on May 25, he was appointed to "a committee to superintend the building of said church under the direction of the vestry."[85] The new building, for which the now famous artist painted an illusionistic window behind the altar, was consecrated on August 10, 1841.[86] Continuing his involvement with St. Luke's beyond the architecture and art for the new building,[87] Cole was elected a delegate to the Annual Convention of the New York Diocese of the Protestant Episcopal Church in New York City on September 30, 1840.[88] An ongoing relationship between the artist and his minister, the Rev. Mr. Joseph F. Phillips, was evident from the correspondence noting Phillips' visits to the artist's studio and their discussions of works-in-progress including *The Voyage of Life*. Cole's extensive knowledge of art history, Christian iconography, and the scriptures was obvious from his journal entries, his correspondence, and his published texts. Given his "isolation" in Catskill, it would not be untoward to assume that the painter had appropriate conversation partners on these issues; the most logical conversation partner being his minister. The minutes and records of the church vestry regularly mentioned Thomas Cole from 1839 to 1841; however there were no entries listing the artist between August 1841 and July 1842, dates which corresponded to his second European study tour.

In Rome, Cole completed the second set of *The Voyage of Life* (1842: National Gallery of Art, Washington, D.C.) (figs. 26-29).[89] Immediately recognized as a landmark in American art, the editor of Harper's *New Monthly Magazine* declared, "there are no works so famous as the series of the Voyage of Life." The artist had planned a careful program for a series on the theme of the "Allegory of Human Life" as early as 1827-9.[90] The untimely death of his patron, Samuel Ward, created a problem for both the completion and proposed exhibitions of *The Voyage of Life* as the family felt obliged to separate themselves from the commission to Cole and, once that failed, to rid themselves of "the white elephant" as expeditiously as possible.[91] During this period, the relationship between the artist and his patron's heirs became strained over the completion of the commission as well as the former's right to receive a portion of the proceeds from the public exhibition(s) of these paintings.[92] To fulfill his own goals for this serial panorama, Cole returned to the theme and repainted the series without the benefit of a patron with the hope of exhibiting and selling the second set

26. Thomas Cole, *The Voyage of Life: Childhood*, 1842. Oil on canvas, 52 7/8 x 77 7/8 inches (1.343 x 1.977). National Gallery of Art, Washington, D.C. Ailsa Mellon Bruce Fund. (1971.16.1[2550]/PA). © 1994 National Gallery of Art, Washington, D.C.

in England; instead, he scheduled a series of public exhibitions for the second set.

The Voyage of Life was a success as witnessed by the numerous engravings, particularly of *Youth*, "that inspired a flood of amateur copies." At least one-half million people viewed this series at a time when the 1840 census counted the American population as barely over seventeen million.[93] This series was best known among middle-class families in antebellum America. After his premature death had immortalized him, an engraving of Cole's *Youth* by James Smillie (1849: Private Collection) (fig. 30) became an Art Union dividend. The Committee on Management predicated this selection on the fact that "it will enable us to take advantage of the interest attached by the public to the memory of Mr. Cole."[94] The Rev. Gorham Abbot purchased the series on behalf of The Spingler Institute[95] in 1849 from Mr. J. T. Brodt of Binghamton, New York, who had "won" it in the Art Union Lottery.[96] The series of four paintings were engraved by George Smillie and Abbot published a pamphlet. For this publication, the erstwhile educator elicited testimonials from such notable American religious leaders as the Reverends Alexander, Bethune, Osgood, and Seabury who affirmed the popularity and appropriateness of *The Voyage of Life* to middle-class American values. "This I know and feel, that in pictorial poetry, there is nothing which more affects me than such works as these," Rev. Dr. Alexander wrote, "so that I think the frequent contemplation of them invaluable as discipline to the gentle mind of Woman."[97] In the same pamphlet, the Rev. Dr. Hawks testified to the moral and spiritual function, and popularity of Cole's series in Christian Romantic language.

> There are few lovers of Art in the United States, unacquainted with the series of Paintings by the late Mr. Cole, known as "The Voyage of Life." Independent of their merit as works of Art, which is great, they have perhaps a higher merit as an impressive moral lesson.[98]

Abbot promoted the "American character" of Cole's series and Smillie's engravings. He argued that these works (paintings and engravings) by American artists, reflected the "strikingly characteristic of the American mind", represented "living scenes in our own land", and advocated a "pure moral tone and Christian sentiment." It would be "difficult," the educator believed, "to find in the whole world of Art a more interesting, appropriate and valuable Series of truly FAMILY PICTURES."[99]

Part of *The Voyage of Life's* "American character" was the connection to spiritual domesticity. Through the painted replicas, imitations, and Smillie's engravings Cole's series found its way into the American parlor. "The just popularity which the 'Voyage of Life' has had among our people," the Rev. Bethune testified, resulted in the placement of "these silent, beautiful sermons on the walls of many a dwelling, where they may suggest to the minds of old and young reflections of a useful character."[100] *The Voyage of Life* became a popular vehicle for moral instruction as Smillie's engravings were hung in those rooms of middle-class homes used for the family prayer gatherings. The emphasis on the necessity of prayer, the guardian angel, and God's grace throughout a life's journey inspired such popular texts as Rev. Jared Bell Waterbury's advice manual, *The Voyage of Life, Suggested by Cole's Celebrated Allegorical Paintings* (1852), who declared that Cole's pictures "constitute together an impressive moral lesson, which speaks through the eye to the heart."[101]

Based on his sketches of the American landscape, Cole's settings depicted the duality of the wilderness and the garden.[102] The garden image was present in the first two scenes, *Childhood* and *Youth*, while the wilderness appeared in the final two, *Manhood* and *Old Age*. This division between the garden and the wilderness paralleled the scriptural tradition well known to both Cole and his audience. Appropriately, the garden scenes were the settings for the voyager as an infant and a youth. In *Childhood*, which was clearly the most paradisiac locale of the series, the voyager was "the child in the garden". In *Youth*, the voyager in his ambition departed from the garden to test his faith in the wilderness. This visualization of the scriptural dichotomy of the garden and the wilderness, so well-known to the nineteenth-century mind, enhanced the popularity of Cole's series. In a similar manner, he expanded the traditional Christian theme of the pilgrimage or journey to faith as found in Dante Alghieri's *The Divine Comedy*, Geoffrey Chaucer's *The Canterbury Tales*, and John Bunyan's *Pilgrim's Progress* for which the young immigrant Cole reputedly prepared a series of engravings to illustrate an American edition of Bunyan's text.

In this particular series, *The Voyage of Life*, the pilgrimage was made upon the water not upon a treacherous terrain. Water was the traditional Christian symbol for cleansing and rebirth which the ritual of baptism sacramentally incorporated. The image of the river had a long scriptural and symbolic history in Christianity including the baptism of Jesus of Nazareth by John the Baptist in the River Jordan.[103] In Cole's contemporary American context, the river was a secular symbol of American progress

through the development of waterways such as the Erie Canal and a religious symbol for the revivalist gatherings at the river to bathe in the waters of salvation. The river was the vehicle for the individual American's journey to salvation as well as a symbol of the movement necessary to achieve America's manifest destiny.

Cole built upon two other traditional images in his series: the boat and the stages of life. In the Christian tradition, the boat symbolized the pilgrim and the missionary both of whom travelled the waters in their spiritual journey. In early Christian art, the boat symbolized the vessel by which Christians made the journey to salvation. By extension, the ecclesiastical edifice was described as the "ship of faith." In the medieval period, a Christian walked down the nave, from the Latin for ship, to receive the sacrament of eucharist. A common image for the journey of life in romantic poetry and painting was the storm-tossed boat with its heroic pilot.[104] In Cole's series, however, the heroic pilot of *Youth* who competently held the rudder himself became the impotent pilot of *Manhood* who prayed as his rudderless boat drifted uncontrollably. As Cole's voyager crossed the treacherous waters of experience he became not the romantic hero of Délacroix or Byron, but a Christian Romantic with limitations and dependence upon God's grace for salvation. The classical theme of the stages of life was merged with the contemporary American fascination with the theme of societal progress and decay as seen in the *Course of Empire*.

The progression from *Childhood* to *Old Age* is represented in the relationship between the radiant light and the voyager. In *Childhood* (fig. 26), the voyager's boat emerges from the darkness of a womblike cavern on the left side of the painting. The guardian angel emits a glowing, soft, and circular light like a traditional halo which serves as the light source for the foreground of the painting. Light coming out of darkness of the cave represents the traditional Christian metaphor for revelation and wisdom. The child and the verdant paradisiac landscape reaffirms traditional Christian symbols. The young child signifies the innocence of the Christian soul advocates by Christian Romanticism while the verdant landscape locates this narrative in the Garden of Eden regained. This is, then, the reverse of Cole's *Expulsion from the Garden of Eden* for *Childhood* was rather "Entry into the Garden of Eden."[105] In both paintings, darkness and rocky barrenness are on the left side of the canvas with light and verdant lushness on the right. The dramatic, almost surreal, rocklike cavern bridge which separates the world from Eden is reflected in the shape of the womblike cavern from which the little voyager's boat emerges. Adam and Eve pass under this

27. Thomas Cole, *The Voyage of Life: Youth*, 1842. Oil on canvas, 52 7/8 x 77 7/8 inches (1.343 x 1.977). National Gallery of Art, Washington, D.C. Ailsa Mellon Bruce Fund. [1971.16.2 [2551]/PA]. © 1994 National Gallery of Art, Washington, D.C.

bridge in a movement from right to left in opposition to the child voyager's boat passage from the womblike cavern into the Garden of Eden regained.

The weighted down figures of Adam and Eve walk together out of the sun-filled right side of the canvas into the darkness on the left. A remorseful Eve looking down and Adam looking back for one last glimpse of Paradise are in marked contrast to the erect figures of the guardian angel and the child voyager. With his right hand, the angel gently steers the boat as his left hand guides the child to the paradise garden. Simultaneously the child faces his landing site with joy emanating from his outstretched arms. Cole's two paintings of the relationship between humanity and nature echoes the differences between the scriptural themes of despair and loss as opposed to hope and promise. However, there is danger and foreboding in *Childhood* as the shadows and dark cavern suggest ignorance and doubt. The gnarled trees in the foreground, and the barren mountains in the background are equally ominous.[106] These elements jar an otherwise pleasant landscape and represent the opposite of the verdant living landscape: chaos and death. They are visual metaphors for human limitations and finitude.

The second painting in the series presented *Youth* (fig. 27) who bids his guardian angel goodbye and sets sail for the outside world. His anticipated success is symbolized by the castle located in the upper left side of the painting.[107] However, the river ends or turns to the left some distance before the castle.[108] What the youth expects at his journey's end, the castle, is different from what is actually there--the unknown, unforeseeable bend in the river. Cole's ubiquitous central mountain is a mirror image of the distant mountain of *Childhood*. This mirror-image motif locates this scene on the other side of the mountain--accounting for the lush paradise garden in the lower right hand corner of each painting. Throughout the series, this mirror-image motif of the mountains parallels a similar presentation of the boat symbolizing the self-reflective "I"--a necessary element to autobiography, confession, and romantic philosophy. The most fantastic image in *Youth* is the castle[109] whose visual relationship to the fantastic architectural renderings in other Cole paintings, especially *The Architect's Dream* (1840: The Toledo Museum of Art, Toledo) and *The Course of Empire*, is that of a common *geist* signifying a Christian Romantic recognition of societal decay and environmental destruction.

In *Youth* the merging of stark clear light with soft palpable light results in the viewer's experience of a vision of the familiar and of the unfamiliar. Only in this painting of the series is there a natural sense of shadows which upon close scrutiny calls into question the naturalness of the trees' shadows

29. Thomas Cole, *The Voyage of Life: Old Age*, 1842. Oil on canvas, 52 7/8 x 77 7/8 inches (1.343 x 1.977). National Gallery of Art, Washington, D.C. Ailsa Mellon Bruce Fund. (1971.16.4 [2553]/PA). © 1994 National Gallery of Art, Washington, D.C.

falling in perfect and precise parallel design. In the series, *Youth* is the most placid in tone, linear in composition, and clear in light; and the most optimistic in its rendering of the young voyager. These factors resulted in its great popularity as an engraved or parodied image in the 1840s and the 1850s.[110] As the young man takes hold of his own boat (a metaphor for his life) and turns his back on his guardian angel, he steers his boat away from the Paradise Garden. His right hand stretches upward towards the castle which in itself is as much an illusion as it is not at the river's end. *Youth* is a visual gloss on Cole's often quoted phrase, "We are still in Eden; the wall that shuts us out of the Garden is our own ignorance and folly."[111] The relationship of ignorance and folly to human limitations and finitude is obvious. A theological reading of human limitations, the need for God's grace, and spiritual nurture of the guardian angel is appropriate.[112]

In the third painting, *Manhood* (fig. 28), the voyager is an adult caught in the turbulence of mid-life. The tempestuous sea and cloudy sky signifies a crisis symbolized by the three phantasms of intemperance, lust, and suicide in the storm-ridden sky. Breaking through the cloud-ridden sky, radiant light encircles the guardian angel. Cole retrieves but turns upside down the left side of *Childhood* in the right side of *Manhood*. In *Childhood*, the angel encircled with radiant light emerged from the womblike cavern whereas in *Manhood* the angel emerges from the dark and stormy sky. The voyager's pose is a study in human finitude and dependence upon God's grace. In a kneeling position, his hands clasped together in prayer, or perhaps in fear, the voyager's body exudes an aura of tension and anxiety.[113] The optimistic and self-sufficient youth finds himself alone and helpless on the sea of life. This recognition of limitations is symbolized by the lack of vegetation, healthy trees, or solid ground. However, to balance the terror of nature's destructive side, Cole paints a calm sea and a sunset sky waiting behind the storm. The relationship between humanity and nature is mirrored in the sympathetic but reversed lines of the voyager's body from those of the gnarled trees. *Manhood* conjures up a mood of anxiety, fear, tension, and penitence in the voyager's body and nature's destructive side, all overseen by the guardian angel.

In *Old Age* (fig. 29), the tempestuous waters are stilled in an atmosphere of calm serenity and acceptance. His hands clasped in prayer, the voyager sits in his rudderless boat attending his guardian angel's counsel. The absence of the boat's masthead hourglass signifies the journey's end. As in *Youth*, the guardian angel's upward gesture with his right hand leads the voyager on a diagonal to the dramatic vision of radiance. Lacking in vegetation,

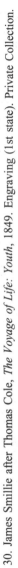

30. James Smillie after Thomas Cole, *The Voyage of Life: Youth*, 1849. Engraving (1st state). Private Collection.

Old Age is composed of water, rocks and sky for the emptiness of details signifies the journey's end. The four paintings of the series symbolizes the four stages of life and the four seasons. *Old Age* is winter: cold and barren.

The strong diagonal line delineated by the upraised arm of the voyager in *Youth* and the guardian angel in *Old Age* calls the viewer's attention to the upper left corner where the visions of radiance explodes. The placement of the vision is identical; only its message is distinctive: *Youth*'s vision is an illusion, *Old Age*'s vision is God's grace. The surrealistic rock formations have two references: first as a mirror image of the central section of the surreal rock formations of *Manhood*; and second, as a suggestion that *Old Age* occurs on the opposite side of *Manhood*. This creates a sense of internal limitations within the two paintings while the internal dialogue(s) between the four paintings are revealed by *Childhood*'s voyager who faces *Old Age*'s voyager. Further, the surrealistic rock formation relates to the womblike cavern of *Childhood*. Although inverted and smaller in size, the surreal rock formation in *Old Age* frames the right side of the canvas. Therefore, the series is framed internally by the surreal rock formations on the left side of *Childhood* and the right side of *Old Age*. *The Voyage of Life* is a series of self-reflective, confessional dialogues as well as a symbolic study of the four stages of life and the four seasons of the year.

The constant presence of the guardian angel visually emphasizes the need for Christian nurture to bring the individual American and America to a recognition of the truths of the Christian message. The guardian angel and the accompanying angels signify Cole's dependence upon an ecclesiastical and domestic religious structure. In *Views of Christian Nurture*, Bushnell offered a theological gloss to Cole's *The Voyage of Life*,

> The growth of Christian virtue is no vegetable process, no mere onward development. It involves a struggle with evil, a fall and rescue. The soul becomes established in holy virtue, as a free exercise, only as it is passed round the corner of fall and redemption, ascending thus unto God through a double experience, in which it learns the bitterness of evil and the worth of good, fighting its way out of one and achieving the other as a victory.[114]

Cole extolled the Christian Romantic virtues of prayer, a Christian life-style, and a life-journey growing in Christian faith. Thus, the artist employed the visual to teach moral values and spiritual truths in a style and form appropriate to the domesticated religiosity of antebellum America.

Thomas Cole and Christian Romanticism

A formative influence upon Cole's religious thinking was the writings of Samuel Taylor Coleridge as indicated in several entries in the artist's sketchbooks and journals. The artist wrote in his journal on August 8, 1835, "I am reading Coleridge's *Table Talk* [;] it is amusing but no less so than I expected. I like him as a poet more than as a metaphysician."[115] In a letter dated January 31, 1838 to his fellow painter, Asher Brown Durand, Cole discussed a hoped-for commission and suggested as the topic for the proposed painting, "Coleridge's poem of Love."[116] In his handwritten inventory lists of "Catalogue of Books, December 1839," he entered under the heading, "Poetry--Plays &c.," the following item under "No. 2": "Coleridge, Shelley and Keats." Further down on this inventory listing under the heading, "Books read during the Fall of '39 and Winter of '40" in the second column were the two entries, "Coleridge, Poems, entire," and "Biographia Literaria in part."[117] Whether his indebtedness was to Coleridge's texts directly or to Coleridge's ideas as mediated through the texts by Allston and others, the landscape painter expressed a clear affinity with Coleridge's ideas on art and religion, and was probably better versed in the poet's thought than the minimal documentation suggested. Only one fragment of a booklist existed from what must have been an extensive library given the artist's constant references to literary, philosophic, and poetic sources in his letters, essays, and journal entries. The fact that the majority of the intellectually and theologically curious minds of this period read the 1829 edition of Coleridge's *Aids to Reflection* make it reasonable to assume that he read that particular text. Although fundamentally self-educated, the painter was well read for his time as both his literary inventory lists and his constant references in letters and essays proved, his familiarity with literary classics such as Shakespeare and Milton, and with the contemporary literature of the Romantic poets including Coleridge.[118]

Sympathetic resonances on the role of imagination, art, and religion were found in Coleridge's *Biographia Literaria* (which Cole read in 1839-40) and Cole's unpublished "Lecture of Art." The British poet wrote:

> The primary IMAGINATION I hold to be the living Power and prime Agent of all human Perception, and as a repetition in the finite mind of the eternal act of creation in the infinite I AM.[119]

The American painter's unpublished and undated "A Lecture on Art" (a preparatory draft for a finished text)[120] states:

> Art is man's imitation of the great Creative power. The World, the Universe were around him with all their mystery and glory the work of the great Artist. Touched by the beauty which everlastingly flowed from their contemplation, man felt an instinct and a power grow within him and was impelled to imitate.[121]

One of the works of art hung in the artist's studio was an oil sketch entitled, *Genevieve* (c. 1838), which was based on Coleridge's poem, "Into the Tale of the Dark Ladie."[122] As with any synthesizing mind, the American painter was influenced by other writers, artists, and thinkers; and he assimilated and reinterpreted these ideas and images. For example, the appeal of *The Voyage of Life* was in the simple fact that it was painted in a heuristic manner; that is to say it was open to a multitude of readings and interpretative influences.[123]

Like other artists of his day, Cole esteemed Washington Allston.[124] In his journal for July 30, 1843, he began a lengthy entry, "Allston is dead!"[125] In his usual fashion, the younger artist described the senior painter's style noting his faulty dependence upon the Old Masters, especially Raphael, Michel Angelo, Poussin, and Salvator Rosa, to the detriment of Allston's own imagination.[126] However, Cole concluded this entry with the highest praise, "But he was a great Artist [and] a good man, an honor to his country, one whose name ought to be revered & respected."[127] Careful throughout his letters, journal, and essays to acknowledge his debt to the Old Masters and the tradition of Christian Art, the landscape painter distinguished his singular style and conception of Art. His critical evaluation of Allston was probably based upon a subliminal need to separate himself from the established master's (and by extension, the Old Masters's) influence; especially since this entry began with a long paragraph about the paintings Cole completed upon his return from Europe. In particular, the younger artist singled out the painting he was currently at work on, *The Angels Ministering to Christ after the Temptation & Fasting* as the most important painting that "I have done for a great length of time."[128]

Cole's respect for Allston outweighed any negative comments about the latter's stylistic dependence upon the Old Masters. Although he authored memorial poems on the deaths of Luman Reed, his mother, and Miss M.A.W., *A Sunset* was the only memorial poem dedicated to an artist that Cole ever wrote.[129] This poem, however, did not mention the older artist by name in the text, nor did it indicate Cole's personal sense of loss. Rather, *A Sunset* was a memorial poem in honor of a dead artist. Christian Romantic language and symbolism pervaded *A Sunset* as natural phenomena were

merely signifiers of the heavenly beauty of God's own being. Art and nature were pale reflections of "what the heavens unfurled." Cole concluded his memorial poem with a recognition of human frailty and with faith in the resurrection.[130] The visual affinities linking these two artists were obvious-- both were romantics in their stylistic and thematic presentations. Responsible for the introduction of the romantic aesthetic into American art and culture, Allston's influence was as much due to his persona and personal reputation as to his paintings and texts. The youthful landscape painter obviously learned these romantic principles through the eye and the mind. Given the foundation the Cambridge artist created for American Romanticism and his preliminary attempts to separate history from landscape paintings, Cole was able to build and develop an American style of "pure landscape" painting.

During that European sojourn, in which he painted the second set of *The Voyage of Life*, spiritual matters were central to Cole's thoughts. Significantly, Noble made the following entry between November 27, 1842, and December 17, 1842, in his biography of the landscape painter:

> A subject which Cole had, for some time, been revolving in his mind very prayerfully, but of which we find no record in his secret journal, was that of becoming a member of the church. The step was taken after his return from Europe, when he received baptism, and the rite of confirmation, and came to communion.[131]

This decision, however, was not predicated upon either a momentary impulse nor a dramatic conversion. It was rather the thoughtful result of an unfolding spirituality influenced as much by personal experience as by intellectual assent. Once baptized, Cole became more involved in ecclesiastical activities. The artist was elected as a Vestryman at the Annual Parish Meeting on April 18, 1843 and as such became involved in the resignation of the Rev. Mr. Phillips and his ensuing salary dispute with the vestry.[132] He was also involved in the selection of a successor to Phillips, and three different times in 1844 served as a committee of one or as a member of a committee to investigate, interview, and invite three different ministers to the call at St. Luke's.[133] Every year from 1843 to 1848, he was elected to the position of vestryman, and from 1844 to 1848, as delegate to the annual Diocese Meeting every year.[134]

The parish register contained the troublesome entry of Cole's baptism in 1844, a date at odds with the 1842 date given by Noble. The entry read "November 15, 1844. Thomas Cole, Artist. Maria Cole, wife. Sponsors, Sarah A. Noble and Miss Emily Bartow. Officiating Clergy, Louis Legrand

Noble."[135] This discrepancy of baptismal dates and their absence from the artist's personal records is troublesome. Building upon John Dillenberger's suggestion that the emergent Tractarian Movement resulted in a general "tightening-up" of Episcopal Church records, and the loss of all records at St. Luke's prior to 1844, this 1844 baptism may have been a "conditional baptism"--a rite in the Episcopal Church in those cases where a previous baptism was not recorded or was deemed to be sacramentally defective.[136] Although the destruction of the church register for 1842 would have sufficed as an unrecorded baptism. The artist's sister wrote her brother on October 23, 1844 of her concern that her own baptism by a dissenting minister was sacramentally invalid and possibly Thomas's and Maria's as well.[137] The church register for 1844 did not indicate the location of this rite which could have taken place in the family home rather than the church proper. The best explanation of Cole's two baptisms is simply that this double "conditional" baptism occurred near the date of the Coles's wedding anniversary at which time a renewal of their wedding vows was appropriate and common practice, especially if they suspected the sacramental invalidity of earlier baptisms and therefore of their marriage.[138]

Since Noble made no serious effort in either his biography of Cole or any of his other published text to argue for his own role in Cole's conversion or baptism, this "second" baptism was probably not a significant event in either Cole's or Noble's eyes, thus corresponding to Sarah's description of her own planned re-baptism. In point of fact, Noble stressed the importance of the 1842 date in his biography of Cole and of Cole's silence, in his journal entries, as to the event itself or the events leading up to it. However, a reading of Noble's letters to his friend, the artist and writer, Charles Lanman, reenforced the minister's admiration for the artist, especially for his spirituality, "Cole is a singular man in many things...He moves much in a world of his own;--meditates sublime things which once in a while, he uncovers for a moment;--looks forward to some great picture which will live in after ages, but--which there is not come of art enough to appreciate now."[139] Noble enhanced the importance of his relationship to the artist for he not only admired Thomas Cole the artist but believed that he had been helpful in the development of Thomas Cole the man of faith. The clergyman wrote to Lanman on January 24, 1845, "Cole, if he never touches pencil again cannot cease to be what he is--a poet of a very sublime cast."[140]

Cole's earlier discussions of the role of the artist, and the relationship between art and spirituality, came to fruition in "*On Frescoes: A Letter to the Churchman*" dated October 31, 1846.[141] In this letter, he revealed his extensive knowledge of the history of western Christian art and the history

of the western Christian tradition. In his response to an anonymous article, "Frescoes," the painter advocated a central and didactic role for the visual arts in Protestant Christianity as a means to both conversion and confirmation. However, that art must not be a pale reflection of earlier forms of Christianity, but rather a genuine reflection of the spiritual and cultural milieu in which it was created.[142] His fundamental position on the role and purpose of art was succinctly stated in the undated "Lecture on Art."[143]

Art for Cole was closely aligned to religion as the artist was to the preacher, therefore being an artist was a religious vocation. His understanding of the role of the artist, the purpose of art, and the relationship between art and spirituality were analogous to the views held by those artists and ministers identified as Christian Romantics. Similarly, Cole intended that his students should have a spiritual sensitivity empathetic to his own. For example, on December 16, 1847, he wrote Frederick W. Mimée, a prospective student, that religious faith was as important as artistic talent.[144]

Cole's journal entries indicated his awareness of human finitude and dependence upon God. For example, he made the following entry on Christmas Day, 1846,

> I am now sitting in my new studio, I have promised myself much enjoyment in it, and great success in the prosecution of my art. But I ought ever to bear in mind that "the night cometh, when no man can work." I pray to God that what I am permitted to accomplish here may be to his glory. If I produce fine works, I must ascribe the honour to the Giver of the gift.[145]

Two years later, the artist began his plans for a series of five paintings, *The Cross and the World*, an uncommissioned series that he never finished. Although, his vision of the American landscape as the Garden of Eden regained influenced the transformation of American art in the nineteenth century, it was the engravings of his moral and religious allegories, *The Voyage of Life* and *The Lord is Shepherd*, that retained their popularity among the American middle-class population throughout the antebellum period.

Thomas Cole's Art as Auto-American-Biography

In his essay, "Conditions and Limits of Autobiography," Georges Gusdorf indicated that autobiography was a late phenomenon in western culture developing at the time when Christianity was grafted onto the

classical tradition. Gusdorf speculated that the concept of autobiography was foreign to any culture which did not accept the basic tenets of the singularity of the individual and of the human person as a responsible agent. Autobiography was not a universal phenomenon, but one rooted in the particular cultural and anthropological system of western Christianity.[146]

It was no accident of history or geography that autobiography took root within the western Christian tradition whose position on the confession of one's sins gave a systematic and fundamental character to the process of self-examination. Spiritual autobiography was a natural outgrowth of fourth-century western Christian theology as seen in Augustine whose *Confessions* was the first spiritual autobiography. This mode of self-reflection became a normative way of recollection and brought coherence to the individual Christian's conversion and spirituality. In the earliest examples such as Augustine's, this spiritual journey was interpreted as being paradigmatic for other Christian believers. Such an autobiography was written as much for the development of a role model of the Christian life as it was for the writer's personal self-reflection and enlightenment.

Several studies in the genre of autobiography evaluated the clear link between autobiography and the American experience.[147] Such studies have shown not only the place of the autobiographical mode in American literature, but also the relationship between autobiography and the development of the American character. For example, Sacvan Bercovitch's *The Puritan Origin of the American Self* in which he defined and examined his category of "auto-American-biography" as, "the celebration of the representative self as America, and of the American self as the embodiment of a prophetic universal design."[148] In that interpretation, the autobiographer loomed larger than simply being the representative of one individual life; rather, he or she spoke to the problem of "being an American" and to a vision of "America."

Gusdorf's discussion was limited to literary examples of autobiography. He only briefly suggests the inadequacies of the visual image as a mode of autobiographical reflection, in the belief that "while the painter captures only a moment of external appearance, the autobiographer strains toward a complete and coherent expression of his entire destiny."[149] William F. Howarth attempted to align the similarities in the varied modes of autobiographical literature to those to be found in artists' self-portraits.[150] However, he concluded that the verbal mode of autobiographical discourse was the more appropriate and authentic one. Nevertheless, my reading of Thomas Cole's painting clearly suggests that the visual was a valid mode of autobiographical discourse and in particular a

significant form of what Bercovitch termed "auto-American-biography." Recognized as among the first American landscape painters, Cole stood at the beginning of a new direction in American art. He saw his landscape paintings as visual rhetoric for his interpretation of America and of America's singular destiny. He intended that his paintings would bring his fellow Americans to both this recognition of America's destiny and, ultimately, an awareness of their need for God. In every thematic presentation, Cole's paintings reflected his own spiritual journey, one which he argued was representative. Further they visualized his call for America to retreat from materialism and social decay and to return to her primary role as the Garden regained, as a land especially blessed by God and progressing under his divine guidance. His paintings may be read in the dialectical fashion of Bercovitch's "auto-American-biography" which merged the cultural with the spiritual in Cole's perceptions of the American landscape.

Thomas Cole's transfer of the rhetoric of history painting to landscape painting allowed for the further development of an indigenous American art tradition. His paintings can be separated from those by later painters from the Hudson River School and the Luminists whose fundamental interest was in the landscape as landscape, not as the symbolic environment for moral or religious teachings. Cole aided in the establishment of the visual icon that became, at least, for antebellum America, the symbol of American identity-- the virgin wilderness transformed into the Garden of Eden regained that was The American Landscape.

In act and through image, this artist developed a style of landscape painting that was empathetic to Christian Romanticism in which the magnificence and vastness of Nature was symbolic of God's presence in human history. With the American landscape as the setting for God's grace and judgment, Cole's secular landscapes contained iconographic elements that caused them to be effectively sacred. In a subliminal response to the social and cultural changes of antebellum America, these landscapes became images of domesticity and spirituality. His allegorical series, *The Voyage of Life*, which combined landscape with theological teachings, was popular with the American middle class as it promoted the spiritual domesticity central to Christian Romanticism.

Like Beecher's newspaper columns, the prints and engravings of Cole's paintings entered into the daily lives of middle-class America. This artist's otherwise personal iconography became familiar interpretations of the middle-class vision of America with the engraved illustrations published in the gift books and annuals such as Hinton's *History and Topography of the United States*; *The Home Book of the Picturesque*; and *The Token*. Imitations

of his paintings in reproductions and engravings and as the decorations on Staffordshire china resulted in popular recognition of his work. The painter's published texts including his *Essay on American Scenery*, letters to news-papers, and poetry reaffirmed his conviction of America's singular destiny as signified by the virgin landscape.

Both his vision of America and his deepening Christian Romanticism were supported by his fundamental commitment to the spiritual role of art and of the artist as a moral teacher. Thus Cole's art became more religiously motivated and morally didactic throughout his life. During his second sojourn in Rome, he confided to George Washington Greene, his plans for future works "in which nature was to tell a story of vaster import than the rise and fall of human power--the triumph of religion."[151] His overtly religious paintings such as *Expulsion from the Garden of Eden* or *The Angels Ministering to Christ* found no ready patron or market. In fact, the majority of these paintings were either retained by the artist, given to friends, or presented to museums during Cole's own lifetime. It was rather his moralizing religious art, like *The Voyage of Life* and *The Hunter's Return*, which by integrating the domestic spirituality of Christian Romanticism with the American landscape gained popularity among patrons and the public. The problematic complexity of the transformation of idea and image into visual allegory succeeded in this latter category of paintings which were closely akin to Beecher's and Bushnell's interpretation of Christian Romanticism. Like Beecher's *Norwood* or Bushnell's *Christian Nurture*, Cole's moralizing religious art was reflective of the contemporary middle-class values of this formative period in American cultural history. These paintings were visual period pieces which portrayed the transition from an American Protestant Christianity which featured ecclesiastical activities to one which advocated a Christian lifestyle and spiritual domesticity.

ENDNOTES

1. The most recent book-length study of Thomas Cole is Ellwood C. Parry's *Ambition and Imagination in the Art of Thomas Cole* (Wilmington: University of Delaware Press, 1989). The standard source for Cole's life is Louis Legrand Noble, *The Life and Works of Thomas Cole* ed. Elliott S. Vessell (Cambridge: Belknap Press of Harvard University Press, 1964 [1853]). The biographical sketch of Thomas Cole is abstracted from the following texts: Matthew Baigell, *Thomas Cole* (New York: Watson-Guptill, 1981); John Dillenberger, *The Visual Arts and Christianity in America. From the Colonial Period Through the Nineteenth-Century* (Chico: Scholars Press, 1984); William Dunlap, *History of the Rise and Progress of the Arts of Design in the United States* (New York: Dover, 1969 [1834]), Volumes I-II; Noble, *The Life and Works of Thomas Cole*; and Esther I. Seaver, *Thomas Cole, 1801-1848. One Hundred Years Later* (Hartford: Wadsworth Atheneum, 1948), Exhibition catalogue.

2. Seaver, "Introduction" in *Thomas Cole*, p. 4.

3. The Thomas Cole Papers, Archives of American Art, The Smithsonian Institution, Washington, D.C. Microfilm ALC #4, no frame number. A drawing for this latter scene was found on page twenty-two of this sketchbook.

4. The Thomas Cole Papers, Microfilm ALC #4, no frame numbers. Unfortunately, Cole's sketchbook is not fully paginated, and these sketches are scattered throughout the book.

5. Thomas Cole, "Essay on American Scenery," *American Monthly Magazine* 1 (January 1836): 1-12. This essay was reprinted in *American Art 1700-1960: Sources and Documents* ed. John W. McCoubrey (Englewood Cliffs: Prentice-Hall, 1965), pp. 98-109. I have used the text as it was reprinted in *Thomas Cole, The Collected Essays and Prose Sketches* ed. Marshall Tymn (St. Paul: John Colet Press, 1980), pp. 3-19. Cole revised this essay and re-titled it "Lecture on American Scenery" before delivering it to the Catskill Lyceum on April 1, 1841. This second version was subsequently published in *Northern Light* 1 (May 1841): 25-26. It is reprinted in Cole, *Collected Essays*, pp. 197-213.

6. Cole, *Collected Essays*, p. 3.

7. Ibid., p. 3.

8. Ibid., p. 6.

9. Ibid., p. 5.

10. Ibid., pp. 5-6.

11. Ibid., p. 4.

12. Ibid., pp. 7-8.

13. Ibid., p. 9.

14. Ibid., pp. 10-11.

15. For the basic iconography of water in Christian art, see George Ferguson, *Signs and Symbols in Christian Art* (New York: Oxford University Press, 1966 [1954]). For an additional scriptural example of the image of the river and its relationship to the rite of baptism and salvation, the reader is referred to the scriptural passage, "As the hart panteth after the water brooks, so panteth my soul after thee, O God. My soul thirsteth for God..." Psalm 42:1-2.

16. For the classic definition of the *coincidentia oppositorum* and its role in the philosophy of Nicholas of Cusa and in western Christian theology, see Mircea Eliade, *A History of Religious Ideas. Volume III: From Mohammed to the Age of the Reforms* (Chicago: University of Chicago Press, 1985), pp. 210-3. For Cole's description of the waterfall, see his *Collected Essays*, p. 11.

17. Ibid., p. 11.

18. Noble, *Thomas Cole*, p. 41.

19. See the two versions of this poem in Cole, *Complete Poetry*, pp. 67-69.

20. Cole wrote to his patron, Luman Reed on March 26, 1836:
> This throws quite a gloom over my spring anticipations. Tell this to Durand--not that I wish to give him pain, but that I want him to join with me in maledictions on all dollar-godded utilitarians.

Reprinted in *Noble, Thomas Cole*, pp. 160-1.

21. Cole, *Collected Essays*, p. 17.

22. For a discussion of the symbolic meaning of the different tree genus in nineteenth-century American landscape painting; see James Moore, "The Storm and the Harvest: The Image of Nature in Mid-Nineteenth-Century Landscape Painting," Unpublished Ph.D. dissertation, Case Western Reserve University, 1970.

23. Cole, *Collected Essays*, pp. 14-15.

24. Ibid., p. 8.

25. Ibid., p. 15.

26. Ibid., p. 16.

27. Ibid., p. 13.

28. Ibid., p. 17.

29. I am indebted to the writings of Barbara Novak on this issue; see especially her essay, "Defining Luminism" in *American Light. The Luminist Movement 1850-1875. Paintings, Drawings, Photographs* ed. John Wilmerding (Washington, D.C.: The National Gallery of Art, 1980), exhibition catalogue, pp. 23-29; and also to her discussion of "light" in Barbara Novak, *Nature and Culture. American Landscape and Painting, 1825-1875* (New York; Oxford University Press, 1980), pp. 41-43. I am also grateful to the following artists for their discussions of the different modes of artistic light: Stephen De Staebler, Isamu Noguchi, and Arthur Hall Smith. In particular, I am happy to acknowledge Professor Smith for his remarks and critique of this particular analysis of radiant light.

30. Even Novak acknowledges this problem in her essay, "Defining Luminism," in Wilmerding, *American Light*.

31. Moshe Barasch, *Light and Color in the Italian Renaissance Theory of Art* (New York: New York University Press, 1978).

32. The currently accepted definition of luminist light is found in Novak's "Defining Luminism" in Wilmerding, *American Light*; see especially under the subheading, "On Luminist Light", p. 25.

33. Ibid., p. 25.

34. I am building upon Novak's understanding of radiant light as discussed in *Nature and Culture*, pp. 40-42, and "Defining Luminism" in Wilmerding, *American Light*, esp. p. 25. See also Abraham Davidson, *The Eccentrics and Other American Visionary Painters* (New York: E.P. Dutton, 1978).

35. For the classic definition of a threshold experience, see Victor Turner, *Forest of Symbols* (Ithaca: Cornell University Press, 1977 [1967]).

36. From her public remarks at The Thomas Cole Symposium, Trinity College, Hartford, in November 1983.

37. For example, see Avery Dulles, *Revelation Theology* (New York: The Seabury Press, 1969).

38. Novak, *Nature and Culture*, p. 42.

39. On November 22, 1836, Thomas Cole was married to Maria Bartow of Catskill by the Rev. Mr. Phillips, rector of St. Luke's Episcopal Church. The wedding date of Thomas Cole and Maria Bartow is from the Bartow Family Bible. I am grateful to Edith Cole Silberstein for this information. The marriage ceremony took place at Cedar Grove, the home of her uncle, John Alexander Thomson in Catskill, which eventually became the Coles' house. The Thomas Cole House located at 218 Spring Street, Catskill, is today a museum and the location of The Thomas Cole Foundation. The basic chronology of Cole's religious life is based on the research of Ellwood C. Parry, III, who shared this information with John Dillenberger. See Dillenberger, *The Visual Arts and Christianity in America*, pp. 76-77. I have, however, supplemented that basic chronology with previously unpublished data from the Archives of St. Luke's Episcopal Church, Catskill, and the Archives of American Art.

40. See Alan P. Wallach, "The Ideal American Artist and the Dissenting Tradition: A Study of Thomas Cole's Popular Reputation." Unpublished Ph.D. dissertation, Columbia University, 1973.

41. In his journal, Cole made the following entry for May 31, 1835:

> I did not go to church to-day; perhaps I should have passed
> my time more profitably if I had [.] as Mr. Prentiss is a
> very sensible preacher. I read a little, walked & wrote & at
> times looked at the landscape.

Cole, *Collected Essays*, p. 127. A paraphrase of this passage was found in Noble, *Thomas Cole*, p. 144.

However significant or insignificant, Noble omitted any specific reference to Mr. Prentiss. Rev. Joseph Prentiss was the Rector of St. Luke's Episcopal Church, Catskill, from 1815 until his resignation on August 3, 1835. Mr. Prentiss represented more than a "very sensible preacher" to Cole who was more than an occasional churchgoer. Cole added the following postscript to his letter of approximately January 14, 1836 to Luman Reed:

> Before the Snow Storm the roads were in a very
> treacherous state, and an accident happened a few days ago
> which has deeply affected our family. I mean in the death
> of the Rev. Mr. Prentiss who was killed instantaneously by
> the upsetting of the stage between Athens and Coxsackie.
> A few evenings previous he spent with us in health and
> spirits.

See Appendix I, No. 12, of Ellwood C. Parry, III, "Thomas Cole's *The Course of Empire*: A Study in Serial Imagery." Unpublished Ph.D. dissertation, Yale University, 1970; p. 156. Note that this letter is identified as "probably of January 14th, 1836." The original is noted as being among The Thomas Cole Papers, The New York State Library, Albany. Parts of this correspondence have been paraphrased in Noble, *Thomas Cole*. The

microfilmed letter is in The Thomas Cole Papers, Roll ALC-#2. The date of January 14, 1836, is more likely than not correct. The records of St. Luke's Episcopal Church indicate that the Rev. Mr. Prentiss was killed in Coxsackie on January 7, 1836. *See Old St. Luke's--A Reminiscent Address by the Reverend Robert Weeks*, June 4, 1899; pamphlet printed by St. Luke's Episcopal Church, 1899; p. 8. The only copy of this pamphlet that I was able to locate was in the collection of The Greene County Historical Society, Coxsackie.

42. Noble, *Thomas Cole*, p. 167.

43. The most detailed study of the patronage, history, and art historical precedents of *The Course of Empire* is found in Parry, "Thomas Cole's 'The Course of Empire': A Study in Serial Imagery." For the life and collection of Luman Reed, see Wayne Craven, "Luman Reed, Patron: His Collection and Gallery," *American Art Journal* 12.2 (1980); 40-59; and Miller, *Patrons and Patriotism*, pp. 151-5. For a discussion of Reed's first visit to Cole's studio, see Noble, *Thomas Cole*, p. 175.

44. Cole wrote:
> A series of pictures might be painted that should illustrate the History of a natural scene as well as be an Epitome of Man, showing the natural changes of Landscape + those affected by man in his progress from Barbarism to Civilization, to Luxury, to the Vicious state or state of destruction, and to the state of Ruin + Desolation.

Thomas Cole to Luman Reed, letter dated September 18, 1833. The Thomas Cole Papers, Microfilm ALC-#2, no frame number.

45. Theodore Allen to Thomas Cole, letter dated December 27, 1836. The Thomas Cole Papers, Microfilm ALC-#2, no frame number. For some inexplicable reason and contrary to all other evidence, Thomas S. Cummings reported that the exhibition was neither a financial or critical success. Thomas S. Cummings, *Historic Annals of the National Academy of Design from 1825 to the Present Time* (Philadelphia: George W. Childs, 1865), p. 142.

46. Eventually, Reed's widow sold his collection as a whole unit in 1844 to a corporation which had been formed to establish the city's first public art museum. The New-York Gallery of Fine Arts, as the corporation was then known, operated as a separate entity from 1844 to 1857 when it became the foundation for the collection of American art of The New-York Historical Society where *The Course of Empire* takes pride of exhibition space in The Thomas Cole Gallery.

47. The Thomas Cole Papers, Microfilm ALC-#3, no frame number.

48. As cited in Ella M. Foshay and Sally Mills, *All Seasons and Every Light. Nineteenth Century American Landscapes from the Collection of Elias Lyman Magoon.* (Poughkeepsie: Vassar College Art Gallery, 1983), Exhibition catalogue; p. 70.
> The Muse, disgusted at an Age and Clime,
> Barren of every glorious Theme,
> In distant Lands now waits a better Time
> Producing subjects worthy Fame:...
> Westward the Course of Empire takes its Way;
> The four first Acts already past,
> A fifth shall close the Drama with the Day;
> Time's noblest Offspring is the last.

This poem was originally published in George Berkeley, *VERSES by the AUTHOR, on the Prospect of planting ARTS and LEARNING in America* (1752); and reprinted in A.A. Luce, *The Life of George Berkeley, Bishop of Cloyne* (New York: Thomas Nelson and Sons, Ltd., 1949), p. 97.

49. Genesis 6:1-8:14.

50. Genesis 8:6-13.

51. Baigell, *Thomas Cole*, p. 54.

52. Cole, *Collected Essays*, p. 5.

53. Ibid., p. 5.

54. For passages on the sacrality of the mountain, see Genesis 18:5; Genesis 19:17; Genesis 22:14; Exodus 3:1; Exodus 3:12; Exodus 4:27; Exodus 24:13; I Kings 19:8; I Kings 19:11-12; Psalm 11:1; Psalm 36:6; Psalm 68:26; I Isaiah 2:2-3; Ezekiel 28:14; Micah 4:1; Matthew 4; Matthew 5-7; Matthew 17; Mark 1:13; Mark 9:2; Luke 4; Luke 6:20ff; Luke 9:29; and John 1:14. As an example of Cole's knowledge of the Judeo-Christian Scriptures, consider the visual-verbal relationships between his *Expulsion: Moonlight and Fire* (1828: Thyssen-Bornemisza Collection, Lugano) and I Kings 19:11-12, "And he said, Go forth, and stand upon the mount before the Lord. And, behold, the Lord passed by, and a great and strong wind rent the mountains, and brake in pieces the rocks before the Lord; but the Lord was not in the wind: and after the wind an earthquake; but the Lord was not in the earthquake: And after the earth quake a fire; but the Lord was not in the fire: and after the fire a still small voice."

55. The obscurity and/or accuracy of which distinguished Cole's work from that of many of his contemporaries.

56. Cole, *Thomas Cole's Poetry*, p. 49.

57. Eliade's interpretation of the symbolism of the center and the *axis mundi* is found in Mircea Eliade, *Images and Symbols: Studies in Religious Symbolism* (New York: Harper and Row, 1961); see especially Chapter I. His recapitulations and summaries of this discussion can be found in either Mircea Eliade, *Cosmos and History; The Myth of the Eternal Return* (Princeton: Princeton University Press, Bollingen Series #46, 1971 [1954]), pp. 12-13, 16-17; or idem., *The Sacred and the Profane* (New York: Harcourt, Brace, Jovanovich, 1959 [1957]), pp. 37-41, 173.

58. Eliade, *Cosmos and History*, p. 12.

59. In *Symbolism, A Comprehensive Dictionary* (Jefferson/London: McFarland & Company, 1986), p. 90; Steven Orderr indicated that the mountain symbolized loftiness of spirit; spiritual elevation; the connection between heaven and earth; realm of meditation; communion with the spirit, deities, wisdom; solitariness; resurrection; world axis; freedom; peace; and majesty. The mountain peak signified meditation, achievement, victory, and oneness.

60. Craig S. Harbison, *The Last Judgement in Sixteenth-Century Northern Europe. A Study of the Relation Between Art and the Reformation* (New York: Garland Press, 1976). See also Jane Dillenberger, *Style and Content in Christian Art* (New York: Crossroad Publishing, 1986 [1966]); and Ferguson, *Signs and Symbols in Christian Art*.

61. At the symposium, "American Paradise: Aspects of the Hudson River School Painting," Ellwood C. Parry, III, presented his own understanding of Cole's adaptation of the traditional Christian iconography of the Last Judgment in relation to Cole's unfinished last series, *The Cross and the World*. I am grateful to Dr. Parry for sharing his unpublished manuscript, "The Road Not Taken: Thomas Cole's Last Series and It's Implications."

62. Cole, *Collected Essays*, p. 9.

63. Gayle L. Smith, "Emerson and the Luminist Painters: A Study of their Styles," *American Quarterly*, Volume 37.2 (Summer 1985): 193-215.

64. Cole, *Collected Essays*, p. 5.

65. Cole, *Complete Poetry*, pp. 67-69. For discussions of the iconography of the tree stump and of trees in nineteenth-century American painting, see Nicolai Cikovski, Jr., "'The Ravages of the Axe': The Meaning of the Tree Stump in Nineteenth-Century American Art," *The Art Bulletin*, 61.4 (1979): 611-26; Moore, "The Storm and the Harvest; and Novak, *Nature and Culture*, pp. 157-202.

66. Cole, *Collected Essays*, p. 8.

67. Ibid., p. 17.

68. Davidson, *The Eccentrics and Other American Visionary Painters*, pp. 17-28.

69. Cole, *Collected Essays*, p. 109.

70. Given both the fame of Albrecht Dürer and of his print, and Cole's extensive knowledge of western Christian art, it is likely that Cole would have been familiar with a reproduction of the print. Unfortunately, there is no catalogued list of Cole's personal collection of prints and engravings in either the Thomas Cole Estate Inventory or the Thomas Cole House Auction Inventory.

71. Other Cole paintings in this category included: *Home in the Woods* (1839: Reynolda House, Winston-Salem); *The Pic-Nic* (1846: Brooklyn Museum of Art, Brooklyn); *Early Morning in the Catskills* (1838: The Metropolitan Museum of Art, New York); *Seigneur's Farewell* (1838: Collection of Charles Sarnoff); and other engravings in Hinton's *History and Topography of the United States.*
　　See also Ellwood C. Parry, III, "Thomas Cole's *The Hunter Return*," *American Art Journal* 17.3 (1985): 3-17, see esp. 3, 10-15.

72. Tuckerman, *Artist-Life*, pp. 119-20. This chapter was reprinted in Henry T. Tuckerman, *Book of the Artists; American Artist Life* (New York: D. Appleton and Company, 1867).

73. George F. Allen to Thomas Cole, letter dated November 3, 1845. The Thomas Cole Papers, Microfilm ALC-#2, no frame number.

74. Note Cole-Gilmor correspondence. See also Parry, "*The Hunter's Return*," for a compatible interpretation to the one suggested in this text.

75. See for example, Catherine Esther Beecher and Harriet Beecher Stowe, *The American Woman's Home, Or Principles of Domestic Science* (New York: J.B. Ford, 1869).

76. Other paintings by Cole which fell into this category were *The Expulsion from the Garden of Eden*; *Expulsion: Moonlight and Fire*; *The Angels Ministering to Christ*; *The Vesper Hymn, An Italian Twilight*; *Tower Landscape*; and *Cross at Sunset.*

77. This inscription reads, "The Cross in the Wilderness from a poem by Mrs. Hemans."
　　Felicia Dorothea Browne Hemans (1793-1835) was a British romantic poet of considerable renown in her day, both in her native England and America. From all reports, Mrs. Hemans' poetry attracted an audience similar to that of Mrs. Lydia Sigourney. A close friend of Shelley, Wordsworth, and Byron, Mrs. Hemans published twenty-seven single volumes of poetry and a collection of seven volumes. The themes of her poetry are appropriate to this analysis: children's verses; romantic accounts of nature; hymns; cross-centered contemplation; domestic piety; feminine spirituality; and Christian nurture. Given both the reputed popularity and the themes of Mrs. Hemans' poetry, Cole's

attraction to her work and his visualization of it is obviously grounded in his Christian Romanticism.

This was not the only painting of Cole's inspired by Mrs. Hemans' poetry; Parry acknowledged at least one other painting, *The Vesper Hymn, an Italian Twilight* (1841: Yale University Art Gallery, New Haven), as being influenced by Mrs. Hemans' poetry; see Parry, "Thomas Cole's 'Course of Empire'," p. 210. Although not noted by Parry, this painting would also be classified within the genre of religious landscape, and the iconography of the painting would argue for a Christian Romantic sensibility. In a footnote, Bruce Chambers acknowledged Howard Merritt's suggestion of Hemans's influence on Cole's paintings; see Bruce Chambers, "Thomas Cole and the Ruined Tower," *The Currier Gallery of Art* (Manchester, New Hampshire, 1983): 30.

Tuckerman, *Artist-Life*, p. 120. Cole himself acknowledged the "experimental" technique to this painting in a letter to his friend and fellow artist, Henry Cheever Pratt. Thomas Cole to Henry Cheever Pratt, letter dated December 28, 184[5]. As quoted in Parry, "*The Hunter's Return*," p. 16.

> I have lately painted a small one, the Subject from Mrs. [Felicia] Hemans poem of the Cross in the Wilderness. I believe it is one of my happiest [most successful] productions. It is a circular picture + though painted in <u>defiance</u> of one of the famous rules of Art viz. that the light should never be exactly in the middle of a picture. I think that it is likely to please as <u>being original</u>.

Parry acknowledges this letter as part of a series of newly discovered letters from Cole to Pratt dating from the mid-1840's, and now in the possession of The Thomas Cole Foundation. I am grateful to Donelson Hoopes, Director, The Thomas Cole Foundation, for making a photocopy of both the original letter and the typescript prepared by Parry available to me.

78. In her catalogue entry for Cole's *Cross at Sunset* (1848: Thyssen-Bornemisza Collection, Lugano), Katharine Manthorne noted the relationship between that painting and Cole's poem, "The Cross," as well as the sketches in his 1827 sketchbook. However, Manthorne connected all of these works to Cole's religious life under the spiritual guidance of Rev. Louis Legrand Noble. See *Nineteenth-century American Painting. The Thyssen-Bornemisza Collection* ed. Barbara Novak (New York: Sotheby's Publications, 1986), pp. 66-69.

79. Thomas Cole, *Thomas Cole's Poetry* ed. Marshall C. Tymn (York: Liberty Cap Books, 1972), pp. 34-35.

80. Ibid., p. 35.

81. Ibid., p. 167.

82. Ibid., p. 167.

83. Ibid., p. 167.

84. *History of St. Luke's Parish, Number #15*, third paragraph of entry dated March 6, 1840. Reverend Jonathan MacKenzie, Rector of St. Luke's Episcopal Church, Catskill, made a scrapbook of the *History of St. Luke's Parish* dating from 1803 available to me during my visit on August 19, 1987. This scrapbook which Rev. MacKenzie had recently located is the only extant church record for the years 1803-1844. Unfortunately, these documents only record the notices and minutes for the meetings of the vestry and do not include the statistical records of baptisms, confirmations, membership, marriages, or burials.

85. *History of St. Luke's Parish, Number #16*, May 25, 1860. Third paragraph in this entry.

86. From the description of Walton Van Loan as reported in Weeks, *A Reminiscent Address*, p. 4. Unfortunately, this window was destroyed during some expansion of the side galleries and chancel recess under the rectorship of Reverend Thomas Rickey. The Rev. Mr. Rickey was Rector of St. Luke's from 1854 to 1858; see Weeks, *A Reminiscent Address*, pp. 4-5.

The church Cole designed was located on Church Street. Today that building houses the local newspaper office, *The Daily Mail*. The last sermon preached in "Old St. Luke's" was by the Reverend Thomas Cole, Jr., who "stated his view that it had stood for order, for beauty, and for inspiration of life;" see Weeks, *A Reminiscent Address*, p. 4. Rev. Cole was the son born to Maria Cole in September 1848 after his father's premature death in February of the same year. Rev. Cole was rector at the Episcopal Church in Saugerties, New York. There is a record of his baptism at St. Luke's by Reverend Louis Legrand Noble on October 30, 1849. His baptismal sponsors were Mr. and Mrs. Noble, and Sarah Cole.

The new St. Luke's Episcopal Church is located at 50 William Street. There is a memorial window to Thomas and Maria Cole over the altar and two works of work associated with Cole were presented to the church by his granddaughter, Florence Cole Vincent in 1962. One of these works is an engraving owned by Cole. The other a preparatory sketch on the theme of "The Cross and The World" was re-attributed by J. Gray Sweeney to Benjamin B.G. Stone. For Sweeney's re-attribution of this painting, see J. Gray Sweeney, "'Endued with Rare Genius' *Frederic Edwin Church's* To the Memory of Cole," *Smithsonian Studies in American Art* 2.1 (1988): 45-72, esp. 58-59.

However, Mrs. Vincent believed in the work's authenticity as a Cole when she presented it to the church. My brief and preliminary study of this preparatory sketch and its iconographic and visual relationship to several finished Cole paintings such as *The Cross in the Wilderness* (1845: Louvre, Paris) and *Cross at Sunset* (1848: Thyssen-Bornemisza Collection, Lugano) as well as to a series of sketches in Cole's sketchbook of 1827 makes me hesitate to accept Sweeney's re-attribution.

87. For example, a letter simply dated Friday, the 4th from Phillips to Cole, requested the artist's presence as a baptismal sponsor for a young Mr. Olmstead in a ceremony which was scheduled to take place at five o'clock that afternoon at the Methodist Church, which was where the congregation of St. Luke's worshipped until the new church was built (September 1839 to August 1841). The Thomas Cole Papers, Roll #ALC-3, no frame number.

88. *History of St. Luke's Parish, Number #17*, September 22, 1840; second paragraph.

89. The genesis of the series, its patronage, and the "mystery" of the second set have been carefully documented in Edward H. Dwight and Richard J. Boyle, "Rediscovery: Thomas Cole's 'Voyage of Life'," *Art in America* 55 (1967): 60-63. These four paintings have also been interpreted in terms of their relationship to the development of aesthetic taste in America; to the development of Cole's religious life; to the discovery of the "lost" second set; to American cultural history; to Coleridge's poetry; and to the history of James Smillie's engravings of *The Voyage of Life*. The most complete history of both sets of Cole's *The Voyage of Life* is found in Paul D. Schweizer, *The Voyage of Life by Thomas Cole. Paintings, Drawings and Prints*. Utica: Munson-Williams-Proctor Institute, 1985, exhibition catalogue. On the relationship of *The Voyage of Life* to the development of an American aesthetic, see Earl A. Powell, III, "Thomas Cole and the American Landscape Tradition: The Naturalist Controversy," *Arts* 52.6 (1978): 114-23; idem., "Thomas Cole and the American Landscape Tradition: The Picturesque," *ARTS* 52.7 (1978): 110-7; and idem., "Thomas Cole and the American Landscape Tradition: Associationism," *Arts* 52.8 (1978): 113-7. The relationship between *The Voyage of Life* and Cole's religious life is discussed in Allan Wallach, "Thomas Cole: British Esthetics and American Scenery," *Artforum* 8 (October 1969): 46-49; idem., "Cole, Byron and The Course of Empire;" and idem., "The Ideal American Artist and the Dissenting Tradition."

The relationship between Cole's series and Coleridge's poetry is examined in Rena M. Coen, "Cole, Coleridge and Kubla Khan," *Art History* 3.2 (1980): 218-28. For the most recent article on the history and rediscovery of the "lost set" of *The Voyage of Life*, see Dwight and Boyle, "Rediscovery." For the fuller discussions of *The Voyage of Life* in American cultural history, see Doug Adams, "Environmental Concern and Ironic Views of American Expansionism in Thomas Cole's Religious Paintings" in *Cry of the Environment, Rebuilding the Christian Creation Tradition* eds. Philip N. Joranson and Ken Butigan (Santa Fe: Bear Publishing, 1984), pp. 296-305; and Joy S. Kasson, "*The Voyage of Life*: Thomas Cole and Romantic Disillusionment," *American Quarterly* 27.1 (1975): 42-56. The most complete discussion of James Smillie's engravings of this series is found in Paul D. Schweizer, "'So exquisite a transcript': James Smillie's Engravings after Thomas Cole's *Voyage of Life*," *Imprint* 11.2 (1986): 2-13; and 12.1 (1987): 13-24. See also Adams, "Environmental Concern and Ironic Views of American Expansionism in Thomas Cole's Religious Paintings."

My primary study of the Cole series has been specifically in terms of the second set of the series which Cole painted in Rome in 1841-2, and which currently belongs to the National Gallery of Art, Washington, D.C. This version of the series was not painted for any particular patron but by Cole to fulfill his own purposes for the series. During the course of my research I was able to consider this series in two other museum settings at the Museum of Fine Arts, Boston, in November 1983, and at the Corcoran Gallery of Art, Washington, D.C. in December 1983.

90. The Thomas Cole Papers, Microfilm #ALC-3, Box #5, Folio #3, no frame numbers. In his journal entry for March 24, 1837, the artist wrote,

> I have received a noble commission from Mr. Samuel Ward, to paint a series of pictures, the plan of which I conceived several years since, entitled, *The Voyage of Life*. I sincerely hope that I shall be able to execute the work in a manner worthy of Mr. Ward's liberality, and honourable to myself. The subject is an allegorical one, but perfectly intelligible, and, I think, capable of making a strong moral and religious impression.

Noble, *Thomas Cole*, p. 203.

The general plane for this four-part series is fulfilled in *The Voyage of Life* with the exception of the moralizing inscriptions intended for the frame of each painting. It is likely that the final title for the series, *The Voyage of Life*, was adapted from the intended inscription for the fourth painting, "Pass on ye Voyager of Life's wild stream." Despite this earlier design, the two sets of *The Voyage of Life* were dependent upon Cole's Christian Romanticism for their actual presentations.

91. For a first hand discussion of Ward's commission for this series, see Julia Ward Howe, *Reminiscences, 1819-1899* (New York: Houghton-Mifflin, 1899).

92. This situation is fully documented in Howe, *Reminiscences*; and further evidence for this situation can be found in Noble, *Thomas Cole*. Correspondence between Cole and Ward's heirs can be found in The Thomas Cole Papers, ALC #2, no frame numbers. In Cole's letters, reference is made to a "replica set" he would offer the Ward family in exchange for the original paintings and the right to publicly exhibit them for profit. During my research visit to The Thomas Cole House in Catskill, I found a full size replica set of *The Voyage of Life* on display. This set credited to De Witt Clinton Boutelle (1820-1884) is on loan to The Thomas Cole Foundation from a private collection. This set duplicates the original Ward set in the collection of The Munson-Williams-Proctor Institute, Utica. In conversation with Donelson Hoopes, Director, The Thomas Cole Foundation, he indicated that infrared examination of these paintings indicates that they are not blocked in the manner appropriate to a copy. Rather, the infrared revealed drawings underneath the painted surfaces. Hoopes is convinced that Cole began this

"third" set of *The Voyage of Life*, and most likely painted in the sky in at least two of the paintings. The inventory of Cole's estate on file at the Surrogate Court, Greene County Courthouse, Catskill, lists "four large unfinished paintings." Hoopes suggested that these unfinished canvases were completed by Boutelle at the request of Mrs. Cole in 1852 to serve as the copy set for the engravings the Rev. Abbot had intended originally be prepared in Europe (see Gorham D. Abbot, *The Voyage of Life. A Series of Allegorical Pictures, Entitled "Childhood," "Youth," "Manhood," and "Old Age," Painted by the Late Lamented Thomas Cole, of Catskill, New York, Engraved in the Highest Style of Art by James Smillie, of New York* [New York: The [Spingler] Institute, 1856], p. 3). It is possible that these paintings are the replica set left unfinished on Cole's departure for Europe in 1841. For an alternative interpretation of this version of the series of *The Voyage of Life* painted by De Witt Clinton Boutelle, see Schweizer, *Thomas Cole's The Voyage of Life*, and idem., "'So exquisite a transcript,'" II.

93. Adams, "Environmental Concern and Ironic Views of American Expansionism in Thomas Cole's Religious Paintings," pp. 298-9.

94. Minutes of the American Art-Union, Committee of Management, June 1, 1848, p. 160. The New-York Historical Society, New York.

95. The Spingler Institute was a seminary for young women in New York City. The financial success of Cole's series, that is through the sale of Smillie's engravings, supported the cause of female education. In *The Historic Annals of The National Academy of Design*, Thomas S. Cummings advised that:

> In December of 1847 or 1848 the series was distributed, and fell by lot to a Mr. J. F. Brodt, of Binghampton, from whom they were purchased by the Rev. Gorham D. Abbott [sic], and placed in the gallery of the Spingler Institute, his splendid school, then in the building on the corner of Thirty-fourth Street and Fifth Avenue. The gallery of that, one of the first educational institutes in the country for young ladies, was free, and formed a distinctive feature of attraction in the establishment. (p. 177).

96. Abbot, *The Voyage of Life*, p. 3.

97. As cited in Abbot, *The Voyage of Life*, p. 8.

98. Ibid., p. 8.

99. Ibid., pp. 3-4.

100. Ibid., p. 9.

101. Jared Bell Waterbury, *The Voyage of Life, Suggested by Cole's Celebrated Allegorical Paintings* (Boston: Massachusetts Sabbath School Society, 1852), p. iii. Rev. Waterbury (1799-1876) was a popular writer of advice manuals. He was a graduate of Yale College (1822) and Princeton Theological Seminary (1824). He served the Congregational Church, Hatfield, Mass. (1826-1829); the Presbyterian Churches of Portsmouth, N.H., (1829-1832), and Hudson, N.Y., (1833-1846); Bowdoin Street Congregational Church, Boston, Ma. (1846-1857); and Central Church, Brooklyn, N.Y. (1859). He served as city missionary in Brooklyn until his death. His most popular advice manuals were *Advice to Young Christians* (1827) and *The Voyage of Life* (1852).

102. Noble, *Thomas Cole*, p. 27.

103. For example, see Psalms 36, 42, and 46; John 7; and Revelations 22. On the baptism of Jesus of Nazareth, see Matthew 3:13-17; Mark 1:9-11; and Luke 3:21-23. For the basic

visual symbolism of water and of river in Christian art, see Ferguson, *Signs and Symbols in Christian Art.*

104. For visual examples contemporary to Cole see: Washington Allston, *Rising of a Thunderstorm at Sea* (1804); Thomas Doughty, *The Raft* (1830); Theodore Gericault, *The Raft of the Medusa* (1818-1819), and Caspar David Friedrich, *The Polar Sea* (1822). For an analysis of this imagery in Romantic painting and poetry, see either Gerald Eager, "The Iconography of the Boat in 19th-Century American Painting," Art Journal 35.3 (1976): 224-30; or Lorenz Eitner, "The Open Window and the Storm-Tossed Boat: An Essay in the Iconography of Romanticism," *Art Bulletin* 37.4 (1955): 281-90.

105. For a fuller discussion of Cole's *Expulsion from the Garden of Eden* from the perspective of psycho-literary criticism, see Bryan Jay Wolf, *Romantic Re-Vision: Culture and Consciousness in Nineteenth-Century American Painting and Literature* (Chicago: University of Chicago Press, 1982), pp. 81-106.

106. These visual motifs were not singular to Cole but were present in nineteenth-century landscape paintings including those of Caspar David Friedrich. Friedrich was also a painter of radiant light, and his theological leanings identified him as a Christian Romantic. Recent research has yielded new evidence and documentation of Friedrich's connection to Friedrich Schleiermacher. The Cole-Friedrich connection has been discussed by several art historians including Rena Coen, Barbara Novak, and Robert Rosenblum. See "Appendix A," "Christian Romanticism in the Paintings of Caspar David Friedrich," to this text for a discussion of the affinities between Cole and Friedrich.

107. See Coen, "Cole, Coleridge and Kubla Khan," 218-28, for a helpful discussion of this image and its relationship to Coleridge's vision of the pleasure palace in his poem.

108. See Adams, "Environmental Concern and Ironic Views of American Expansionism Portrayed in Thomas Cole's Religious Paintings," esp. pp. 297-9 for an interesting analysis of the theological and cultural implications of the river in *Youth*.

109. For example, see any of the aforementioned or bibliographical citations on *The Voyage of Life.*

110. Wolf, *Romantic Re-Vision*, pp. xiii-xviii; and Adams, "Environmental Concern."

111. Cole, "Essay on the American Scenery," *Collected Essays*, p. 17.

112. See Coen, "Cole, Coleridge and Kubla Khan," p. 225.

113. The major distinction between the two versions of *The Voyage of Life* is the position of the voyager in *Manhood*. In the first set, the voyager stands in the boat; while in the second set, the voyager is in a kneeling position. The distinction between these two postures may signify the difference in Cole's own spirituality.

114. Horace Bushnell, *Views of Christian Nurture*, p. 15.

115. Cole, *Collected Essays*, p. 134.

116. Noble, *Thomas Cole*, p. 186.

117. The Thomas Cole Papers, Microfilm #ALC-3, Box 5, Folio #3, no frame numbers.

118. In her essay, "Cole, Coleridge and Kubla Khan," Rena N. Coen extended the factual evidence which attested to Coleridge's influence on Cole who actually paraphrased and parodied Coleridge's poems in his own verses. Coen argued persuasively that Coleridge's poetry inspired much of the imagery present in *The Voyage of Life*, especially in the second painting of the series, *Youth*.

119. Samuel Taylor Coleridge, *Biographia Literaria*, p. 304.

120. This text probably dates after 1842 as a handwritten entry to "Thoughts and Occurrences" dated November 27, 1842, appears to be the rough draft of this larger essay.

121. Cole, *Collected Essays*, pp. 103-4; 171. The handwritten originals and the preparatory notes are located in The Thomas Cole Papers.

122. *Thomas Cole, N.A.* (New York: Kennedy Galleries, Inc., 1964), exhibition catalogue.

123. For example, Bryan Jay Wolf discussed the influence of John Milton on Cole's *The Expulsion from the Garden of Eden* and other paintings; see Wolf, *Romantic Re-Vision*, esp. pp. 81-106; Alan Wallach suggested the relationship between the poetry of George Gordon Lord Byron and Cole, see Alan Wallach, "Cole, Byron and the Course of Empire," *Art Bulletin*, 50.4 (1968): 375-9; and Rena M. Coen argued for the connection to Coleridge, see Coen, "Cole, Coleridge and Kubla Khan."

124. William A. Gerdts, "Washington Allston and the German Romantic Classicists in Rome," *The Art Quarterly*, 32.2 (1969): 167-96. In his letter of May 26, 1835, Luman Reed wrote Cole to request a letter of introduction for himself and Durand to Allston. Letter from Luman Reed to Thomas Cole, dated May 26, 1835. The Thomas Cole Papers, Microfilm ALC-#2; no frame number. See also Appendix I, No. 3 to Parry, "*The Course of Empire*," p. 147. On June 16, 1835, Reed gratefully acknowledged the receipt of these letters and reported about his and Durand's meeting with the Cambridge artist. Letter from Luman Reed to Thomas Cole, dated June 16, 1835. The Thomas Cole Papers, Microfilm ALC-#2, no frame number. See also Appendix I, No. 4 to Parry, "*The Course of Empire*," p. 148. The fact that Reed requested a letter of introduction to Allston from Cole indicated that the contact between the two artists was more extensive than has been recognized or attested by any extant documentation.

125. Thomas Cole, *Collected Essays*, p. 174. The edited version is found in Noble, *Thomas Cole*, p. 262.

126. Cole, *Collected Essays*, pp. 174-5. N.B. Noble edited this section from this version of this text, see Noble, *Thomas Cole*, pp. 262-3.

127. Cole, *Collected Essays*, p. 175; see also Noble, *Thomas Cole*, p. 263.

128. Cole, *Collected Essays*, pp. 173-4.

129. Cole, *Complete Poetry*, pp. 83-87; 92; and 172 respectively.

130. Ibid., p. 140.

131. Noble, *Thomas Cole*, p. 252.

132. *History of St. Luke's Parish, Number #20*, April 18, 1843, second paragraph. Cole was absent from the Vestry Meetings of January 19, January 20, and January 22, 1844, when Phillips's resignation was read and accepted, and a subscription was initiated to raise the funds necessary to settle payments to Phillips. Nevertheless, Phillips's letter of July 8, 1845 to Cole indicates that eighteen months after Phillips's departure, the salary dispute remained unresolved. In this letter, Phillips stated that he would accept Cole's negotiated settlement for one-half the disputed amount ($600) and enclosed a receipt for $300 and a release of any further claim against St. Luke's. *History of St. Luke's Parish, Numbers ##20 and 21*; January 19, January 20, and January 22, 1844. The Thomas Cole Papers, Microfilm #ALC-2, no frame number.

133. See the appropriate numbers of *History of St. Luke's Parish* for April 1, 1844 (Rev. Mr. William H. Walter was highly recommended to Cole at this meeting); May 29, 1844 (Rev. Mr. Liburtus Van Bokkelen invited); and July __, 1844 (call and acceptance of Rev. Mr. Louis Legrand Noble).

134. See the appropriate numbers for the Annual Church meetings for 1843 to 1847 of the *History of St. Luke's Parish*. Also, there is a letter from Noble dated August 8, 1845 inviting Cole to attend the next Meeting of the Wardens, Vestry of St. Luke's. This letter is among The Thomas Cole Papers, Microfilm #ALC-2, no frame number.

135. Parish Register, St. Luke's Episcopal Church, Catskill; np. This entry is troublesome for several reasons: Noble's discussion of Cole's baptism in 1842; Cole's active involvement with St. Luke's in a series of varied but responsible capacities since 1839 (although the more responsible and public activities date from 1844); the lack of any entry in Cole's journal, notebooks, or letters concerning his own baptism (either in 1842 or 1844); and Maria Cole's life-long residency in Catskill and family membership at St. Luke's. The interpretative problems focus on the exact nature of Noble's relationship with Cole and the significance of this event in Cole's life.

136. See Dillenberger, *The Visual Arts and Christianity in America*, pp. 76-77. The parish records of St. Luke's were twice destroyed by fire in 1839 and 1844 respectively. The first fire destroyed the church building and all its contents. The second fire was at the home of the Rev. Mr. Phillips who after his resignation had taken the register with him to complete and update all his entries. See Weeks, *A Reminiscent Address*, pp. 9-10.

I am grateful to the Rev. Mr. Jonathan MacKenzie, Rector of St. Luke's Episcopal Church, for his helpful discussion of this puzzle during my visit to St. Luke's on August 19, 1987. I am also grateful to John Dillenberger and Dewey Wallace for their roles as devil's advocates during my investigations.

137. Sarah Cole to Thomas Cole, letter dated October 23, 1844, Thomas Cole Papers, ALC #2.

138. See the letter from Sarah Cole as to theological ramifications of an invalid baptism upon other sacramental rites.

139. Louis Legrand Noble to Charles Lanman, letter dated December 11, 1844. Charles Lanman Papers, The New-York Historical Society, New York.

140. Louis Legrand Noble to Charles Lanman, letter dated January 24, 1845. Charles Lanman Papers, The New-York Historical Society, New York.

141. Cole, *Collected Essays*, pp. 64-69. This letter was originally published in the *Churchman*, 31 October 1846, p. 138.

142. Cole, *Collected Essays*, p. 67.

143. Ibid., pp. 103-20. "A Lecture on Art" was evidently prepared for delivery before the National Academy of Design in New York, although there is no record of its presentation.

144. Cole wrote:
> I took the liberty of asking Mr. Smith [Mimee's former painting instructor] as to your religious sentiments, but he did not answer. This is a matter on which I hesitate to speak, but you will excuse the desire that I have, that one with whom I may have intimate intercourse should not be strongly at variance with myself who am of the Protestant Episcopal Church.

The Thomas Cole Papers, Microfilm ALC-#3, no frame number. This letter is also cited by Dillenberger, *The Visual Arts and Christianity in America*, pp. 190-1.

145. Noble, *Thomas Cole*, p. 281.

146. Georges Gusdorf, "Conditions and Limits of Autobiography" in *Autobiography: Essays Theoretical and Critical* ed. James Olney (Princeton: Princeton University Press, 1980): pp. 28-48. This essay originally appeared as "Conditions et limites de

l'autobiographie" in *Formen der Selbstdarstellung: Analekten zu einer Geschichte des literarischen Selbstportraits* ed. Gunther Ruchenkron and Erich Haase (West Germany: Duncker and Humblot, 1956).

147. See for example, Robert F. Sayre, "Autobiography and the Making of America" in *Autobiography: Essays Theoretical and Critical*, pp. 146-68; Robert F. Sayre, "The Proper Study--Autobiographies in American Studies," *American Quarterly* 29 (1977): 241-62; and Albert E. Stone, "Autobiography and American Culture," *American Studies: An International Newsletter* 11 (1972): 22-36.

148. Bercovitch, *The Puritan Origins of the American Self*, p. 136.

149. Gusdorf, "Conditions and Limits of Autobiography," p. 35.

150. William L. Howarth, "Some Principles of Autobiography" in *Autobiography: Essays Theoretical and Critical*, pp. 84-122. This essay originally appeared in *New Literary History* 5 (1974): 363-81.

151. George Washington Greene, "Cole" in *Biographical Studies* (New York: G.P. Putnam, 1860); pp. 105-10; as cited by Chambers, "Thomas Cole and the Ruined Tower," p. 22.

CHAPTER V

The Return to the Wilderness:
Frederic Edwin Church and the Transformation
of the American Landscape

Throughout his life, Frederic Edwin Church maintained a regular and public affiliation with ecclesiastical institutions, and numbered ministers among his closest friends.[1] Charles Dudley Warner reported that the young Frederic "followed the Trinitarian Congregational worship of his parents."[2] In Hartford, he attended the Central Congregational Church with whose minister, the Reverend Dr. Joel Hawes, he formed a friendly association.[3] Similar in format and theme to Beecher's later volume, Hawes' *Lectures to Young Men* signified an attempt to infuse all aspects of daily life with Christian virtues. During his tenure as Thomas Cole's student in Catskill, the young painter began a lifelong friendship with the Reverend Mr. Louis Legrand Noble who was both Cole's minister and biographer. This lifelong association with Noble encouraged him in his artistic fusion of the landscape with Christian Romanticism while the minister's original interest in the young artist probably evolved out of his admiration for Cole. Like other Americans involved in the cultural life of the nation, Noble undoubtedly saw the promising pupil as Cole's successor and as the future preeminent painter of American art.[4]

During Church's two-year apprenticeship, Cole painted a series of major canvases including *The Hunter's Return* (1845) (fig. 23), *The Cross in the Wilderness* (1845) (fig. 25), and *The Pic-Nic* (1846), and the pre-liminary plans and sketches for *The Cross and the World*. The student learned not

171

only from "formal" lessons and sketching trips, but also from his observation of the master at work and of the master's works. The young Church adopted, as the mature Church would adapt, Cole's use of radiant light as well as other symbolic and compositional characteristics.[5] One enduring memorial to his mentor was the continued representation of the spiritual values of the American landscape.

After leaving Cole's tutelage in 1846, Church established a studio for a brief period in Hartford where he seemed to have heard the sermons of Horace Bushnell at North Congregational Church.[6] The Bushnell whom the young artist would have heard preach in 1846 was the Christian Romantic minister who had just authored the first and most controversial edition of *Discourses on Christian Nurture.*[7] Once settled in New York City in 1847, Church became closely associated with the Reverend Dr. George Washington Bethune.[8] Warner indicated that "every Sunday Church used regularly to cross the ferry for worship" at the Central Reformed Church in Brooklyn where Dr. Bethune preached.[9] The relationship between the young painter and the elder churchman was closer than the usual bond between minister and congregational member as evidenced by Bethune's counsel on the purchase of the land on which Olana would be built.[10] A copy of the minister's *Lays of Love and Faith; with Other Fugitive Poems* was on the painter's library shelves as were two copies of A.R. van Nest's *Memoirs of Rev. George W. Bethune.*[11] Writing to Church on August 29, 1862, the Rev. Noble consoled the artist on the "great loss" he had suffered with Bethune's death.[12] Both Bethune and Church benefited from this friendship, especially in the exchange of artistic and theological ideas that would have informed their conversations.

Niagara: America's New Icon of the Landscape

Church's new methods of public presentation of his major paintings proved his entrepreneurial talents.[13] *Niagara* (1857: The Corcoran Gallery of Art, Washington, D.C.) (fig. 31) was exhibited on May 1, 1857 as a one-person, one-work, "pay-as-you-enter" attraction at a private gallery, that of Williams, Stevens, and Williams, prominent New York art dealers and publishers at 353 Broadway, New York City, rather than as part of the annual group show at the National Academy of Design. In conjunction with the exhibition, proposals for chromolithographs or engravings were offered to the public as well as specially published pamphlets. These publications contained essays which described the history of the particular painting and assisted the viewer in experiencing the "great picture." Such pamphlets were

forerunners of the modern exhibition catalogue, just as the "great picture" was the ancestor of the twentieth-century's "blockbuster" exhibition. The advance publicity, which included newspaper advertisements and magazine articles, heightened the public's anticipation of the exhibition. Media coverage of the reception of the "great picture" in other cities, including international sites, spotlighted the importance of Church's visual presentation of "America."

This orchestrated publicity, media coverage, and exhibition publications, including the taking of an immediate subscription for prints of the painting, was an innovation in the American art world. Appropriate to contemporary interest in the "grandeur" and "vastness" of America, Church's exhibition techniques captured the American imagination at a time marked by the advent of World's Fairs and the technological dynamics of transatlantic and transcontinental communications.[14] The exhibition of *Niagara* proved so successful, financially and critically, that the artist duplicated his basic exhibition and marketing method with refinements and additions for *The Heart of the Andes* (1859: The Metropolitan Museum of Art, New York) (fig. 32), *Twilight in the Wilderness* (1860: The Cleveland Museum of Art, Cleveland) (fig. 33), and *The Icebergs* (1861: Dallas Museum of Art, Dallas) (fig. 34). These successful exhibitions not only brought him critical acclaim and financial security; the publicity and prints insured widespread recognition of his art. Part of the enthusiastic public response to his "great pictures" must be credited to Church's entrepreneurial acumen, absent in Allston and Cole, which was likely his heritage from his successful businessman father.

Combining his inherited business orientation with a recognition of the earlier financial and critical success of the serial panorama paintings of Cole and Martin, Church included advance publicity through essays in newspapers and magazines. In his planned exhibition of a single painting, the artist took a carefully calculated risk. Before the exhibition opened, he sold the painting to Williams, Stevens, Williams & Company for $2,500 with an additional fee of $2,000 for the copyright. This monetary reward was duly noted by a mercantile middle class which measured artistic quality by financial value and which sought a new icon to express what it believed was the singularity of America. Thus, his painting was so popular that chromolithographs "sold by the thousands at $30 or $20 a print, depending on what sort of proof it was."[15] *In Church's Niagara*, middle-class Americans found a vision of the nation that surpassed Cole's interpretations of America as the Garden of Eden regained and that responded to the changing values of the late 1850s and early 1860s.

With the transition to an industrial economy, a matriarchal domesticity, and a secularized educational system, Americans who had earned material success and sought also to acquire a recognizable culture.[16] Cole's images of the landscape were appropriate to the emergent consciousness of national identity; Church's *Niagara*, however, visualized the singularity of America on a monumental and international scale. The 1857 London exhibition of *Niagara* merely confirmed its American success,[17] even John Ruskin praised this artistic achievement. With his paintings acclaimed by European audiences, Church was raised to a level of national and international prominence not yet experienced by any other American artist. His triumph marked the beginning of a new era in American art.

Niagara was immediately popular. Within the first two weeks of its initial exhibition, 100,000 people had paid the necessary admission fee of twenty-five cents to view "the great picture." At the age of thirty-one, Church was pronounced the great American painter. This success had as much to with the painting itself as with the "marketing package" that the entrepreneurial artist had developed with his agent. Capitalizing on contemporary American interests in "the biggest is best" ideology, in science (i.e., geology), and in the never-ending quest for a national identity, he built upon the basic popularity, recognition, and nationalistic significance of Niagara Falls.[18] Every American artist from John Trumbull to Thomas Cole to George Inness painted Niagara Falls, but no artistic image was as famous as that of Frederic Edwin Church's.[19] He also capitalized upon the public's recognition of him as Cole's heir and the leading American landscape painter. This artistic standing based upon his early landscape paintings added to the success of *Niagara* (fig. 31). Both the theme and composition were inherited from his mentor whose artistic fascination with the scriptural theme of the deluge resulted in *The Oxbow* (fig. 18) and *The Course of Empire* (figs. 13-17). In *Niagara*, the younger painter continued visual affinities to Cole's work by adapting and extending his composition and symbolism to present a new icon of the American landscape. The major new element in the painting was the artist's reversal of his point of orientation from the traditional American border looking out onto Canada to a view from the Canadian border looking towards the vast openness of space that was America.

Church emphasized the scriptural metaphor by including a rainbow--an essential element of the Noah story which Cole never painted in either his landscapes or serial panoramas. As the scriptural symbol of the covenant

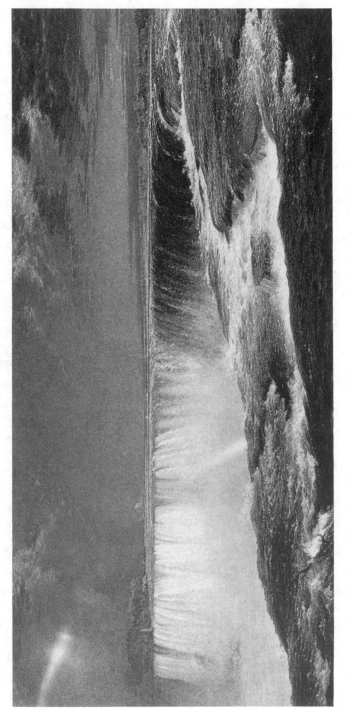

31. Frederic Edwin Church, *Niagara*, 1857. Oil on canvas, 42 1/2 x 90 1/2 inches (107.95 x 229.87 cm.). In the collection of The Corcoran Gallery of Art, Washington, D.C. Museum Purchase, Gallery Fund. (76.15). Courtesy of The Corcoran Gallery of Art, Washington, D.C.

between God and Noah, the rainbow was the divine sign of the restoration of the earth. The perennial sign of this covenant was the promised reappearance of the rainbow at the end of every storm.[20] Church made the rainbow a central focal point of the painting by his exacting method of presentation. On the left side of the canvas, the rainbow immediately attracted the viewer's eye as the arch of color appeared and disappeared as it crossed the foaming waters. The initial glance of the viewer is stationed on the soft bands of color which appeared to be refractions of light upon water. The viewer was startled by the realization that the rainbow was in fact an actual part of the painting and not an optical illusion caused by the reflection of the exterior light upon the canvas.[21]

The size of Church's canvas was another factor in *Niagara's* spectacular success. More than twice the size of the average painting by Cole, *Niagara's* length was more than double its width emphasizing the linearity of the horizon. The curvilinear lines within the painting de-emphasized the initial horizontality of this canvas. Nevertheless, the painting's format evoked a recognition of the fundamental human orientation to a horizon. Church's icon of America was therefore a participative style of art as the larger-than-life-size canvas enveloped the viewer who symbolically became the human presence within the painting. Like his other "great pictures," *Niagara* was not a precious image to be held in the hands of the adoring viewer, rather it was a physical threshold for the viewer's entry into the American landscape. Viewers regularly commented that standing before *Niagara* was like being in front of Niagara Falls. In his rendering of this experience, this painter achieved what Cole and other artists intended for their serial panoramas--to move the viewer so that she felt as a participant in the story. The visual and physical effect of Church's lengthy canvas was similar to the sensation of moving from one canvas to the next in serial panoramas like Cole's *The Voyage of Life*. However, the unity of the single canvas in this presentation afforded the viewer's eye a more realistic impression than the distancing breaks of separated canvases.

With the natural spectacle that was Niagara, Church involved his viewers in the presentation of the power and majesty of water. The metaphorical Christian content was suggested by the subliminal connections between the waters of Niagara to the Christian ritual of cleansing by the waters of baptism and the scriptural significance of the deluge. Additionally, the artist played upon his audience's ability to associate the visual metaphor of the power and majesty of Niagara with that of God. Premised on a Christian Romantic understanding of nature as symbolic of God, this natural wonder painting evoked the possibility of God shedding his singular grace

upon America. In Genesis 9:13, God told Noah, "I do set my bow in the cloud, and it shall be for a token of a covenant between me and the earth." For those viewers with a religious mindset similar to that of the painter, the divine providence and new covenant between God and America were sealed by the rainbow which crossed Niagara Falls. In this interpretation, then, the apparent absence of the human figure was significant and did not negate human presence. As Cole's presentation of the human figure as the new Adam appeared to affirm the Garden of Eden regained, Church's interpretation emphasized that the partners of this new covenant were God and the spectator of the painting, who was a descendant of the first Noah. The blessing and the burden of the newly cleansed and habitable world fell upon the shoulders of the painting's physical audience, not upon some figural metaphor within the canvas.

The multi-layered success of *Niagara* proved Church's ability to completely engage his viewers. Through nature metaphors he was able to do with the image what Beecher did with the word--to subtly but convincingly persuade middle-class Americans of the singular destiny of America and of the continued reality of God's judgment as well as his providence.

The Heart of the Andes: The Garden Regained Again

Church's second "great picture", *The Heart of the Andes* (fig. 32), turned his own and his audience's attention to the tropics and jungles of South America. Once again, Church's painting was a success. *The Heart of the Andes* was sold to William Blodgett of New York for $10,000, the highest price ever paid to a living American artist who also earned the profits from both the entry fees and reproductions rights for all exhibitions of this work of art. The New York presentation of *The Heart of the Andes* was at the Studio Building on West Tenth Street. In the three-week exhibition period, over 12,000 people paid the twenty-five cents admission fee to see the painting.[22] Originally the canvas was on view at Lyric Hall, 765 Broadway, where the physical facilities, in particular the artificial illumination by gaslight, proved both unsatisfactory and inappropriate. At the Tenth Street Studio Building, "*The Heart of the Andes* was brightly illuminated by cool, natural light during the daytime hours;" according to Kevin Avery, "other evidence indicates that thereafter in its lengthy United States tour, McClure sought interiors with adequate natural light sources."[23] To heighten the drama of the presentation and to shield the painting from

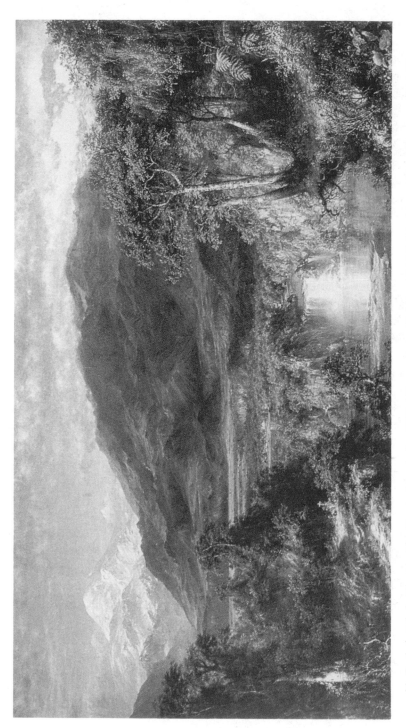

32. Frederic Edwin Church, *The Heart of the Andes*, 1859. Oil on canvas, 66 1/8 x 119 1/4. The Metropolitan Museum of Art, New York. Bequest of Mrs. David Dows 1909. (09.95). Courtesy of The Metropolitan Museum of Art, New York.

reflected light, Church controlled the immediate environment by constructing an elaborately draped frame which "created the impression that the light emanated from the picture itself, making of it a living world of its own."[24] Explanatory texts authored by Theodore Winthrop and Louis Legrand Noble accompanied the exhibition.[25] Arranged through the managerial services of John McClure, the London exhibition was an even greater success with a private premiere for Queen Victoria and Prince Albert held on June 28, 1859[26] as the British press hailed Church as the successor to Turner, American art, thanks to Cole's protege, stood at the pinnacle of international recognition.

The Heart of the Andes was the result of Church's excursions to South America in 1853 and 1857.[27] Although he produced other paintings such as the *Cotopaxi* series from his South American sketches, *The Heart of the Andes* was the painterly triumph of this artistic vision of South America.[28] Influenced by the writings of Baron Alexander von Humboldt, Church mapped out an itinerary through Colombia and Ecuador similar to that of the German naturalist.[29] The artist sought to abide by Humboldt's dictum that the "function of the landscape painter [was] as a scientific discoverer as well as recorder."[30] His visualization of this untouched world was complemented by the written analysis of his friend, Winthrop, "who had himself made two extended visits to these regions as an agent for the Pacific Mail Steamship Company in 1852 and as a volunteer on the United States Exploring Expedition to the Darien Peninsula in 1854."[31] Neither Church nor Winthrop were daring explorers into a virginal and uncivilized jungle. Journies to South American regions by other Americans including Louis Agassiz and Louis Mignot were common in the 1850s. South America had become the symbolic goal for the expansionist tendencies of the United States. In the minds of many Americans in the 1850s, South America was the next "savage and uncivilized" territory to be domesticated and Christianized as a part of America's Manifest Destiny. In point of fact, Church once again captured the American imagination simply because he combined the familiar with the ideal in his vision of the spectacular and the exotic.

Just as *Niagara* built upon the scriptural basis of the deluge, Church's *Heart of the Andes* visualized the Garden of Eden regained.[32] Like Cole's images, *The Heart of the Andes* was a vision of the spiritual pilgrimage to the Garden regained. In the darkened wilderness on the left side of the canvas, the radiant light highlighted the presence of pilgrims kneeling before a cross.[33] A contemporary reviewer commented that,

> The happy introduction of the Holy Cross, the symbol of
> our faith, and the figures kneeling, as the vesper chimes
> float faintly from younder hamlet, are highly suggestive in
> the blending of the spiritual and material, and by one subtle
> *coup de grace* place the picture in the highest range of
> art.[34]

Like the medieval pilgrims, Church's pilgrims found a place of contemplative rest at the sign of the cross which was also a marker for the remainder of their journey and towards the sacred mountain. "To us also the Cross, prominent against the dark background, has sweet symbolical meaning, sanctifying the glories of the spot," Winthrop explained, "and, as in the old saintly legends, flowers sprang up under the feet of martyrs, so here a spontaneous garland has grown to wreathe this emblem of sacrifice and love."[35]

In *The Heart of the Andes*, the pilgrims' departure out of the wilderness and their re-entry into the Garden were signified by their crossing the river which wound through the left side of the canvas into the central waterfall. The image of crossing the river had multiple scriptural referents, including the passage of the Red Sea and, more significantly, the baptism of Jesus at the River Jordan. In Church's vision, then, the entryway into the regained Garden of Eden was through the waters of baptism and the cross. "And the Artist," Winthrop wrote, "sets up his own symbol of faith in the church and the foreground cross, and recognizes here that religions whose civilization alone makes such a picture as this possible."[36] On the opposite shore from the pilgrim cross was a church building--Christianity reigned in the Garden regained for those initiated into the church. Although these paintings, like *The Heart of the Andes* (fig. 32), were less overtly didactic than Cole's, they were carefully constructed visualizations of Christian Romanticism comparable to Beecher's sermons and texts. Church's spiritual message was not lost to his contemporary audience for "the metaphorical Christian content of his paintings was emphasized by reviewers, and *The Heart of the Andes* was mentioned in church sermons."[37]

In his *A Companion to The Heart of the Andes*, Winthrop advised his readers and, therefore, Church's viewers that the artist had a public responsibility as a moral teacher because of his God-given talent.[38] Art was both a product and a process: an exchange of ideas and information as well as an aesthetic image. Winthrop believed that art brought the viewer to a state of both intellectual exchange and religious conversion.[39] Winthrop verbalized the painter's understanding of art as a gift and a responsibility, of the artist as a moral and social teacher, of art as Christian rhetoric, and of the responsibility of the viewer to art. As both confidante and writer, Winthrop listened

to and voiced the artist's ideas. Winthrop informed his readers of the current status and importance of the development of an American art and by implication of an American culture. He re-sounded the then familiar themes of the need for an identifiable American art and the appropriateness of the landscape as the singular identification of both America and American art.[40] Winthrop described the role and position to which Church aspired: international recognition for American art.

As in *Niagara*, the painter employed a large canvas to re-create in *The Heart of the Andes* the visual and emotive sensations of a participative style of art. In fact, *The Heart of the Andes* was his largest picture to date measuring almost six by ten feet (66 x 119 inches) as opposed to *Niagara's* almost four by eight feet (42 x 90 inches). In a composition similiar to those of Cole's *The Oxbow* (fig. 18) and *Schroon Mountain* (fig. 19), Church placed a clear emphasis on curvilinear lines such as those which created the shadowed and highlighted divisions between the right and the left sides of the canvas. These curvilinear lines and compositional divisions minimized the initial and overwhelming horizontality of *The Heart of the Andes*. Similarly, the larger canvas presented a visual experience based upon but more unified than the serial panoramas of earlier artists. Just as viewers described themselves as standing in front of Niagara Falls, they now felt themselves thrust deep within the Andean jungle.

As Winthrop suggested, his painting was dramatic while it provided an experience of being in the Andes. Simultaneously, this painting, like all art, made demands upon the viewer, in return for which spiritual rewards could be reaped. Winthrop concluded his essay with a Christian Romantic admonition: "'The Heart of the Andes' is in itself an education in Art...It opens to us...a new earth more glorious than any we have known...Men are better and nobler when they are uplifted by such sublime visions, and the human sympathies stirred by such revelations of the divine cannot die."[41] Church and Winthrop advocated an identifiable Christian spirituality as was evident from their scriptural analogies, such as "a new earth more glorious than any we have known" and "the new heaven and the new earth."[42] In his analysis Winthrop consistently referred to images from the Book of Revelations thus substantiating the larger metaphor of the "revelations of the divine [which] cannot die." The artist was then both seer and prophet.

In his more abbreviated pamphlet, Louis Legrand Noble echoed both Winthrop and Church on the critical themes of the role and the duty of the artist, and of the role of art in American culture.[43] Noble also emphasized the connections between Church and Cole. In the first instance, Noble told his readers that Cole had only the highest praise for his protege's artistic

skills, particularly his draftsmanship.[44] Therefore, Church's discipline and dedication to "reality" were indicated by his careful observations to nature. Secondly, Noble analyzed this painting from the perspective of Cole's dictum that "art is but nature continued by the hand of man."[45] Noble also emphasized the implicit spirituality of the painting in his detailed discussion of the painter's use of composition, color, and light which were guided by the artist's fundamental conviction of the relationship of the parts to the whole and of Nature as symbolic of God.[46]

The spectacle of *The Heart of the Andes* was a secular artistic and financial achievement just as the artist's implicit visual rhetoric was a successful presentation of the basic tenets of Christian Romanticism. For his vision of the pilgrim's re-entry into the Garden, Church employed not only the metaphysical and sublime power of the visual but also the accessible and subtle power of the word.

Twilight in the Wilderness: Visual Apocalypse on the Eve of the Civil War

The smallest of Church's "great pictures," *Twilight in the Wilderness* (fig. 33) was commissioned by William T. Walters of Baltimore. As opposed to his earlier "great pictures" and their exhibitions, the painter was at no great financial risk. *Twilight in the Wilderness* completed a series of sunset images on which he had been engaged for many years, and therefore, was a painting for which he had a built-in audience. Although much smaller in size than either *Niagara* or *The Heart of the Andes*, *Twilight in the Wilderness* influenced other American artists including Bierstadt, Gifford, Heade, Inness, and Whittredge. As the artist's summary heroic landscape, *Twilight in the Wilderness* was interpreted as his visual statement of the coincidence of the impending Civil War and the continuing struggle between industrialization and nature.[47] Church's visual ode to solitude, however, was related to his sketching trip in 1856 with Theodore Winthrop to Maine. In his posthumously published account of this trip *Life in the Open Air*, Winthrop described the experience of the sunsets which paralleled this painting.[48] Even though the canvas for *Twilight in the Wilderness* measured a little more than three by five feet (40 x 64 inches), or approximately one-half the size of *The Heart of the Andes*, the intensity of its effects upon the viewer was no less dramatic or perduring. To effect participative art Church employed the smaller format to reduce the viewer's sense of distance within the painting by a perspectival foreshortening in the foreground of the painting. As opposed to *The Heart of the Andes* where the foreground allowed an

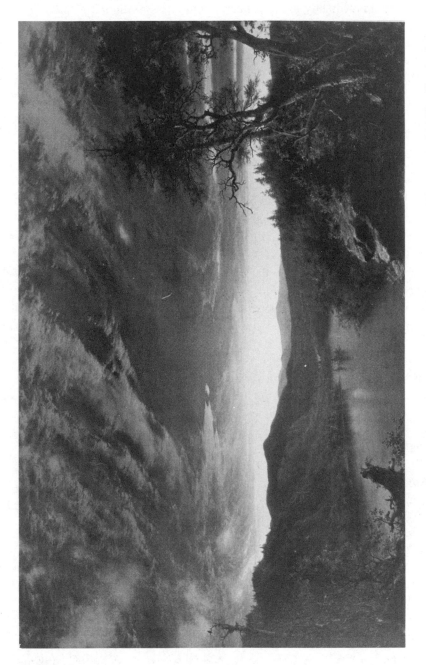

33. Frederic Edwin Church, *Twilight in the Wilderness*, 1860. Oil on canvas, 40 x 64 inches. © 1994 The Cleveland Museum of Art. Mr. and Mrs. William H. Marlatt Fund. (65.233). Courtesy of The Cleveland Museum of Art.

entryway into the painting, the viewer who stood before *Twilight in the Wilderness* was immediately in the painter's wilderness twilight.

Visual affinities to Cole's landscape compositions were obvious such as the trees which assumed an anthropomorphic character. The only apparent life-form in *Twilight in the Wilderness* was the eagle perched serenely atop the leafless tree on the left reminiscent of the bird nesting above the ruined pillar of Cole's *The Course of Empire: Desolation* (fig. 17). Both paintings were twilight scenes which depicted an atmosphere of solitude and fulfillment at the day's end. The two paintings were similar in size, *The Course of Empire: Desolation* measuring a little over three by five feet (39 x 63 inches). The thematic tie between the two paintings seemed evident. *Desolation* was the final painting in Cole's serial panorama which depicted the rise and the fall of a classical empire. The paintings which immediately preceded *Desolation* were *Consummation* (fig. 15) and the *Destruction* (fig. 16). *Desolation* represented both the calm after the storm and the moment before the new beginning just as *Twilight in the Wilderness* was a transition from one moment in history to the next. Church's history was governed by a force other than human or nature as "the crown of a treestump assumes the shape of a kneeling angel holding a Cross and facing towards the golden light on the horizon."[49] This wilderness was under the providence and judgment of God.

Twilight in the Wilderness was painted at a time when Church's memory of Cole was once again vivid. Thoughts of Cole and, by extension, Cole's paintings were prominent in the younger painter's thinking during this period. The visual and thematic connections between *Twilight in the Wilderness* and *The Course of Empire: Desolation* were clear. Both were visions of a fundamental faith in a God who acted in history. Church's painting, more so than Cole's, was an image of confidence in the providence of America--an America which would experience a re-birth after the destruction wrought by the approaching apocalypse of the Civil War.

The North (The Icebergs): The White Wasteland as The Landscape

In 1859, the artist continued his study of the American hemisphere with a sketching trip to the coast of Newfoundland and Labrador in the company of the Reverend Mr. Noble. As both companion on sketching trips and a writer, Noble played an important role in Church's artistic life.[50] He wrote the texts for the pamphlets that accompanied the public exhibitions of *The Heart of the Andes* and *The North (The Icebergs)*, an unpublished pam-

phlet-length text on *Cotopaxi*,[51] and the "promotional" essay on *The North (The Icebergs)* which, appearing in the *Atlantic Monthly* prior to the exhibition, whetted the public's appetite. Noble also wrote a major account of the journey to Newfoundland and Labrador which became such a popular publication that it was published in two editions, one in 1861 and the other in 1862.[52] Noble was Church's most consistent interpreter of his "great pictures"--his public voice--since the artist authored neither an autobiographical memoir or a theory of art.[53] The minister's essays on *The Heart of the Andes*, *The North (The Icebergs)*, and *Cotopaxi* were expressions of the artist's own aesthetic reflections.[54]

The relationship between Church and Noble also had a religious dimension as the minister's felt a sense of responsibility for Church's spiritual life.[55] For his part, the painter expressed deep-felt affection for the clergyman. Correspondence detailing significant personal events in Noble's life to mutual friends indicated the continuing close association between the artist and the minister.[56] Church's gentle affection for Noble paralleled Warner's description of the artist. The extant correspondence and the cleric's published texts indicated that these two men shared common experiences, opinions, and friendships. On their excursion in 1859 through the waters of Newfoundland in search of icebergs, Church intended to sketch the icebergs in preparation for another "great picture," while Noble's assignment as he happily wrote his friend Charles Lanman, was that "I am to 'take notes' and, faith I may publish them!"[57] So the artist and the minister-writer set off on a journey much in keeping with the temper of the times.

Just as earlier excursions into South America had been influenced by his reading of von Humboldt's scientific studies, so contemporary scientific writings influenced the artist's trip to the Arctic regions. In fact, there was something akin to "Arctic fever" present in the hearts of undaunted explorers and the armchair travelers. Early nineteenth-century explorations into the mysterious Northwest Passage had been undertaken predominantly by the British: Sir John Ross, James Clark Ross, Sir William Edward Parry, and Sir John Franklin.[58] The details of these journeys became known to the American public through the travel journals and diaries, several of which were illustrated, written and published by either exploration leaders or members of their crews. Tales of unexplored wastelands and savage animals filled the pages of these publications, while the stories of these adventures were highlighted with descriptions of the magnificence and awesomeness of the natural wonders of the icebergs, the Aurora Borealis, and the frozen seas. First-hand accounts were complemented by poetic essays of such armchair explorers as Samuel Taylor Coleridge whose popular "Rhyme of the Ancient

Mariner" was influential upon Church's painting and upon the audience's receptivity to the painting itself. In fact, Noble even quoted passages from Coleridge's poem during the journey through the waters of Newfoundland.[59]

Many of these Arctic explorations ended in tragedy. The most memorable tragedy was that of Sir John Franklin who died on June 11, 1847 while involved in a third attempt to find the Northwest Passage. Franklin's death was multiplied by the total loss of his crew of 128 men who perished in an attempt to escape from an ice-locked Victoria Strait in 1848. The tragedy was not discovered until 1854 by Dr. John Rae who retrieved the first relics of Franklin's command. The search for Franklin was tinged with all the appropriate dimensions of romanticism: a valiant hero lost in his search for new territory, a grieving but courageous widow, and the necessary touch of exotica in the dramatic Northwest Passage; the cause although hopeless was glorious. The search for Franklin included an expedition led by Henry Grinnell and immortalized by Elisha Kent Kane whose two-volume *Arctic Explorations in the Years 1853, '54, '55* was owned by the artist.[60] Additionally, he was friends with Dr. Isaac Hayes, a surgeon and a polar explorer.[61] Through prose, scientific text, personal friendships, and the general cultural excitement, Frederic Edwin Church became entranced by the Arctic. As always, he found an eager audience for his portrayal of the mansions of ice and the wonders of the unknown north. However, his drawings and painting were not the first such images in American art. Titian Ramsey Peale, Asher Brown Durand, and James Hamilton had made use of this subject matter. Church was, however, the first American artist to initiate an expedition for the sole purpose of sketching icebergs, and then to paint an image of icebergs as a "great picture", or as "grand art."

His invitation to Noble to accompany the artist on his journey and make a written report of it served as clever pre-publicity and whetted the appetite of Church's audience for America's great landscape painter's newest "great picture." The regular newspaper reports detailing the progress of the actual painting of *The Icebergs* (fig. 34) and Winthrop's adulatory essay in *Harper's Weekly* combined in the now usual fashion of pre-exhibition media excitement. History intervened so that despite the artistic brilliance or entrepreneurial skills, *The Icebergs* opened at Goupil's on April 24, 1861 to smaller than usual crowds--the Civil War had taken an immediate toll upon the cultural life of the nation.[62]

A loyal unionist, Church exhibited his new "great picture" under the title *The North (The Icebergs)* and proceeded to donate the profits from the exhibition fees to the Patriotic Fund. Nonetheless, the crowds were small, the subscription for prints minimal, and the usual fervor surrounding the artist's

34. Frederic Edwin Church, *The Icebergs*, 1861. Oil on canvas, 64 1/2 x 112 3/8 inches. Dallas Museum of Art, Dallas. Foundation for the Arts, anonymous gift. (1979.28). Courtesy of the Dallas Museum of Art.

"great picture" absent. Although both *Niagara* and *The Heart of the Andes* found purchasers and sold rapidly as engravings, this fourth "great picture," *The Icebergs*, proved to be a financial albatross for both the artist and his agent. Even the press reports were less colorful than normal as the descriptions of the war captivated the nation. A successful exhibition of *The Icebergs* took place in London in the summer of 1863.[63] The position Church held in the London art world, the success of Noble's book in its British publication,[64] and the British interest in Arctic explorations contributed to the exhibition's popularity. It was, therefore, no surprise that the eventual purchaser of *The Icebergs* turned out to be a British railroad-industrialist, Sir Edward Watkin. The painting was chromolithographed by the Days of London and successfully distributed by McClure.

The painting itself was monumental both in size and in theme. *The Icebergs* (fig. 34) measured a canvas similar in size to *The Heart of the Andes* that is almost six feet wide and ten feet long. Without doubt, it was participative art which defended the triadic relationship between art, nature, and spirituality then so familiar to Church's audience. By his careful control of the composition, the painter subdued the initial impact of the orientation to a horizon with the curvilinear body of water which formed a diagonal relief across the painting. The viewer's eye rested on the dominant images of the central majestic iceberg on the horizon and the iceberg grotto on the right side of the canvas. The pristine quality of the white icebergs and the virginal wilderness they projected symbolized the artist's unconscious attempt to present an image of America clean of the tremors of the impending disaster of the Civil War and of the theological and scientific crisis wrought by Darwin. As with his earlier *The Heart of the Andes*, Church appealed to the fundamental American expansionist ethos of the new wilderness: the new frontier was the Arctic--an arctic which was not untouched by God or Christianity. To emphasize this fact, the artist added a shipwreck to the center foreground of the painting before its London exhibition in 1863.

During the explorations, the artist sketched while the minister recorded what he saw.[65] Noble's description of the splendor of an iceberg at sunset was appropriate to the central majestic iceberg in this painting.

> In this delicious dye it stands embalmed--only for a minute, though; for now the softest dovecolors steal into the changing glory, and turn it all into light and shade on the whitest satin. The bright green waves are toiling to wash it whiter, as they roll up from the violet sea, and explode in foam along the broad alabaster. Power and Beauty, hand in hand, bathing the bosom of Purity. I need not pause to explain how all this is; but so it is, and many times more, in the passing away of the sunshine and the daylight. It is wonderful! I had never dreamed of it, even while I have

been reading of icebergs well described. As I sit and look at this broken
work of the Divine fingers,--only a shred broken from the edge of the
glacier, vast as it is--I whisper these words of Revelation: "and hath
washed their robes, and made them white in the blood of the Lamb." It
hangs before us, with the sea and the sky behind it, like some great robe
made in heaven.[66]

Noble and by extension Church interpreted the majesty of the icebergs as
symbols for the presence of God. The universality of God's action in history
was apparent in Church's art which ventured across the American landscape
to South America and now to the Arctic regions. The common denominator
in this artist's search for natural wonders was his recognition that the power
and spectacle of nature had been created by and symbolized God.

The similarities between Cole's *The Voyage of Life* (figs. 26-29) and
Church's *The Icebergs* perpetuated the visualization of Christian Roman-
ticism. The younger painter's composition was structured along the par-
ameters his mentor established in *The Voyage of Life* as the open foreground
invited and entry through a manipulation of both the painting's space and the
viewer's eye. The internal framing created by the vertical forms on each side
of the painting resulted in a lateral enclosure within the painting. In a fashion
similar to Cole's central vortex, Church employed a series of diagonal
elements to create simultaneously the impression of depth and to re-affirm
the hierarchical structure of God and humanity. A series of partial views in
the background of the painting heightened the illusion of spatial depth and
suggested the ambience of a panorama within a single canvas. The enormous
variety of the shapes and surface textures highlighted the tactile quality of
the protege's canvas thus heightening the viewer's emotive response. The
complexity of both the structure and the arrangement within the composition
signified Church's artistry and his internalization of his teacher's canvases.

The Icebergs had other affinities to Cole's *Voyage of Life*. The basic
atmosphere of serenity and the diagonal pull to the upper left were derived
from the final canvas of *The Voyage of Life*, *Old Age* (fig. 29). The move-
ment of the water on a foreground diagonal towards the lower right and the
surrealistic forms of the icebergs related to *Childhood* (fig. 26) and *Manhood*
(fig. 28). The visual connectives between the grotto from which Cole's child
voyager emerged and Church's ice grotto in the lower right corner were
startling, while the rock formation directly behind the adult voyager in
Manhood was a visual analogy for the ice formation in the lower left corner
of *The Icebergs*. The broken mast in Church's foreground was reminiscent
of the broken hour glass masthead of the aged voyager's boat. Thus, the
former pupil re-interpreted the master's work fusing Christian imagery and

a spectacular natural setting. "Like all the larger structures of nature," Noble wrote, "these crystalline vessels are freighted with God's power and glory."[67] The pilgrim's spiritual journey through obstacles and trials culminated in a rebirth signified by the cleansing waters of baptism. In *The Icebergs*, the waters were plagued by natural obstacles. Further the womblike grotto through which one passed to enter into the waters of baptism (symbolizing spiritual re-birth) and the majestic mountain on the distant shore were visual connectors between Church and Cole.

Contemplative viewers were confronted with an image that Noble alternately described as "a vision of the heavenly Jerusalem" and "in the glorious visions of St. John."[68] *The Icebergs* illustrated the revelations of the evangelist who had been privileged with a prophecy of the apocalypse and the new world which would then be established. The relation between this painting and scripture highlighted Noble's (and Church's) commitment to the Christian Romantic tenets of human fallibility and God's grace. The day of judgment which the apocalypse represented and the ensuing establishment of the "heavenly Jerusalem" as the glorious home of the saved were signified by the destructive power and awesome majesty of the icebergs.[69]

At the same time, the polar region was the new frontier and in its condition of virginal wilderness was waiting to be transformed into the garden. The artist's extension of "America" beyond its geographic borders indicated his subliminal interest in an image which was simultaneously cleansed of all association with the impending disasters of the Civil War and devoid of nationalistic identification. *The Icebergs* was the last vision of a world premised upon that Christian Romantic triad of art, nature, and spirituality. Just as the United States was to be shattered by the Civil War, so Christian Romanticism was to be devastated by Darwin's theories and by the social and cultural changes brought about by the war. In its dazzling whiteness, *The Icebergs* represented a world soon to be lost forever.

After his marriage in June 1860, Church and his bride moved permanently to Hudson, where he joined the Presbyterian Church under the ministry of Rev. Dr. George C. Yeisley.[70] From all available evidence, the Churches were regular and supportive members of the Presbyterian Church in Hudson. The painter's surviving letters to the Rev. Yeisley included regular contributions for church expenses and charities and indicated a continuing interest in theological matters.[71] As with his other ministerial associations, Church found a traveling companion as well as a friend in the Reverend Yeisley. On at least one occasion, Yeisley was the painter's guest on a trip to Maine.[72] Yeisley officiated at familial religious ceremonies held

at Olana, and in June 1890, he renewed the marriage vows between Frederic and Isabel Church.[73] In June 1897, he offered Holy Communion at Olana[74] and baptized the Church's only grandchild at Olana.[75]

In 1890, the artist offered his services for the redecoration of the Presbyterian Church at Hudson so that the "church's second century [would] begin with Christian not heathenist decor."[76] He supervised the redecoration of the church for its centennial celebration. The original interior design of the church in the classical Greek style with Corinthian columns precipitated Church's comment about a "heathenist decor." His new design was more in accord with the Gothic revival style then popular in the United States. Church's nineteenth-century decor was deemed inappropriate by newer members of the congregation, so the church was redecorated in the mid-twentieth century.[77]

More reserved in his public affirmations or statements of religious values than either Allston or Cole, Church's spiritual life can only be suggested by his regular ecclesiastical affiliations and ministerial friendships. Additional insight into what must have been a deep spiritual sensibility was indicated by the inventory of his library.[78] A voracious reader, the painter owned a large number of theological texts including the full fifteen volumes of *The Evangelical Family Library* published by the American Tract Society. Additional publications of the American Tract Society found on the shelves of Olana included Jacob Abbott's *The Young Christian = or a Familiar Illustration of the Principles of Christian Duty* (1832), and *The Power of Faith: Exemplified in the Life and Writings of the late Mrs. Isabella Graham* (1843). Multiple copies of the *Book of Common Prayer*, *Hymnals*, and the Holy Bible filled some of the shelves of this library. Publications on the importance of religious education such as *A Help to Catechizing* published by the General Protestant Episcopal Sunday School Union and Church Society in 1855 were also found at Olana. Appropriate to a Christian Romantic perspective Bushnell's *Sermons for the New Life*, Coleridge's *Collected Works* (all seven volumes), and the 1849 English translation of Friedrich Schlegel's essays were on these bookshelves. This extensive spiritual and theological book collection, along with texts in artistic, scientific and cultural matters, indicated the artist's literary milieu. In his reading materials, then, Church evidenced the world of Christian Romanticism: the organic unity of all creation, the understanding of nature as symbolic of God's revelation, spiritual domesticity, Christianity as a life process, Christian nurture, and the idealization of childhood.[79]

The painter's excursions outside of the United States also had religious significance. His journeys to South America and the Arctic were simulta-

neously sketching trips and pilgrimages in quest of the magnificence of the Garden of Eden regained. His mentor Thomas Cole had made similar jour- nies throughout the "virgin wilderness" of the United States and instilled a pilgrimage mentality in his student. Further, Church's travels through the Middle East had spiritual associations evidenced in his travel diaries and paintings such as Jerusalem from the *Mount of Olives*.

The combination of the public evidence of his religious life and the private evidence of his spiritual life clearly indicated that Frederic Edwin Church was actively a Christian Romantic. This recognition of Church's spiritual sensibility clarified the implications found in Warner's concluding assessment that Church

> was essentially liberal in his belief...and in his practical application of his religion to the conduct of life Christianity was above all the gospel of love....the underlying motive in what for him was his supreme enjoyment-- the practice of his art--in which his aim was to share with his fellows his own realization of the beauty and the grandeur of the world about them.[80]

Christianity for Church, as for Coleridge, Bushnell, Beecher, and Cole, was a life process in which Nature had a central role.

In Frederic Edwin Church's art, Christian Romanticism attained both visual apogee and denouement. His development of landscape painting as a participative art form signified his fundamental conviction that nature was symbolic of, but not equal with, God. The spectacles of Niagara Falls or the icebergs were natural symbols of God's actions in history. These paintings, therefore, were natural spectacles and spiritual thresholds. As natural spec- tacle, they captured the imagination of an audience interested in the vastness of America and in the natural sciences. As spiritual threshold, they opened up a new world of vision and, specifically, God's providential acts for America. Just as Cole offered the first presentations of the American landscape as the Garden regained, Church presented the consummate images of America as the Garden as yet untouched by the blood of the Civil War.

His "great pictures" were visualizations of the crossroad experience for American art and culture, and for Christian Romanticism. In his four major paintings, Church represented the traditional theme of the four seasons or the four ages of man: *Niagara* signified spring or childhood, *The Heart of the Andes* summer or youth, *Twilight in the Wilderness* autumn or mid-life, and *The Icebergs* winter or old age. These seasonal associations related to the scriptural analogies presented in the painter's oeuvre: the theme of the cleansing of the deluge of *Niagara* symbolized the new beginning that is spring, the Edenic imagery of *The Heart of the Andes* represented the gar-

dens of summer, the apocalyptic judgment of *Twilight in the Wilderness* related to autumnal harvests, and the pilgrim's vision of the heavenly Jerusalem of *The Icebergs* signified the winter.

At the same time, these four paintings emphasized pilgrimage. Like Church's earlier canvas, *Christian at the Borders of the Valley of Death*, his great pictures presented a view of a physical, and by extension, spiritual, crossroad. The pilgrimage theme, adapted from Cole, related to the expansionist ethos of America from the earliest settlers whose "errand into the wilderness" became the mid-nineteenth century pioneers's "manifest destiny." From the beginning, American pilgrims were at both cultural and spiritual crossroads as they expanded geographic borders. Such integration of the spiritual and cultural offered direction to the definition of "America."

In his emphasis on the spectacular in nature, Church depicted the grandeur of America and the symbolic presence of a God who acted in history. His paintings, like those of his mentor, signified the different seasons as harbingers of time and history. Through his participative art, Church dramatized the necessary role of each individual American in the unfolding drama of American history and as an active participant in Christian history. With his adaptation of Cole's visual rhetoric of the American landscape as the Garden of Eden regained into his own dramatic presentations of natural spectacles, Church earned international recognition for an indigenous American style of landscape painting.

Church's assimilation of Cole's overt visual rhetoric into a subtle visual rhetoric paralleled the analogous development in Noble's writings. In his biography of Cole, the clergyman argued vociferously for the artist whose fundamental Christian faith identified him as a paradigm and moral teacher for other Christians. Noble interpreted Church's paintings as having subtle religious language and confessional affirmation. Christian Romanticism no longer required the didactic explication of the earlier period; rather the subtlety of this painter's images and of this minister's texts evidenced the middle-class acceptance of Christian Romanticism.

Although Church's art captured the public's imagination in the 1850s and was without doubt the most popular art of that generation, it went into rapid decline with the advent of the Civil War and Reconstruction. This waning of his popularity had as much to do with the changes in aesthetic taste as with the political and social upheaval of the war and post-war experience. Americans who had encountered and survived the horror of the Civil War could not look at images of America as the garden regained with the same innocent eyes of Americans who had known only the romanticism and progress of the antebellum period.

Church's artistic fusion of the American landscape with Humboldt's scientific theories appropriate to the antebellum mindset were inadequate for the new scientific world represented by Darwin. Since neither Church nor his art made the necessary transitions to the Darwinian vision and social liberalism of post-war evangelical theology, America's most popular and recognized painter retreated from the forefront of the American artworld in a gesture symbolic of the decline of Christian Romanticism.

ENDNOTES

1. The standard biographical sources for the life of Frederic Edwin Church are the modern studies by David C. Huntington, and the unpublished and unfinished contemporary manuscript, "Frederic Edwin Church," by Charles Dudley Warner which is in the Archives, New York State Office of Parks, Recreation and Historic Preservation, Olana State Historic Site, Taconic Region. A complete biography of Church is anticipated as part of the catalogue raisonné in preparation by Gerald L. Carr.

2. Warner, "Frederic Edwin Church," p. 53.

3. In the Library at Olana, there is a copy of Joel Hawes, *Lectures to Young Men: on the Formation of Character, & C[hristian Faith]* (Hartford: Belknap and Hammersley, 1836) with the inscription, "From His Pastor to Frederic Edwin Church." Library Records, Olana State Historic Site, Hudson. Hawes's text was categorized within the same genre as Henry Ward Beecher's *Lectures to Young Men*. The young Church was raised within an environment oriented to the fundamental Puritan values of honesty, integrity, duty, hard work, and thrift attested to by scriptural authority and incorporated a "Christian lifestyle."

In his most recent studies of Church, Huntington indicated the theological empathy between Bushnell and Church. See David C. Huntington, "*Church and Luminism: Light for the Elect*" in *American Light: The Luminist Movement, 1850-1875. Paintings, Drawings, Photographs* ed. John Wilmerding (Washington, D.C.: National Gallery of Art, 1980), exhibition catalogue, pp. 154-90, esp. pp. 156-7, and idem., "Frederic Church's *Niagara: Nature and Nation's Type*," *Texas Studies in Literature and Language* 25.1 (1983): 100-138, esp. 106.

Although I would be in basic agreement with John Dillenberger's assessment of Huntington's argument for Church's theological connections to a nineteenth-century hybrid of traditional Puritanism as "theological overkill," I agree with Huntington as to Church's fundamental religiosity and his belief that both that religiosity and Church's paintings were neither Transcendentalist (in either its Emersonian or Christian form) nor Luminist.

4. Warner, "Frederic Edwin Church," p. 26.

5. Franklin Kelly and Gerald L. Carr, *The Early Landscapes of Frederic Edwin Church, 1845-1854* (Fort Worth: Amon Carter Museum, 1987), exhibition catalogue. For a helpful discussion of the student-teacher relationship, see Kelly's "The Legacy of Thomas Cole," pp. 31-51.

6. Huntington, "Church and Luminism," p. 156.

7. During the revival of 1851-1852 in Hartford, a controversy arose between Bushnell and Hawes over the right of Rev. Charles Grandison Finney to preach, see Cheney, *Life and Letters of Horace Bushnell*, p. 253. For the complete correspondence on this issue, see ibid., pp. 326-38.

8. George Washington Bethune (1805-1862) was ordained in the Dutch Reformed Church in 1827 following his graduation from Princeton Seminary. He held pastorates in Rhinebeck, New York (1827-1830), Utica, New York (1830-1834), Philadelphia, Pennsylvania (1834-1849), Brooklyn Heights, New York (1850-1859), and New York City (1859-1862). Raised in a wealthy, cultivated New York family, Bethune was of Scotch and Huguenot descent. A staunch Democrat, Bethune supported the Unionist cause. He was a musician and poet as well as a prolific writer, popular lecturer, and avid fisherman. He anonymously edited and revised Walton's *Compleat Angler*.

Bethune was directly involved in the development of an American art tradition. He voiced the then familiar argument that the initial pragmatic concerns of the settlers and colonists had passed and that America needed to develop a distinctive American art.

However, Bethune wisely counseled that until the finest works could be produced by American artists the public should substitute the best etchings and engravings for the development of taste, which would be more appropriate and effective than poor paintings or replicas. Bethune presented an address before the National Academy of Design which was published in the *Bulletin of the American Art Union* in May 1851. He also wrote several important articles and pamphlets on the role of the artist in American society, and the development of an "American" art, see George Washington Bethune, *The Claims of Our Country on its Literary Men, An Oration Before the Phi Beta Kappa Society of Harvard University, July 19, 1849* (1849); and, "Art in the United States," and "The Prospects of Art in the United States" in George Washington Bethune, *Orations and Occasional Discourses* (1850). He also edited The British Female Poets, with *Biographical and Critical Notices* (1848); and wrote *Lays of Love and Faith* (1848).

Bethune and his writings were also known by Washington Allston. In a letter to Henry Reed, the Cambridge artist added the following postscript:

> Pray present my respects to Dr. Bethune--from whom I had received a pleasant visit last summer; and I beg to thank him also for his Discourse which he sent me, and which I read with great pleasure--though in one part of it (respecting Michael Angelo) I could not agree with him.

Washington Allston to Henry Reed, letter dated June 11, 1843. The Dana Family Papers, Massachusetts Historical Society, Boston.

9. Warner, "Frederic Edwin Church," pp. 53-54.

10. See Bethune's letters to Church in the Archives, Olana State Historic Site, Hudson.

11. George Washington Bethune, *Lays of Love and Faith; with Other Fugitive Poems* (Philadelphia: Lindsay and Blakiston, 1848). A.R. van Nest, *Memoirs of Rev. George W. Bethune* (New York: Sheldon and Company, 1867).

12. Letter dated August 29, 1862 from Noble to Church, p. 4; Archives, Olana State Historic Site, Hudson.

13. The most detailed account of the "business-side" to the exhibitions of Church's great paintings is found in Carr, *The Icebergs*, see esp. pp. 23-31.

14. The first World's Fair was held at the famous Crystal Palace, London, in 1851. The first World's Fair in the United States was held in New York City in 1853.

15. Russell Lynes, *The Art-Makers. An Informal History of Painting, Sculpture and Architecture in Nineteenth-Century America* (New York: Dover, 1982 [1970]), p. 224.

16. Carr, *The Icebergs*, p. 24.

17. For a detailed discussion of the exhibitions of *Niagara*, see Carr, *The Icebergs*, pp. 23-30.

18. The most complete discussion of *Niagara* as both image and idea in Church's oeuvre is found in Jeremy Elwell Adamson, "Frederic Church's "Niagara': The Sublime as Transcendence," Unpublished Ph.D. dissertation, University of Michigan, 1981. The most complete study of the iconography of Niagara Falls in American art and culture is found in Elizabeth McKinsey, Niagara Falls. *Icon of the American Sublime* (New York: Cambridge University Press, 1985). Also helpful for understanding the vast and continuing popularity of Niagara Falls in American art and cultural ideology is Jeremy Elwell Adamson, *Niagara. Two Centuries of Changing Attitudes, 1697-1901* (Washington, D.C.: The Corcoran Gallery of Art, 1985), exhibition catalogue. An alternative interpretation of Church's *Niagara*, especially in terms of its theological significance is found in Huntington, "Frederic Church's *Niagara*."

19. Cole's interpretation of Niagara Falls was successfully reproduced both as an engraving and as an illustration for Staffordshire china.

20. Genesis 9:11.

21. John Ruskin carefully inspected the painting to satisfy himself that the rainbow was, in fact, part of the canvas and not an optical illusion. He highly praised Church's technical achievements in this painting, noting especially the effects of light and water.

22. In his well-documented essay, Kevin J. Avery proved that previous interpretations of Church's presentation of *The Heart of the Andes* had been misinformed and erroneously based upon the assessment of Worthington Whittredge. For the most complete discussion of the exhibition history of *The Heart of the Andes* and its influence upon contemporary American art exhibition practices, see Kevin J. Avery, "*The Heart of the Andes*," *The American Art Journal* 18.1 (1986): p. 52-72. The passage cited is found on p. 52.

23. Ibid., p. 54.

24. Ibid., p. 55.

25. Theodore Winthrop, *A Companion to the Heart of the Andes* (New York: Appleton, 1859); and Rev. Louis L. Noble, *Church's Painting The Heart of the Andes* (New York: Appleton, 1859).

26. For a discussion of Church's relationship with John McClure, see Gerald L. Carr, "American Art in Great Britain: The National Gallery Watercolor of *The Heart of the Andes*," *Studies in the History of Art* 12 (1982): 81-100; and idem., *The Icebergs*, p. 28.

27. For the fullest discussion of these excursions, see David C. Huntington, "Landscapes and Diaries: The South American Trips of F.E. Church," *The Brooklyn Museum Annual* 5 (1963-1964): 65-98.

28. For the fullest discussion of the *Cotopaxi* series, see Katherine Manthorne, *Creation and Renewal. Views of Cotopaxi by Frederic Edwin Church* (Washington, D.C.: Smithsonian Institution, 1985), exhibition catalogue.

29. For the fullest discussions of the influence of von Humboldt's writings on Church, see Manthorne, *Creation and Renewal*, pp. 31-52; and Novak, *Nature and Culture*, pp. 66-74.

30. As quoted by Lynes, *The Art-Makes*, pp. 225-6.

31. Katherine Manthorne, "The Quest for a Tropical Paradise: Palm Tree as Fact and Symbol in Latin American Landscape Imagery, 1850-1875," *The American Art Journal* 44.4 (1984): 374.

Theodore Winthrop (1828-1861) was Church's contemporary. A Yale graduate, Winthrop passed the bar in 1855, and earned public recognition for his support of General Charles Fremont. His novels were published posthumously: *Cecil Dreeme* (1861), *Joel Brent* (1862), and *Life in the Open Air, and Other Papers* (1863). This latter volume included Winthrop's account of his 1857 journey with Church to Niagara Falls and Maine. Winthrop also authored the more extensive exhibition pamphlet for Church's *The Heart of the Andes*.

32. The most extensive analysis of Church's *The Heart of the Andes* relationship to the image of the Garden of Eden is found in Manthorne, "The Quest for a Tropical Paradise." Although I find her analysis to be both thorough and well documented, I think that Church's image of Eden as the Garden regained was more appropriate to Christian Romanticism than to Transcendentalism.

33. The image of the cross in the wilderness as well as the image of the contemplative pilgrim(s) before the cross in the wilderness were, of course, common elements in Cole's oeuvre.

34. Blanch d'Artois, "World of Art. 'The Heart of the Andes'." *Leader* (New York), 28 May 1859, as cited by Carr, *The Icebergs*, p. 61.

35. Winthrop, *A Companion to The Heart of the Andes*, p. 42.

36. Ibid., p. 31.

37. Carr, *The Icebergs*, p. 28. In a similar vein, Russell Lynes reported that, "The clergy praised it [*The Heart of the Andes*] for its high morality and were gratified that it had provided 'a wholesome antidote to the sensual nakedness of the Greek Slave and the White Captive.'" Lynes, *The Art-Makers*, p. 222.

38. Ibid., p. 5.

39. Ibid., p. 5.

40. Ibid., p. 7.

41. Ibid., p. 43.

42. Book of Revelations 21:1-2.

43. Rev. Louis L. Noble, *Church's Painting The Heart of the Andes* (New York: Appleton, 1859). N.B. Noble's text ran twenty-four pages of large typed print while Winthrop's text filled forty-three pages of small typed print. Since both texts were published by the same publisher and written at Church's request, the distinction in length suggested that one pamphlet was prepared for those deeply interested in the painting, while those viewers with less time or interest could scan the shorter text. Clearly, Noble could be as exactingly detailed and verbose as Winthrop upon the appropriate occasion.

44. Ibid., p. 6.

45. Ibid., p. 12.

46. Ibid., p. 21.

47. However, as Joseph Czestochowski indicated, there were two technical innovations in the mid-1850s which worked together to produce a painting such as Church's *Twilight in the Wilderness*. The first of these technical innovations

> was the introduction beginning in 1856 of a series of brilliant chemical pigments, replacing earlier mineral ones. This enabled the artists to vary the hue (range of the spectrum from red to violet) of a canvas greatly, a reversal of the traditional order in which hue was limited and tone (range from light to dark) varied. So prevalent in the 1860s was the use of hot reds, yellows, and oranges that Jarves complained, "we are undergoing a virulent epidemic of sunsets."

The second innovation was the fact that these new colors permitted the full exploration of light's effects. Once these new pigments combined with the continuing interest in precise detail which had been encouraged by the development of the camera, the visual effect of American art was different in more than color. Taken together these technical advances benefited the American Luminists who sought primarily to explore the varied effects of light in landscape painting. See Joseph Czestochowski, *The American Landscape Tradition. A Study and Gallery of Paintings* (New York: E.P. Dutton, 1982).

In his recent study of Church's *Twilight* paintings, Franklin Kelly proved that Church did not use these newly available chemical pigments. See "Appendix C, Church's Palette" to Franklin Kelly, "Frederic Edwin Church and the North American Landscape, 1845-1860." Unpublished Ph.D. dissertation, The University of Delaware, 1985.

48. Theodore Winthrop, *Life in the Open Air* (1863) as cited by David C. Huntington, *The Landscapes of Frederic Edwin Church* (New York: George Brazillier, 1966), p. 28.

49. Carr, *The Icebergs*, p. 62.

50. Church and Noble made a sketching trip to Maine in 1876. Letter dated August 9, 1876; from Church to Erastus Dow Palmer. Photocopy at the Archives, Olana State Historic Site, Hudson. Original letter in The Erastus Dow Palmer Papers, The Albany Institute of Art and Sciences, Albany. The pertinent passage is found on the last lines of page 4.

51. This handwritten text was first published as an appendix to Manthorne, *Creation and Renewal*, pp. 60-64.

52. For the most complete discussion of the artistic and cultural history of this painting, see Carr, *The Icebergs*. See also Gerald Carr, "Beyond the Tip: Some Addenda to Frederic Church's *The Icebergs*," *Arts* 56.3 (1981): 107-111.
 A popular publication *After Icebergs with a Painter* saw two editions in 1861 and in 1862. The 1861 edition was published by Appleton, New York; and the 1862 edition was published simultaneously by Appleton, New York, and Sampson, Low, Son & Company, London.

53. Warner reported,
> He [Noble] wrote an interesting book about a voyage to the North that he made with Church, "After Icebergs with a Painter," and later he accumulated much material for a life of his friend that he proposed to write. Death came before he could realize an intention that might have made the present work superfluous. (p. 26)

Coincidentally, neither Noble's or Warner's authorized biographies of Church were published; and in both cases, the writer's notes seem to have vanished. In Warner's case, this disappearance of materials was tragic for Church had given Warner access to all his personal papers and letters as well as his scrapbook, so that the lost materials included primary Church materials as well as the writer's own notes. In Noble's case, the lost materials probably included his correspondence and conversation notes with Church as well as with other artist friends, including William Bradford, Erastus Palmer Dow, and Charles Lanman.
 Noble's handwritten manuscript on Church's *Cotopaxi* was mailed anonymously in 1899 and reached Olana after a diverse route as it was originally addressed to a New York City Art Gallery and then forwarded to Frederick Stuart Church. Unfortunately in the process of forwarding the letter, the original postmark was inked out and is now illegible.

54. Noble continued to maintain a singular position in Church's professional life. The minister dedicated his volume of poetry, *The Lady Angeline, A Lay of the Appalachians; the Hours, and other Poems* (1857), to the artist.

55. In a letter dated February 13, 1867, Noble counseled Church, "I wish you would get a Prayer Book and look over the Baptismal Services carefully, and the Confirmation Service too, and the Communion Service likewise. You will find them very scriptural and plain." Letter dated February 13, 1867 from Noble to Church. Archives, Olana State Historic Site, Hudson. Throughout this letter, Noble offered spiritual counsel to Church.

In other letters, Noble described his sermons to Church, analyzed scriptural passages, and consoled the artist on the death of the Reverend Dr. George Washington Bethune.

56. For example, in describing the death of Sarah Hayes Noble, Church wrote "He (Noble) is all alone in the world now. We are filled with grief." Reverend Louis Legrand Noble and his first wife had two children. Their son, Louis S. Noble, died at the age of six, probably from a diphtheria epidemic. Their daughter, Mary, died after a long illness at the age of twenty-three. Painful descriptions of the lengthy illnesses and deaths of Mary and Sarah Noble are found in the Noble-Lanman Correspondence, The New-York Historical Society, New York City. The Noble Family, that is Louis Legrand, Sarah, Mary, and Louis S., were buried in the Catskill Village Cemetery not far from the final resting place of the Cole Family.

Church's genuine concern for Noble was evident in a letter to George S. Austin eighteen months after Mrs. Noble's death that "since then he (Noble) has married....But you knew he was always amazingly impulsive. I look at his actions differently than I would those of another--you for instance. Do send him a cheerful letter." Letter dated April 26, 1878 from Church to Palmer. The pertinent passages are found on page one, and the first paragraph of page two. Letter dated August 27, 1879; from Church to Austin. Archives, New York States Office of Parks, Recreation and Historic Preservation, Olana State Historic Site, Taconic Region. I am grateful to James Ryan for bringing this letter and the fact of Noble's second marriage to my attention. The reaction of Noble's colleagues as described by Church explained both the sudden departure from his position as Professor of History and Poetry, St. Stephen's College, Annandale-on-Hudson, and his new service as Rector, St. John's Episcopal Church, Ionia, Michigan.

57. Letter dated June 9, 1859, from Noble to Lanman; Noble-Lanman Correspondence, The New-York Historical Society, New York. ^Note that in an earlier letter, Noble advised Lanman of the proposed voyage with Church and requested letters of introduction from Lanman to officials and dignitaries in Newfoundland. Letter dated May 24, 1859, from Noble to Lanman; Noble-Lanman Correspondence, The New-York Historical Society, New York.

58. For a detailed account of these varied explorations, their ensuing publications, and their effect upon the American cultural milieu; see Carr, *The Icebergs*, pp. 37-42.

59. Rev. Louis L. Noble, *After Icebergs with a Painter: A Summer Voyage to Labrador and Around Newfoundland* (New York: Appleton, 1861), pp. 94-95.

60. Library Records, Olana State Historic Site, Hudson.

61. For a detailed description of the relationship between Church and Hayes, see Carr, The Icebergs, p. 39.

62. For a full discussion of the initial effects of the Civil War on the cultural and artistic life of New York City, see ibid., p. 80.

63. *The Icebergs* faded out of public view until it re-appeared in 1979 at Watkin's former residence which had been converted into a home for boys. On October 25, 1979, the painting was sold by Sotheby Parke Bernet for the record-setting price of $2,500,000.00 to an anonymous bidder. At the time, this was the highest figure ever bid for a work of art in the United States and also the highest price ever paid for an American painting. Over a hundred years after his last "great picture" had faded into oblivion, Frederic Edwin Church's *The Icebergs* was restored to the center of the American art world and captivated the American press.

64. Letter dated April 21, 1862, from Noble to Lanman; Noble-Lanman Correspondence, The New-York Historical Society, New York.

65. Noble, *After Icebergs*, pp.

66. Ibid., p. 177. See Book of Revelations 7:14.

67. Noble, *After Icebergs*, p. 110.

68. Ibid., pp. 127, 158.

69. Book of Revelations 21:1-27.

70. Warner, "Frederic Edwin Church," p. 54.

71. See the letters dated April 26, 1892; June 28, 1897; and 29 December 189? for an accounting of Church's contributions; and the letters dated January 8, 1888, and December 29, 1891 for Church's comments on Yeisley's sermons and the latter's paper, "The Uses of the Imagination in Historical Science" which was presented to the Hudson River Ministerial Association in 1891; Archives, New York State Office of Parks, Recreation and Historic Preservation, Olana State Historic Site, Taconic Region.

72. Letter dated December 30, 1878, from Church to Yeisley in which Church enclosed a check for $25 to cover Yeisley's travel expenses; Archives, New York State Office of Parks, Recreation and Historic Preservation, Olana State Historic Site, Taconic Region.

73. I was advised of this fact by James Ryan, Site Manager, New York State Office of Parks, Recreation and Historic Preservation, Olana State Historic Site, Taconic Region, during my research visit on August 17 & 18, 1987.

74. In a letter dated June 28, 1897, Church thanked Yeisley for the service of Holy Communion offered at Olana. From Church to Yeisley; Archives, New York State Office of Parks, Recreation and Historic Preservation, Olana State Historic Site, Taconic Region.

75. I was advised of this fact by James Ryan, Site Manager, New York State Office of Parks, Recreation and Historic Preservation, Olana State Historic Site, Taconic Region, during my research visit on August 17 & 18, 1987.

76. Letter dated April 29, 1890, from Church to Yeisley; Archives, New York State Office of Parks, Recreation and Historic Preservation, Olana State Historic Site, Taconic Region.

77. I was advised of this fact by James Ryan, Site Manager, New York State Office of Parks, Recreation and Historic Preservation, Olana State Historic Site, Taconic Region, during my research visit on August 17 & 18, 1987.

78. The inventory of Church's library at Olana is complete as to those books currently shelved at Olana, all of which were purchased by Mr. Church. The receipts from booksellers are available for study. However, books which may have belonged to Church and removed by his heirs are not yet indicated on the inventory listings.

79. Other writers whose volumes were found on the shelves of Olana included Lydia Sigourney, Alexander von Humboldt, Ernest Renan, Henry T. Tuckerman, George Washington Bethune, Goethe, and Mrs. William Parkes. Unfortunately, texts by Washington Allston, Henry Ward Beecher, Felicia Hemans, or James Marsh do not appear to have been included among Church's reading matter.

80. Warner, "Frederic Edwin Church," p. 54.

CONCLUSIONS

Christian Romanticism as represented in the theology of Horace Bushnell and Henry Ward Beecher emerged as a particular style of middle-class American spirituality which reflected religious, cultural, and social changes. A Christian Romantic style of American art, especially in terms of landscape painting, was visually appropriate to the concerns and desires of middle-class America. The modification of the theology of Christian Romanticism from the writings of Samuel Taylor Coleridge through James Marsh to Bushnell's theology of Christian Nurture ultimately resulted in the cultural identification of these "familiar" values in Beecher's popular theology. A similar transfer of theory to practice occurred in American art as Washington Allston's assimilation of Coleridge's romanticism found its way into Thomas Cole's moral allegories and resulted in the cultural adulation for Frederic Edwin Church's "great paintings." These artistic and religious styles of antebellum American culture and values were disseminated through the popular vehicles of prints and engravings, gift books and annuals, cultural and religious journals, and sentimental novels.

Christian Romantic art and theology in America paralleled the contemporary development of both styles of Transcendentalism and Luminist landscape painting. However, these later styles of art and theology, although philosophically supportive of each other, had an influence limited to New England and New York intelligentsia. Christian Romantic art and theology, however, found its audience throughout the American middle class. Horace Bushnell and Henry Ward Beecher supported the integral role of the arts and aesthetic concerns in the development of their theologies. The examination of contemporary clergy views of the arts, as evidenced through the writings

of other Christian Romantics such as Cyrus Bartol, George Washington Bethune, Orville Dewey, Elias L. Magoon, and Louis Legrand Noble, indicated that neither Bushnell nor Beecher was singular in his interest in or support of art. Rather, the general milieu of Christian Romanticism was conducive to artistic expression, especially in terms of the development of a distinctive American art.

The relationship between religion and art, especially in Christian Romanticism, was viable in antebellum America. These connections were further supported by and reflected cultural and social changes, especially those relating to the roles of women and children, and the popularization of knowledge. Whether or not this partnership between religion and art in antebellum America survived the disasters of both Darwinian science and the Civil War becomes a question for future study. Recent studies of women's roles and the cultural history of the American home suggest that "the epic style of domesticity, with its linkage of the home and the world through the redemptive process of love, perished in the late nineteenth century under the dual impact of economic upheaval and evolutionary theory."[1]

Like the proverbial phoenix, the romantic impulse in American religion rose from its ashes in the later nineteenth century to reformulate itself in terms of cultural and social change. The spirit that had been the Christian Romanticism of antebellum America became the foundation for Protestant Liberalism and the Social Gospel. Although the specific concerns of these new movements were oriented toward social action, the fundamental tenet of Christian Romanticism, that is, of Christianity as a process of living, remained. The importance of the home and of domestic spirituality evolved from the active society of antebellum culture to a passive center effected by the forces of late nineteenth-century American values.[2]

American art likewise responded to the cultural shifts brought about by the world of Reconstruction and the American Renaissance. However, the artists of the second half of the nineteenth century were less interested in the development of an indigenous "American" landscape tradition and more interested in identification with European traditions of academic and landscape paintings and portraiture. Both the styles and patterns of art patronage and collecting changed to accommodate the economic upheavals in personal fortunes and art values. Middle-class tastes also evidenced these shifts, excepting a continued loyalty to Raphael's Madonnas. The elite class and the connoisseur began "to decorate their new homes with French academic and Barbizon pictures."[3] The landscape painting of the later nineteenth century, excepting that of George Inness, did not seem to reflected a particular Christian interpretation of either nature or America as the art of

Allston, Cole, and Church had. The quality and style of the interrelationship between Christianity and art, as well as that between artists and ministers, was never to be repeated, at least on such a large-scale basis. The secularization of American culture and the pluralism of worldviews nurtured by the new world of modern science irrevocably transformed the relationship between religion and art in America.

ENDNOTES

1. Mathews, "*Just a housewife*", p. 144.

2. Ibid., p. 110.

3. Brown, *Raphael and America*, p. 30.

BIBLIOGRAPHY

Manuscript Materials

Washington Allston Architectural Records File, The Cambridge Historical Commission, Cambridge.

Washington Allston Clipping File, The National Museum of American Art, Washington, D.C.

Washington Allston Papers, The Archives of American Art, New York City.

Washington Allston Papers, Massachusetts Historical Society, Boston.

A. W. Anthony Collection, Manuscript Division, New York City Public Library, New York City.

Esther Seaver Bruno Papers, The Archives of American Art, The Smithsonian Institution, Washington, D.C.

Bryant-Godwin Collection, Manuscript Division, New York City Public Library, New York City.

Horace Bushnell Papers, The Divinity School Library, Yale University.

William Ellery Channing Papers, Massachusetts Historical Society, Boston.

Frederic Edwin Church Clipping File, The National Museum of American Art, Washington, D.C.

Frederic Edwin Church Clipping File and Scrapbook, New York City Public Library, New York City.

Frederic Edwin Church Papers, The Archives of American Art, New York City.

Frederic Edwin Church Papers, Olana State Historic Site, Hudson, New York.

Clark-Dwight Miscellaneous Manuscripts, Manuscript Division, New York City Public Library, New York City.

Thomas Cole Clipping File, The National Museum of American Art, Washington, D.C.

Thomas Cole Estate File, Surrogate Court, Greene County Court House, Catskill, New York.

Thomas Cole Papers, The Archives of American Art, The Smithsonian Institution, Washington, D.C.

Thomas Cole Papers, Greene County Historical Society, Coxsackie, New York.

Thomas Cole Photograph File, Art Reference Library, Frick Collection, New York City.

Thomas Cole Sketchbook and Drawings, The Art Museum, Princeton University, Princeton.

James Fenimore Cooper Letters, The New-York Historical Society, New York City.

Dana Family Papers, Alderman Library, University of Virginia.

Dana Family Papers, Massachusetts Historical Society, Boston.

E.A. Duyckinck Papers, Archives of American Art, Smithsonian Institution, Washington, D.C.

First Church of Cambridge, Congregational, Architectural File, The Cambridge Historical Commission, Cambridge.

Lanman-Noble Correspondence, Charles Lanman Letters, The New-York Historical Society, New York City.

Parker Lesley Collection, The New-York Historical Society, New York City.

Registry and Records, All Saints' Anglican Church, Rome.

Registry and Records, St. James' Episcopal Church, Florence.

Registry and Records, St. Luke's Episcopal Church, Catskill, New York.

Registry and Records, St. Mark's Anglican Church, Florence.

Registry and Records, St. Paul's Episcopal Church, Archives, Episcopal Diocese of Boston.

Registry and Records, St. Paul's Episcopal Church, Rome.

Registry and Records, The Shepard Society, First Church of Cambridge, Congregational.

Florence Cole Vincent Memorial Collection, Greene County Historical Society, Coxsackie, New York.

Charles Dudley Warner. "A Biography of Frederic Edwin Church." Unfinished, unpublished manuscript. Olana State Historic Site, Hudson, New York.

Primary Sources

Allston, Washington. *Lectures on Art, and Poems* ed. Richard H. Dana, Jr. New York: Baker and Scribner, 1852.

_____. *Lectures on Art, and Monaldi* ed. Nathlia Wright. Gainesville: Scholars' Facsimiles & Reprints, 1967.

Beecher, Henry Ward. *Eyes and Ears*. Boston: Ticknor and Field, 1863.

_____. [ascribed to]. "Henry Ward Beecher on Church Architecture," *The Crayon* 6.5 (May 1859): 154-5.

_____. *Lectures to Young Men on Various Important Subjects*. New York: Ford and Company, 1873 (1844).

_____. *Norwood; or, Village Life in New England*. New York: Fords, Howard, and Hubbert, 1887 (1867).

_____. *Star Papers; Or Experiences of Art and Nature*. New York: Ford and Company, 1873 (1855).

Bushnell, Horace. *Christian Nurture*. Grand Rapids: Baker Book House, 1984 (1861).

_____. *Selected Writings on Language, Religion and American Culture* ed. David L. Smith. Chico: Scholars Press, 1984.

Cole, Thomas. *The Collected Essays and Prose Sketches* ed. Marshall Tymn. St. Paul: The John Colet Press, 1980.

_____. *The Correspondence of Thomas Cole and Daniel Wadsworth* ed. J. Bard McNulty. Hartford: Connecticut Historical Society, 1983.

_____. "The Lament of the Forest," *Knickerbocker* 17 (1841): 516-19.

_____. *Thomas Cole's Poetry* ed. Marshall Tymn. York: Liberty Cap Books, 1972.

Coleridge, Samuel Taylor. *Aids to Reflection*, with a preliminary essay by James Marsh; ed. Henry Nelson Coleridge. Port Washington: Kennikat Press, 1971 (1829).

_____. *Biographia Literaria*. London: Dent & Co., 1975 (1817).

_____. *Collected Letters of Samuel Taylor Coleridge. Volume IV: 1815-1819* ed. Earl Leslie Griggs. Oxford: Clarendon Press, 1959.

_____. *The Friend. Volume 4: The Collected Works of Samuel Taylor Coleridge* ed. Barbara Rooke. 2 volumes. Princeton: Princeton University Press, Bollingen Series 75.4, 1972.

_____. *The Lay Sermons. Volume 6: The Collected of Samuel Taylor Coleridge* ed. R.J. White. Princeton: Princeton University Press, Bollingen Series 75.6, 1972.

_____. *Letters of Samuel Taylor Coleridge. Volume II*. ed. Ernest Hartley Coleridge. London: William Heinemann, 1895.

_____. *Miscellaneous Criticism* ed. Thomas Middleton Raysor. Cambridge: Harvard University Press, 1936.

_____. *The Notebooks of Samuel Taylor Coleridge. Volume 3, Parts 1 and 2: 1808-1819* ed. Kathleen Coburn. Princeton: Bollingen Series 50, Princeton University Press, 1973.

_____. *The Portable Coleridge* ed. Ivor A. Richards. New York: Viking Penguin Inc., 1977.

_____. *Shakespearean Criticism*, 2 volumes, ed. Thomas Middleton Raysor. Cambridge: Harvard University Press, 1930.

_____. *Unpublished Letters of Samuel Taylor Coleridge* ed.

Noble, Louis Legrand. *After Icebergs with a Painter*. New York: D. Appleton, 1861.

_____. *Church's Painting. "The Heart of the Andes."* New York: D. Appleton, 1859.

_____. "Cole's Dream of Arcadia," *Bulletin of The American Art-Union*. (November 1849): 23-27.

_____. [ascribed to]. *"The Iceberg of Torbay,"* *Atlantic Monthly* 6.10 (1870): 443-8.

_____. *Lady Angeline; A Lay of the Appalachians*. New York: Sheldon, Blakeman and Company, 1846.

_____. *The Life and Works of Thomas Cole* ed. Elliott S. Vessell. Cambridge: Belknap Press of Harvard University Press, 1964 [1853].

_____. "The Titan's Goblet" in *The Titan's Goblet by Thomas Cole*. Brooklyn: J.M. Falconer, 1886; pp. 5-7. Exhibition catalogue.

Contemporary Sources

Abbott, Gorham D. *The Voyage of Life, A Series of Allegorical Pictures, Entitled "Childhood," "Youth," "Manhood," and "Old Age", Painted by the Late Lamented*

Contemporary Sources

Abbott, Gorham D. *The Voyage of Life, A Series of Allegorical Pictures, Entitled "Childhood," "Youth," "Manhood," and "Old Age", Painted by the Late Lamented Thomas Cole of Catskill,New York, Engraved in the Highest Style of Art by James Smillie of New York, New York.* New York: The [Splinger] Institute, 1856.

"Affairs of the Association, Opening of the Autumn Exhibition. Response of Rev. Samuel Osgood to President Cozzens' toast: "Christian Art, the ally of religion," *Bulletin of American Art Union* 3 (1851): 117.

Albro Rev. John Adams. *The Blessedness of Those Who Die in the Lord. A Sermon Occasioned by the Death of Washington Allston, Delievered in the Church of the Shepard Society, Cambridge, July 16, 1843.* Boston: Little and Brown, 1843.

"Allegory in Art," *The Crayon* 3.3 (April 1856): 114-115.

"American Painters--Frederick Edwin Church, N.A.," *The Art Journal* (1878): 153-68.

"Art and Artists of America," *Christian Examiner* 75 (1863): 114-7.

"American Art," *The Illustrated Magazine of Art* 3 (1854): 211-6.

"The Art of American and the 'Old Masters'," *Christian Examiner* 73 (1862): 63-84.

"The Artists of America," *The Crayon* 7.2 (February 1860): 44-55. Extracted from *New American Cyclopedia.*

Baird, Robert. *Religion in America*. Introduction by Henry Warner Bowden. New York: Harper and Row, 1970 (1856).

Bartol, Cyrus Alexander. *Pictures of Europe, Framed in Ideas*. Boston: Crosby, Nichols, and Co., 1856 (2nd ed.).

"The Beecher Collection," *The Critic* 11.201 (October 29, 1887): 221-2; 11.203 (November 19, 1887): 264; and 11.204 (November 26,1887): 276.

Beecher, William C. and Samuel Scoville. *A Biography of Henry Ward Beecher*. New York: Webster and Company, 1888.

Bethune, George Washington. "The Prospects of Art in the United States." Philadelphia: The Artists' Fund Society, 1840.

Brook, James. "Our Own Country," *Knickerbocker New-York Monthly Magazine* 5 (1835): 46-56.

"'The Brushes He Painted With That Last Day Are There...': Jasper F.Cropsey's Letter to His Wife, Describing Thomas Cole's Home and Studio, July 1850," *American Art Journal* 16.3 (1984): 78-82.

Bryant, William Cullen. *A Funeral Oration Occasioned by the Death of Thomas Cole Delivered Before the National Academy of Design, New York, May 4, 1848.* New York: Appleton and Company, 1848.

C.W. "Washington Allston," *The Christian World* July 22, 1843, np.

Channing, William Ellery. *Memoirs of William Ellery Channing. Volumes I-III.* Boston: Crosby and Nichols, 1848.

"Chapel and Church Architecture," *The Crayon* 6.10 (November 1859): 307-8.

Cheney, Mary Bushnell. *The Life and Letters of Horace Bushnell*. New York: Arno Press, 1969 (1880).

"Christianity and the Fine Arts," *The Crayon* 6.10 (October 1859): 307-8.

Cummings, Thomas A. *Historic Annals of the National Academy of Design, New-York Drawing Association, Etc., with Occasional Dottings by the Way-Side, From 1825 to the Present Time.* Philadelphia: George W. Childs, Publisher, 1865.

Derby, James C. *Fifty Years Among Authors, Books and Publishers.* New York: G.W. Carleton and Company, 1884.

Dewey, Orville. *The Old World and the New; or, A Journal of Reflections and Observations Made on a Tour in Europe. Volumes I-II.* New York: Harper & Brothers, 1836.

Duffy, John J., ed. *Coleridge's American Disciples. The Selected Correspondence of James Marsh.* Amherst: University of Massachusetts Press, 1973.

Dunlap, William. *History of the Rise and Progress of the Arts of Design in the United States. Volumes I-II.* New York: Dover, 1969 (1834).

Editorial. "Christian Art," *The Crayon* 7.7 (July 1860): 183-8.

_____. "Christianity and the Formative Arts," *The Crayon* 6.11 (November 1859): 325-32; and 6.12 (December 1859): 357-67.

_____. "The Creed of Art," *The Crayon* 2.21 (November 1855): 319.

_____. "Duty in Art," *The Crayon* 1.4 (January 1855): 49-50.

_____. "Religious Art," *The Crayon* 2.23 (December 1855): 351.

_____. "The Revelation of Art," *The Crayon* 2.22 (November 1855): 335-6.

Eidlitz, Leopold. "Christian Architecture," *The Crayon* 5.2 (February 1858): 53-58.

Ellinwood, T.J., ed. *Autobiographical Reminiscenes of Henry Ward Beecher.* New York: F.A. Stokes, Co., 1898.

Emerson, Ralph Waldo. *The Journals and Miscellaneous Notebooks of Ralph Waldo Emerson, Volume IV* ed. Alfred R. Ferguson. Cambridge: Harvard University Press, 1964.

_____. *The Portable Emerson* ed. Carl Bode and Malcolm Cowley. New York: Viking Penguin Inc., 1981 (1959).

Exhibition of the Paintings of the late Thomas Cole at the Gallery of the American Art-Union. New York: Snowden and Prael, 1848. Exhibition catalogue.

Exhibition of Pictures Painted by Washington Allston. Harding's Gallery. Boston: John H. Eastburn, 1839. Exhibition catalogue.

Felton, Cornelius Conway, *"Allston's Poems and Lectures on Art," North American Review* 71 (1850): 149-68.

_____. *"Monaldi. A Tale." North American Review* 54 (1842): 397-419.

Flagg, Jared B. *The Life and Letters of Washington Allston.* New York: Benjamin Blom. 1969 (1892).

Fuller, Margaret. *The Letters of Margaret Fuller. Volume II: 1839-1841* ed. Robert N. Hudspeth. Ithaca: Cornell University Press, 1983.

Fuller, Sarah Margaret. "A Record of Impressions Produced by the Exhibition of Mr. Allston's Pictures in the Summer of 1839," *The Dial* 1.1 (1840): 73-83.

Greene, George Washington. *Biographical Studies.* New York: G.P. Putnam, 1860.

_____. [ascribed to]. "The Voyage of Life, Course of Empire and Other Pictures of Thomas Cole," *North American Review* 77 (1853):302-31.

Hemans, Felicia. *Poetical Works of Felicia Hemans.* Boston: Phillips, Samson and Co., 1867.

Fuller, Sarah Margaret. "A Record of Impressions Produced by the Exhibition of Mr. Allston's Pictures in the Summer of 1839," *The Dial* 1.1 (1840): 73-83.

Greene, George Washington. *Biographical Studies*. New York: G.P. Putnam, 1860.

_____. [ascribed to]. "The Voyage of Life, Course of Empire and Other Pictures of Thomas Cole," *North American Review* 77 (1853):302-31.

Hemans, Felicia. *Poetical Works of Felicia Hemans*. Boston: Phillips, Samson and Co., 1867.

_____. *The Poetical Works of Mrs. Felicia Hemans Complete in One Volume*. Philadelphia: Claxton, Ramsen and Haffelfinger, 1876.

The Home Book of the Picturesque: Or American Scenery, Art, And Literature. Facsimile reproduction with an introduction by Motley F. Deaver. Gainesville: Scholars' Facsimile and Reprints, 1967 (1852).

Higginson, Thomas Wentworth. *Margaret Fuller Ossoli*. New York: Greenwood Press, 1968 (1890).

Holmes, Oliver Wendell. "The Allston Exhibition," *North American Review* 50 (1840): 358-82.

Howard, John R. *Remembrance of Things Past, a Familiar Chronicle of Kinsfolk and of Folks Worthwhile*. New York: Thomas Y. Crowell, 1925.

Howe, Julia Ward. *Margaret Fuller (Marchesa Ossoli)*. Westport: Greenwood Press, 1970 (1883).

_____. *Reminiscences, 1819-1899*. New York: Houghton-Mifflin, 1899.

Huntington, J. "The Allston Exhibition. A Letter to an American Artist, Travelling Abroad." *Knickerbocker Magazine* 14 (1839): 163-74.

Irving, Washington. "A Biographical Sketch of Washington Allston, with three letters from Washington Irving to E.A. Duyckinck." Handwritten, unpublished manuscript in the E.A. Duyckinck Papers, Archives of American Art, Smithsonian Institution, Washington, D.C. Microfilm Roll #DDU, Frame Numbers 701-31. Original manuscript in the Manuscript Division, New York Public Library, New York.

Jameson, Anna B. *The History of Our Lord as Exemplified in Works of Art*. London: Longman, Green, Longman, Roberts, and Green, Volume I, 1864; Volume II, 1865.

_____. "Memoir of Washington Allston, and His Axioms on Art" in *Memoirs and Essays illustrative of art, literature and social morals*. London: Richard Bentley, 1846; pp. 159-206.

_____. "Washington Allston" in *Atheneum*, Part One: 845 (January 6, 1844): 15-16; Part Two 846 (January 13, 1844): 39-41.

Jarves, James Jackson. *The Art-Idea*. ed. Benjamin Rowland. Cambridge: Belknap Press of Harvard University Press, 1960.

_____. *Art Thoughts*. Cambridge: Riverside Press, 1887.

_____. [ascribed to] "Can We Have An Art Gallery?" *Christian Examiner* 72 (March 1862): 204-23.

A Landscape Book by American Artists and American Authors. New York: Garland Publishing, 1976 (1868). Facsimile edition.

Lanman, Charles. *Letters from a Landscape Painter*. Boston: James Munroe and Company, 1845.

Munger, Theodore T. *Horace Bushnell, Preacher and Theologian.* New York: Houghton, Mifflin and Company, 1899.

The North. Painted by F.E. *Church from Studies of Icebergs made in the Northern Seas in the Summer of 1859.* Announcement of Engraving Subscription, nd.

Osgood, Samuel. "Art in its Relation to American Life," *The Crayon* 2.3 (July 1855): 54-55.

_____. "Our Artists," *Harper's New Monthly Magazine* 28 (1863-4): 240-6.

Ossoli, Sarah Margaret (Fuller). *Art, Literature, and the Drama* ed. Arthur B. Fuller. Boston: Roberts Brothers, 1889.

_____. *Papers on Literature and Art.* New York: Wiley and Putnam, 1846.

Parker, H.W. "A Natural Theology of Art, The Moral Significance of the Crystal Palace," *North American Review* 79 (July 1854): 1-30.

Peabody, Elizabeth Palmer. *Last Evening with Allston, and Other Papers.* Boston: D. Lothrop & Co., 1886.

_____. *Reminiscences of Rev. Wm. Ellery Channing, D.D.* Boston: Roberts Brothers, 1880.

Peck, G.W. "Monaldi," *The American Whig Review* 7.4 (1848): 341-57.

_____. "Lectures on Art, and Poems," *The American Whig Review* 10.4 (1850): 17-32.

Porter, Noah, Jr. "Coleridge and His American Disciples," *Bibliotheca Sacra and Theological Review* 4 (1847): 117-71.

R.C.W. "American Art and Art Unions," *Christian Examiner* 48 (March 1850): 205-23.

Rensselaer, Mariana G. van. "Washington Allston, A.R.A.," *Magazine of Art* 12 (1889): 145-50.

Rio, Alexis François. *The Poetry of Christian Art.* London: T. Bosworth, 1854.

Rockwell, Rev. Charles. *The Catskill Mountains and the Region Around. Their Scenery, Legends and History; with sketches in Prose and Verse by Cooper, Irving, Bryant, Cole, and Others.* New York: Taintor Brothers and Co., 1869, revised edition (1867).

Schleiermacher, Friedrich. *The Christian Faith in Outline.* Edinburgh: W.F. Henderson Publishers, 1922.

_____. "On the Discrepancy between the Sabellian and the Athanasian Method of Representing the Doctrine of the Trinity," *The Biblical Repository Quarterly Observer* 5.18 (1835): 265-353; 6.19 (1836): 1-116. Translated by Moses Stuart.

Shenstone, N.A., ed. *Anecdotes of Henry Ward Beecher.* Chicago: Donohue and Henneberry, 1887.

Simms, W.H. "The Writings of Washington Allston," *The Southern Quarterly Review* 4.8 (1843): 363-414.

Simons, G.F. "Prospects of Art in this Country," *The Christian Examiner* 25 (January 1839): 304-20.

"Sketchings: Religion and Art in Their Philosophical Relations," *The Crayon* 3.8 (August 1856): 248-9.

"Statement of the Trustees of Plymouth Church to Architects," *The Crayon* 6.5 (May 1859): 155-7.

Simons, G.F. "Prospects of Art in this Country," *The Christian Examiner* 25 (January 1839): 304-20.

"Sketchings: Religion and Art in Their Philosophical Relations," *The Crayon* 3.8 (August 1856): 248-9.

"Statement of the Trustees of Plymouth Church to Architects," *The Crayon* 6.5 (May 1859): 155-7.

Sturgis, Russell, Jr. *Manual of the Jarves Collection of Early Italian Pictures, Deposited in the Gallery of The Yale School of the Fine Arts.* New Haven: Yale College, 1868.

"Thomas Cole Is No More: A Letter from John Falconer to Jasper Cropsey, February 24, 1848," *American Art Journal* 15.4 (1983): 74-76.

Tuckerman, Henry T. *Artist-Life: or Sketches of American Painters.* New York: D. Appleton & Company, 1847.

_____. *Book of the Artists.* New York: G.P. Putnam and Son, 1870 (1867).

Ware, William. *Lectures on the Works and Genius of Washington Allston.* Boston: Phlips, Sampson and Company, 1852.

Waterbury, Jared Bell. *The Voyage of Life, Suggested by Cole's Celebrated Allegorical Paintings.* Boston: Massachusetts Sabbath School Society, 1852.

Weeks, Robert. *Old St. Luke's--A Reminiscent Address by the Rev. Robert Weeks. June 4, 1899.* Pamphlet printed by St. Luke's Episcopal Church, Catskill, 1899.

White, A.D. "Architecture: Cathedral Builders and Medieval Sculptors," *The Crayon* 5.11 (November 1858): 320-1. Extracted from a report in *The New York Tribune.*

White, Richard Grant. *Companion to the Bryan Gallery of Christian Art.* New York: Baker, Godwin and Company, 1853.

Winthrop, Theodore. *A Companion to The Heart of the Andes.* New York: D. Appleton and Company, 1859.

Secondary Works

Abbott, Lyman, ed. *Henry Ward Beecher: A Sketch of His Career.* New York: Funk and Wagnalls, 1883.

Abrams, Meyer H. *The Mirror and the Lamp. Romantic Theory and the Critical Traditition.* New York: Oxford University Press, 1953.

_____. *Natural Supernaturalism: Tradition and Revolution in Romantic Literature.* New York: Norton, 1971.

Achen, Sven Tito. *Symbols Around Us.* New York: Van Nostrand Reinhold, 1978.

Adams, Doug. "Environmental Concerns and Ironic Views of American Expansionism Portrayed in Thomas Cole's Religious Paintings" *in Environment and Vision: Transforming the Christian Creation Tradition* eds. Philip N. Joranson and Ken Butigan. Santa Fe: Bear Press, 1984; pp. 296-305.

_____. *Humor in the American Pulpit from George Whitefield Through Henry Ward Beecher.* Austin: The Sharing Company, 1986 (1975).

_____. "Meaning in Kellogg Lithographs and New England Sentiment" in *Kellogg Lithographs Checklist* ed. Jacques Schurre, forthcoming.

Ahlstrom, Sydney. *A Religious History of the American People*. New Haven: Yale University Press, 1966.

Albanese, Catherine. *Corresponding Motion*. Philadelphia: Temple University Press, 1977.

Allston, Elizabeth Deas. *The Allstons and Alstons of Waccamaw*. Charleston: Walker, Evans and Cogswell, 1936.

"American Paintings from the Collection of John J. McDonogh," *Antiques* 112.5 (1977): 946-53.

The American Tradition. Part I: Paintings of the eighteenth and nineteenth centuries. New York: Kennedy Galleries, 1982. Exhibition catalogue.

Anders, Sarah F. "Role of Women in American Religion," *Southwest Journal of Theology* 18 (1976): 51-61.

Anderson, Dennis. *Three Hundred Years of American Art in the Chrysler Museum*. Norfolk: Chrysler Museum, 1976. Exhibition catalogue.

Anderson, Patricia. *The Course: the Erie Canal and the American Landscape, 1825-1872*. Rochester: Memorial Art Gallery, University of Rochester, 1984. Exhibition catalogue.

Andrews, Wayner and Garnett McCoy. "Romantic America and the Discovery of Nature, 1825-1860," *Art in America* 53 (1965): 38-53.

Annual II: Studies on Thomas Cole, An American Romanticist. Baltimore: Baltimore Museum of Art, 1967.

Aries, Philippe. Centuries of Childhood. *A Social History of Family Life*. New York: Vintage Books, 1965.

Armour, Richard W. and Raymond F. Howes. *Coleridge the Talker*. New York: Johnson Reprint Corporation, 1969 (1940).

Art and Commerce: American Prints of the Nineteenth Century. Charlottesville: University Press of Virginia, 1978.

Avery, Kevin J. "The Heart of the Andes Exhibited: Frederic E. Church's Window on the Equatorial World," *American Art Journal* 18.1 (1986): 52-72.

Baigell, Matthew. "Frederic Church's 'Hooker and Company': Some Historic Considerations," *Arts* 56.5 (1982): 124-5.

_____. *Thomas Cole*. New York: Watson-Guptill, 1981.

_____. and Allen Kaufman. "Thomas Cole's *The Oxbow*: A Critique of American Civilization," *Arts* 55.5 (1981): 136-9.

Barasch, Moshe. *Light and Color in the Italian Renaissance Theory of Art*. New York: New York University Press, 1978.

Barbour, Brian M., ed. *American Transcendentalism: An Anthology of Criticism*. Indiana: University of Notre Dame Press, 1973.

Barzun, Jacques. *Classic, Romantic, and Modern*. Chicago: University of Chicago Press, 1975 (1943).

Baym, Nina. *Novels, Readers, and Reviewers: Responses to Fiction in Antebellum America*. Ithaca: Cornell University Press, 1984.

_____. *Woman's Fiction. A Guide to Novels by and about Women in America, 1820-1870*. Ithaca: Cornell University Press, 1978.

The Beckoning Land. Nature and the American Artist. A Selection of Nineteenth Century Paintings. Atlanta: The High Museum of Art, 1971.

Barzun, Jacques. *Classic, Romantic, and Modern*. Chicago: University of Chicago Press, 1975 (1943).

Baym, Nina. *Novels, Readers, and Reviewers: Responses to Fiction in Antebellum America*. Ithaca: Cornell University Press, 1984.

_____. *Woman's Fiction. A Guide to Novels by and about Women in America, 1820-1870*. Ithaca: Cornell University Press, 1978.

The Beckoning Land. Nature and the American Artist. A Selection of Nineteenth Century Paintings. Atlanta: The High Museum of Art, 1971.

Bednarowski, Mary Farrell. "Women in American Religious History," *American Theological Library Association Proceedings* 34 (1980): 102-4.

_____. "Outside the mainstream: Women's religion and women religious leaders in nineteenth-century America," *Journal of the American Academy of Religion* 48 (1980): 207-31.

Bell, Michael David. *The Development of American Romance. The Sacrifice of Relation*. Chicago: University of Chicago Press, 1980.

Bellah, Robert. *The Broken Covenant: Varieties of Civil Religion in America*. New York: Harper and Row, 1975).

Bercovitch, Sacvan. "The Biblical Basis of the American Myth" in *The Bible in American Arts and Letters* ed. Giles B. Gunn. Philadelphia and Chico: Fortress Press and Scholars Press, 1984; pp. 221-

_____. *The Puritan Origin of the American Self*. New Haven: Yale University Press, 1975.

Bevan, Edwyn. *Symbolism and Belief*. Boston: Beacon Press, 1957 (1938).

Bjelajac, David Voss. "Washington Allston's Masterpiece *Belahsazzar's Feast* (1817-1843): Millenial Desire and Social Conservativism in The New American Israel." Unpublished Ph.D. dissertation, The University of North Carolina, 1984.

Bjelajac, David. *Millenial Desire and the Apocalyptic Vision of Washington Allston*. Washington, D.C.: Smithsonian Institution Press, 1988.

Blackmun, George L. *St. Paul's Cathedral, A Center for Mission of the Episcopal Diocese of Massachusetts*. Pamphlet, nd., np.

Boas, Ralph P. "The Romantic Lady" in *Romanticism in America* ed. George Boas. New York: Russell & Russell, 1961; pp. 63-88.

Bosch-Supan, Helmut. *Caspar David Friedrich*. New York: George Braziller, 1974.

Bridges, William E. "Family Patterns and Social Values in America, 1825-1875," *American Quarterly* 17.1 (1965): 3-11.

Brown, David Alan. *Raphael and America*. Washington, D.C.: The National Gallery of Art, 1983. Exhibition catalogue.

Brown, E.K. "Archetypes and Stereotypes: Church Women in the Nineteenth-Century," *Religion in Life* 43 (1974): 325-36.

Burke, Doreen Bolger. "Frederic Edwin Church and 'The Banner of Dawn'," *American Art Journal* 14.2 (1982): 39-46.

Callow, James T. *Kindred Spirits: Knickerbocker Writers and American Artists, 1807-1855*. Chapel Hill: University of North Carolina Press, 1967.

Canady, John. *Metropolitan Seminars on Art. Portfolio #12: The Artist As A Visionary*. New York: The Metropolitan Museum of Art, 1959.

Caskey, Marie, *Chariot of Fire. Religion and the Beecher Family.* New Haven: Yale University Press, 1978.

Caspar David Friedrich. New York: German Library of Information, 1940.

Caspar David Friedrich, Kunst im 1800. Munich: Prestel-Verlag, 1974. Exhibition catalogue.

Caspar David Friedrich und Sein Kreis. Tokyo: Museum of Modern Art, 1978. Exhibition catalogue.

Cenkner, William, "Understanding the Religious Personality," *Horizons* V (1978): 1-16.

Chambers, Bruce D. "Thomas Cole and the Ruined Tower," *The Currier Gallery of Art Bulletin.* Manchester: The Currier Gallery of Art, 1983. Exhibition catalogue.

Chase, George Davis. "Some Washington Allston Correspondence," *The New England Quarterly* 16 (1943): 628-34.

Cherry, Conrad. *Nature and Religious Imagination from Edwards to Bushnell.* Philadelphia: Fortress Press, 1966.

Chmaj, Betty E. "The Journey and the Mirror: Emerson and the American Arts," *Prospects* 10 (1985): 353-408.

Christy, Arthur. *The Orient in American Transcendentalism: A Study of Emerson, Thoreau, and Alcott.* New York: Octagon Books, 1978 (1932).

Cikovski, Nicolai, Jr. "'The Ravages of the Axe': The Meaning of the Tree Stump in Nineteenth-Century American Art," *Art Bulletin* 61.4 (1979): 611-26.

Clark, Jr., Clifford E. "The Changing Nature of Protestantism in Mid-Nineteeth Century America: Henry Ward Beecher's Seven Lectures to Young Men," *Journal of American History* 57.4 (1971): 832-46.

_____. "Domestic Architecture as an Index to Social History: The Romantic Revival and the Cult of Domesticity in America, 1840-1870," *Journal of Interdisciplinary History* 7.1 (1976): 33-56.

_____. Henry Ward Beecher, *Spokesman for a Middle-Class America.* Chicago: University of Illinois Press, 1978.

Clark, Kenneth. *Landscape into Art.* New York: Harper and Row, 1979 (1949).

_____. *The Romantic Rebellion. Romantic versus Classical Art.* New York: Harper and Row, 1973.

Clark, Marcia. "A Visionary Artist Who Celebrated America," *Smithsonian Magazine* (1975): 90-97.

Clarke, John R., "An Italian Landscape by Thomas Cole," *Arts* 54.5 (1980): 116-20.

Clebsch, William. *From Sacred to Profane America.* Chico: Scholars Press, 1981 (1968).

Coburn, Kathleen, ed. *Inquiring Spirit: A Coleridge Reader.* New York: Minerva Books, 1968 (1953).

_____. "Notes on Washington Allston from the Unpublished Notebooks of S.T. Coleridge," *Gazette des Beaux Arts* 25 (1944): 249-52.

Coen, Rena M., "Cole, Coleridge and Kubla Khan," *Art History* 3.2 (1980): 218-28.

Cohn, Marjorie B. *Francis Calley Gray and Art Collecting for America.* Cambridge: Harvard University Press, 1986.

Cook, Kathryn Gill. "'A Past Always Present' Coleridge on Human Development and Education." Unpublished Ph.D. dissertation, The George Washington University, 1983.

_____. "Notes on Washington Allston from the Unpublished Notebooks of S.T. Coleridge," *Gazette des Beaux Arts* 25 (1944): 249-52.

Coen, Rena M., "Cole, Coleridge and Kubla Khan," *Art History* 3.2 (1980): 218-28.

Cohn, Marjorie B. *Francis Calley Gray and Art Collecting for America*. Cambridge: Harvard University Press, 1986.

Cook, Kathryn Gill. "'A Past Always Present' Coleridge on Human Development and Education." Unpublished Ph.D. dissertation, The George Washington University, 1983.

Craven, Wayne. "Asher B. Durand's Imaginary Landscapes," *Antiques* 116.5 (1979): 1120-7.

_____. "Luman Reed, Patron: His Collection and Gallery," *American Art Journal* 12.2 (1980): 40-59.

_____. "Thomas Cole and Italy," *Antiques* 114.5 (1978): 1016-27.

Crean, Hugh R. "Agony's Crown Attained: Thomas Cole and the Double Work of Art," *Arts* 56.3 (1981): 90-93.

Cross, Barbara M. *Horace Bushnell: Minister to a Changing America*. Chicago: University of Chicago Press, 1958.

Cross, Whitney R. *The Burned-Over District*. New York: Harper Torchbook, 1950.

Curti, Merle. *The Growth of American Thought*. New York: Transaction Press, 1951 (1943).

Czestochowski, Joseph S. *The American Landscape Tradition. A Study and Gallery of Paintings*. New York: E.P. Dutton, 1982.

_____. *The Pioneers: Images of the Frontier*. New York: E.P. Dutton, 1977.

Dana, H.W.L. "Allston at Cambridgeport," *Cambridge Historical Society Proceedings* 29 (1943): 34-67.

_____. "Allston at Harvard, 1796-1800," *Cambridge Historical Society Proceedings* 29 (1943): 13-33.

Davidson, Abraham A. *The Eccentrics and Other American Visionary Painters*. New York: E.P. Dutton, 1978.

Davidson, Cathy. *Revolution and the Word. The Rise of the Novel in America*. New York: Oxford University Press, 1986.

Davidson, Cathy N., Special Editor. "Special Issue: Reading America," *American Quarterly* 40.1 (1988).

Davidson, Marshall. "Whither the Course of Empire?," *American Heritage* 8.6 (1957): 52-61, 104.

Davis, John. "Frederic Church's 'Sacred Geography'," *Smithsonian Studies in American Art* 1.1 (1987): 79-96.

Dean, Dennis R. "The Influence of Geology on American Literature and Thought" in *Two Hundred Years of Geology in America* ed. Cecil J. Schneer. Hanover: University of New Hampshire Press, 1979; pp. 289-303.

Dee, Elaine Evans. *To Embrace the Universe: Drawings by Frederic Edwin Church*. Yonkers: The Hudson River Museum, 1984. Exhibition catalogue.

Degler, Carl N. *At Odds. Women and the Family in America from the Revolution to the Present*. New York: Oxford University Press, 1980.

Dillenberger, Jane and Joshua C. Taylor. *The Hand and the Spirit: Religious Art in America, 1700-1900* (Berkeley: University Art Museum, 1972). Exhibition catalogue.

Dillenberger, Jane. *Style and Content in Christian Art*. New York: Crossroad Publishing, 1986 (1966).

Dillenberger, John. *The Visual Arts And Christianity In America. From The Colonial Period Through The Nineteenth-Century*. Chico: Scholars Press, 1984.

Dixon, John W., Jr. "The Bible in American Painting" in *The Bible and American Arts and Letters* ed. Giles B. Gunn. Philadelphia and Chico: Fortress Press and Scholars Press, 1984; pp. 159-188.

Douglas, Ann. *The Feminization of American Culture*. New York: Alfred P. Knopf, 1977.

Driscoll, John Paul. *All That Is Glorious Around Us*. University Park: The Pennsylvania State University, 1981. Exhibition catalogue.

Duke, James O. *Horace Bushnell on the Vitality of Biblical Language*. Chico: Scholars Press, 1984.

Dulles, Avery. *Revelation Theology*. New York: The Seabury Press, 1969.

Dunn, Esther H. "Thomas Cole--A Man and His Mountain," *The Conservationist* 17.5 (1963): 2-7.

Dwight, Edward H. and Ricgard J. Boyle, "Rediscovery: Thomas Cole's 'Voyage of Life'," *Art in America* 55 (1967): 60-63.

Eager, Gerald. "The Iconography of the Boat in 19th-Century American Painting," *Art Journal* 35.3 (1976): 224-30.

_____. "Washington Allston's *The SIsters*: Poetry, painting, and friendship," *Word and Image* 6.4 (1990): 298-307.

Edwards, Lee M. Domestic Bliss. *Family Life in American Painting, 1840-1910*. Yonkers: The Hudson River Museum, 1986. Exhibition catalogue.

Eigner, Edwin M. *The Metaphysical Novel in England and America. Dickens, Bukwer, Hawthorne, Melville*. Berkeley: University of California Press, 1978.

Eitner, Lorenz. "The Open Window and the Storm-Tossed Boat: An Essay in the Iconography of Romanticism," *Art Bulletin* 37.4 (1955): 281-90.

Eliade, Mircea. *A History of Religious Ideas. Volume III: From Muhammed to the Reformers*. Chicago: University of Chicago Press, 1985.

_____. *Images and Symbols: Studies in Religious Symbolism*. New York: Harper and Row, 1961.

_____. *The Myth of the Eternal Return, or Cosmos and History*. Princeton: Princeton University Press, Bollingen Series 46, 1971 (1954).

_____. *Myths, Dreams and Mysteries. The Encounter between Contemporary Faiths and Archaic Realities*. New York: Harper and Row, 1975 (1960).

_____. *Patterns in Comparative Religion*. New York: World Publishing, 1958.

_____. *The Quest. History and Meaning in Religion*. Chicago: University of Chicago Press, 1975 (1969).

_____. *The Sacred and the Profane*. New York: Harcourt, Brace, Jovanovich, 1959 (1957).

Ellis, Elizabeth Garrity. "The 'Intellectual and Moral Made Visible': The 1839 Washington Allston Exhibition and Unitarian Taste in Boston," *Prospects* 10 (1985): 39-76.

_____. *Myths, Dreams and Mysteries. The Encounter between Contemporary Faiths and Archaic Realities.* New York: Harper and Row, 1975 (1960).

_____. *Patterns in Comparative Religion.* New York: World Publishing, 1958.

_____. *The Quest. History and Meaning in Religion.* Chicago: University of Chicago Press, 1975 (1969).

_____. *The Sacred and the Profane.* New York: Harcourt, Brace, Jovanovich, 1959 (1957).

Ellis, Elizabeth Garrity. "The 'Intellectual and Moral Made Visible': The 1839 Washington Allston Exhibition and Unitarian Taste in Boston," *Prospects* 10 (1985): 39-76.

Epstein, Barbara L. *The Politics of Domesticity: Women, Evangelism, and Temperance in Nineteenth-Century America.* Middletown: Wesleyan University Press, 1981.

Epstein, Suzanne Latt. "The Relationship of the American Luminists to Caspar David Friedrich." Unpublished M.A. thesis, Columbia University, 1964.

An Exhibition of Paintings by Thomas Cole N.A. from the artist's studio. Catskill, New York. New York: Kennedy Galleries, Inc., 1964. Exhibition catalogue.

Fair Ladies. A Salute to the World's Fair. Paintings, Drawings,and Sculpture of Three Centuries. New York: Charles Slatkin Galleries, 1964. Exhibition catalogue.

Feld, Stuart P. *Lines of Different Character. American Art from 1727 to 1947.* New York: Hirschl and Adler Galleries, Inc., 1983. Exhibition catalogue.

Felheim, Marvin. "Two Views of the Stage; or The Theory and Practice of Henry Ward Beecher," *New England Quarterly* 25 (1952): 314-26.

Ferber, Linda S. "Themes in American Genre Painting: 1840-1880," *Apollo* 115.242 (1982): 250-9.

Ferguson, George. *Signs and Symbols in Christian Art.* New York: Oxford University Press, 1966 (1954).

Ferm, Robert L., ed. *Issues in American Protestantism. A Documentary History from the Puritans to the Present.* New York: Doubleday Anchor, 1969.

Fink, Lois. "Children as Innocence from Cole to Cassatt," *Nineteenth Century* 3.4 (1977): 71-75.

Fitts, Deborah, "Una and the Lion: The Feminization of District School Teaching and its Effects on the Roles of Students and Teachers in Nineteenth Century America," *Regulated Children/Liberated Children* ed. Barbara Finkelstein. New York: Psychohistory Press, 1979: pp. 140-54.

Flexner, James Thomas. *History of American Painting. Volume 3: That Wilder Image (The Native School from Thomas Cole to Winslow Homer.* New York: Dover, 1970 (1962).

_____. *Nineteenth Century American Painting.* New York: G.P. Putnam, 1970.

Flint, Janet A. *The Way of Good and Evil. Popular Religious Lithographs Nineteenth-Century America.* Washington, D.C.: National Collection of Fine Arts, 1972. Exhibition catalogue.

Foshay, Ella M. and Sally Mills. *All Seasons and Every Light. Nineteenth Century American Landscapes from the Collection of Elias Lyman Magoon.* Poughkeepsie: Vassar College Art Gallery, 1983. Exhibition catalogue.

Gage, John, ed. *Goethe on Art*. Berkeley: University of California Press, 1980.

Garrett, Elayne Genishi. "The British Sources of American Luminism." Unpublished Ph.D. dissertation, Case Western Reserve University, 1982.

Geertz, Clifford. *The Interpretations of Culture*. New York: Basic Books, 1973.

Gemalde der Deustchen Romantik: Caspar David Friedrich, Karl Friedrich Schinkel, Carl Blecken. Berlin: Nationalgalerie, 1985. Exhibition catalogue.

Gerdts, William H. "Allston's 'Belshazzar's Feast'," *Art in America* 61.2 (1973): 59-66.

_____. "American Landscape Painting: Critical Judgements, 1730-1845," *American Art Journal* 17.1 (1985): 28-59.

_____. "The American 'Discourses': A Survey of Lectures and Writings on American Art, 1770-1858," *American Art Journal* 15.3 (1983): 61-79.

_____. "Belshazzar's Feast II: 'That is his shroud'," *Art in America* 61.3 (1973): 58-65.

_____. "Washington Allston and the German Romantic Classicists in Rome," *Art Quarterly* 32.2 (1969): 166-96.

_____ and Mark Thistlethwaite. *Grand Illusions. History Painting in America*. Fort Worth: Amon Carter Museum of Art, 1988.

_____ and Theodore E. Stebbins, Jr. "A Man of Genius" *The Art of Washington Allston (1779-1843)*. Boston: Museum of Fine Arts, 1979. Exhibition catalogue.

German Masters of the Nineteenth Century. Paintings and Drawings from the Federal Republic of Germany. New York: Metropolitan Museum of Art, 1981. Exhibition catalogue.

Gifford, Carolyn De Swarte, ed. *The American Ideal of the "True Woman" as Reflected in Advice Books to Young Women*. New York: Garland Publishing, Inc., 1987.

Gilmore, Michael T. *American Romanticism and the Marketplace*. Chicago: University of Chicago Press, 1985.

Glaser, Hermann, ed. *The German Mind of the 19th Century. A Philosophical and Historical Anthology*. New York: Continuum Publishing Company, 1981.

Glassie, Henry H. "Thomas Cole and Niagara Falls," *The New-York Historical Society Quarterly* 58.2 (1974): 88-111.

Goss, Peter L. "Olana--the artist as architect," *Antiques* 110.4 (1976): 764-75.

Greven Philip. *The Protestant Temperament. Patterns of Child-Rearing, Religious Experience, and The Self in Early America*. New York: Alfred P. Knopf, 1977.

Gunn, Giles B., ed. *The Bible in American Arts and Letters*. Philadelphia and Chico: Fortress Press and Scholars Press, 1984.

_____. *New World Metaphysics. Readings on the Religious Meaning of the American Experience*. New York: Oxford University Press, 1971.

_____. *New World Metaphysics and the Religious Interpretation of American Writing*. Tempe: Arizona State University, 1980. The University Lecture in Religion, October 16, 1980.

Gusdorf, Georges. "Conditions and Limits of Autobiography" in *Autobiography: Essays Theoretical and Critical* ed. James Olney. Princeton: Princeton University Press, 1980; pp. 28-48. Originally published as "Conditions et limites de l'autobiographie" in *Formen der Selbstdarstellung: Analekten zu einer Geschichte des literarischen Selbstportraits* ed. Gunther Ruchenkron and Erich Haase (West Germany: Duncker and Humblot, 1956).

Gunn, Giles B., ed. *The Bible in American Arts and Letters*. Philadelphia and Chico: Fortress Press and Scholars Press, 1984.

_____. *New World Metaphysics. Readings on the Religious Meaning of the American Experience*. New York: Oxford University Press, 1971.

_____. *New World Metaphysics and the Religious Interpretation of American Writing*. Tempe: Arizona State University, 1980. The University Lecture in Religion, October 16, 1980.

Gusdorf, Georges. "Conditions and Limits of Autobiography" in *Autobiography: Essays Theoretical and Critical* ed. James Olney. Princeton: Princeton University Press, 1980; pp. 28-48. Originally published as "Conditions et limites de l'autobiographie" in *Formen der Selbstdarstellung: Analekten zu einer Geschichte des literarischen Selbstportraits* ed. Gunther Ruchenkron and Erich Haase (West Germany: Duncker and Humblot, 1956).

Gussow, Alan. *A Sense of Place: The Artist and the American Landscape*. New York: The Seabury Press, 1971.

Halttunen, Karen. *Confidence Men and Painted Women. A Study of Middle-Class Culture in America, 1830-1870*. New Haven: Yale University Press, 1982.

Hannah Winthrop Chapter, Daughters of the American Revolution. *An Historic Guide to Cambridge*. Cambridge: Hannah Winthrop Chapter, DAR, 1907.

Hanson, Bernard. *Frederic Edwin Church: The Artist at Work*. Hartford: University of Hartford, 1974. Exhibition catalogue.

Happel, Stephen P. *Coleridge's Religious Imagination*. Salzburg: Institut fur Anglistik und Amerikonistck, 1983.

_____. "The Function of Imagination in Religious Discourse: An Historical-Critical Study of the Theological Development of Samuel Taylor Coleridge." Unpublished S.T.D. dissertation, Katholieke Universiteit Te Leuven, 1977. Volumes I-IV.

Harbison, Craig S. *The Last Judgement in Sixteenth Century Northern Europe: A Study of the Relation Between Art and the Reformation*. New York: Garland Press, 1976.

Harris, Neil. *The Artist in American Society, The Formative Years, 1790-1860*. Chicago: University of Chicago Press, 1982 (1966).

Heinninger, Mary Lynn Stevens, ed. *A Century of Childhood, 1820-1920*. Rochester: The Margaret Woodbury Strong Museum, 1984. Exhibition catalogue.

Heslip, Michael. "Conservation Notes on *Cotopaxi*," Bulletin of The Detroit Institute of Arts 56.3 (1978): 196-8.

Hess, Thomas B. and John Ashbery, ed. *Light: From Aten to Laser. Art News Annual* 35 (1969). New York: Macmillan Company, 1969.

Hess, Thomas B. and Linda Nochlin. *Woman as Sex Object. Studies in Erotic Art, 1730-1790*. New York: Newsweek, 1972.

Hibben, Paxton. *Henry Ward Beecher: An American Portrait*. New York: Doran Company, 1927.

Holcomb, Adele M. "Anna Jameson on Women Artists," *Woman's Art Journal* 8.2 (1987/88): 15-24.

_____. "John Sell Cotman's *Dismasted Brig* and the Motif of the Drifting Boat," *Studies in Romanticism* 14.1 (1975): 29-40.

Hood, Graham. "Thomas Cole's Lost *Hagar*," *American Art Journal* 1.2 (1969): 41-52.

Hulme, F. Edward. *The History, Principles and Practice of Symbolism in Christian Art.* Detroit: Gail Research Company, 1969 (1891).

Huntington, David Carew. *Art and the Excited Spirit: America in the Romantic Period.* Ann Arbor: University of Michigan Museum, 1972. Exhibition catalogue.

_____. "Church and Luminism: Light for America's Elect" in *American Light. The Luminist Movement, 1850-1875. Paintings, Drawings, Photographs* ed. John Wilmerding. Washington, D.C.: National Gallery of Art, 1980; 155-90. Exhibition catalogue.

_____. "Frederic Edwin Church, 1826-1900. Painter of the Adamic New World." Unpublished Ph.D. dissertation, Yale University, 1960.

_____. "Frederic Church's *Niagara*: Nature and the Nation's Type," *Texas Studies in Literature and Language* 25.1 (1983): 100-38.

_____. "Landscape and Diaries: The South American Trips of F.E. Church," *The Brooklyn Museum Annual* 5 (1963-1964): 65-98.

_____. *The Landscapes of Frederic Edwin Church. Vision of an American Era.* New York: George Braziller, 1966.

_____. "Olana. The Estates of the Painter Frederic Edwin Church." Mimeographed text. September, 1964.

Hutchinson, William R. *The Modernist Impulse in American Protestantism.* New York: Oxford University Press, 1982 (1976).

Hutton, William. *Heritage and Horizon: American Painting, 1776-1976.* Buffalo: Albright-Knox Art Gallery, 1976. Exhibition catalogue.

The Influence of Spiritual Inspiration on American Art. Vatican City: Libreria Editrice, 1977. Conference Proceedings.

Johns, Elizabeth. "Washington Allston's *Dead Man Revived*," *The Art Bulletin* 61.1 (1979): 78-99.

_____. "Washington Allston's Later Career: Art About the Making of Art," *Arts* 54.4 (1979): 122-9.

_____. "Washington Allston's Library," *American Art Journal* 7.2 (1975): 32-41.

_____. "Washington Allston: The Artist as Philosopher" in *The Paintings of Washington Allston.* Miami: Lowe Art Museum, 1975: 13-17. Exhibition catalogue.

_____. "Washington Allston: Method, Imagination, and Reality," *Winterthur Portfolio* 12 (1977): 1-18.

_____. "Washington Allston and Samuel Taylor Coleridge: A Remarkable Friendship," *Archives of American Art Journal* 19.3 (1979): 2-8.

Johns, Sara Elizabeth. "Washington Allston's Theory of the Imagination." Unpublished Ph.D. dissertation, Emory University, 1970.

Johnson, Paul E. *A Shopkeeper's Millennium.* New York: Hill and Wang, 1970.

Jones, Mary Sheriff. "The 'Portraits de Fantasie' of Jean-Honore Fragonard: A Study in Eighteenth-Century Art and Theory." Unpublished Ph.D. dissertation. University of Delaware, 1981.

Kasson, Joy S. "*The Voyage of Life*: Thomas Cole and Romantic Disillusionment," *American Quarterly* 27.1 (1975): 42-56.

Kellner, Sydner. "The Early Hudson River School and the Beginning of Landcsape Painting in America." Unpublished M.A. thesis, New York University, 1936.

_____. "Washington Allston: Method, Imagination, and Reality," *Winterthur Portfolio* 12 (1977): 1-18.

_____. "Washington Allston and Samuel Taylor Coleridge: A Remarkable Friendship," *Archives of American Art Journal* 19.3 (1979): 2-8.

Johns, Sara Elizabeth. "Washington Allston's Theory of the Imagination." Unpublished Ph.D. dissertation, Emory University, 1970.

Johnson, Paul E. *A Shopkeeper's Millennium*. New York: Hill and Wang, 1970.

Jones, Mary Sheriff. "The 'Portraits de Fantasie' of Jean-Honore Fragonard: A Study in Eighteenth-Century Art and Theory." Unpublished Ph.D. dissertation. University of Delaware, 1981.

Kasson, Joy S. *"The Voyage of Life*: Thomas Cole and Romantic Disillusionment," *American Quarterly* 27.1 (1975): 42-56.

Kellner, Sydner. "The Early Hudson River School and the Beginning of Landcsape Painting in America." Unpublished M.A. thesis, New York University, 1936.

Kelly, Franklin W. "Frederic Edwin Church and the North American Landscape." Unpublished Ph.D. dissertation, The University of Delaware, 1985.

_____. "Myth, Allegory, and Science: Thomas Cole's Paintings of Mount Etna," *Arts in Virginia* 23.3 (1983): 2-17.

_____ and Gerald L. Carr. *The Early Landscapes of Frederic Edwin Church*. Fort Worth: Amon Carter Museum, 1987.

Keyes, Donald D., curator. *The White Mountains. Place and Perceptions*. Hanover: University Art Galleries, University of New Hampshire, 1980. Exhibition catalogue.

Kirkham, Edwin B., and John W. Fink. *Indices to American Literary Annuals and Gift Books, 1825-1865*. New Haven: Research Publications, Inc., 1975.

Korshak, Yvonne. "Realism and Transcendent Imagery: Van Gogh's 'Crows over the Wheatfield'," *Pantheon* 43 (1985): 115-23.

Kramer, Michael P. "Horace Bushnell's Philosophy of Language Considered as Cultural Criticism," *The American Quarterly* 38.4 (1986): 573-90.

Krieger, Peter. *Gemalde der deutschen Romantik as der Nationalgalerie Berlin: Caspar David Friedrich, Karl Friedrich Schinkel, Carl Blechen*. Berlin: Frolich and Kaufman, 1985. Exhibition catalogue.

Kroeber, Karl and William Walling, ed. *Images of Romanticism: Verbal and Visual Affinities*. New Haven: Yale University Press, 1978.

Kuspit, Donald B. "19th-Century Landscape: Poetry and Property," *Art in America* 64.1 (1976): 64-71.

La Budde, Kenneth J. "The Mind of Thomas Cole." Unpublished Ph.D. dissertation, University of Minnesota, 1954.

_____. "The Rural Earth: Sylvan Bliss," *American Quarterly* 10 (1958): 142-53.

Landscape and Life in 19th Century America. Brockton: The Brockton Art Center, 1974. Exhibition catalogue.

Langer, Sandra L. "The Aesthetics of Democracy," *Art Journal* 39.2 (1979/80): 132-5.

Larkin, Oliver W. *Art and Life in America*. New York: Holt, Rhinehart and Winston, 1964 (1949).

Lloyd, Phoebe. "Washington Allston: American Martyr?," *Art in America* 72.3 (1984): 145-55, 177-9.

A Loan Collection of Portraits and Pictures of Fair Women. Boston: The Copley Society, 1902. Exhibition catalgue.

Lovejoy, David S. "American Painting in Early Nineteenth-Century Gift Books," *American Quarterly* 7.4 (1955): 345-61.

Loveland, A.C. "Domesticity and Religion in the Antebellum Period: The Career of Phoebe Palmer," *Historian* 39 (1977): 455-71.

Lynes, Russell. *The Art-Makers. An Informal History of Painting, Sculpture and Architecture in Nineteenth-Century America.* New York: Dover, 1982 (1970).

Maddox, Kenneth W. *In search of the picturesque: nineteenth-century images of industry along the Hudson River Valley.* Annandale-on-the-Hudson: Bard College, 1983. Exhibition catalogue.

Malen, Lenore. "The Living Landscape of Frederic Church," *American Art and Antiques* 2.1 (1979): 76-83.

Mann, Maybelle. "The New-York Gallery of Fine Arts: 'A Source of Refinement," *American Art Journal* 11.1 (1979): 76-86.

Manthorne, Katherine. *Creation and Renewal. Views of Cotopaxi by Frederic Edwin Church.* Washington, D.C.: Smithsonian Institution, 1985. Exhibition catalogue.

_____. "The Quest for a Tropical Paradise: Palm Tree as Fact and Symbol in Latin American Landscape Imagery, 1850-1875," *Art Journal* 44.4 (1984): 374-82.

Martinez, Ann Katharine. "The Life and Career of John Sartain (1808-1897). A Nineteenth Century Philadelphia Printmaker." Unpublished Ph.D. dissertation. The George Washington University, 1986.

Marx, Leo. *The Machine in the Garden: Technology and the Pastoral Ideal in America.* New York: Oxford University Press, 1964.

_____. "The Railroad-in-the-Landscape: An Iconological Reading of a Theme in American Art," *Prospects* 10 (1985): 77-118.

Master and Pupil: Thomas Cole and Frederick Church. Northampton: Smith College of Art, 1958. Exhibition catalogue.

Matthews, Glenna. *"Just a Housewife." The Rise and Fall of Domesticity in America.* New York: Oxford University Press, 1987.

Matthiessen, F.O. *American Renaissance. Art and Expression in the Age of Emerson and Whitman.* New York: Oxford University Press, 1957 [1941].

McCoubrey, John W. *American Art, 1700-1960; Sources and Documents.* Englewood Cliffs: Prentice-Hall, 1965.

McDannell, Colleen. *The Christian Home in Victorian America, 1840-1900.* Bloomington: Indiana University Press, 1986.

McGinnis, Karin Hertel. "Moving Right Along: Ninteenth Century Panorama Painting in the United States." Unpublished Ph.D. dissertation. University of Minnesota, 1983.

McKenzie, Alexander. *Lectures on The History of the First Church of Cambridge.* Boston: Congregationalist Publishing Society, 1873.

McKinsey, Elizabeth. *Niagara Falls. Icon of the American Sublime.* New York: Cambridge University Press, 1985.

McLoughlin, William G. *The American Evangelicals, 1800-1900. An Anthology.* New York: Harper and Row, 1968.

Master and Pupil: Thomas Cole and Frederick Church. Northampton: Smith College of Art, 1958. Exhibition catalogue.

Matthews, Glenna. *"Just a Housewife." The Rise and Fall of Domesticity in America*. New York: Oxford University Press, 1987.

Matthiessen, F.O. *American Renaissance. Art and Expression in the Age of Emerson and Whitman*. New York: Oxford University Press, 1957 [1941].

McCoubrey, John W. *American Art, 1700-1960; Sources and Documents*. Englewood Cliffs: Prentice-Hall, 1965.

McDannell, Colleen. *The Christian Home in Victorian America, 1840-1900*. Bloomington: Indiana University Press, 1986.

McGinnis, Karin Hertel. "Moving Right Along: Ninteenth Century Panorama Painting in the United States." Unpublished Ph.D. dissertation. University of Minnesota, 1983.

McKenzie, Alexander. *Lectures on The History of the First Church of Cambridge*. Boston: Congregationalist Publishing Society, 1873.

McKinsey, Elizabeth. *Niagara Falls. Icon of the American Sublime*. New York: Cambridge University Press, 1985.

McLoughlin, William G. *The American Evangelicals, 1800-1900. An Anthology*. New York: Harper and Row, 1968.

_____. *The Meaning of Henry Ward Beecher*. New York: Alfred A. Knopf, 1970.

_____. *Revivals, Awakenings, and Reform*. Chicago: University of Chicago Press, 1978.

McSchine, Kynaston, ed. *The Natural Paradise. Painting in America:1800-1950*. New York: The Museum of Modern Art, 1976. Exhibition catalogue.

Merritt, Howard S. *Thomas Cole*. Rochester: Rochester Memorial Art Gallery, University of Rochester, 1969. Exhibition catalogue.

_____. *To Walk with Nature: The Drawings of Thomas Cole*. Yonkers: Hudson River Museum, 1982. Exhibition catalogue.

Meservey, Anne Farmer. "The Role of Art in American Life: Critics' Views on Native Art and Literature, 1830-1865," *American Art Journal* 10.1 (1978): 72-89.

Miller, Lillian B. "'An Influence in the Air': Italian Art and American Taste in the Mid-Nineteenth Century" in Italian Influences on Nineteenth-Century American Art ed. Irma B. Jaffe. New York: Fordham University Press, 1990.

_____. *Patrons and Patriotism. The Encouragement of the Fine Arts in the United States, 1790-1860*. Chicago: University of Chicago Press, 1966.

_____. "The Lovely and the Wild: The Correspondence Between American Literature abd Painting Before the Civil War" in *Papers on American Art* ed. John C. Milley (Maple Shade: The Edinburgh Press, 1976): 61-86.

Miller, Perry. *Errand into the Wilderness*. Cambridge: Belknap Press of Harvard University Pres, 1978 (1956).

_____. "The Garden of Eden and The Deacon's Meadow," *American Heritage* 7.1 (1955): 54-61, 102.

_____. *The Life of the Mind in America*. New York: Harcourt, Brace and World, 1965.

_____. *Nature's Nation*. Cambridge: Belknap Press of Harvard University Press, 1967.

Nichols, Aidan P. *The Art of God Incarnate. Theology and Symbol from Genesis to the Twentieth-Century*. New York: Paulist Press, 1980.

Nichols, James Hastings. *Romanticism in American Theology. Nevin and Schaff at Mercersburg*. Chicago: University of Chicago Press, 1961.

Noble, David. W. *The Eternal Adam and the New World Garden. The Central Myth in the American Novel Since 1830*. New York: George Braziller, 1968.

_____. *Historians Against History. The Frontier Thesis and the National Covenant in American Historical Writing since 1830*. Minneapolis: University of Minnesota Press, 1965.

Novak, Barbara. *American Painting of the Nineteenth Century. Realism, Idealism, and the American Experience*. New York: Harper and Row, 1979 (1969).

_____. *Nature and Culture. American Landscape and Painting*, 1825-1875. New York: Oxford University Press, 1980.

_____. "Introduction," *Next to Nature. Landscape Paintings from The National Academy of Design*. New York: Harper and Row, 1980, pp. 9-16. Exhibition catalogue.

_____. "On Defining Luminism" in *American Light.The Luminist Movement, 1850-1875. Paintings, Drawings, Photographs*. ed. John Wilmerding. Washington, D.C.: National Gallery of Art, 1980; pp. 23-29.

_____. "On Divers Themes From Nature. A Selection Of Texts" in *The Natural Paradise. Painting in America, 1800-1950*. ed. Kynaston McShine. New York: The Museum of Modern Art, 1976. Exhibition catalogue; pp. 59-106.

_____. "Thomas Cole and Robert Gilmor," *Art Quarterly* 25 (1962): 41-53.

_____. The Thyssen-Bornemisza Collection. *Nineteenth-century American Painting*. London: Sotheby's Publications, 1986.

Nunn, Pamela Gerrish. "Ruskin's Patronage of Women Artists," *Woman's Art Journal* 2.2 (1981/82): 8-13.

Nygren, Edward J., ed. *Views and Visions. American Landscape Before 1830*. Washington, D.C.: The Corcoran Gallery of Art, 1986. Exhibition catalogue.

O'Brien, Raymond J. *American Sublime. Landscape and Scenery of the Lower Hudson Valley*. New York: Columbia University Press, 1981.

Owens, Gwendolyn. *Golden Day, Silver Night*. Ithaca: Cornell University, 1982. Exhibition catalogue.

Packer, B.L. *Emerson's Fall. A New Interpretation of the Major Essays*. New York: Continuum Publishing Company, 1982.

The Paintings of Washington Allston. Essays by Edgar Preston Richardson, Kenyon C. Bolton III, and Elizabeth Johns. Miami: The Lowe Art Museum, 1975. Exhibition catalogue.

Paley, Morton D. *The Apocalyptic Sublime*. New Haven: Yale University Press, 1986.

Palmer, David H. *Be-larged, Be-organed & Be-beautified...A Short History of All Saints' Anglican Church, Rome*. Rome: Studio Grafico ERRE.DI.E., 1981.

Papshvily, Helen Waite. *All the Happy Endings. A Study of the Domestic Novel in America, The Women Who Wrote It, The Women Who Read It, in the Nineteenth Century*. Port Washington: Kennikat Press, 1972 (1956).

Parry, Ellwood C., III. *Ambition and Imagination in the Art of Thomas Cole*. Wilmington: University of Delaware Press, 1989.

Nunn, Pamela Gerrish. "Ruskin's Patronage of Women Artists," *Woman's Art Journal* 2.2 (1981/82): 8-13.

Nygren, Edward J., ed. *Views and Visions. American Landscape Before 1830.* Washington, D.C.: The Corcoran Gallery of Art, 1986. Exhibition catalogue.

O'Brien, Raymond J. *American Sublime. Landscape and Scenery of the Lower Hudson Valley.* New York: Columbia University Press, 1981.

Owens, Gwendolyn. *Golden Day, Silver Night.* Ithaca: Cornell University, 1982. Exhibition catalogue.

Packer, B.L. *Emerson's Fall. A New Interpretation of the Major Essays.* New York: Continuum Publishing Company, 1982.

The Paintings of Washington Allston. Essays by Edgar Preston Richardson, Kenyon C. Bolton III, and Elizabeth Johns. Miami: The Lowe Art Museum, 1975. Exhibition catalogue.

Paley, Morton D. *The Apocalyptic Sublime.* New Haven: Yale University Press, 1986.

Palmer, David H. *Be-larged, Be-organed & Be-beautified...A Short History of All Saints' Anglican Church, Rome.* Rome: Studio Grafico ERRE.DI.E., 1981.

Papshvily, Helen Waite. *All the Happy Endings. A Study of the Domestic Novel in America, The Women Who Wrote It, The Women Who Read It, in the Nineteenth Century.* Port Washington: Kennikat Press, 1972 (1956).

Parry, Ellwood C., III. *Ambition and Imagination in the Art of Thomas Cole.* Wilmington: University of Delaware Press, 1989.

----------. "Acts of God, Acts of Man: Geological Ideas and the Imaginary Landscapes of Thomas Cole" in *Two Hundred Years of Geology in America* ed. Cecil J. Schneer. Hanover: University of New Hampshire Press, 1979; pp. 53-71.

_____. "A Cast of Thousands: Thomas Cole's *Course of Empire* was the box-office hit of the 1836 New York season," *Artnews* 82.8 (1983): 110-2.

_____. "Gothic Elegies for an American Audience: Thomas Cole's Repackaging of Imported Ideas," *American Art Journal* 8.2 (1976): 27-46.

_____. *The Image of the Indian and the Black Man in American Art, 1590-1900.* New York: George Braziller, 1974.

_____. "Landscape Theater in America," *Art in America* 59.6 (1971): 52-62.

_____. "Recent Discoveries in the Art of Thomas Cole: New Light on Lost Works," *Antiques* 120.5 (1981): 1156-65.

_____. "The Road Not Taken: Thomas Cole's Last Series and It's Implications," unpublished manuscript presented to "Symposium: American Paradise: Aspects of the Hudson River School Paintings," Metropolitan Museum of Art, December 11, 1987.

_____. "Some Distant Relatives and American Cousins of Thomas Eakin's Children at Play," *American Art Journal* 18.1 (1986): 21-41.

_____. "Thomas Cole and the Practical Application of Landscape Theory," *New Mexico Studies in the Fine Arts* 3 (1978): 13-22.

_____. "Thomas Cole and the Problem of Figure Painting," *American Art Journal* 4.2 (1972): 66-86.

Porte, Joel, ed. *Emerson in His Journals*. Cambridge: Belknap Press of Harvard University Press, 1982.

Porter, J.R. and A.A. Albert, "Subculture of Assimilation: A Cross-Cultural Analysis of Religion and Women's Role," *Journal of the Scientific Study of Religion* 16 (1977): 345-59.

Porterfield, Amanda. *Feminine Spirituality in America, From Sarah Edwards to Martha Graham*. Philaldephia: Temple University Press, 1980.

Portraits of Women. New York: National Academy of Design, 1894. Exhibition catalogue.

Portraits of Women. Boston: Copley Hall, 1895. Exhibition catalogue.

Powell, Earl A., III. "Luminism and the American Sublime" in *American Light. The Luminist Movement, 1850-1875. Paintings, Drawings, Photographs* ed. John Wilmerding. Washington, D.C.: National Gallery of Art, 1980; pp. 69-94. Exhibition catalogue.

_____. "Thomas Cole's *Dream of Arcadia*," *Arts* 52.3 (1978): 113-7.

_____. "Thomas Cole and the American Landscape Tradition: Associationism," *Arts* 52.8 (1978): 113-7.

_____. "Thomas Cole and the American Landscape Tradition: The Naturalist Controversy," *Arts* 52.6 (1978): 114-23.

_____. "Thomas Cole and the American Landscape Tradition: The Picturesque," *Arts* 52.7 (1978): 110-7.

Powers, Katherine. The Cathedral Church of St. Paul, 1912-1987. *An Anniversary History*. Pamphlet, np., nd.

Prickett, Stephen. *Coleridge and Wordsworth: The Poetry of Growth*. Cambridge: Cambridge University Press, 1970.

_____. *Romanticism and Religion. The Tradition of Coleridge and Wordsworth in the Victorian Church*. Cambridge: Cambridge University Press, 1976.

Rapson, Richard L. "The American Child as Seen by British Travelers, 1845-1935," *American Quarterly* 17.3 (1965): 520-34.

Ratcliff, Carter. "Allston and the Historical Landscape," *Art in America* 68.8 (1980): 96-104.

Reynolds, D.S. "Feminization controversy: sexual stereotypes and the paradoxes of purity in nineteenth-century America," *New England Quarterly* 53 (1980): 96-106.

Reynolds, David S. *Beneath the American Renaissance. The Subversive Imagination in the Age of Emerson and Melville*. New York: Alfred P. Knopf, 1988.

_____. "From Doctrine to Narrative: The Rise of Pulpit Storytelling in America," *American Quarterly* 32 (1980): 479-98.

Richardson, Edgar Preston. "Allston and the Development of Romantic Color," *Art Quarterly* 7.1 (1944).

_____. "The Romantic Genius of Thomas Cole," *Art News* 55 (1956): 43, 52.

_____. *Washington Allston, 1779-1843. A Loan Exhibition of Paintings, Drawings, and Memorabilia*. Detroit: Detroit Institute of Art, 1947. Exhibition catalogue.

_____. *Washington Allston. The Biography of a Pioneer of American Art and a Study of the Romantic Artist in America*. New York: Thomas Y. Crowell Company, 1967 (1948).

Ringe, Donald A. "Kindred Spirits: Bryant and Cole," *American Quarterly* 6 (1954): 233-44.

Prickett, Stephen. *Coleridge and Wordsworth: The Poetry of Growth*. Cambridge: Cambridge University Press, 1970.

_____. *Romanticism and Religion. The Tradition of Coleridge and Wordsworth in the Victorian Church*. Cambridge: Cambridge University Press, 1976.

Rapson, Richard L. "The American Child as Seen by British Travelers, 1845-1935," *American Quarterly* 17.3 (1965): 520-34.

Ratcliff, Carter. "Allston and the Historical Landscape," *Art in America* 68.8 (1980): 96-104.

Reynolds, D.S. "Feminization controversy: sexual stereotypes and the paradoxes of purity in nineteenth-century America," *New England Quarterly* 53 (1980): 96-106.

Reynolds, David S. *Beneath the American Renaissance. The Subversive Imagination in the Age of Emerson and Melville*. New York: Alfred P. Knopf, 1988.

_____. "From Doctrine to Narrative: The Rise of Pulpit Storytelling in America," *American Quarterly* 32 (1980): 479-98.

Richardson, Edgar Preston. "Allston and the Development of Romantic Color," *Art Quarterly* 7.1 (1944).

_____. "The Romantic Genius of Thomas Cole," *Art News* 55 (1956): 43, 52.

_____. *Washington Allston, 1779-1843. A Loan Exhibition of Paintings, Drawings, and Memorabilia*. Detroit: Detroit Institute of Art, 1947. Exhibition catalogue.

_____. *Washington Allston. The Biography of a Pioneer of American Art and a Study of the Romantic Artist in America*. New York: Thomas Y. Crowell Company, 1967 (1948).

Ringe, Donald A. "Kindred Spirits: Bryant and Cole," *American Quarterly* 6 (1954): 233-44.

_____. "Painting as Poem in the Hudson River Aesthetic," *American Quarterly* 12 (1960): 71-83.

Rivard, Nancy J. "Notes on the Collection: *Cotopaxi*," *Bulletin of The Detroit Institute of Arts* 56.3 (1978): 193-6.

Robertson, Darryl M. "The Feminization of American Religion: An Examination of Recent Interpretations of Women and Religion in Victorian America," *Christian Scholar's Review* 8 (1978): 238-46.

Robertson, James Oliver. *American Myth, American Reality*. New York: Hill and Wang, 1980.

The Romantic Vision. *19th Century American Landscape Painting in the Walker Art Center Permanent Collection*. Minneapolis: Walker Art Center, 1978.

The Romantic Vision in America. Dallas: Dallas Museum of Fine Arts, 1971. Exhibition catalogue.

Romantiken I Dresden. Caspar David Friedrich och hans samtida,1800-1900. Oslo: Nastionalmuseum, 1980. Exhibition catalogue.

Roque, Oswaldo Rodriquez. "*The Oxbow* by Thomas Cole: Iconography of an American Landscape Painting," *Metropolitan Museum Journal* 17 (1984): 63-72.

Rose, Anne C. *Transcendentalism as a Social Movement, 1830-1850*. New Haven: Yale University Press, 1981.

Rosen, Charles and Henri Zerner. *Romanticism and Realism: The Mythology of Nineteenth-Century Art*. New York: Viking, 1984.

_____. "The Proper Study--Autobiographies in American Studies," *American Studies* 29 (1977): 241-62.

Schenk, H.G. *The Mind of the European Romantics.* New York: Oxford University Press, 1979 (1966).

Schleisinger, Arthur M. and Morton White, eds. *Paths of American Thought.* Boston: Houghton Mifflin, 1963.

Schmitt, Evelyn L. "Two American Romantics: Thomas Cole and William Cullen Bryant," *Art in America* 41.2 (1953): 61-68.

Schorsch, Anita. *Images of Childhood. An Illustrated Social History.* New York: Mayflower Books, Inc. 1979.

Schneider, Herbert. *A History of American Philosophy.* New York: Columbia University Press, 1963 (1946).

Schweizer, Paul D. "'So exquisite a transcript': James Smillie's Engravings after Thomas Cole's *Voyage of Life,*" *Imprint* 11.2 (1986): 2-13 (Part One); and 12.1 (1987): 13-24 (Part Two).

Seaver, Esther I. *Thomas Cole, One Hundred Years Later.* Hartford: Wadsworth Atheneum, 1948. Exhibition catalogue.

Seifert, Carolyn J. "Images of Domestic Madness in the Art and Poetry of American Women," *Woman's Art Journal* 1.2 (1980/81): 1-6.

Sellin, David. *American Art in the Making: Preparatory Studies for Masterpieces of American Painting, 1800-1900.* Washington, D.C.: Smithsonian Institution Press, 1976. Exhibition catalogue.

Seymour, Jr., Charles. "The Jarves Collection as a Tool for General Education and Research" in *Rediscovered Italian Paintings.* New Haven: Yale University Art Gallery, 1952; pp. 6-9. Exhibition catalogue.

Sharples, Stephen Paschall. *Records of The Church of Christ, at Cambridge, New England, 1632-1860.* Boston: Eben Putnam, 1906.

Shephard, Lewis A. *American Painters of the Arctic.* Amherst: Amherst College, 1975.

Shiels, Richard D. "The Feminization of American Congregationalism, 1730-1835," *American Quarterly* 33 (1981): 46-62.

Silberfeld, Kay. "The Lost Painting of Thomas Cole," *Museum News* (1965): 31-38.

Sill, Gertrude G. *A Handbook of Symbols in Christian Art.* New York: Macmillan Company, 1975.

Sizer, Theodore. "James Jackson Jarves, 1818-1888" in *Rediscovered Italian Paintings.* New Haven: Yale University Art Gallery, 1959; pp. 4-5. Exhibition catalogue.

Smith, David L. *Symbolism and Growth in the Thought of Horace Bushnell.* Chico: Scholars Press, 1983.

Smith, Gayle L. "Emerson and the Luminist Painters: A Study of Their Styles," *American Quarterly* 37 (1985): 193-215.

Smith, Henry Nash. *Democracy and the Novel. Popular Resistance to Classic American Writers.* New York: Oxford University Press, 1978.

_____. "A Textbook of the Genteel Tradition: Henry Ward Beecher's *Norwood,*" *Prospects* 3 (1977): 135-54.

_____. *Virgin Land. The American West as Symbol and Myth.* Cambridge: Harvard University Press, 1970.

Sellin, David. *American Art in the Making: Preparatory Studies for Masterpieces of American Painting, 1800-1900.* Washington, D.C.: Smithsonian Institution Press, 1976. Exhibition catalogue.

Seymour, Jr., Charles. "The Jarves Collection as a Tool for General Education and Research" in *Rediscovered Italian Paintings.* New Haven: Yale University Art Gallery, 1952; pp. 6-9. Exhibition catalogue.

Sharples, Stephen Paschall. *Records of The Church of Christ, at Cambridge, New England, 1632-1860.* Boston: Eben Putnam, 1906.

Shephard, Lewis A. *American Painters of the Arctic.* Amherst: Amherst College, 1975.

Shiels, Richard D. "The Feminization of American Congregationalism, 1730-1835," *American Quarterly* 33 (1981): 46-62.

Silberfeld, Kay. "The Lost Painting of Thomas Cole," *Museum News* (1965): 31-38.

Sill, Gertrude G. *A Handbook of Symbols in Christian Art.* New York: Macmillan Company, 1975.

Sizer, Theodore. "James Jackson Jarves, 1818-1888" in *Rediscovered Italian Paintings.* New Haven: Yale University Art Gallery, 1959; pp. 4-5. Exhibition catalogue.

Smith, David L. *Symbolism and Growth in the Thought of Horace Bushnell.* Chico: Scholars Press, 1983.

Smith, Gayle L. "Emerson and the Luminist Painters: A Study of Their Styles," *American Quarterly* 37 (1985): 193-215.

Smith, Henry Nash. *Democracy and the Novel. Popular Resistance to Classic American Writers.* New York: Oxford University Press, 1978.

_____. "A Textbook of the Genteel Tradition: Henry Ward Beecher's *Norwood*," *Prospects* 3 (1977): 135-54.

_____. *Virgin Land. The American West as Symbol and Myth.* Cambridge: Harvard University Press, 1970.

Smith, Shelton. *Changing Conceptions of Original Sin. A Study in American Theology Since 1750.* New York: Charles Scribner's Sons, 1955.

Snow, Julia D. Sophronia. "Delineators of the Adams-Jackson American Views. Part I. Thomas Cole, R.A.," *Antiques* 30.5 (1936): 214-9.

Soria, Regina. "Washington Allston's Lectures on Art: The First American Art Treatise," *The Journal of Aesthetics and Art Criticism* 18.3 (1960): 329-44.

Spencer, Harold, ed. *American Art. Readings from the Colonial Era to the Present.* New York: Charles Scribner's Sons, 1980.

Stebbins, Theodore E., Jr. *Hudson River School: 19th century American Landscapes in the Wadsworth Atheneum.* Hartford: Wadsworth Atheneum, 1976. Exhibition catalogue.

_____. "Thomas Cole at Crawford Notch," National Gallery of Art Studies in the *History of Art* 2 (1968): 133-45.

Stebbins, Theodore E., Jr., Carol Troyen and Trevor J. Fairbrother. *A New World: Masterpieces of American Painting 1760-1910.* Boston: Museum of Fine Art, 1983. Exhibition catalogue.

Stein, Roger B. *The View and The Vision: Landscape Painting in Nineteenth-Century America.* Seattle: University of Washington, 1968. Exhibition catalogue.

Trensky, Anne Tropp. "The Saintly Child in Nineteenth-Century American Fiction," *Prospects* 1 (1975): 389-413.

Truettner, William H. "The Genesis of Frederic Edwin Church's *Aurora Borealis*," *Art Quarterly* 31.3 (1968): 266-83.

Tunnard, Christopher. "Reflections on *The Course of Empire* and other Architectural Fantasies of Thomas Cole, N.A.," *Architectural Review* 104 (1948): 291-94.

Turner, Victor. *Forest of Symbols*. Ithaca: Cornell University Press, 1977 [1967].

Tyler, Alice Felt. *Freedom's Ferment*. New York: Harper Torchbook, 1962 [1944].

Vassar College Art Gallery Catalogue. Poughkeepsie: Vassar College Art Gallery, 1939.

Vassar College Art Gallery. *Selections from the Permanent Collection*. Poughkeepsie: Vassar College Art Gallery, 1967.

Vaugh, William. *German Romantic Painting*. New Haven: Yale University Press, 1980.

Wallace, Richard W. *Salvator Rosa in America*. Wellesley: The Wellesley College Museum, 1979. Exhibition catalogue.

Wallach, Alan. "Cole, Byron, and *The Course of Empire*," *Art Bulletin* 50.4 (1968): 375-9.

_____. "The Ideal American Artist and the Dissenting Tradition: A Study of Thomas Cole's Popular Reputation." Unpublished Ph.D. dissertation, 1973.

_____. "Thomas Cole: British Esthetics and American Scenery," *Artforum* 8.10 (1969): 46-49.

_____. "Thomas Cole and the Aristocracy," *Arts* 56.3 (1981): 94-106.

_____. "The *Voyage of Life* as Popular Art," *The Art Bulletin*: 234-41.

_____. "The Word from Yale," [review of Wolf's *Romantic Re-Vision*], *Art History* 10.2 (1987): 256-61.

Warren, David B. *Nineteenth-Century American Landscape Painting: Selections from The Thyssen-Bornemisza Collection*. Houston: Museum of Fine Arts, 1982.

Weiskel, Thomas. *The Romantic Sublime. Studies in the Structure and Psychology of Transcendence*. Baltimore: Johns Hopkins University.

Welch, Claude. *Protestant Thought in the Nineteenth Century. Volume I: 1799-1870*. New Haven: Yale University Press, 1974 [1972].

Welchans, Roger Anthony. "The Art Theories of Washington Allston and William Morris Hunt." Unpublished Ph.D. dissertation, Case Western Reserve University, 1970.

Welsh, John R. "An Anglo-American Friendship: Allston and Coleridge," *American Studies* 5.1 (1971): 81-91.

Welter, Barbara. *Dimity Convictions. The American Woman in the Nineteenth Century*. Athens: Ohio University Press, 1976.

_____. "The Feminization of American Religion: 1800-1860" in *Clio's Consciousness Raised* ed. Lois W. Banner and Mary Hartman. New Harper and Row, 1974; pp. 137-57.

_____. "She Hath Done What She Could: Protestant Women's Missionary Careers in Nineteenth-Century America," *American Quarterly* 30 (1978): 624-38.

Whittick, Arnold. *Symbols, Signs and Their Meaning*. London: Leonard Hill Books, Ltd., 1960.

Wildenstein, Georges. *The Paintings of Fragonard*. London: Phaidon Press, 1960.

Williams, George H. *Wilderness and Paradise in Christian Thought. The Biblical Experience of the Desert in the History of Christianity and The Paradise Theme in the Theological Idea of the University*. New York: Harper and Row, 1962.

_____. "Thomas Cole: British Esthetics and American Scenery," *Artforum* 8.10 (1969): 46-49.

_____. "Thomas Cole and the Aristocracy," *Arts* 56.3 (1981): 94-106.

_____. "The *Voyage of Life* as Popular Art," *The Art Bulletin*: 234-41.

_____. "The Word from Yale," [review of Wolf's *Romantic Re-Vision*], *Art History* 10.2 (1987): 256-61.

Warren, David B. *Nineteenth-Century American Landscape Painting: Selections from The Thyssen-Bornemisza Collection*. Houston: Museum of Fine Arts, 1982.

Weiskel, Thomas. *The Romantic Sublime. Studies in the Structure and Psychology of Transcendence*. Baltimore: Johns Hopkins University.

Welch, Claude. *Protestant Thought in the Nineteenth Century. Volume I: 1799-1870*. New Haven: Yale University Press, 1974 [1972].

Welchans, Roger Anthony. "The Art Theories of Washington Allston and William Morris Hunt." Unpublished Ph.D. dissertation, Case Western Reserve University, 1970.

Welsh, John R. "An Anglo-American Friendship: Allston and Coleridge," *American Studies* 5.1 (1971): 81-91.

Welter, Barbara. *Dimity Convictions. The American Woman in the Nineteenth Century*. Athens: Ohio University Press, 1976.

_____. "The Feminization of American Religion: 1800-1860" in *Clio's Consciousness Raised* ed. Lois W. Banner and Mary Hartman. New Harper and Row, 1974; pp. 137-57.

_____. "She Hath Done What She Could: Protestant Women's Missionary Careers in Nineteenth-Century America," *American Quarterly* 30 (1978): 624-38.

Whittick, Arnold. *Symbols, Signs and Their Meaning*. London: Leonard Hill Books, Ltd., 1960.

Wildenstein, Georges. *The Paintings of Fragonard*. London: Phaidon Press, 1960.

Williams, George H. *Wilderness and Paradise in Christian Thought. The Biblical Experience of the Desert in the History of Christianity and The Paradise Theme in the Theological Idea of the University*. New York: Harper and Row, 1962.

Willson, A. Leslie, ed. *German Romantic Criticism. Novalis, Schlegel, Schleiermacher, and Others*. New York: Continuum Publishing Company, German Library #21, 1982.

Wilmerding, John, ed. *American Light. The Luminist Movement, 1850-1875. Paintings. Drawings. Photographs*. Washington, D.C.: National Gallery of Art, 1980. Exhibition catalogue.

_____. "Luminism: The Poetry of Light," *Portfolio* 1.2 (1979): 20-30.

Wilson, Christopher Kent. "Rediscovered Thomas Cole Letter: New Light on the *Expulsion from the Garden of Eden*," *The American Art Journal* 18.1 (1986): 73-74.

Winslow, Ola Elizabeth. "Books for the Lady Reader, 1820-1860" in *Romanticism in America* ed. George Boas (New York: Russell & Russell, 1971), pp. 89-109.

Wolf, Bryan Jay. "A Grammar of the Sublime, or Intertextuality Triumphant in Church, Turner and Cole," *New Literary History* 16.2 (1985): 321-41.

_____. "All the World's a Code: Art and Ideology in Nineteenth-Century American Painting," *Art Journal* 44.4 (1984): 328-37.